THE SUBJECT OF CRUSADE

THE
Subject OF
Crusade

Lyric, Romance, and Materials, 1150 to 1500

MARISA GALVEZ

THE UNIVERSITY OF CHICAGO PRESS
Chicago & London

The University of Chicago Press, Chicago 60637
The University of Chicago Press, Ltd., London
© 2020 by The University of Chicago
Published 2020
Printed in the United States of America

29 28 27 26 25 24 23 22 21 20 1 2 3 4 5

ISBN-13: 978-0-226-69321-7 (cloth)
ISBN-13: 978-0-226-69335-4 (paper)
ISBN-13: 978-0-226-69349-1 (e-book)
DOI: https://doi.org/10.7208/chicago/9780226693491.001.0001

The University of Chicago Press gratefully acknowledges the generous
support of Stanford University toward the publication of this book.

Library of Congress Cataloging-in-Publication Data

Names: Galvez, Marisa, author.
Title: The subject of crusade : lyric, romance, and
materials, 1150 to 1500 / Marisa Galvez.
Description: Chicago : University of Chicago Press, 2020. |
Includes bibliographical references and index.
Identifiers: LCCN 2019035336 | ISBN 9780226693217 (cloth) |
ISBN 9780226693354 (paperback) | ISBN 9780226693491 (ebook)
Subjects: LCSH: Crusades in literature. | Crusades in art. |
Poetry, Medieval—History and criticism.
Classification: LCC PN690.C7 G35 2020 | DDC 809/.93358207—dc23
LC record available at https://lccn.loc.gov/2019035336

CONTENTS

ILLUSTRATIONS

BLACK-AND-WHITE FIGURES

The Courtly Crusade Idiom

WHEN MEDIEVAL PEOPLE went to war over religion, they prayed, took up arms, bade farewell to their families—and sometimes wrote lyric poetry. These warrior-artisans expressed their culture in poetry as live performance as well as in other art forms, from prayer books and tombstones to elaborate embroidered tapestries. More than historical documents or expressions of a common spirit of crusade, these fundamentally *lyric* works, I will be claiming—including songs, tapestries, and manuscripts—enabled their makers to process experiences of popular piety and personal sacrifice related to holy war.

In this book I argue that these specifically lyrical articulations are crucial for understanding the crusades as a complex cultural and historical phenomenon. By the *crusades* I mean generally the largest collective religious undertaking in the Middle Ages, the movement by the Roman Catholic Church to liberate the Holy Land in the East from Islamic rule, which took place from about 1095 to 1300.[1] During the twelfth and thirteenth centuries, some crusaders were poets, and many of them wrote lyrics about their experiences and the events they witnessed. What do their poetic accounts represent? How do the crusades "speak" through competing lyric discourses and value systems? When individual poets and artists speak crusades, they might use their medium to think through alternative positions without reaching a conclusion. The works produced in this way are dynamic, open-ended, and contradictory rather than ideologically cohesive. They often adapt, transform, or even subvert the dominant crusade ideology found in sermons and ecclesiastical mandates, and they sometimes comment on the more official language with which crusaders were enjoined to take up the cross.

They may register a desire for an agency of conscience or social status within a context of spiritual vocation while revealing an ambivalence about crusading intention based on earthly desire and fear.

In a period during which the church imagined the need to recover the Holy Land as inseparable from the individual and collective moral reform of its believers, the crusader subject of vernacular literature and media sought to reconcile competing ideals of earthly love and chivalry with crusade as a penitential pilgrimage. For some, such a reconciliation was untroubled; certainly there are many chronicles, sermons, works of art, and narrative poems (e.g., chansons de geste) that affirm the preaching of the church to reclaim the Holy Land.[2] This book concerns a certain version of speaking crusades, in which courtly art forms such as lyric, romance, and material objects such as tapestries and textiles manifest ambivalence about crusade ideals. It limits itself to works from roughly 1150 to 1300, with a passing glance at the fifteenth century: works such as crusade departure songs, romances about Lancelot as a crusader and about the heart separating from the body, and a chronicle that describes a feast for taking crusading vows. I describe how poetic figures do the work of accommodation and assimilation and how literary texts permit competing ideals to be maintained adjacently, thereby producing what I call a *courtly crusade idiom* whose movement we can track through various constellations of genres, manuscripts, and objects related to being a *crucesignatus* (one who takes up the cross). Before literature about collective warfare became more obviously confessional in the modern era, what conventions registered the inner conditions of crusaders and other warriors? The performance of this crusade idiom and its translation into particular types of materials show how medieval discourses of penance, holy war, and pilgrimage could be adapted for an elite audience invested in the ideals of chivalry and courtliness.

Much of the scholarship on crusade tacitly assumes that the ideology, practices, and even poetic language about crusade are unified and self-evident — a kind of European lingua franca that transcends historical moments and national or regional situations. This idea of

a unified language of the church and philosophy coincides with one sense of the term *idioma* developed by clerics and philosophers such as Giles of Rome and others — namely, the Latin learned in school as opposed to the vernacular language whose meaning was established by custom and learned from one's mother. As Giles says, "philosophers saw that no vulgar idiom was complete and perfect enough to express perfectly . . . things that they wished to dispute about. So they fashioned for themselves a sort of idiom [*proprium idioma*] appropriate to these ends, that is called Latin . . . which they made so large and copious that with it they could sufficiently express everything they thought of."[3] The study of this kind of learned universal Latin idiom in sermons, treatises, and encyclicals has provided the textual evidence (the *logos*) for foundational studies on crusade mentalities by scholars such as Paul Alphandéry.[4] Such studies place a collective psychology dependent on a certain identity of language above historical causality and context. Yet this is not the only definition of *idiom* among medieval writers. According to Thomas Aquinas and Roger Bacon, *idiomata* (Bacon) or *locutiones* (Aquinas) are particularisms accidentally differentiated from a unified *lingua*. As Bacon explains in his Greek grammar, differences within the Greek language are called dialects (*idiomata*). He calls them *idiomata* and not *linguae* because they are not different languages, but different peculiarities (*proprietas*) which are dialects (*idomata*) of the same language.[5] Bacon defines *idioma* as "the determined peculiarity (*proprietas*) of language, which one *gens* uses after its custom. Another *gens* uses another *idioma* of the same language."[6] This sense of idiom is structurally related to the distinction between *idiomata* and *lingua*. Moreover, because of its rhythmic and musical properties, an idiom is often challenging to paraphrase or translate. More than dialects in this linguistic sense, idioms exist through their usage, an untranslatable quality independent of the "substance" of their meaning.[7] This distinction provides a helpful way to distinguish between *idiomata* and *lingua*. In the period under consideration here, what *idiomata* are to *linguae* for Aquinas and Bacon, the courtly crusade idiom is to crusade ideology in my period.

Jean-François Lyotard identifies verbal categories such as "rai-
sonner, connaître, décrire, raconter, interroger, montrer, ordonner"
which, as "régimes de phrases" (phrase regimens), emerge from
situations in which rule-bound discourses are being remade and
hence new idioms being formulated.[8] For the courtly crusade idiom,
such rule-bound discourses might include courtly, feudal, and peni-
tential. A *différend* occurs when two parties are speaking and one
party's "idiom" cannot be recognized in the other's discourse, what
Lyotard calls "le règlement du conflit" (the settling of the conflict).[9]
This incomprehensible speaking must be put into new phrases to
avoid one phrase's silencing of another. The *différend* recognizes
silence that demands to be put into new phrases and rules, with new
receivers and referents.[10] Much like Lyotard's *différend*, the courtly
crusade idiom declares nothing but instead speaks of positions in
unsettled and heterogenous ways. I describe such phrasings of cru-
sade in poetry and in the material archive, looking for crusade exis-
tences in objects such as manuscripts and tapestries, and in literary
genres across time.[11]

In describing this movement of the idiom in texts and various
media, this book emphasizes the term *materials* rather than *objects*
or *artworks* specifically because I am interested in foregrounding the
idiom in this Lyotardian sense, and in the social, historical, eco-
nomic, and artistic processes that produce an idiom through a spe-
cific medium. Rather than limiting my analysis to bounded material
objects with temporal and linguistic designations, I show how the
object's materiality might be separated into elements such as frag-
ments of sewn together parchment rolls or threads that have their
own history or mobility. As I hope to show, the materials of a tapes-
try (silk thread wrapped in gold), manuscript illustrations (grisaille
with gold and red details), crusader effigies, and steles with epitaphs
all speak idiomatically.

The crusade idiom developed with the rise of the new Chris-
tian knightly code in the twelfth and thirteenth centuries that in-
cluded the formal liturgical rite of "taking the cross," a ceremony
that turned a warrior into a knight with Christian values.[12] Histo-

rians such as William Chester Jordan and Jonathan Phillips have studied the rich documentation of crusaders undergoing the rituals of taking confession, offering and receiving prayers, and showing devotion to a relic or saint in a particular place. These protocols of departure by militant pilgrims involved ceremonial gestures that took on a religious character and coincided with rituals of nonviolent penitential pilgrimages.[13] This study depends on the foundational scholarship of Richard Kaeuper, John Baldwin, and others who have shown how chivalric works in Old French reflect changes in ideas about penance and confession. By adapting penance according to their feudal values, such texts might advance knightly ideology for an aristocratic audience.[14]

To the vast scholarship on crusading literature, this book contributes a deliberately experimental yet focused study of select cases that articulate competing ideals through artistic conventions informed by this knightly code. Discussing examples from the twelfth to the fifteenth centuries, I see the idiom's emergence after the trauma of Saladin's victory in 1187—a disaster that was unforeseen by the Christian army despite the appeals that had come from the kingdom of Jerusalem in recent years.[15] Saladin's capture of Jerusalem and the True Cross provoked lyric responses from the poets who open my study. While the dating of many songs is uncertain and complicated (as poets tended to revise their works in light of events), Linda Paterson's recent study of Old Occitan and Old French songs confirms a change in attitude and sensibility soon after the fall of Jerusalem and during the Third and Fourth Crusades (1187–94; 1202–4).[16] Around this period, poets begin to compose songs of departure and separation known as *chansons de départie*. While these songs are quantitatively overshadowed by those that exhort crusade, they articulate a lack of enthusiasm for taking up the cross or a need to dramatize the painful duty of turning away from earthly cares for a more penitent life in God's service. Carefully crafted, they enlist the poetic conventions of aristocratic lyric poetry of the period.[17]

The story told here begins with the love song of departure not only because of this change in sensibility by the end of the twelfth

century. This kind of lyric speaks implicitly and indirectly about worldly concerns, indecision, and the fear of death and damnation for an elite public that looked to courtly art for an eloquent way out of the moral dilemma of departure. For these poets and their audiences, the language of the church that encouraged a crusader to find strength from within by embracing God wholeheartedly, and from ideals of faith and fealty to kin and king, were not enough. The departure song—and by extension other forms of art that would draw from its poetic figures—gave voice to an ethical unsettledness and equivocation, lending complex form to a painful, life-defining moment so the crusader could eventually master conflictual desires and, in a dramatic gesture of self-sacrifice and self-exile, turn toward the spiritual duty of the pilgrim and holy warrior. There are many contemporaneous critiques of crusading. Indeed, the twelfth-century poet Conon de Béthune criticizes the tyrants who crusade for their own earthly benefits, those who take advantage of the crusading tax (*dîme saladine*) to finance their war against the English: "ces tirans. . . . ki sont croisiet a loier / Por dismer clers et borgois et sergans; / Plus en croisa covoitiés ke creance" (those tyrants . . . who have taken up the cross to enrich themselves by the tax on clerics, burghers, and officers; they crusade more by greed than by faith; "Bien me deüsse," lines 26-29).[18] *The Subject of Crusade* follows a different track, exploring how the idiom speaks resistance and ambivalence through literature and art that has a different kind of effect in the quotidian medieval world as well as implications for modern views of crusade and holy war. An examination of how one culture speaks crusades shows the process by which one lyric or artifact bestows meaning and form on the volition that drives religious violence. A sympathetic attention to this drive from a historical and literary perspective grants complexity to the simplistic binaries of good and evil, us versus them, that permeate the political climate of the modern world.

While these poets belonged to various social classes, the transmission of their songs in luxurious manuscripts indicates that they composed primarily for an elite audience attuned to the complexity

of speaking crusades in a courtly manner that could deflect and equivocate upon clerical discourse.[19] While some poets were crusaders themselves (e.g., the count Thibaut de Champagne IV led the failed campaign of 1239), others accompanied or praised their crusading lords and traveled with them to courts in Europe and the Latin East, as in the case of Raimbaut de Vaqueiras. Songs were likely composed and performed for initiated groups in courts in France and Outremer and formed part of departure rites among family members and peers. They might be performed in a fortress to keep up spirits in Thessalonica, in a prison as in the captive king Richard the Lionheart's song composed when he was imprisoned in Germany, or on the battlefield before the siege of Constantinople, or in various courts of Limousin or Malaspina along the routes where crusaders waited for reinforcements.[20] During the period of the Barons' Crusade led by Thibaut IV, he and other poets of his status composed songs about painful separation and departure. Addressed to a courtly audience, these songs make no attempt at exhorting crusade. Indeed, these poets of different classes and languages were likely in contact with one another or at least were familiar with this elite art form that reinforced courtly and knightly values.[21]

If the idiom expresses something other than unequivocal support for crusade, lyric poems and other works of art do so in particular ways. Poems that identify themselves as written during or around crusades nonetheless often neglect to address the events related to military campaigns abroad, and instead praise the courtliness they have left behind. In one poem composed in the Holy Land, the troubadour Giraut de Borneil (fl. 1165–c. 1211), celebrated by Dante as the poet of rectitude, defends the courtly way of life. He describes how his type of song is not only a political tool to criticize unworthy people but also a comfort during difficult times:

> De chantar
> ab deport
> mi for'eu totz laissatz;
> mas quant soi ben iratz

estenc l'ir'ab lo chan

e vau mi conortan.

Qu'estiers non fora patz

entre l'ir'e·l coratge;

qu'ieu vei d'un mal usatge

que puei'ades e creis,

[. . .]

Alegrar

mi voill fort

e son aisi passatz,

e si non sembles fatz,

no camiera·l talan;

mas tenon s'a masan

mains bos sonetz qu'eu fatz

vilan d'aol linatge,

qu'anc pros hom de paratge,

s'en ben auzir ateis,

de l'escoutar no·s feis

ni·l plaszer no n'estrais.

 (lines 1–31)

I would give up singing and pleasant pastimes altogether, but when
I feel sad I comfort myself by drowning my sorrows in song. Other-
wise my heart would have no peace from sadness; for I see that an
evil way of life is constantly on the rise and increase. . . . I wish to live
most joyfully and have crossed to the Holy Land in this spirit. If I
did not look a fool I should not change my inclination; but churl-
ish, base-born people think many of the fine melodies I compose are
a form of rowdiness, even though any excellent man of noble birth
who takes care to hear them properly has never excused himself
from listening to them or abstained from the pleasure they afford.[22]

Here Giraut concedes that courtly song must adjust to the new situa-
tion abroad and in this, as Paterson suggests, he responds to Sala-
din's victory and the new spiritual ethos after the catastrophic event.

The courtly song attempts to create stability during disastrous times and in new places. It also calls for a certain attentiveness—note the double use of "auzir" and "escoutar," to hear and listen: Giraut emphasizes the receptiveness required if one wants the rewards of comfort and joy. Crusade song is based on current events, the locations of different courtly publics, and the changing mentalities about crusade. But as Giraut tells us, song also does something else: it creates courtly communities between Europe and the Latin East by invoking the integrity of an art for an invested public. Giraut trusts his public understands a certain quiddity about singing, or *chantar*, a something that is adaptable and mobile. If one listens carefully, the song may give voice to contradictory intentions about crusade—carnal, material, and spiritual. This process of performance, of an engagement between the singer and his public that emerges from our knowledge of his specific location, illuminates the value of the crusade idiom's use as well as the conditions of its production.

With this in mind, the book describes first how the idiom emerged under historical conditions and in the lyric poetry of the Old French, Old Occitan, Middle High German, and Italian traditions. I then turn to the *Perlesvaus* and the *Roman du Castelain de Couci*, romances about crusade that draw from this lyric tradition. These texts are in dialogue with new ideas about penance and confession from the second half of the twelfth century to the end of the thirteenth. In taking up the cross, crusaders were supposed to have a pure conscience (*pura conscientia*).[23] Clerical apologists of the Second Crusade who subscribed to the pilgrimage tradition, such as Peter the Venerable, Bernard of Clairvaux, and Ralph Niger, emphasized that the physical *imitatio Christi* (imitation of Christ) was of little value unless it was accompanied by an internal, spiritual *imitatio*. This *imitatio* took the form of a moral regeneration that was a mark of true repentance.[24] In his treatise "De Laude Novae Militiae" (c. 1128–37), addressed to the Templars but applicable to crusaders, Bernard of Clairvaux emphasizes that the true soldier of Christ accepts death as a martyr and is therefore fearless. In his elaboration of the crusader's pure conscience and right intention (*intentio recta*),

Bernard warns that the knight must fight for no cause other than Christ.[25] Being a *crucesignatus* means the renunciation of the world, family, and possessions; it also includes spiritual purgation on the hard pilgrimage east as an imitation of Christ.[26]

In preparation for a new campaign that would come to be known as the Fourth Crusade, in 1198 and 1199, Pope Innocent III introduced a series of reforms and an important indulgence that would resonate with his contemporaries and demonstrate the influence of Bernard. He promised crusaders that their military service would give them full remission of their sins and absolve them of any punishment in this world and the next, provided they showed proper penitence for their transgressions in voice and heart. In the period of the Fifth Crusade (1213–21), Innocent and other Paris-educated reformers saw the need for more organized means of moral and social reform. Like earlier reformers, they attributed past failures to sinful disposition and dissension among Christians and therefore saw the task of recruiters as leading crusaders to moral purity and repentance through prayers and sermons widely preached to large groups of people. It is often noted that sermons of this period advocated the idea of the crusade as a vocation, a tool of conversion, and a pathway to salvation. As James Powell has written, by the time of the Fifth Crusade, "crusade was being forged into an instrument for the moral transformation of society."[27]

By placing love lyrics and romances in dialogue with texts concerning sincere confession, this book reads the conventions of these genres as responding to historical and moral problems of the day that directly affected how lay people thought about crusading. Homiletic literature and love lyric both speak of "vraie amour" (true love) for God or for the lady, and often the term equivocates between both of them.[28] *The Subject of Crusade* also builds on genre studies of literary texts: such work focuses on how lyric adapts the self-referentiality of *fin'amors* (courtly love, also *fine amour*) for crusade, or how narrative poems reflect personal and ceremonial accounts of the crusader's experience.[29] I argue that the courtly aesthetic of lyric and romance does more than articulate crusade ideology through an eroticized

discourse. Rather than simply converting earthly chivalry to celestial chivalry, the idiom maintains both at the same time and keeps adapting these competing ideals according to changing historical and social conditions. The vitality of the idiom is to maintain competing values under the pressure of contemporary events and the new terms of the "semiotically charged geography" of the crusade enterprise.[30]

In its engagement with official and religious language, the idiom relies on the development of an art language functioning alongside other discourses. In this sense, the idiom is neither the personal expression of crusade sentiment emerging from "the twelfth-century rise of the individual" nor a version of individual sentiment that represents a personal experience of real events (as in a nineteenth-century Romantic lyric of feeling about going overseas).[31] While they might be influenced by medieval genres of personal religious experience and individual conscience (e.g., Peter Abelard), courtly genres in their materiality mediate the subject of crusade and the manner in which it speaks.

When the thirteenth-century crusader-poet the Châtelain d'Arras sings that as his body goes to Syria his heart remains with his lady, he adapts a conversion narrative of repentance that the proper crusader should practice, at least according to churchmen: rather than repenting inwardly and turning away from earthly cares as a soldier of Christ, the knight devotes himself to his lady. Although the heart left behind reinforces his heroic intention for his spiritual mission, he defers the proper ritual of confession, repentance, and crusade. In this performance of self-exile, poets stage the difficulty of taking leave from their beloved as a wavering and/or turning to the "right path" of going on crusade. For instance, when Thibaut declares, "Ne me soi onques jor *faindre*" (Lady, I have never wavered [or feigned] in loving you) and "par maintes foiz m'en serai repentiz … vers vous [Deus] me suis guenchiz" (many times I will have repented [having taken this path when I think of you (Lady)], God toward you I turn), he insists on the difficulty of turning toward crusade and the sincerity of his avowal. The association of *faindre*, to

waver, with *feindre*, to dissimulate or conceal, reinforces his posture of almost repenting.[32] This ambivalence complicates crusade as an act of love in return for God's unwavering love for his people; as one anonymous crusade lyric declares, "ne nos amait pais *faintemant*" (he did not love us in a wavering or insincere manner).[33]

This affective scenario of crusade lyric—the movement of wavering and then not wavering as the courtly crusader comes to terms with God's unwavering love—delivers a sincere image of self-sacrifice and self-constraint through the discourse of courtly love. In the Augustinian sense, crusader-lovers prove their sincere intentions as lovers of both Christ and the beloved because love in these two situations belongs to the continuum of the Good (*Confessions*, book 7). *Fine amour* (perfect earthly love) and penitence figure as love within a continuum of the Good, the less Good, and the more Good. In the idiom, contrary to Bernard's version of crusading love, there is no contradiction between loving a lady and loving God, although at any time the crusader might privilege one over the other. *The Subject of Crusade* tracks this idiomatic movement of wavering between *fine amour* and penitence.

THE AVOWAL ("AVEU") AND THE CURRENCY OF CRUSADE INTENTION

The idiom traced in this book coincides with the emergence of confession as a literary and textual phenomenon, the subject of Michel Foucault's influential thesis on the institution of confession. Contemporary vernacular and Latin homiletic literature describes what a sincere confession should be: the textual process of confession emerges from a dialogue between priest and sinner, to be discussed in chapter 1.[34] This homiletic literature anticipates the more codified pastoral manuals in the second half of the thirteenth century, especially in the literary tradition of the British Isles. If not directly responding to the rise of a "penitential regime," as Aden Kumler aptly calls it in her study of confessional manuscripts, courtly for-

mulations about heart, voice, intention, and repentance converse
with Latin and vernacular writings concerning sincere contrition
and confession studied by Jean-Charles Payen, Michel Zink, and
most recently Claire Waters.[35]

The Fourth Lateran Council came to be known for its promulga-
tion of canon 21, *Omnis utriusque sexus*, the injunction of annual oral
confession to a parish priest. Because of the procedures it imposed
on the individual, this canon had a pivotal role, Foucault argues, in
the emergence of modern subjectivity. He rightly illuminates the
centrality of confession in public discourse, where the council effec-
tively placed the practice of confession at the center of a legislated
body of knowledge concerning sin.[36] According to Foucault, "the
confession became one of the West's most highly valued techniques
for producing truth."[37]

With the establishment of confession as episteme, the notion
of "aveu," or avowal, evolved along with the "legal function it des-
ignated": formerly meaning "status, identity, and value granted to
one person by another," he claims, "it came to signify someone's ac-
knowledgment of his own actions and thoughts."[38] The authenticity
of status became situated within a discourse of truth and power,
where the individual had to look inward to identify what was true.
For example, the repressed subject emerges within the structures of
confession as institution and discourse:

> L'aveu de la vérité s'est inscrit au coeur des procédures d'individual-
> isation par le pouvoir. En tout cas, à côté des rituels de l'épreuve, à
> côté des cautions données par l'autorité de la tradition, à côté des
> témoignages, mais aussi des procédés savants d'observation et de
> démonstration, l'aveu est devenu, en Occident, une des techniques
> les plus hautement valorisées pour produire le vrai.

> The truthful confession [or literally, confession of the truth] was in-
> scribed at the heart of the procedures of individualization by power.
> In any case, next to the testing rituals, next to the testimony of wit-

nesses, and the learned methods of observation and demonstration, confession became one of the West's most highly valued techniques for producing truth.[39]

Confession transformed the "aveu," or vow: indeed, the literal translation of "l'aveu de la vérité" as "confession of the truth" foregrounds the social transaction as constitutive of the "aveu."

Bonds of knightly homage and performances of loyalty between lord and vassal were also central to the crusade idiom, which affirms the social idea of "aveu" by extolling aristocratic aesthetic rituals and feudal codes through the professional avowal: a status conferred by another and based on mutual, contingent obligations that deflect confessional interiority. In this sense the idiom constitutes its own truthful discourse, one that is public rather than secret. While a lyrical avowal in the setting of crusade was a public act among a restricted social group, confession increasingly became, at least in homiletic literature, a private encounter with the priest even when done openly among the community of believers in the church.[40] This avowal creates a sense of being governed and authenticated by ties to another, what Foucault calls "lien à autrui (famille, allégeance, protection)."[41] Whereas one might expect that courtly crusade literature will articulate the intentions of crusaders that motivated religious war (and certainly there are many exhortative lyrics that sound like sermons), certain lyrics embody an aesthetic code that averts internal self-reflection and contrition and extols feudal and chivalric service to an earthly other.

This idea of a *professional* rather than a *confessional* mode— profession as a type of affirmation, as a social or economic calling bound up with beliefs, a pious "job"—resists or is at least in tension with the rise of a confessional interiority. We might even say that this mode facilitates an essential crystallization of the professional holy warrior: a person whose spiritual calling depends as much on secular bonds to another and/or others as on belief. We can see the later genealogy of spiritual professions in the example of an Italian pamphlet of the hospital order of Alto Pascio that dates to the

eighteenth century. Beginning with the phrase "modo di far la pro-
fessione," the manuscript explains the manner in which "one under-
takes the profession" as an essential avowal for induction into the
hospital order that had assisted pilgrims—crusaders were consid-
ered pilgrims—since the Middle Ages.[42]

The crusader-poet thus maintained a professional status as an
earthly "lien à autrui." The idiom responds to the production of the
confessional "vrai" at a time when the feudal "aveu" is being adapted
to various discourses of truth and power. In the call for crusade, the
church marshaled courtly and feudal pledges of allegiance to encour-
age believers in the cause of reclaiming the Holy Land. Jonathan
Riley-Smith describes how "the idea of the crusader expressing love
through his participation in acts of armed force was an element in
the thinking of senior churchmen in the central Middle Ages."[43]
One also recalls Innocent's use of feudal service to describe the obli-
gation to save the rightful domain of Christ Outremer in official
calls for crusade, or exhortative songs that use tropes of *fine amour*
to remind crusaders of their love for God. Against this institutional
adaptation of courtly and feudal discourses, and the rise of a more
codified protocol of penance, the idiom I am following pushes back
with a different form of adaptation. It provides a competing ana-
logue to the rise of the internalized and discursive "aveu" through
its own procedure and aesthetic ritual of self-constructed power. For
this elite audience, a poetics of courtly love can affirm the crusade
avowal as service and allegiance to an earthly other, even as it refuses
the interiority of repentance.

At the same time, the idiom responds to the increasing politi-
cization of crusades and the rise of indulgences in which other
acts could replace the physical journey of crusade as a pilgrimage.
Crusader-poets found a way to speak crusades that was a sincere
(*vrai*) but ambivalent expression of faith. The controversies around
commutations of vows suggest why an aristocratic elite developed its
own sincere form of an avowal. Although the fulfillment of the vow
had been a problem since the First Crusade when the traditional
pilgrimage destination of Jerusalem became divorced from an expe-

dition's military goal, in the Fifth Crusade this proved a particularly vexing issue because of crusaders who left the army prematurely and had their vows commuted.[44] The increasing ethical complexity of the right intention arose in large part from Innocent III's change of policy toward enforcing vows. In his letter *Quia maior*, promulgated in 1213 and a centerpiece of crusading propaganda,[45] Innocent sought to make the benefits of the vow available to all Christians without compromising the practical goal of taking back the Holy Land, including the need to raise money and limit the role of the unsuitable by granting indulgences instead of expecting participation. Under Innocent, crusade provided an opportunity to gain salvation. As Penny Cole observes:

> In France, England, and Germany the merit of the cross was preached in light of the doctrine of redemption, and the incentive to act arose from the idea of the crusade as a testing ground for faith, a means of expiating guilt, an expression of man's love, obedience and service for Christ, and, in short a divinely conferred opportunity for salvation.[46]

Toward this end, Innocent states that he will enforce vows but also grant deferment, commutation (the performance of another penitential act in place of the one originally vowed), and redemption (dispensation in return for a money payment) of the vow.[47] The question of right intention became significant after the Second Crusade: church officials beset by reversals in the East connected human sinfulness to military losses. Yet Innocent's redemption of vows for money payments and sale of indulgences introduced a new discourse of vows in the context of intentionality, a new currency whereby a vow could mean something other than the act of going to the Holy Land.

The crusade idiom should be seen in light of this developing currency of intention, in which participating in the ritual processions that Innocent described in his letter, such as listening to sermons, donating money, or giving supportive advice, could translate into a vow.[48] At least one poet demonstrated his sincerity in both acts

and verse. Before his departure for crusade in 1239, Thibaut presided over the burning of 180 heretics at Mont-Aimé in Champagne. This act bolstered both his public image as a penitential crusader and his finances.[49] As we will see in my discussion of his inquest upon his return in chapter 5, Thibaut's financial and penitential interests function in complex ways in his departure and exhortative songs and in his identity as a crusader-poet. Because of the widening culture of granting indulgences, a competing currency of intention emerged across audiences and purposes.[50] The intention of a crusader, whether nobleman, rich wife, or merchant, could be articulated in multiple ways—to name a few examples from this book, through a troubadour song, instructions for a crusader's effigy upon return (Jean d'Alluye's gisant), a confessional text composed in the Latin East before returning home to France (the Frankish Cypriot Jehan de Journi), or a splendid Burgundian banquet (the Feast of the Pheasant). Indulgences made the representations, rituals, and acts of intention almost more important than the material acts of warfare. It is hard to argue against Cole's assessment that "for James of Vitry, hearing sermons, being the first to take the cross, confessing sins, and equipping others to take the cross were as essential to the sacred character of the crusade as crusading itself."[51] As military reversals diminished the commitment of the faithful, James promised a reduction of twenty to forty days in purgatory for simply attending his sermons.[52]

Indeed, while extending the benefit of crusade as a penitential activity, Innocent's policy of redemptions and commutations made expressions of sincere love for God more varied and artful, even as would-be crusaders could be more deceptive. Preachers and poets alike criticized those who were thought to have abused the system for financial advantage, particularly the papacy and its agents, the Dominicans and Franciscans. This economy of commutations—for instance, penance and devotion expressed by hearing sermons or money payments—and its exploitation suggest why poets might have sought to express their "right intention" otherwise or to critique those who were insincere about their vow. One story from a

collection of spiritual anecdotes for the instruction of novices, Cae-
sarius of Heisterbach's *Dialogus miraculorum* (c. 1213), relates how
an usurer named Gottschalk brags that while fools go overseas and
expose themselves to danger, he happily stays at home and gains a
similar reward for the five marks of his redemption.[53] The French
poet Rutebeuf was a keen castigator of the indulgence market, as
he shows in his "Complainte de Constantinople," composed around
1262: "Hom sermona por la croix prendre, / Que hom cuida paradix
vendre / Et livreir, de par l'apostole" (They preach the cross in such a
way, that man believed that paradise was being sold and delivered by
the pope, lines 97–99). In another poem dating from the same time,
"La Desputizons dou Croisié et dou Descroisié," Rutebeuf applies
the term *descroizié* not to a knight who reneges on his vow but to one
who has not yet taken the cross. He models the debate between the
crusader and the reluctant knight on similar debates from sermons
as well as the various traditions of poetic debate such as the *jeu-parti*.
Rutebeuf presents the *descroizié* as one who enjoys the spiritual privi-
leges of redemption because he fears the sea and is reluctant to relin-
quish his material possessions at home. This unrighteous type argues
that God can be found both at home and overseas.[54]

These developments attest to Christopher Tyerman's claim that
large-scale preaching as a stated objective coincided with the rise of
indulgences for those who did not physically go on crusade.[55] Re-
cruitment was based on feudal bonds rather than the impulsive mass
enthusiasms depicted in the sermons and exempla. Such accommo-
dations affirm Innocent's stress on the Christian vassal's duty to save
the Holy Land despite churchmen's wariness of the suggestion that
the relationship between man and God was one of mutual exchange.
In fact, as Tyerman suggests, although "bonds of lordship, client-
age, locality and family had always lain at the heart of crusading,"
they were now "increasingly expressed in the form of written con-
tracts and cash."[56] Such comparisons to vassal bonds would have
had particular relevance to someone like Thibaut, whose family had
a history of involvement in the crusades.[57] But how does one express
the sincerity of his vow to his liegemen and peers for whom it rep-

resented the ideals of their knightly class? The lyric idiom provided one mode in which a crusader could profess a sincerity that deliberately separated itself from this economy of commutations.

DESCRIPTIVE HISTORICAL POETICS
AND SPEAKING CRUSADES

The Subject of Crusade takes crusades as an ethically fraught object with what I call a *descriptive historical poetics*. I aim to uncover the literariness of texts that treat the crusades that are neither the product of private subjective experience nor documents of religious practices. Foucault's first definition of "aveu" as a ritualistic avowal to another concerns social transactions as articulations of status rather than of the emergence of a subjectivity through confessional practices.[58] The tension between profession and confession during this period has been often overlooked by those for whom the courtly crusade lyric has been limited to its philological aspect (as an extension of courtly love poetry applied to the crusades) and its role as historical document or as an expression of inner repentance. As I see it, a descriptive poetics shows a heterogeneous artistic corpus—in this case, the courtly crusade idiom—as a dynamic activity, here a profession in multiple modes: for instance, a reconfiguration of confessional discourse through the courtly code, or service to an external object, whether the lady, God, or both in a lyrical continuum. Highly diverse descriptive examples—an unrepentant Lancelot as crusader in the *Perlesvaus*, courtly tropes of separation occasioned by crusade, cartulary rolls that attest to social changes attributed to crusader-poets, textual arrangements in *chansonniers* (songbooks), crusader effigies and epitaphs, tapestries, and mimed plays—establish a poetics that forms a "crusader subject" along different axes of time, place, and cultural context. While limited to a period and a certain European perspective, the diversity of examples affords a more complex view than we have had of how a crusader emerges not only from discrete poems but also from the interaction of discourses (e.g., confessional/courtly), the reception of audiences (Latin East/Europe), and

the performance of manuscripts associated with a crusader (Thibaut as Lord of Champagne who commissions inquests and shapes his crusading identity through chansonniers and lyric texts). In more broadly historical terms, this approach complicates the categorical oppositions in the scholarship of the period, such as historical events versus literary representations and West versus East.

In proposing a descriptive historical poetics, I find the work of Alexander Veselovsky on historical poetics and Hugo Kuhn on medieval literature useful in addressing the cultural phenomena, concrete historical factors, and artistic form of the texts of my period.[59] Emerging as part of the Russian formalist school of criticism, Veselovsky avoids ahistorical aestheticism, *epistemologism* (texts as documentations of worldviews), and traditional historicism to see genres and works as actively responsive to "a correlation between [life's] demands and particular poetic forms, *even if both have not emerged at the same time*" (my emphasis). As his recent editors explain his historical poetics, "form reenacts the original syncretic ritual ... with the belief that the symbolic recreation of what is desired influences its actualization."[60] The twentieth-century German medievalist Hugo Kuhn, who was foundational for a medieval studies grounded in structuralism and German reception theory that would lead to the work of Hans Robert Jauss and others, complements this view. Veselovsky's view of texts as asynchronic formal responses to a historical lack— worldviews are encoded in works as actions—complements Kuhn's view of medieval art as "objective." In his discussion about how medieval architecture rhythmically responds to space qualitatively rather than in the quantitative manner of the Renaissance, Kuhn shows the importance of understanding the ritualistic, rhythmic, and performative function of medieval art. For instance, he describes how medieval spaces anticipate the physical progression of the viewer, and how stained-glass windows and Gothic arches envelop the believer in sacral performance. For Kuhn, medieval art is differently objective from its modern counterpart because it is actualized by the beholder qualitatively and immediately as part of rituals circumscribed in space and time rather than beheld: images on the same continuous

plane produce time and space in itself through engagement with the viewer, rather than from a quantitative measurable distance based on an "objective" (in a modern sense) concept of temporality and perspective.

Developing these ideas about literary history and medieval art, I describe in the first four chapters how crusader-poets, writers, and patrons of romance from the mid-twelfth to the late thirteenth centuries produced a pious and chivalric intention for crusade in an idiom that responds to the emergent confessional discourse we know from homiletic literature of the period. This poetic idiom accommodates female voices and various lyric hesitations within the movement of pilgrimage. Some crusader-poets were actively responding to a discourse of penitence prescribed by the church: through figures such as a traveling heart or an unrepentant Lancelot, their texts might be resistant acts of autonomy, serve as moral or ethical preparation for crusade, or respond to political and economic realities. Adapting Veselovsky's view of historical poetics, we can view these idealized heroic or sacrificial voices as complex responses to going abroad into the unknown and leaving earthly attachments and obligations behind. This idiom encodes such a need in a courtly language that in turn affirms the values of an elite class.

In the fifth and sixth chapters, I examine how the courtly crusade idiom emerges in a variety of materials and frames of reference. In these last two chapters, descriptive poetics is essential to follow the idiom, and while I am mindful and engage with the scholarship and disciplines from which objects, materials, and texts emerge, I focus on lapses of information or problems of translation to reorient the discussion: how does a tombstone inscription of a crusader multiply possibilities of a crusader subject when we probe into the status of the Outremer French language used for the inscription, the discipline of epigraphy, even the questionable location of the stele in a museum after it was moved from an archaeological excavation in Tyre? The chapters examine configurations of personal names and toponyms to show how the subject of crusade orients itself in multiple localities, audiences, and courtly cultures.

The fifth chapter describes the conditions in which crusader-poets emerge from courtly publics in France, Italy, and the Latin East. I compare lyric texts and feudal documents related to the crusader-trouvère Lord Thibaut IV of Champagne with the manuscript transmission of the lyric texts of the crusader-troubadour Raimbaut de Vaqueiras, vassal of the Marquis Boniface I of Montferrat. The transmission of Raimbaut's texts articulates the culture of the northern Italian courts; as a crusader, troubadour, and vassal, Raimbaut's presence in northern Italian Occitan songbooks shows the function of literary genres and courtly publics for making crusader-poets from the descriptive frame of thirteenth- and fourteenth-century Italian and Catalan Occitan manuscripts. Finally, I take the example of the Frankish Cypriot crusader Jehan de Journi to show a different case: his idiom registers through an adaptation of liturgical prayers at the end of his confessional text. His French prayers are the only versified recension known of the medieval vernacular Prône prayer offered during Sunday Mass. The prayers were supplications in which the priest would invite the faithful to offer up prayers for peace, the state of the Roman Catholic Church, the lords of the kingdom, and the Holy Land. They would have incorporated unwritten discursive practices such as recitation and ritualistic gestures as part of the parish Sunday Mass. Through these adapted prayers, Jehan creates his own community of the faithful in Outremer and France even as he criticizes the rulers in the Latin East and laments the fall of Christendom that he sees before him. He offers up these prayers as a bid for a return home. I place this Outremer subject in dialogue with the lyrics of the Templar of Tyre, who like the Continental French poet Rutebeuf is called upon to write lyric (*rime*) in his history of the Latin East because of his experience of events. Through these various constellations of places and names, activated through specific literary and performative modes, the crusading subject in relation to Europe and Outremer acquires a temporality and existence more complex than the itineraries of the subject traveling from here to there, or texts about home or Holy Land such as official chronicles, pilgrimage diaries, or exhortative chansons de geste. This chapter

demonstrates how we might locate the subject of crusade from two places at once (through adapted prayers or through a comparison of two poets approaching *historia* from different perspectives); from the idiom's movement through new literary genres and chansonniers; and finally from disparate names and places in the contiguity of archival spaces (e.g., chansonniers and cartulary rolls concerning landholdings).

In the sixth chapter, I focus on the multimedia event of the Feast of the Pheasant that took place in Lille in 1454, a celebration hosted by Duke Philip the Good that featured crusading vows taken by the Burgundian nobility. Through a description of what I call the "deep surface" of tapestry, I examine in conjunction the performance of a mimed play (*mistere*) and the texture of a manuscript related to the feast recorded by Olivier de la Marche. The Greek hero Jason, sometimes present and sometimes suggestively absent in these works, is advanced as an unrepentant crusader who maintains the worldly and spiritual ambitions of Philip the Good. I propose a "textural" reading of the color details of grisaille manuscripts that correlate with the surface effects of the Burgundian tapestries and the ambiguous nature of a *mistere* that features Jason as an appropriate crusading hero for the Burgundian nobility. A descriptive poetics reveals the idiom in part as it would have been performed and received through these media. While an event such as the Feast of the Pheasant might resist analysis by conventional methods, my approach licenses it to speak crusades in new collations associated with the culture of Burgundian princes.

METHODOLOGY:
THE MOVEMENT OF THE IDIOM

In tracking the movement of this idiomatic "sincerity" distinct from penitential discourse, I describe the crusading subject through what Roland Barthes describes as the "choreography" of a lover's discourse, or the movement of figures, tropes, and metaphors: crusade love lyric's adaptation of love from afar for the situation of separated

lovers; the fascination with an unrepentant yet pious Lancelot in the *Perlesvaus* who refuses to repent his "volenté," or desire, for Guine-vere; and the secular relic such as the heart served to the crusader's lady by the cuckolded husband in the *Castelain de Couci*.[61] Objects and events such as the strange Chinese sword of the armored gisant of the French crusader Jean d'Alluye or the multimedia Feast of the Pheasant are contingent, material witnesses of the crusader's devo-tion to God and chivalry and correspond to the secular relic of the *Castelain de Couci*. Emulating the quotations that head the chapters of Barthes's *Discours amoureux* (*Lover's Discourse*), I begin each chap-ter with a passage from one of my primary texts or a description of an object in order to emphasize the idiomatic mobility of figures and their translation into multiple genres and media.[62] Thus I describe a courtly discourse of performative utterances ("As long as my heart is with you, I will be fearless over there," "I cannot repent my desire ... but I will do penance for it," and "Let this song be my witness"); of actions such as the colophon of one *Perlesvaus* manuscript dedi-cated to a politically motivated crusader such as Jean II de Nesle Castellan of Bruges; and of material objects such as tapestries and Burgundian manuscripts that memorialize and adapt crusade piety for aristocratic or political interests.

My approach of a descriptive historical poetics arose from the challenges I encountered when reading literary texts about "cru-sade" or "the crusades." I subscribe to Sheldon Pollock's formulation of philological practice as the assessment of three dimensions of a text's existence—"its moment of genesis, its reception over time, and its presence to my own subjectivity."[63] To complement this view of philology, I adapt Bruno Latour's model of describing associa-tions and the pluralistic "existences" of our texts.[64] Where crusade texts are concerned, artifacts, Latin chronicles, and epics have often been privileged over lyric because of the information about events and persons they document as witnesses.[65] Despite being encoded with complex figures, poetic articulations of crusade have often been interpreted as mimetic representations of historical events or

as vows of repentance. Given the quantitative evidence and discursive weight of homiletic literature or the reality of historical persons and events, we might ask: these people went on crusade, so why should we dwell on how they talked about it before they departed or while they were abroad?[66] The answer is on every page of this book, as I show the value of poetic texts and other works as "crusade existences," to adapt Latour's phrase, composed of mobile associations on their own terms. If we are attentive to practicing a philology that summons multiple interpretations of a text over time while enlisting the attentive and sympathetic evaluations of a reading tradition, how should we do this with a subject as ethically and morally fraught as crusades, where contemporary religious and racial violence most crucially depends on the interpretation of texts and events of the past? These kinds of questions are often put aside in discussions of medieval literary texts in which other disciplines are less invested (e.g., Chaucer, the troubadours), with the result that we offer little practical response to advance the value of philological and literary inquiry. And it is all these questions that *The Subject of Crusade* addresses in terms of a descriptive historical poetics of the idiom.

In developing such a poetics, I am indebted to other critical approaches: for example, one might relate this idiom to a kind of "surface reading" that "locates patterns that exist within and across texts"[67] or a "New Formalism" that calls for a recommitment to form in all its historicity and the aesthetic modes through which form shapes the affective experience of a work.[68] Recently scholars of late medieval England have energized the long-standing critical issue regarding the relation between form and literariness, especially the Kantian purposelessness of the literary. They address how medieval readers engaged with verse, devotional manuscripts, and libraries in ways that expand modern categories of the literary: for example, books of hours engaged readers as a creative practice and through habitual use; the experiential quality of medieval texts as verse, play, or music could make the reader a coproducer of its form and inherent value over time.[69] Taking these approaches into account, *The Subject*

of Crusade advances a new method with various materials, vernacular traditions, and historical circumstances to provisionally grasp a subject that speaks in various forms and modes—performative, material, and experiential. Occasioned by a renewal of critical practice, this is a shift from an epistemology to an ontology of crusades.

Treating crusades in terms of ontology might serve to remind us that modern examples exist in some relation to those of the medieval period. Poetry articulates the fantasies, beliefs, and sense of community among believers inside and outside of modern nation-states. Today it is easy to see how rap and other popular genres of lyric build communities within and across disparate places and social groups. More than romanticized justifications of violence, these contemporary avowals in a penitential and lyrical mode call upon us to make a new assessment of similar avowals in the history of Western Christendom.[70] Like their medieval counterparts, modern holy warriors prepare for militant action through poetry of religious convictions, but today such poems are often transmitted via online networks rather than live performances or manuscripts.[71] The form and transmission of this lyric of religious conviction in preparation for militant action—in specific media and addressed to a certain audience—invite us to reflect on these same qualities in poetic expressions of medieval holy war. Such lyric holds the appeal of ancient poetic traditions. Often the substance of these lyrical expressions departs from the tenets of conventional religious thought or combines archaic culture with contemporary political realities through poetry: these expressions of religious beliefs emerge from the particular social and economic backgrounds of the participants. These ways of speaking militant religious action often profess a higher calling that draws from a sacred cultural heritage. Poetry provides linguistic conventions that the poet can shape and adapt according to a personal situation. Verse and other forms of poetry give witness to self-sacrifice, and to the sense of election into a communal history in the name of a higher spiritual cause. I argue that the modern phenomenon of speaking religious violence in poetry has roots in

literary texts of the Middle Ages: that is to say, modern usage inherits the earlier tradition of texts that personalized crusade in various ways. I hope this book helps continue an ongoing conversation about how we can productively complicate modern movements that simplistically appropriate discourses about religion and militant acts.

The Unrepentant Crusader:
The Figure of the Separated Heart

"Sans cuer m'en vois el regne de Surie . . . se le vostre ai od moi en compaignie, / Adès iere plus joians et plus preus, / del vostre cuer serai chevalereus."

Without a heart, I go away for the kingdom of Syria . . . if I have your heart with me in company, I will be the most joyful and brave. By your heart, I will be valiant.

CHÂTELAIN D'ARRAS, "Aler m'estuet" ("I must go")[1]

Through the fragmentation of bodies, the crusader-poet transforms loss into valiant self-sacrifice. Adapted from courtly love songs about distant love (*amor de lonh*), the figure of the heart separated from the body and/or the exchange of hearts occurs in a number of crusade departure songs. Here the Châtelain d'Arras reluctantly leaves his heart with his lady as his body goes overseas to serve the Lord. With her heart, he will be more chivalrous and brave abroad.[2] The exchange of hearts and willful separation from his lady heightens the view of his earthly sacrifice for crusade.[3] How does the figure of the separated heart and the divided body transform the right intention of inward repentance? How does it condition the crusader's turn from earthly to celestial chivalry?

From a noble family of Artois, the Châtelain (or Huon) d'Arras went on the Third Crusade (1187–94) and shares a courtly aesthetic with other trouvères such as Conon de Béthune, the Châtelain de Couci, and Thibaut de Champagne.[4] He belongs to the same cultural and social milieu as the aforementioned trouvères, all high-ranking nobles from northern France who were active in crusade expeditions. Their songs were known during a time of ecclesiastical

reform that affected the preaching and practice of crusading. As leaders of expeditions abroad, trouvères were invested in how they fashioned themselves as crusaders.[5] The transmission of these love songs in thirteenth- and fourteenth-century chansonniers attests to their creators' prestige. This transmission also makes it likely that these works were performed in public and reached a large audience either at home or abroad long after their composition, at a time when the crusading movement is generally considered to have come of age.[6] Perhaps because of the shared background of the poets, these lyrics reflect a standardization of courtly tropes applied to crusade.[7]

The first part of this chapter will examine the figure in "Aler m'estuet" by the Châtelain d'Arras, dated to the first quarter of the thirteenth century. Reading "Aler m'estuet" against penitential discourse of the period, I will show how the chatelain's idiom emerges through that of the ventriloquized lady, in opposition to the silent voice of internal reflection that was supposed to accompany a crusader embarking on a penitential journey. Seen together, the heart left behind in the Châtelain d'Arras's song and the memory of the lady in Thibaut's crusade departure song "Dame, ensi est q'il m'en couvient aler" ("Lady, since I must leave") poetically oppose confessional discourse.[8] Invoking the heart and remembering his lady, Thibaut deploys penitential language to express his intention to go on crusade and not forget his lady. Both the Châtelain d'Arras and Thibaut distinguish and authorize their idiom by claiming to be at once pious crusaders and unrepentant courtly lovers who leave their hearts behind with their ladies. By looking at various examples of pastoral literature, I will explain how these poets create an idiom in dialogue with the immediate cultural climate of penance and confession.

Much has been written on the adaptation of the canso's *amor de lonh* into the bitter self-exile of crusade departure lyric.[9] What has been missed in the scholarship is the extent to which the trope acquires new purchase when it defers the act of inward repentance in these lyrics of departure. By the end of the two songs, the Châte-

lain d'Arras and Thibaut depart for Outremer. Yet they dramatize their intentions by externalizing their heart. While not a confession in the strict sacramental sense, their mode of expressing repentance and conversion resists what Linda Georgianna calls the "internal voice urging repentance" that translates into sincere confession.[10] To understand how this resistance operates through the use of the crusader's separated heart, we must see how preachers enlisted tropes of the heart and voice in their sermons about crusade and repentance.

CRUSADING AS AN ACT OF LOVE: THE VOICE OF TRUE LOVE

At a time when preachers invoked the voice of the Lord and encouraged crusaders to do penance with a true voice, crusader-poets were interested in finding their own voices. In his first general crusade letter issued in 1198, *Post miserabile*, Pope Innocent III explicitly established crusading as a penitential activity in that those who went on crusade and who had "done penance [for sins] with voice and heart" would receive the reward of eternal salvation. Following contemporary theological discussions, he emphasized both inner contrition and confession. Innocent described crusade as a divine test and the Holy Land as Christ's patrimony. A model sermon for use in his newly established system for preaching the cross, the letter shows how Innocent guides preachers to invoke God's voice in need:

> We cry out on behalf of him, made obedient to God the Father even to the death on the cross, who, *while dying on the cross called out in a loud voice* [*moriendo voce magna clamavit in cruce*], crying out that he might save us from the torture of eternal death [Mt 27:50; Lk 23:46]. And he cried out also for himself and said, "If anyone wishes to follow me, he should deny himself, and take up his cross and follow me." [Mt 16:24] (my emphasis)[11]

Here Innocent invokes not only the image of the Lord on the cross but also his voice: the Lord calls out to his followers to take up the

cross. Hearing God's voice in need, crusaders should respond in a spirit of penance, conversion, and action.

Before this encyclical was issued, trouvères were already embracing crusade as a penitential activity in their lyrics, apparently having absorbed contritionist sermons and taking up the position of preacher. A participant in the Third and Fourth Crusades, the twelfth-century trouvère Conon de Béthune in "Ahi! Amour, con dure departie" ("Ah, Love, what a cruel separation") exhorts all people—including clergy, the elderly, and women—to go on crusade in their own ways as a penitential activity. In "Bien me deüsse targier" ("I should defer to another time") he encourages an internal and physical process of self-denial: "On se doit bien efforchier / De Dieu servir, ja ni'i soit li talans, / Et la char vaintre et plaissier" (One must force oneself to serve God, even if one has desires elsewhere, and vanquish and break corporeal desires; lines 9–11).[12] As Payen notes, the penitential language here likely alludes to the doctrine of double penitence espoused by Hugh of Saint Victor that espouses internal and external acts of penance.[13] "Plaissier" also refers to the notion of overcoming through acts of breaking and bending, and reinforces the "vaintre." For those who because of their earthly attachments might hesitate to go on crusade (or the equivalent of the physical journey to the Holy Land), Conon suggests the ascetic training of "vaintre" and "plaissier" to overcome that weakness.

Chronicles and the writings of clerical apologists affirm Innocent's exposition of crusading as successful only if accompanied by a spiritual reawakening. Crusaders understood that divine aid would be forthcoming if soldiers carried out religious obligations, particularly confessing their sins before battle. They participated in penitential activities to maintain morale. In his chronicle of the Fourth Crusade, Henry of Valenciennes reports that crusaders participated in penitential activities directed by clerics. After assuring the men that divine aid would come to those who were sincerely repentant, the cleric Philip commands them "in the name of penitence to fight against the enemies of Jesus Christ" ("Je vous commanc a toz, en non

de penitence, que vous poigniés econtre les anemis Jhesu Crist").[14] Not only would victory come to those who were properly repentant, but attacking the enemy was a form of penance.

Indeed, much vernacular literature of the period shows lay people confessing and converting to the right path, although it was a commonplace of preachers to criticize their lay audience for being more willing to listen to chansons de geste or Arthurian tales than sermons about Jesus Christ. As a late twelfth-century or early thirteenth-century Lenten sermon in Walloon dialect explains, "Il sunt mainte gent qui ja ne vorroient oïr de Deu parler . . . et plus volentirs oroit tos tens parler des batailhes Roland et Olivier qu'il ne feroit de Nostre Seignor Jhesu Crist" (There are many people who rather than wishing to hear of God spoken . . . would more willingly listen to the battles of Roland and Oliver spoken of all the time rather than of Our Lord Jesus Christ).[15] Chrétien de Troyes's romances and courtly love lyrics represent the idealization of aristocratic secular values, while other narrative genres represent the church's attempts to spiritually discipline the audience of courtly literature within institutional frameworks: the description of Saint Alexis's aristocratic family's worldliness as foundational for his saintliness in the eleventh-century *Vie de Saint Alexis* (*Life of Saint Alexis*); or the repentance of proud knights in the twelfth-century *Girart de Rousillon* and thirteenth-century *Le Chevalier au Barisel*.[16] The spiritual submission of a figure emblematic of the values of the aristocratic class seen in the unrepentant or naïve knight's confession to the hermit (in the case of the latter, Perceval in Chrétien's *Conte du Graal*, or *Story of the Grail*), a frequent moral hermeneutic, reaches its height with the *Queste del Saint Graal* (*Quest for the Holy Grail*) — Arthurian romance transformed into a symbolic quest with explicit Christological references and closely following the Bernardian doctrine emphasizing the penitent's internal disposition and grace and the mystical union with God.

Through lyric, poets could respond to penitential sermons differently than in narrative genres because they could foreground and shape the relation between heart and voice. Bernard's crusade ser-

mons cultivate an affective piety that served as an important template for crusade love songs, especially in his emphasis on expressing sincere love.[17] In a recruitment letter to the duke and people of Bohemia from 1147, in addition to his emphasis on right intention, he portrays crusade as a test and act of love, an opportunity for laymen to set aside earthly cares and gain salvation. In addressing potential soldiers of Christ, he uses affective language that enlists the heart, voice, and desire:

> I am urged by this zeal to write to you what I would prefer to try *to inscribe in your hearts with my voice* and I would do that if I had the means [*voce cordibus vestris inscribere laborarem*]. . . . But the part of me about which I have been complaining is not with you; the part which will be of more use to you, my heart, is brought straight to you, in spite of the distance which separates our burdensome bodies (my emphasis).[18]

His effort to inscribe his voice within the hearts of his listeners parallels his preaching of the crusader as desiring bodily union with Christ in "De Laude novae militiae":

> What in fact is there to fear for the man, whether he is living or dying, for whom to live is Christ and for whom it is gain to die? He remains in this world faithfully and willingly for Christ; *but his greater desire is to be dissolved and to be with Christ* [*sed magis cupit dissolvi, et esse cum Christo*]; this in fact is better (my emphasis).[19]

Bernard appeals to his listeners by first vividly stressing the emotional and spiritual relation between himself and his listeners: he inscribes himself within their hearts. This affective relation between preacher and would-be crusader corresponds to the second image of a desired union between Christ and his penitent soldier. Having no earthly cares, the knight with "right intention" enters fearlessly into battle.

The Châtelain d'Arras's "Aler m'estuet" transforms Bernard's

emphasis on a crusader's heartfelt contrition: he exchanges sincere repentance for courtly unrepentance. *Fine amour* becomes the basis of his crusading intention. The Châtelain d'Arras creates another idiomatic voice that responds to Innocent's call to hear the voice of Christ as well as Bernard's emphasis on the voice reaching hearts and desire for spiritual union with Christ. The desirous right intention of the penitent crusader who longs to dissolve himself with Christ becomes the desirous courtly intention of the unrepentant crusader who longs to be with his lady. Both Bernard and the Châtelain d'Arras form an intention based on longing and corporeal distance, and they rely on the heart's transmission through the voice to create the crucial affective relation between crusader and other as either Christ or lady. The opening strophe of "Aler m'estuet" demonstrates how the Châtelain d'Arras has internalized the homiletic message of crusade as penitential activity through the image of God's suffering. However, at the same time that he proclaims his willingness to suffer Outremer, he declares his love for his lady left behind:

> Aler m'estuet la u je trairai paine,
> En cele terre ou Diex fu travelliés;
> Mainte pensee i averai grevaine,
> Quant je serai de ma dame eslongiés;
> Et sacies bien ja mais ne serai liés
> Dusc'a l'eure que l'averai prochaine.
> Dame, merci! Quant serai repairiés,
> Pour Dieu vos proi prenge vos en pitiez.

> I must go there where I will endure suffering
> In that land where God was tortured;
> I will have many heavy thoughts
> because I will be away from my lady;
> And know well that I will never be happy
> Until the time I will have her close to me.
> Lady, have mercy! When I will have returned,
> I beg you by God that pity takes you. (lines 1–8)

The Châtelain d'Arras opens his song with an image of Christ's suffering that ought to inspire the pious crusader with right intention. Yet the external physical suffering that will earn him salvation conflicts with his "pensee," or thoughts, that are focused on his lady and his hoped for reunion with her upon his return. This hope replaces the internal activity of desiring spiritual union with Christ preached by Bernard. Like Bernard, the Châtelain d'Arras thinks about how voices can reach hearts, but now in an earthly context: the memory of her voice, which at first resembles a dangerous siren that tempts him from the moral path, gives him the fortitude to be a good crusader:

> Douce dame, contesse et chastelaine
> De tout valoir, cui sevrance m'est griés,
> Si est de vos com est de la seraine
> Qui par son chant a pluisors engigniés;
> N'en sevent mot, ses a si aprociés
> Que ses dous cans lor navie mal maine;
> Ne se gardent, ses a en mer plongiés;
> Et s'il vos plaist, ensi sui perelliés.

> En peril sui, se pités ne m'aïe;
> Mais, se ses cuers resamble ses dous oex,
> Donc sai de voir que n'i perirai mie:
> Esperance ai qu'ele l'ait mout piteus.
> Sovent recort, quant od li ere seus,
> Qu'ele disoit; "Mous seroi esjoïe,
> Se repariés; je vos ferai joiex;
> Or soiés vrais conme fins amourex."

> Ha! Diex, dame, cist mos me rent la vie;
> Biaus sire Diex, com il est precieus!
> Sans cuer m'en vois el regne de Surie:
> Od vos remaint, c'est ses plus dous osteus.
> Dame vaillans, conment vivra cors seus?

Se le vostre ai od moi en compaignie,
Adès iere plus joians et plus preus.
Del vostre cuer serai chevalereus.

Sweet lady, countess and mistress overlord
of high worth, separation from whom grieves me,
it is with you as with the siren
who by her song deceived many sailors.
They didn't understand [lit.: know her words],
 she approached them in such a way
that her sweet song made their ship go off on a bad course;
they weren't careful, and so she made them drown at sea.
And so it pleases you, in this way I am in the same peril.

I am in peril, if pity does not rescue me.
But if her heart resembles her sweet eyes,
I know in truth that I will never perish there;
I have hope that she has a pitiful heart.
Often I remember when, being alone with her,
she said, "I would be very happy
If you returned, I will make you joyous;
for now be loyal like a true lover."

Ah! God, lady, these words restore life to me;
Good lord God, how they are precious!
Without a heart, I go away to the kingdom of Syria:
With you it remains, its sweetest refuge.
Worthy lady, how will a body live without a heart?
If I have your heart with me in company,
I will be the most joyful and brave.
By your heart, I will be valiant. (lines 9–32)

Replacing the preacher's voice that advocates right intention, the lady's voice inspires crusading chivalry. While the poet-narrator begins the song thinking of Christ's suffering, in the process of *recorder*,

or remembering, the lady's voice begins to inhabit his thoughts and ultimately inspires crusade. The memory of her voice occasions the exchange of his heart with hers, and with her heart he will be "chevalereus," or valiant. The Châtelain d'Arras establishes his crusade intention as one founded on the courtly ideal of *fine amour* that embraces crusading as a meritorious act, one leading to salvation according to Bernard's preaching of the Second Crusade and Innocent's policy of crusade as a means for salvation. Yet through the exchange of hearts, the lady promises earthly fulfillment upon his return. I would thus go further than Lisa Perfettti's emphasis on the crusader-lover's status as a "suffering lover" and "erotic attachment to the lady" as "not necessarily incongruous with his dedication to fight in the Holy Land."[20] In my view, we should pay attention to how the Châtelain d'Arras deliberately transforms the ecclesiastical discourse of the penitent voice or preacher by creating a distinct voice that embodies wayward earthly intention (seen explicitly in the corporeal desire of the siren) transformed into a force for good that aligns with Christian morality. This voice affirms his earthly sacrifice for crusading but also valorizes the corporeal desires that he supposedly should "vaintre" and "plaissier" (vanquish and break) by adhering to the courtly code.

Moreover, through this deployment of earthly love and sacrifice, the Châtelain d'Arras maintains his own crusade *intentio* against ecclesiastical writing that increasingly used the language of feudalism to engage the popular imagination for crusade recruitment. For example, in *Quia maior* of 1213, Innocent III proclaims the Fifth Crusade in this way:

> How many men, converted to penance, have delivered themselves up to the service of the Crucified One in order to liberate the Holy Land and have won a crown of glory as if they had suffered the agony of martyrdom. . . . For if any temporal king is thrown out of his kingdom by his enemies, when he regains his lost kingdom surely he will condemn his vassals as faithless men and for these bad

men will devise unimagined torments.... In just such a way will the King of Kings, the Lord Jesus Christ, who bestowed on you body and soul and all the other good things you have, condemn you for the vice of ingratitude and the crime of infidelity if you fail to come to his aid when he has been, as it were, thrown out of his kingdom, which he purchased with the price of his blood.[21]

Innocent believes that the crusader should feel obliged to serve God in time of need in the same way a vassal should want to serve his lord and protect his kingdom; a vassal should not desert his lord in need. A crusading song "Vos qui ameis de vraie amor" (1150–1200), composed at the same time as Bernard's preaching, testifies to the appropriation of feudal language by the mid-twelfth century. Those who truly love God ("vraie amor") will take the cross, and "anyone deserves to be condemned who has deserted his lord in need" ("Cil doit bien estre forjugiés / Ki a besoing son seignor lait"; lines 11–12).[22]

In light of these ecclesiastical efforts to make crusade ideology more accessible through the appropriation of feudal language and invocation of crusade service as an act of Christian love, or "vraie amor,"[23] the Châtelain d'Arras distinguishes his intention through courtly *fine amour*. He produces an idiom by combining two competing spiritualities through the craft of lyric: continual devotion to the lady and a willingness to physically fulfill a crusade vow that brings spiritual redemption. The maintenance of these spiritualities as a continuum of the Good, cleansed by penitential acts such as crusading, demonstrates what Richard Kaeuper has called a "confident lay independence within an undoubted knightly piety."[24] Indeed, in his study of chivalric romances Kaeuper explains how "knightly ideology fused elements of current theological thinking on confession and penance in a manner best calculated to advance chivalry."[25] In "Aler m'estuet" the Châtelain d'Arras asserts his idiom through the voice of the lady: he ventriloquizes her voice to demonstrate a piety that outwardly devotes itself to Christ yet maintains an *intentio* of earthly love.

Comparing the Châtelain d'Arras's use of *heart* and *voice* to articulate intention reveals his close engagement with contemporary sermons, especially the concern with external manifestations of a repentant heart. In the first strophe and in the chatelain's departure "without a heart," the trouvère constructs his own crusading voice against a penitential discourse that is increasingly more explicit in mapping the process of inward contrition and external confession. A pious, repentant crusader about to depart should have a voice that arises from a contrite heart. In the *Sermones per annum* Bernard explains that the voice (*vox*) should come from the contrition of the heart (*contritio cordis*), as oral confession should proceed from a humble, simple, and true heart as a proper *vox confessionis*, or confessional voice ("ex voce confessionis corde humili, simplici fidelique processerit illa confessio"), and true remorse should be manifested through tears.[26] In a public performance among peers, and in addressing a lady ("Dame, merci!"; line 7), instead of reflecting inwardly and repenting his sin, the chatelain instead professes his continual service to his lady. That is, his voice of crusading intention comes from a place outside of himself—his love for his lady—rather than from *within* a repentant heart. He wants two things at once: to be attached inwardly to his lady but to demonstrate outwardly his piety as a crusader. Therefore, he resolves this predicament by taking his intention outside of himself: his body goes to Syria *without* his heart. The Châtelain d'Arras constructs a crusading voice against Bernard's contritionist view in which external signs (ideally tears, but also tongue and voice) should ac-*cord* with the heart. By externally aligning his heart with his lady, his voice moves his intention outward and makes his earthly intention consistent with his spiritual one. At first his body contradicts his intention, which is to remain with his lady; this is why his voice through song ultimately makes his heart leave his body.

The Châtelain d'Arras replaces the proper textual object of confession—the sincere voice or external sign—formed through the sacramental encounter, with a penitential self-presentation formed through the code of courtly lyric. Having his lady's heart with him

as he goes on crusade, he compares himself to Lancelot, whose reward earned was doubled when he endured earthly pains for his true love of Guinevere:

> Se le vostre ai od moi en compaignie
> Adès iere plus joians et plus preus.
> Del vostre cuer serai chevalereus.
>
> Del gentil cuer Genievre la roïne
> Fu Lancelos plus preus et plus vaillans;
> Pour li emprist maine dure aatine,
> Si en souffri paines et travas grans;
> Mais au double li fu gueredonans
> Après ses maus Amors loiaus et fine:
> En tel espoir serf et ferai tous tans
> Celi a cui mes cuers est atendans.
>
> If I have your heart with me in company,
> I will be the most joyful and brave.
> By your heart, I will be valiant.
>
> With the noble heart of Guinevere the queen,
> Lancelot was the most brave and bold;
> for her he endured many hard conflicts,
> he suffered pains and great tortures;
> but the reward he earned was double
> after these hardships, from loyal and true Love,
> in such a hope I serve and will always serve
> She to whom I have entrusted my heart.
> (lines 30–40)

He endures hardship for his lady, and these chivalric, courtly acts in turn serve the Lord. By comparing himself to Lancelot, he emphasizes the pains he can endure in the service of true love for both the lady and the Lord, elevating this courtly crusader love in his version

of the doubled reward. The joyfulness and sadness that comprise his "amour vraie enterine" (true, sincere love; line 42) come from the hope of return and the sense that she will continue to remember him (stanzas 4 and 5), not from the hope of redemption in service of the Lord as seen in Bernard's description of the crusader who hopes to "be dissolved with Christ." Like private confession that is actually public and social in returning the penitent back to the Christian community and engaging the sinner in the discourse of the confessional project,[27] the courtly crusade avowal purports to be a private confession to an unnamed beloved but functions as witness and public performance of his authentic intention as a crusader. His credibility assumes his public's valorization of both earthly and spiritual sacrifice for crusade. In this sense, both confession and courtly profession are public secrets.

In addition to focusing on bodily instruments such as the tongue to qualify and emphasize true contrition, preachers also qualify what constitutes sincerity by describing the efficacy of signs such as tears and penitential works. For instance, in an Anglo-Norman collection of anonymous sermons from the thirteenth century, the preacher explains that sincere tears have a voice that reaches God, but vain tears do not:

Il sunt larmes qui unt voiz et altres qui n'unt nule voix. Les larmes que home plore pour vanité si cum pur perte d'aucun avoir u de aucun mal talent u par carnel amor, u par carnel haenge celes larmes n'unt nient de voiz.... mais celes larmes sunt raisonables e unt grant voiz devant deu qui vienent del celestel.

There are tears that have a voice and others that don't have a voice. The tears that man cries out of vanity as for the pure loss of not having something or of some bad desire or carnal love, or by carnal hate, these tears have nothing of a voice ... but when they come from the heavens, those tears are reasonable and have a great voice before God.[28]

Sinners have many instruments at their disposal with which to express their devotion; the heart and works can pray if the tongue cannot, as a late twelfth- or early thirteenth-century Lenten sermon in Walloon dialect explains:

> Se la lengue ne puet tant orer, si (hore) li cuers et nos ueures soient teles qu'eles orent por nos a Deu, et ensi porons orer sens entrecessement et par lengue u par cuer et par bones oeures.

> If the tongue cannot pray, so then the heart and our works are such that they pray to God for us, thus we can pray incessantly by either tongue or heart, and by good works.[29]

The practical emphasis on bodily instruments reveals a pastoral attention to corporeal or material signs (tongue, voice, tears) constitutive of subjective expression. In striving to explain how the tongue, the voice, and a penitential act can function as signs for the heart, these pastoral texts encourage the lay penitent to think of these signs as subjects that can efficaciously express the inner repentance of the sinner before God or the priest.

The sincerity of the Châtelain d'Arras's crusading voice, his professed "amour vraie enterine" that inspires crusade, opposes the sincere repentance stressed by preachers. In explaining how such repentance should transform the voice or tongue and the relation between heart and voice, theologians and reformers were drawing from the Augustinian tradition of "a sign as a thing which causes us to think of something beyond the impression the thing itself makes upon the senses."[30] The concept of sincere tears as having a silent voice that reaches God follows Augustine's description in *Confessions* 11.27–28 of the bodily voice (*vox corporis*) in contrast to silent, noncorporeal speech (*vox mentis*). Indeed, as Stephen G. Nichols notes in his discussion of Augustine and troubadour lyric, the bodily voice is precognitive until it becomes silent as a mental image. In a celebrated passage of the *Confessions* (11.28–38), Augustine uses the

example of the oral recitation of a psalm to show how as the mind turns inward and commits bodily expression to memory, the bodily voice becomes silent and points back to the image of the psalm. Nichols draws our attention to Augustine's fundamental distrust of the "free play of vocal expression" and the conversion of oral performance to an anterior written text (referring to the model of scripture) in book 11. In establishing a "link between oral performance, the body and its passions," Nichols argues, Augustine shows how these things should be "perceived as transitive markers of material life" because they "give way once they have transmitted their content to memory."[31] The conversion from "former" to "new" tongue and the voice of tears represent priests' efforts to incorporate such sign theory into the practice of confession. How does the confessor collaborate with the penitent to invent a sincere repentance in language and external signs? How does the penitent recollect private memory toward the proper, silent textual object that signifies reconciliation with God? These examples indicate rhetorical and metaphorical strategies to avoid imperfect (forced or mechanical) confession that lacks true sorrow, known as *attrition*.

Moreover, the Châtelain d'Arras's unrepentant avowal responds to what modern readers might recognize as the "literariness" of penitential self-representation invented in the sacramental encounter between priest and sinner. It is almost as if, in the emphasis on the external signs of sincere contrition that preachers try to explicate, the trouvère instead professes an authentic avowal that comes from the kind of sincere intention valorized among his peers—*fine amour*, in this context, a true, perfect love that balances chivalric-courtly ideals with spiritual ambitions. This literariness is also evident in Bishop Maurice of Sully's sermon on penance (transmitted in the vernacular during the thirteenth century), where he explains how the sinner might shape the confessional narrative as a proper textual object of penitential self-representation. Sully's detailed description of the formal structure of the sacrament demonstrates the practice of confession as producing what I call a *voice-text*—a representation of internal repentance that emerges in the dialogue between

priest and sinner. The pastoral syllabus structures the sacrament as interior contrition (*la repentance del corage*), oral confession (*la confessions de la bouce*), and performance of penance (*la penitance*).[32] After describing how the sinner must reflect inwardly and bitterly repent of his sin ("asprement repentir"), he stresses how oral confession must accord with internal repentance so that the penitent does not fall into the trap of an imperfect confession.

> Apres la repentance del cuer, si est la confessions de la bouce par coi on se doit acorder a Deu; quar lues qu'il s'en repent en son cuer de son pecié: ne se doit il pas iluekes arester, ançois doit tost venir a son provoire, e soi humilier e ageneillier devant lui, e crier li merci, e regeher li son pecié par sa bouce, e dire comment e quant il l'a fait. Il i a de tels qui vuelent metre essoine en lor pecié, e dire: "Sire, jo n'en puis mais, jo sui en tele compaignie que jo ne m'en puis garder ne tenir de cest mesfait faire," e par ço veulent *dauber e dorer lor pecié*. Mais ce ne doit pas prodom faire qui se veult acorder a Deu; mais ausi com il vuelt parfitement conquerre l'amor Deu, issi doit il parfitement regeher son pecié.

> After the repentance of the heart, then it is confession by mouth by which one must reconcile himself with God; because as soon as he repents of his sin in his heart, he must not stop here, but right away he must soon go to his priest, and humble himself and kneel before him, and cry to him mercy, and confess to him his sin by his mouth and say how and when he did it. There are those who want to excuse their sin, and say, "Lord, I can never stop this, I am in such company that I can not help myself nor hold back from committing this fault," and by that they want to *amend and gild their sin*. But this thing a good man must not do who wants to reconcile himself to God; but just as he wants to sincerely seek the love of God, in this way he must sincerely confess his sin (my emphasis).[33]

Inward reflection and repentance should be quickly followed by the penitent's "sincerely confess[ing] his sin" ("parfitement regeher son

pecié") without "amend[ing] or gild[ing] it" ("dauber e dorer"). The sinner must relate the circumstances of his sin ("dire comment e quant il l'a fait") and perform the ritual acts of penance such as kneeling before the priest. In keeping with theological discussions over the sacrament, Sully concedes that to "parfitement regeher son pecié" presents a problem during the sacramental encounter: the external form of contrition that emerges from the dialogue between confessor and sinner is subject to interpretation as a representational oral text, what Robert Grosseteste describes in a treatise dated around 1215 as a mediated "narratio" of intermediary status.[34] The priest interprets the outward sincerity of inward repentance—the extent to which the sin is confessed "perfectly" and the extent to which bitterness appears in the penitent's self-presentation. (Grosseteste describes a "sufficient narration" as one that is "true, complete, full, plain, better and modest," guided by appropriate questions from the priest).[35] Because he helps ensure that the oral confession signifies sincere repentance, Sully stresses the performative qualities of confession concerning time and gestures. In quoting what the penitent might say when he or she misrepresents sins, and describing how the sinner might edit his or her sin—as a voice-text—in confession, he recognizes the problematic nature of penitential self-representation.

Bishop Sully anticipates these later attitudes about personal confession as a narration of one's sins and the inaccessibility of the penitent's inward thoughts to the confessor and to the penitent himself. As Dallas Denery explains, "confessional self-examination removed the penitent outside of himself, the opacity of intention rendering true self-knowledge and one's true self always just out of reach."[36] As homiletic examples depict tears as having a silent voice that reaches God, the expression of repentance should fall silent as a mental image reaching toward God and *caritas* (the tears that have a voice that reaches God). Sully recognizes oral confession as a form of representation. Most essentially, by emphasizing the possibility of editing the voice-text ("dauber e dorer"), he concedes that this literariness of confession might be in tension with Augustinian her-

meneutics. In practice, one must develop techniques (e.g., the pastoral syllabus that presents a common framework for both priest and penitent) that recognize the arbitrary relation between the signifier (*signifiant*) and signified (*signifié*) that produce the confession as sign, or *narratio*.[37] The representation and interpretation of self-disclosure between priest and penitent can be seen as an arbitrary relation between the signifier and the signified—that is, between the confession as a dialogic invented text and repentance. The penitent and priest hope to discover the penitent's sincere contrition through the process of recollection and reflection according to the pastoral syllabus and prescribed interrogation.

Over the course of the thirteenth century, the sincerity of the confessional voice-text as sign was evaluated within an increasingly prescribed system of other signifiers of the sacrament such as the circumstances of sin, the pastoral syllabus of interrogation, ritual performance, or the priest's words of absolution.[38] Sully, Grosseteste, and others recognized the problematic *narratio* of penitential self-representation as a voice-text that may deviate from Augustine's idea of a voice that falls silent into memory. The insistence on correct or perfect expression ("parfitement regeher") of sin and repentance reflects the work involved to invent a text in the performance of confession. More precisely, these descriptions of how confession should represent the "repentance de corage" reveal a pastoral concern about the severance of a natural connection between language and interiority. Sully's efforts to discern a sincere confession during the event of confession indicate the syntagmatic and associative elements of confession as sign—respectively, those present in time and those present in mind but absent in sequence. Just as Bernard elsewhere in his *Sermones* explained how those with true compunction and confession speak "new tongues" who no longer speak a former language that excuses sins, Sully warns the penitent against embellishing or editing his sins and describes the process of a literary activity. Sully's use of "dauber" and "dorer" indicates a heightened awareness of the arbitrary nature of the confessional voice-text beyond the repen-

tance it should signify. Returning now to further analysis of "Aler m'estuet," we see that the Châtelain d'Arras responds to this emergent awareness of the literariness of confession—especially the dialogic voice-text that emerges in the event of a performance with an interlocutor. Using courtly tropes, he establishes a different kind of penitential voice outside of an increasingly codified framework of penance transmitted in pastoralia.

THE PENITENTIAL MODE OF "ALER M'ESTUET": MEMORY, VOICE, AND SONG

Given this pastoral awareness of penitential self-representation as literary text and discursive sign, the Châtelain d'Arras crafts a penitential self through multiple voices and an embodied memory. He refuses a confessional text that strives towards the silent, disembodied Augustinian voice when memory turns toward the intellect, the internal speech of the soul where one might grasp the divine mystery (Logos). In contrast, the act of remembering (*recorder*; line 21) the lady is an embodied performance of song (*chant*; line 41). If the purpose of confession is recognition and sorrow for one's sins leading to reconciliation with God and return to the Christian community, then the poet avoids this confession and establishes his penitential intention through remembrance of the lady. His unrepentant, personalized avowal valorizes and authorizes his crusade intention and the courtly community that subscribes to his avowal. He embraces the literariness of a penitential mode seen in the autonomy of external signs. This process of reconfiguration to produce a new literariness constitutes a version of the idiom, one made available through the interplay of penitential discourse and courtly figures.

We have already seen how the Châtelain d'Arras remembers (*recort*) his lady's voice as a direct quotation (lines 22–24). As he departs for crusade, the voice of the lady's request that he remain true to her replaces the repentant inner voice that should emerge in the confessional dialogue, following the pastoral syllabus and rhetori-

cal formulas of interrogation that prompt the circumstances of sin
to which Sully alludes ("e dire comment e quant il l'a fait"; and say
how and when he did it). The Châtelain d'Arras constructs a voice
that orders him to be loyal as a true lover, "vrais" as a "fins amou-
rex" through direct quotation. This professional voice of erotic self-
constraint, as opposed to the confessional voice, inspires him for
crusade without obliging him to repent.

The imagined dialogue with the lady allows the Châtelain d'Ar-
ras to regulate his own intention and to replace penitential self-
representation with courtly servitude, as he says in his closing *envoi*:

> Li chastelains d'Arras dit en ses chans
> Ne doit avoir amour vraie enterine
> Ki a la fois n'en est liés et dolans:
> Par ce se met del tout en ses comans.

> The chatelain says in his songs that
> he must not have a true sincere heart
> who at the same time is not joyful and sad:
> this is why he places
> himself entirely under (Love's) commands.
> (lines 41–44)

The memory of the lady, as an external voice that calls for his obe-
dience, allows the poet to create and morally justify a paradoxical
crusade avowal that is both joyful and sad, "liés et dolans." By being
a servant of Love and following her commands ("par ce se met del
tout en ses comans"), he creates an alternative discourse to the repre-
sentational framework of penitential self-representation. The trou-
vère embraces his "chant" as a discursive one, his voice becoming
the voice of the beloved. Crafting another kind of syllabus towards
"vraie amour," he explicitly ventriloquizes another to form his inten-
tion. The external voice of the lady sets the conditions of the heart
and moreover calls for its separation from the lover.

Following the courtly topos, the act of *recorder* that figures the desire for physical union occasions the separation of his heart and body (lines 25–30).³⁹ This fragmentation of the body challenges the apparent transparency and unity that should occur between heart and voice (*langue, parole, narratio*) in confession. But the departure of his heart and the exchange of hearts also make his crusade intention a sign in the Saussurian sense: one that alternates between his and her voice. The performed voice of intention shifts between his crusade obligation and his loyalty to the lady, between the voice in the body that must depart and her ventriloquized voice that sustains him abroad. The lady's voice, transformed from the siren's incomprehensible, dangerous song into a voice that calls for the Good of *fine amour*, locates his heart as both in and out of his professing subjectivity: an irreducible, dynamic ambivalence constituted through a *chant*, or song—such a polyphonic voice follows the sense of "chant" that according to Godefroy can mean the elevation or inflection of the voice in both humans and animals. This lyrical form negotiates the physical and psychological distance between here and there, Christian and profane values, social affirmation as a "chevalreus" crusader and longed-for union with an idealized earthly object of desire. The memory of the lady gives voice to earthly values in tension with the crusader's penitential code.

Further, by bringing his loved one to heart (literally to *recorder*)⁴⁰ through her envoicement and then removing his heart in exchange for hers, the poet-narrator defers the need to turn within himself to cleanse and purge himself of sin. He practices a memorial bodily engagement *with* his lady through the voice, rather than a penitential distancing *from* her. The lady's voice as sign of earthly desire should fall silent when the penitent bitterly repents of carnal attachments as he embarks on crusade. In contrast, he embodies her voice in order to cause a fragmentation of his body and consciously foregrounds his earthly self as a constructed sign: a self-representation embodied through the corporeal envoicement of his conflicted will. Not a silent voice that returns to the anterior text of Logos, this double voice sings of hopeful return.

COURTLY *RECORDER* AS NOTATION AND WITNESS

> Par maintes foiz m'en serai repentiz,
> Quant j'onques voil aler en ceste voie
> *Et je recort voz debonaires diz.*

> Many times I will have repented,
> Whenever I want to go on this path
> *And I remember your gracious words.*
> Thibaut de Champagne, "Dame, ensi est q'il m'en
> couvient aler" ("Lady, since I must leave")[41]

The Châtelain d'Arras must go there: he transforms the record of leave-taking from a penitent act into a chivalric boast. By portraying his process of departure and attachment to the courtly codes, he professes a sincerity that competes with the sincerity of self-disclosure in the sacramental encounter. By the time such lyrics were transmitted in chansonniers and inserted in romances in the thirteenth century, *recorder* could refer alternatively to something remembered by heart, such as a song, or a text to be written down.[42] Although authentic confessions were not to be written down, confession was frequently described in exempla in relation to written texts intended to instruct the laity about the efficacy of confession; sins were "written in the Book of Damnation" and erased (*effacié*) upon confession.[43] Further, in addition to the priest's role as solicitor, interpreter, and finally absolver (and hence authorizer) of the penitent's sin as confessional text (e.g., Sully's description of the invention of sin as a dialogic encounter and textual production), exempla encouraged sinners to think about confession as a self-reflexive act. One example compares a dog licking his wounds to sin being healed by the tongues of confession.[44] Against this idea of confessional notation and erasure, and confession as a self-reflexive act, courtly remembering (*recorder*), whether in performance as song or through written transmission in chansonniers or lyric romances, produces a self-authorized idiom of crusade. The trouvère produces and memorializes an intermediary text—the voice of the lady, a lyrical record

that guarantees the truth-value of his crusade intention apart from the confessional encounter.

REMEMBERING (*RECORDER*) AS POETIC NOTATION: THIBAUT AND THE HEART OF AMBIVALENCE

The Châtelain d'Arras remembers his lady's voice, and that act occasions the separation of his heart from his body. Thibaut of Champagne also remembers his lady and externalizes his heart in a way that produces a different configuration of the idiom in "Dame, ensi." Although he does not ventriloquize her voice, remembering (*recorder*) the lady is a form of poetic notation, and he leaves his heart with her as a sign of continual devotion:

> Deus! Pour quoi fu la terre d'Outremer,
> Qui tanz amanz avra fet desevrer
> Dont puis ne fu l'amors reconfortee,
> *Ne porent leur joie remenbrer!*

> Ja sanz amor ne porroie durer,
> *Tant par i truis fermement ma pensee,*
> *Ne mes fins cuers ne m'en let retorner,*
> Ainz sui a li la ou il veut et bee.

> [...]
> Par maintes foiz m'en serai *repentiz,*
> Quant j'onques voil aler en ceste voie
> *Et je recort voz debonaires diz.*

> God! Why does the land Overseas exist
> Which will separate so many lovers
> Who then will not have comfort from love
> *Nor will they be able to remember their joy!*

I could never last without love,
So completely is my thought devoted to it,
Nor could my true heart allow me to renounce it,
Thus I think to her, there where my heart desires and lies.

[…]
Many times I will have *repented*,
Whenever I want to go on this path
And I remember your gracious words. (lines 5–23; my emphasis)[45]

As in "Aler m'estuet," Thibaut remembers ("recort") the words of
his lady but he takes a different tactic in his use of the figure of the
separated heart. Like the Châtelain d'Arras, Thibaut remembers as
a form of resistance to the confessional mode and produces poetic
notation. By employing "recorder" with "repentiz" without creating
the voice of the lady, Thibaut is more explicit in his replacement of
inward repentance with the idiom. He reconfigures spiritual repen-
tance for his own agenda: the memory of her gracious words ("debo-
naires diz") makes him repent having taken the crusade vow and
his departure for crusade. He inverts the function of repentance—
he should be repenting his love for his lady—and remembering her
words incites him to repent the right path ("en ceste voie") of his
crusading pilgrimage. Thibaut justifies his right intention through a
commitment to his lady and devotion to her memory. At the begin-
ning of the song, he curses "la terre d'Outremer" because it separates
lovers and prevents them from remembering their joy, "ne porent
leur joie remenbrer" (line 8). Rather than a narrative of sin inter-
preted by a priest, wherein remembrance as part of repentance erases
the sinful self, Thibaut produces a memorial object, her "debonaires
diz," that causes him to repent his current life as a crusader.

As he remembers his lady, Thibaut takes explicit steps to deflect
internal repentance: his thoughts are devoted to love, and his heart
does not allow him to renounce it (lines 9–11). Turning to love and
devoting himself to his heart, he opposes the confessional role of
memory in which the mind should turn back into itself. In a sermon

dating from around 1227, John of Abbeville describes the importance of remembering past sins as a penitential activity, whereby the sinner deploys the allegorical sense of past sins to distance himself from the past self. Just as John imagines the powerful impact that this recall should have on the penitent as a purgation of conscience, like "wax melting at the flame,"[46] Bernard of Clairvaux had argued earlier in his sermon *De conversione ad clericos* that to experience conversion, one must have a certain conscience of fault. Humiliating himself, the penitent realizes that he is a different person from his former self (*purganda memoria*).[47] Contrition results from remembering the guilt of the past self with detachment. Thibaut also inverts James of Vitry's idea that one should recollect the Passion (as opposed to our own sins) in a distant, textual (or in the above homiletic examples, allegorical) manner. According to Vitry, one should remember not *in monumento* but as the holy women who saw Christ did in the *sudarium*—remembering as a desire for something, the *sudarium* reminding the viewer of at once the lack of presence and the present Passion of Christ. This remembrance gives life to the agony of Christ and his labors and reproduces the Passion to direct our conscience toward proper penitence.[48]

By remembering ("remenbrer," "recorder"; lines 8, 24) the words of his lady in his mind and repenting the path to salvation, Thibaut maintains his attachment to his sin. Not only does he create his own discourse of repentance, but he inverts the process of contrition: the motif of the separate heart and body represents a refusal to forget his past self through the lady ("ainz sui a li la ou il veut et bee," I am there with my heart, there where it wants and desires; line 12). In his denial of internal repentance, he desires something that lies outside himself ("la," where his "fins cuers" lies; lines 11–12). Even when he does turn toward God, he defines the worth of his turn as a loss of his heart and joy, replaced with a new love and Lady of the heavens:

> *Biaus sire Deus, vers vous me suis guenchiz;*
> Tout lais pour vous ce que je tant amoie.

Li guerredons en doit estre floriz,
Quant pour vous pert et mon cuer et ma joie.
 De vous servir sui touz prez et garniz;
A vous me rent, biaus Peres Jhesu Criz!
Si bon seigneur avoir je ne porroie:
Cil qui vous sert ne puet estre traïz.

Bien doit mes cuers estre liez et dolanz:
Dolanz de ce que je part de ma dame,
Et liez de ce que je sui desirranz
De servir Dieu, qui est mes cors et m'ame.
Iceste amor est trop fine et puissanz,
Par la couvient venir les plus sachanz;
C'est li rubiz, l'esmeraude et la jame
Qui touz guerist des vius pechiez puanz.

Dame des cieus, granz roïne puissanz,
Au grant besoing me soiez secorranz!
De vous amer puisse avoir droite flame!
Quant dame pert, dame me soit aidanz!

Good Lord God, toward you I turn
Forsaking everything for you that I have ever loved.
The reward for it should be garnished with flowers
When for you I lose both my heart and joy.
I am ready and armed to serve you;
To you I surrender myself, good Father Jesus Christ!
Such a good Lord I could never have
He who serves you cannot be betrayed.

Well should my heart be *joyous and doleful*:
Doleful because I leave my lady,
And joyous because I am desirous
to serve God, who is my heart and soul.
This love is exceedingly true and powerful

It's fitting that the most learned come to its path;
It is the ruby, emerald, and the gem
Which completely cures ugly, foul-smelling sins.

Lady of the heavens, great, almighty queen,
Help me when the need is great!
May I be rightly inflamed to love you!
When I lose a lady, may a lady come to my aid!
 (lines 25–44)[49]

At the end of the song Thibaut does, after all, forsake everything he has ever loved as he turns to God. Luca Barbieri argues that the song reconciles love for the lady with crusading values, ultimately absorbing earthly love into a divine, mystical love.[50] However, rather than reading the ending as the culmination of a spiritual progression, one can read it as questioning that progression: Thibaut establishes the value of his earthly love in equal opposition to the divine love of his crusade. Even after his seeming turn toward the right path, we are reminded of his ambivalence, the state of his heart as "liez et dolanz" (happy and sorrowful; line 33): sad for leaving his lady and joyous in his desire to serve God who is his heart and soul ("et liez de ce que je sui desirranz / De servir Dieu, qui est mes cors et m'ame"; and joyous of what I am desirous of, serving God who is my heart and soul; lines 35–36). It is not possible to think of his right path without defining it against his lady's love, and the heart is the place where he can have contradictory feelings. He declares that his love of God is most true and powerful ("trop fine et puissanz"; line 37), a ruby, emerald, or gem that completely cures base, foul-smelling sins ("c'est li rubis, l'esmeraude et la jame / Qui touz guerist des vius pechiez puanz"; lines 39–40). Here he seems to have finally transcended his earthly love in the acquisition of a love of the highest value. But why symbolize his love with gemstones of purity and value alongside his heart vacillating between joy and sorrow, especially when this new true love is supposed to heal this kind of sin? Through the heart, Thibaut leaves traces of his earthly love

before his divine turn, if only to measure the worthiness of his sacrifice. The trace of being *dolanz* in his moment of supposed conversion (particularly in the parallel rhetorical construction of being *liez* and *dolanz*) affirms the value of his new *vraie amour* in the currency of another love—one in which his thoughts and memory were so absorbed that at one point in the song he repented his turn toward God. In the *envoi* where Thibaut asks for the aid of "the Lady of the heavens" ("Dame des cieus"; 41), C. T. J. Dijkstra has argued, we can see his refusal to forget his lady and his inability to conquer his earthly desire in the subjunctive of line 43: "de vous amer puisse avoir droite flame!" (May I be rightly inflamed to love you!). This line highlights his equivocation; a "conversion under constraint" as a wish to overcome his earthly love rather than an avowal of his true conversion.[51] The last line of the lyric also reaffirms the poetic currency of his sincerity made possible through the separated heart: "Quant dame pert, dame me soit aidanz!" (When I lose a lady, may a lady come to my aid! line 44). Thibaut not only foregrounds the question of motivation concerning conversion and right intention (conversion under constraint) when it comes to taking up the vow but also returns to the idea of his vow as a transaction or substitution rather than a teleological transcendence: "losing and gaining a lady." He expects a reward for such a sacrifice: "Li guerredons en doit estre floriz / Quant pour vous pert et mon cuer et ma joie" (the reward for it should be garnished with flowers, when for you I lose both my heart and joy; lines 27–28). Through his use of "floriz" that recalls the promise of paradise for those who die on crusade, Thibaut implies that he knows the sacrifices that his vow entails and expects spiritual rewards.

CONCLUSION

For both the Châtelain d'Arras and Thibaut de Champagne, the heart affords a way to remember and notate an idiom that maintains ambivalence between worldly and spiritual chivalry. The heart, invoked and separated from the body, activates a process of deflec-

tion from confession: a deflection from inward repentance through a devotion to an external, love object that is envoiced or remembered.

In the case of the Châtelain d'Arras, the trouvère creates a *chant* that situates the heart in the relational embodied voice. This song goes against the authorized confessional voice that should translate a *contritio cordis*, or contrite heart. Concerned about forced or mechanical confession and stressing the sincerity of external signs of contrition, theologians and parish priests alike betrayed an awareness of the literariness of the confessional voice-text when judging the translation of a "contrition vraie" or "vraie amour."[52] A sinner might amend and gild ("dauber e dorer") sins in order to excuse them or have vain tears that fail to reach God. In reaction to the emergence of a confessional voice-text that emphasizes the ritual of the sacrament and the proper qualities of Bernard of Clairvaux's *vox confessionis*, which implies the authority of the priest who collaborates in the production of the confessional voice-text, the Châtelain d'Arras creates his own professional idiom of intentionality, his own voice as song. The poet inhabits the voice of his lady to justify his paradoxical position as a crusader-lover and to extol aristocratic values of courtliness and chivalry. Through the act of courtly remembering (*recorder*) and the exchange of hearts, he refuses the inner reflection, remembrance, and distancing from earthly love necessary for the emergence of the confessional voice and a crusader's right intention (*intentio recta*). As long as he remains apart from the lady and envoices her memory, she guarantees his crusading intention. The Châtelain d'Arras thus maintains the dissonance of an external voice even as he justifies his right intention as a true, sincere love, an "amour vraie enterine." Where the confessional voice's sincerity relies on conversion and the expunging of sin and silencing of earthly voices in order for the voice of repentance to emerge, the chatelain relies on the external voice of his lady to formulate an intention that is joyful and sad, "liés et dolans," a voice of contradictory intentions that nevertheless establishes his credibility as crusader.

In the case of Thibaut, the heart creates an opportunity for a courtly devotion that deflects or resists the process of inward re-

flection and repentance. The rhetoric of currency and exchange implicit in Thibaut's supposed turn to God in "Dame, ensi" commemorates and gives value to the continuum of the Good, a value created through the movement between earthly and divine love, each one dynamically defined against the other through lyrical reconfigurations of penitential language. His lyric maintains and celebrates this idiom that resides between happy and sorrowful, "liez et dolanz." Remembering his lady's words causes him to repent his right path. With the heart established as the anchor for his resistance to full conversion to the right path, even as he turns to God, he cannot help but create a currency of ambivalence in which he values his true love for God through the waverings of his heart. In opposition to the pure gemstone that symbolizes his love, his heart is a testimony to his own sincere wavering about crusade. By commemorating his lady as a textual object that only he can emend and interpret, and creating currencies of value through comparisons between different loves, he authorizes his avowal through her. Even though he ultimately turns away from her and toward God in "Dame, ensi," Thibaut still records his earthly memory as proof of his turn toward the true love of God. The use of the same phrase, "liez et dolanz," / "liés et dolans," by both Thibaut de Champagne and the Châtelain d'Arras demonstrates that these poets recognize the wavering state of courtly departure as fertile ground for developing their own idiom. Both find inventive ways to articulate a true love against penitential discourse through the beloved lady. In that space between joy and sorrow, they shape a path that transforms a personal love into a positive force for the crusading cause.

Idiomatic Movement and Separation in Middle High German and Occitan Crusade Departure Lyric

Sît ich dich, herze, niht wol mac erwenden,
Du wellest mich vil trûreclîchen lân,
sô bite ich got, daz er dich geruoche senden
an eine stat, dâ man dich welle enpfân.

Heart, since I cannot turn you back
from deserting me so sadly,
I pray God reach down to send you
where they will welcome you in.

FRIEDRICH VON HAUSEN, "Mîn herze und mîn lîp
diu wellent scheiden" ("My heart and body want to separate"), 2.1–4[1]

Ez ist geminnet, der sich durch die Minne ellenden muoz.
nû séht, wie sî mich ûz mîner zungen ziuhet über mer.

A man who must go into exile for love—
There is a man who loves.
Now behold how she [true Love] draws me
across the sea away from my native tongue.

HARTMANN VON AUE, "Ich var mit iuweren hulden"
("I go with your good grace"), 2.5–6[2]

THE HEART, THE TONGUE, AND GOOD WORKS

In this chapter I examine departure songs in other vernaculars to gain a sense of how particularly and creatively one could speak bodily fragmentation and crusader intention. Like their French counterparts, Middle High German and Occitan poets responded to the new calls for crusades, the sermons about taking the cross,

and the preacher's encouragement to look within and repent sincerely before going abroad. In these traditions, poets consider the moral framework of God versus the lady, courtly preoccupations of sincere will and works, and the movement of pilgrims. A comparative study with select examples productively illuminates the diversity and intensity of the idiom. I draw out not only the similarities across the traditions but also the particular way poets diverge on conventions concerning the heart, the tongue, and the voice of crusading intention.

Minnesang crusade lyric flourished in the same period as the Occitan and French traditions, and leaving aside the songs of Walter von der Vogelweide, they consist mostly of love lyrics rather than exhortative and political songs. Critics suggest that certain Old French or Occitan crusade songs may have served as source material for the Middle High German poets; otherwise there is a general consensus that when the major crusade leaders Richard of Aquitaine, Friedrich Barbarossa, and Philip II took the cross around 1187, these campaigns elicited responses from poets in French, Occitan, and German-speaking territories. These poets were composing simultaneously and might have exchanged and borrowed sources or may have met in courts.[3]

Like the Old French lyrics, *Minnesang* crusade lyrics respond to pastoral concerns of a crusader's undivided heart and body of right intention with poetic figures of ambivalence. These poets express competing loves as bodily fragmentation, and painful separation proves their crusading sincerity. Both Friedrich von Hausen (c. 1150–90) and Hartmann von Aue (c. 1160–1210) were knights (in Friedrich's case he was an imperial *ministerialis*, or unfree noble, in the service of Barbarossa) and *Minnesänger* (minnesingers), and their works include lyrics of love service and crusading songs. Associated with the Hohenstaufen court, Hausen participated in the Third Crusade with Barbarossa. Albrecht von Johansdorf composed songs at the same time as Hausen and like him participated in the crusade of 1189. Little is known of Hartmann, but he likely participated in the Third Crusade with Barbarossa in the late twelfth cen-

tury. Both Hartmann's and Johansdorf's works borrow themes and motifs from Hausen, whom they probably met or at least with whose work they were familiar. In a different way from the trouvères, these poets reflect upon inner moral purity through the divided body and see an irreconcilable conflict between the heart and body (Hausen) or use this fragmentation as a way to progress toward the true rewards of serving God (Hartmann). In their idiom, *Minnesänger* respond to the crusading call for internal repentance by translating an inner moral purity to the externalized heart or tongue. As scholarly consensus suggests, compared with the French and Occitan traditions, these crusade love lyrics are more abstract: they do not address a particular lady but rather all ladies, and they are generally more philosophical reflections on the conflict between worldly true love (*Minne*) and crusade. They function as set pieces using the figure of the lady rather than a direct address to a lady. Yet this more philosophical view of the conflict between devotion to God or the lady as true love causes a different version of the idiom to emerge in specific lyric situations, such as in dialogues between the personal and impersonal states of the heart and "I" ("herze" versus "ich"), in various transformations of the will ("willen"), and in considerations of personal contracts and obligations against those of crusading.

Crusade was a subject of one-third of Hausen's lyric output, and three of his crusade songs relate explicitly to the conflict between love for the Lord and love for the lady (the *Gottesminne-Frauenminne* conflict).[4] In "Mîn herze und mîn lîp diu wellent scheiden" ("My heart and body want to separate"), a departure song in which Hausen probably borrowed the figure of the separated heart and body from Conon de Béthune's "Ahi! Amours, com dure departie," he chastises his heart because it retains an ignorant desire ("tumben willen"; line 14) for his lady. The increased abstraction of *Minne-sang* lyric is clear in the case of Hausen's struggle between his heart and body. Hausen leaves this conflict unresolved and vows to go on crusade in a sorrowful state of two irreconcilable halves.[5] While the trouvères resolve the conflict of serving God and the lady through the exchange of hearts, for Hausen the body that goes on crusade

without a heart is a personal failure: his inability to separate himself from his lady constitutes a sinful act that lacks right intention. At the end of his song, Hausen prays to God to forgive him for his wayward heart and asks his heart to follow him:

> Sît ich dich, herze, niht wol mac erwenden,
> Dun wellest mich vil trûreclîchen lân,
> sô bite ich got, daz er dich ruoche senden
> an eine stat dâ man dich welle enpfân.
> owê wie sol ez armen dir ergân!
> wie ge tórstest du eine an solhe nôt ernenden?
> wer sol dir dîne sorge helfen enden
> mît solhen trîuwen, als ich hân getân?

> Heart, since I cannot turn you back
> from deserting me so sadly,
> I pray God reach down to send you
> Where they will welcome you in.
> Alas, poor Heart, how will it go with you?
> How could you dare to go boldly into this
> danger all alone?
> Who will help you end your cares
> with such loyalty as I have shown? (2.1–8)[6]

He cannot convert his separated heart into a service for God as Conon de Béthune does in "Ahi! Amors, com dure departie," where the service to the lady inspires valor: "Ja ne m'en part je mie! / Se li cors va server Nostre signor, / li cuers remaint del tot en sa baillie. / Por li m'en vois sospirant en Surie" (I am not leaving her at all! If my body goes off to serve our Lord, my heart remains entirely in her service; sighing for her, I set out for Syria"; lines 6–9). Hausen's address to his heart illuminates the importance of the Châtelain d'Arras's address to and ventriloquization of his lady: the conversion of the siren to a lady inspires his pious service abroad. Rather than a triumphant profession to his lady or God of his self-sacrifice and

renewed intention, Hausen ends with a plea for his heart to follow him. He fears for its fate.

In his other two crusade love lyrics, Hausen describes his turn away from courtly love as a necessary duty. Like other departure songs, in "Sî darf mich des zîhen niet" ("She may not accuse me"), he exchanges his love for his lady for a new love for God. He rewards those who serve him, as Hausen explains, "nu wil ich dienen dem, der lönen kan" (now I will serve he who can reward; 4.10).[7] The poet compares the danger of fruitless love of the lady ("ich sô lange gotes vergaz"; 5.8) to the secure love of God and its reward of forgiveness and salvation given to the crusader. Here we can see the extent to which the figure of the separated heart in "Mîn herze" actualizes the reluctance about leaving earthly cares. The fragmented body embodies intention in flux, whereas here Hausen prosaically portrays two different states of the poet, before ("sô lange") and after ("nu"): lover and crusader.

Likewise in "Mîn herze den gelouben hât" ("My heart believes"), the poet presents an unambiguous turn to the crusade, placing himself as one among other crusader-lovers who must leave their ladies behind. He grieves over the separation from his dear friends and homeland (the Rhine) as part of his personal ascesis:

> Mîn herze den gelouben hât
> Solt iemer man beliben sîn
> Durch liebe oder durch der minne rât,
> sô waere ich noch alumbe den Rîn;
> Wan mir daz scheiden nâhe gât,
> Daz ich von lieben vriunden mîn.

> My heart believes:
> If any man could rightly stay behind
> for pleasure or for Minne's sake,
> then I would still be on the Rhine.
> For the parting I had from dear friends
> moves me deeply. (1.1–6)[8]

Here his way of dealing with the grief of departure is not bodily fragmentation. Rather, he becomes a public figure of earthly loss: an everyman, "iemer man," who identifies with all lovers who must leave friends and ladies behind. This public address of collective loss might be seen as an unambiguous moral endorsement of crusade, the necessary parting and grief involved with departure, as especially in the second stanza (the song transmits only two) he chastises women who remain attached to men who do not love God. How could a man ever serve such women, he says (2.11–15). But at the end of the first stanza the syntax and diction of intention, the wanting or "willen" associated with the lady, articulate the vexed movement of the idiom. The personal desire of the "I" bound to the lady still forms an integral part of his public heart even as it aligns with crusade morality. That is, this personal "I" remains a part of the "any man" ("iemer man"):

> swie ez dóch darumbe mir ergât.
> Herre gót, ûf die genâde dîn
> sô wil ich dir bevelhen die,
> die ich durch dînen willen lie.

> But whatever happens to me,
> Lord God, on your graces
> Let me commend you the one
> The one I left behind in doing
> your will. (1.7–10)[9]

The repetition of "die" (the lady) from the end to the beginning of lines 9 and 10 signals that he emphatically wants to leave his lady behind for God ("wil" of line 9), and it structures his transformation of will: he deliberately transforms that personal articulation of want, "ich wil" into a new "willen" in service of God (line 10) as he leaves her to him. The syntax of repetition and the move from transitive action ("wil") to a completed act ("willen") dramatizes the effort of leaving his lady in his turn to God. In the previous lines when he

makes his public stance as one crusader among many, this effort appears absent: he speaks impersonally of his "heart," and even when he uses the personal "ich," it is in the conditional tense ("waere ich"; line 4) that aligns with "the parting that moves him" ("mir daz scheiden nâhe gât")—the dative further affirms the impersonal status of his crusade profession. What follows in the stanza then shows a desire of intention in tension with this public profession, and it is this tension that once again makes the idiom surface through verbal constructions in which the profession is being formulated—the "will" in the process of becoming.

In contrast to Hausen's "Mîn herze und mîn lîp," Hartmann rejects unrequited love and the divided body and calls for an inner moral purity to match the knight's public duty and military obligations in the service of religion. The ethics of love service and the relation between word and deed were a particular preoccupation for the knightly audience of Hartmann and Hausen. Hartmann resolves the conflict of service to lady or God by leaving his lady behind. Rather than staging his ascesis and conversion, with a unified intention of body and heart he uses a fragmented body to question the right intention of others. In his crusade departure song "Ich var mit iuweren hulden" ("I go with your good grace"),[10] Hartmann makes explicit his true turn to the right path by invoking his good works ("werc"; 2.2) that go beyond mere "speeches" ("die rede"; 2.2). In this work he professes that he has found true Love by breaking with the illusion of mere courtly love ("der wân"; 3.2). In the last stanza, he boasts to his public that he knows how to sing a true song inspired by true love. For this reason he has to leave his old "native tongue" behind as he is drawn overseas:

> Sich rüemet maniger, waz er dur die minne taete;
> wâ sint diu werc? die rede hoere ich wol,
> doch saehe ich gern, daz sî ir eteslîchen baete,
> daz er ir diente als ich ir dienen sol.
> Ez ist geminnet, der sich durch die Minne ellenden muoz.
> nû séht, wie sî mich ûz mîner zungen ziuhet über mer.

Many men boast about what they would do for Love:
where are their works? I hear their speeches well enough,
but I would like to see her ask a single one of them
to serve her as I am setting out to serve.
A man who must go into exile for love — there is a man who loves.
Now behold how she draws me across the sea away from my native
 tongue. (2.1–6)[11]

Here Hartmann reconfigures the external signs of intention and
the confessional text through an emphasis on his new tongue that
leaves behind his native tongue. Inspired by true *Minne*, his song is
different from mere "rede." In this version of exile, Hartmann pro-
fesses his own idiom of loss and separation: the metonymy of the
tongue articulates a sincerity undergirded by inner moral purity and
right intention. Recalling the homiletic literature discussed earlier
that focused on tongue, heart, and good works as signs of sincere
confession, here his tongue is parallel to the figure of the separated
heart in the trouvère songs but follows the confessional discourse to
affirm a contritionist sincerity — the new tongue embodies right in-
tention. In another song about his commitment to crusade ("Dem
kriuze zimt wol einer reiner muot"), Hartmann criticizes knights
who fail to go on crusade, and he takes up this common theme
by invoking Bernard's right intention: he says that the crusading
knight should have a pure mind or intention, as death in crusade
will win a twofold reward of the world's acclaim and the soul's sal-
vation ("der welte lop, der sêle heil"; 2.12).[12] Hence Hartmann's in-
sistence on inner moral purity with external signs occasioned by
departure (the new tongue, crusade action) reconciles salvation of
the soul with the enhancement of secular, military glory.[13] A com-
parison of how these *Minnesänger* imagine a fragmented body indi-
cates the extent to which the penitential discourse permeated cru-
sade lyric and prompted poets to use different figural strategies to
profess true love as a crusader.

The crusade love lyrics of Albrect von Johansdorf show an ex-
tended reflection on the conflict between love for his lady and cru-

sade service, and critics have considered them together as a series.[14] While they are not necessarily less abstract in their examination of the conflict between *Minne* and crusade, these lyrics elaborate on certain conventions of the departure song, such as the intervention of the lady, to more fully examine the complexity of the conflict. For Johansdorf, "will" is something you cannot order around, as Hausen seems to do, or reconcile through bodily fragmentation, as Conon does, but may examine at length in an irreconcilable situation. Through that process one can find some kind of respite from the bitterness of departure: this is, as we will see, his "practice" of loving well that makes the idiom.

In two songs he examines in imaginative ways how courtly love could be compatible with his crusade piety. I leave aside the other songs that treat crusade, "Die hinnen varn" ("Those who decide") and "Mîn erste liebe, der ich ie began" ("My first love which I ever began"; crusade is mentioned only in the last stanza) that are more appropriate in a discussion of exhortative verse, and will analyze the lady's voice in "Guote liute" ("Good people") in my discussion of female crusade lyric.[15] Like Hausen's "Mîn herze," the departure song "Mich mac der tôt von ir minnen wol scheiden" ("Death may separate me from her love") might have been influenced by Conon de Béthune's "Ahi! Amors com dure departie." In this song and "Ich und ein wîp" ("A lady and I") *Minne* competes on equal terms with the obligations of crusade service. In "Mich mac," it remains unclear whether the two loves can ever be reconciled.

"Mich mac" is striking in the way Johansdorf declares from the very beginning his commitment to crusade but follows this statement with a description of how intensely and purely he is dedicated to his lady. I agree with Hugo Bekker that despite knowing that his reward lies in heaven, the speaker cannot let go of seeing his self-worth in his lady and his social existence rather than from within himself:[16]

> Mich mac der tôt von ir minnen wol scheiden;
> anders niemán; des hân ich gesworn.

ern ist mîn vriunt niht, der mir si wil leiden,
wand ích ze einer vröide sî hân erkorn.
Swenne ich von schulden erarne ir zorn,
sô bin ich vervluochet vor gote als ein heiden.

Death may separate me from her love,
(but) nobody else; I have sworn to that.
He is not my friend who seeks to lure her from me,
for I have chosen her for my joy.
If ever I incur her ire justifiably,
Then I am cursed before God as a heathen. (1.1–6)[17]

Although he emphasizes his decision to go on crusade (1.1), he
seems more concerned with the exclusivity of his service to her and
his determination to serve the one he has chosen. What follows then
is this extraordinary line that illuminates the power of *Minne* as a
social contract justified by God: He guarantees love service to the
lady and punishes those who fail in that domain, as the poet says "If
ever I incur her ire justifiably, / Then I am cursed before God as a
heathen" (1.5–6). In this stanza he seems intent to demonstrate the
bond he has with his lady despite his decision to depart.

Johansdorf solves the problem of earthly attachment by creating
two distinctly separate competing categories of love that exist in
the continuum of the Good: first through a ventriloquized lady
similar to "Aler m'estuet" and then through an uncourtly idiom.
Through this poetic figure and shift in verbal register, he allows
Minne to speak on its own terms and for the loves to exist in this
competitive continuum rather than one transcending another. The
second stanza gives voice to the woman and her view of these com-
peting loyalties:

Dô diu wolgetâne gesach án mînem kleide
Daz crûze, dô sprach diu guote, e ich gie,
"wie wiltu nû geleîsten diu beide,
varn über mer und iedoch wesen hie?"

Sî sprach wie ich wold gebârn umbe sie

…

ê wâs mir wê: dô geschach mir nie sô leide.

Nu mîn herzevrouwe, nu entrûre niht sô sêre:
daz wil ich iemer zeim liebe haben.
wir suln varn dur des rîchen gotes êre
gerne ze helfe dem heiligen grabe.

When the beauteous one saw the cross
on my garment, the good one spoke, ere I left,
"how do you intend to fulfill the two,
going across the sea and yet remaining here?"
she asked how I intended to behave regarding her
[…]
Formerly I was woeful, but I never suffered more
than at that moment.

Now, now, lady of my heart, do not sorrow so;
I shall love you forever.
We have to go on account of the honor of God
Almighty
gladly to help the holy grave. (2.1-8; 3.1-4)[18]

The lady confronts the crusader about his betrayal of her despite his words of loyalty in the previous stanza: he cannot at once declare crusade piety and commit to her at this time of departure. She makes this impossibility explicit in her reference to the cross on his garment that materially signals before the world his commitment to God. She forces him to see the pragmatic reality and this confrontation deflates his carefully constructed professional avowal that shows his commitment to competing loyalties. Exposed, he is now woeful and suffers from her inquiry, which, as Bekker says, "demands an answer."[19] With this confrontation of reality, he shifts into what many critics have observed as "unhöfisch," or uncourtly language, in

the use of words such as "herzevrowe" (akin to "sweetheart"), the "soothing" repetition of "nu" ("now, now"), and then the use of the first person plural "wir suln varn" ("we have to go").[20] While it might be limiting to categorize this change as uncourtly, the shift recalls the language of lovers such as Tristan and Isolde rather than the avowal of a knight to his inaccessible lady—Tristan uses the word to address Isolde in his farewell speech (line 18266) in Gottfried von Strassburg's romance.[21]

Further, perhaps the shift to a more intimate or personal register occurs because of the pressure to turn away as a crusader, a turn affirmed in another shift in register directly after this personal address. Instead of the siren transformed into the good lady who prompts the heart to leave body, as we saw in "Aler m'estuet," here the lady's confrontation creates two discourses based on a pragmatic view of two incompatible loves: an intimate language of lovers and then homiletic language. After tender words, he turns to ecclesiastical exhortation in the surprising turn to "we." The verses about helping the holy grave ("heiligen grabe"; line 20) recall sermons to take the cross. James of Vitry describes the crusader's cross as standing for the love and devotion of Christ which draws him to Jerusalem to see the tomb of Christ, so that he can "serve [it], come to its aid and liberate it from the enemies."[22] Preachers develop themes such as the signing of the cross in their sermons and invoke the first person plural, such as the close of Eudes of Châteauroux's sermon: "Let us, therefore go out and follow Christ, so that we may gain the reward which those who follow him will gain and so that we ward off the eternal punishment which those who do not want to follow Christ will incur."[23] What remains, however, are grief and suffering from this harsh incompatibility of lovers' and homiletic discourses left unresolved: the unconvincing emptiness of the poet's last words seems to ventriloquize a sermon and thus implicitly gives voice to the lady's grief. The lady reveals the artificially constructed idioms of crusade service versus courtly service. This incompatibility and the configuration of discourses through the lady's inquiry make the

idiom speak: they reflect the extent to which these competing avow-als are constructed, and, as such, are dependent on each other for their definition and force.

It has been suggested that the unconvincing tone of the last lines of this lyric speak to the persona as driven by attrition rather than contrition, an inadequate state of sorrow that comes from an im-perfect or forced confession.[24] Indeed, by the end of the lyric, the speaker's crusade enthusiasm is less than convincing, having been put on trial by the lady's direct confrontation. If here through the incompatibility of God's will and man's will Johansdorf artfully ar-ticulates the courtly sincerity of ambivalence that I have developed in chapter 1, in another song "Ich und ein wîp" he justifies the value of *Minne* service while carefully placing it below crusader service.[25] The poet gives weight and reality to this moral conflict through another dramatization between the lady and the speaker: he must prove to her that, even though she thinks he sets her free as he goes on crusade (1.5–6), that is not his intent.[26] By including the lady's challenge, he proves the worthiness of earthly love despite being a devout crusader. As in the French lyrics, the crusader-lover swears "by God" that he is faithful to her over all other women (2.1–6) and even more that "his senses and body are subject to her" ("alle mînne sinne und ouch der lip / das stêt in ir gebote"; 2.7–8). After he establishes his devotion to his lady, thinking of her even when he is abroad (3.1–2), he sets the worthiness of his love in relation to the highest love of God by noting how everything is in flux. He sees that he might not find upon his return people whom he leaves behind in good health: "Wir haben in eime jâre der liute vil verlorn. / dâ bî sô merkent gotes zorn" (we have lost so many people in one year, note from this the wrath of God; lines 3b.9–10). This statement is imbued with the idea that he has seen many people lost, presumably in the battles in which he has participated or from calamities at home. The last two stanzas demonstrate how he sets up the hierarchy of earthly and spiritual love but also justifies the process of reflection drama-tized in his lyric:

dâ bî sô merkent gotes zorn.
und erkenne sich ein ieglichez herze guot.
diu werlt ist unstaete.
ich meine die da minnent valsche raete:
den wirt ze jungest schîn wies an dem ende tuot.

Swer mine minnechliche treit
gar ane valschen muot,
des sünde wirt vor guot niht geseit.
Si tiuret unde ist guot.

note from this the wrath of God.
let therefore everyone search his own heart.
The world is unreliable.
I mean those who love false counsel;
to them it will become evident in the end how it rewards.

Whoever practices love lovingly,
entirely without guile,
about that no sin is spoken before God;
It elevates and is good. (3.10–14 [version a]; 2.1–4 [version b],
 my emphasis)[27]

We realize what the poet has accomplished: he has taken us with
him through his "practice of loving lovingly." He has asserted that
he loves his lady faithfully and truly, but after reflecting upon the
unreliability of false counsel, he has had to come to terms with the
proper place of this earthly love in relation to God. While this song
does not end with the competing loves of equal status as in "Mich
mac der tôt," Johansdorf stages the process of coming to terms with
his crusade service in his own way, his own practice of love: "let
therefore everyone search his own heart." His idiom speaks the pro-
cess of finding one's way through competing loves. The song gives
agency to the poet: he chooses his lady and gives her an elevated

status in his own language and in relation to his own experience of the unreliable world.

THE COURTLY CRUSADE IDIOM OF MATERIALITY AND MOVEMENT

Moving to Occitan departure songs, we see that they take on a different confrontation with feudal and homiletic discourses: they emphasize the turn toward God and departure from the lady through figures of movement and metaphors of translation—the poet's will translated into a material emblem of love or crusade, or the song translated from one place or public to another. Occitan departure songs are more varied than the monothematic trouvère corpus; they may depict situations of departure in a local political context or emphasize a lover's fidelity rather than focusing on the pain of departure.[28] Despite this diversity of troubadour crusade lyric as well as the more varied social status of the poets, there are songs that demonstrate a similar lyrical response to the penitential discourse of crusade, which we can productively place in dialogue with the German and French lyrics.[29] The troubadours Jaufre Rudel and Peire Vidal both went on crusade: Jaufre went on the Second Crusade; Peire commented on the Reconquista of the 1180s and was active at the court of Count Raymond II of Tripoli. Their songs transform the memory of the lady into a textual or material object. Similar to the trouvères' penitential reconfiguration, they develop strategies of remembering that resist inward repentance.

In these departure songs the competing love for God and the lady produces a concretization of space and movement, intensifying earthly desire before the turn toward God and the Holy Land. In addition to penitential discourse about inward repentance and right intention, poets were responding to the idea of crusade as a penitential pilgrimage: this was the mentality that translated images and spaces from disparate places into a unified Christian topography. The pilgrim saw the topography of the Holy Land through biblical

description. Manuscripts such as the Morgan Crusade Bible (MS M 638), commissioned by Louis IX like other monumental art objects and liturgical texts, were aimed to depict the eternal truths about crusade as a spiritual pilgrimage: Old Testament stories about the Israelites who fought for the Promised Land (such as one on fol. 23v depicting Saul cleaving the skull of the fleeing Nahash) would be enlisted for contemporary holy war. The multilinguistic marginalia of various owners in this manuscript (Judeo-Persian, Persian, and Latin) prompt us to think of the diverse cultural environment of Palestine and the Eastern Mediterranean during crusades. In contrast to this complex situation of languages, religions, and ethnicities in the Holy Land, crusaders as pilgrims did not seek simply to visit holy sites and then return home. As Stephen G. Nichols argues in his work on crusade lyric, "they wanted to appropriate" those places, "to transform them from places supporting multiple orthodoxies and meanings in accord with a variety of foundational texts to spaces signifying a single set of meanings linked to a single book, the Bible."[30] Providing a unified script, often with vivid images and texts, such works prepared pilgrims to translate the environment they encountered in their travels.

In response to these dominant discourses of crusade pilgrimage, in his canso with crusade references "Lanquan li jorn," Jaufre Rudel styles himself as a pilgrim who reconciles his distant love ("amor de lonh") with his love for God as he departs for crusade. He is able to do this by transforming his desire for his lady into a desired faraway love. He is a pilgrim who seeks to be close to his lady:

> Ai! Car me fos lai pelegris,
> si que mos fustz e mos tapis
> fos pels sieus belhs huelhs remiratz!
>
> Ai! I wish I were a pilgrim there,
> my staff and my cloak might be
> reflected in her beautiful eyes.
> (lines 33–35)[31]

This wished-for love is one he longs for while he is away on crusade.
That is, the love he enjoys must be a faraway love:

> Ja mais d'amor no·m jauziray
> si no·m jau d'est'amor de lonh,
> que gensor ni melhor no·n sai
> vas nulha part, ni pres ni lonh;
> Tant es sos pretz verais e fis
> que lai el reng dels sarrazis
> fos ieu per lieys chaitius clamatz!

> I shall have no pleasure in love
> if it is not the pleasure of this love far away,
> for I do not know a more noble or a better one
> anywhere, not close by, not far away;
> her worth is true, and perfect, so
> that there, in the kingdom of the Saracens,
> I wish I were a prisoner for her. (lines 9–14)[32]

Yet in his songs "Quan lo rius" ("When the water") and "Quan lo
rossinhol" ("When the nightingale"), the shift from an earthly to
spiritual love, from worldly to crusade pilgrimage, leaves a residue of
uncertainty through the excessive emphasis on troubled movement.
In "Quan lo rossinhol" his final stanza affirms that one should fol-
low God to Bethlehem, the turn to salvation as a turn to the school
of Jesus ("escola"; line 42). Jaufre is unable to enjoy, give, and receive
his lady ("jau jauzitz jauzen"; line 18) because nobody "teaches" him
("essenha"; line 20) how to have pleasure from her beauty: "Mas sa
beutat no·m val nien / quar nulhs amics no m'essenha / cum ieu ja
n'aia bonsaber" (But her beauty avails me nothing, for no friend ever
teaches me how have pleasure from it"; lines 19–21).[33] This statement
is in opposition to the proper "escola" after his turn to the Good Pro-
tector: "qu'ieu sai e crei, mon escien, / que selh cui Jhesus ensenha /
segur'escola pot tener" (for I know and firmly believe that anyone
taught by Jesus can rely on a sure school; lines 40–42).[34] The use of

"escola" institutionalizes and commemorates a straight path and his complete turn toward God as a crusader-pilgrim.

However, this linear journey of the proper school has a history of contradictory motion that embodies his desire ("torn," "fugen"), one that finally leads to a mastery of his desire ("parcer mon voler") in the stanzas before he turns to Bethlehem:

> D'aquest' amor sui tan cochos
> que quant ieu vau ves lieis corren
> vejaire m'es qu'a reversos
> m'en torn e qu'ela·s n'an fugen.
> E mos cavals vai aitan len,
> a greu cug mais que i atenha,
> s'ela no·s vol aremaner.

> Amors, alegre·m part de vos
> per so quar vau mo mielhs queren;
> e sui en tant aventuros
> qu'enqueras n'ai mon cor jauzen:
> mas pero per mon Bon Guiren,
> que·m vol e m'apell' e·m denha
> m'es ops a parcer mon voler.

> I am so hard-pressed by this love
> That when I rush towards her it seems
> as if I am turning backwards away from her
> and that she is fleeing from me.
> And my horse goes so slowly that I think
> it will be hard ever to reach her
> unless she is willing to stop.

> Love, happily I part from you,
> Because I go to seek what is best for me;
> and I am fortunate inasmuch as my heart
> already rejoices at it;

> but on account of my Good Protector,
> who wants me and calls me and judges me
> worthy of love,
> I need to restrain my yearning. (lines 22–35)[35]

In his efforts to turn to the right school, these stanzas embody his pursuit as a forward and backward movement at different paces. The mention of being on a horse makes him a prisoner of an animalistic movement of desire that he will ultimately control when he learns to restrain himself ("parcer mon voler"). Jaufre reconfigures this paradoxical movement of frustration, his inability to attain a lady who flees from him and whom he cannot enjoy to a movement toward a new adventure that calls him ("que·m vol e m'apell' e·m denha"). The physical back-and-forth movement of his desire is replaced by a real place and the true school: Bethlehem and the "escola" of salvation. Although one can read this song like Thibaut's "Dame, ensi," as a reconciliation of love with crusading ideals, Jaufre problematizes the path and intentionality of the crusade pilgrimage that should be a linear and circular path: this paradox is explained by the idea that the pilgrim's journey toward the sacred place of Bethlehem signifies a true return to God and ecclesia after the painful acceptance of his duty. The song reinforces the disorienting movement of desire that has no proper school except experience, and it articulates the process of having to restrain his desire—tracking the animalistic movement that leaves love behind (like the heart left behind, or Thibaut's currency of conversion that produces a gemstone). Finally it records the physical movement before his turn toward a new adventure, the lyrical phrase before the turn—this is the residue or trace of the idiom. This spiritual pilgrimage magnifies and concretizes the paradoxical movement of desire.

This concretization produced from the tension between love and crusade pilgrimage occurs in a different way in "Quan lo rius." The only reference to crusade might be the comparison of the lady, a beautiful Christian, to the "other" of crusade ideology, the "Jewess or Saracen." However, Jaufre does speak about his "love from a far-

off land" ("amors de terra lonhdana"; line 8), and we might place this song in relation to the biographical *vida* that mentions his love of the Lady of Tripoli and the vexed movement of "Quan lo rossinhol." In the final stanza or tornada, Jaufre sends his song in the romance language ("tramet lo vers, que chantam / en plana lengua romana") with no parchment document ("senes breu de pargamina"; lines 29–31). The emphasis on the transmission of his song—remembered as a *vers* in the romance tongue rather than a text on parchment—commemorates the distance he has put between his lady and himself. Moreover, he sends his song to "Lord Hugo with Filhol" and rejoices that his transmitted song enables diverse kinds of people from "Poitevein, Berry, Guyenne and Brittany" to rejoice in him. His song is carefully crafted to move from one performer to the next. Through this transmission, the art of *trobar* creates a community of troubadours, performers (*joglars*), patrons, and publics. Parallel to the communal vision of crusade pilgrimage that was open to all believers through imagined itineraries, liturgical practices, or the practice of indulgences, here Jaufre creates a song in which people can participate from various locations.[36] If the idiom is present in Jaufre's two songs as competing practices of pilgrimage in space and time, registered through the enhanced material and physical aspects of distant love (the space between lovers, the material transmission of poetry), we also see how it creates textual communities in the expression of these desires and frustrations related to crusade departure.

Another physical manifestation of desire occurs in Peire Vidal's image of himself as a pilgrim in "Anc no mori" ("I never died"), a song composed in Languedoc after the fall of Jerusalem. Rather than changing desire to an "escola" that teaches the right way to move towards God and away from learning about pleasure (*saber*) as in Jaufre's song, here love becomes an object of transcendent purity, a crystal. By using a physical object that embodies the transformation of elements over time, Peire notates a process of departure in which the time of service and physical separation are important factors in his version of love pilgrimage:

Estiers mon grat am tot sol per cabal
lieis que no·m denha vezer ni auzir.
Que farai doncs, pus no m'en puesc partir,
ni chauzimens ni merces no mi val?
Tenrai·m a l'us de l'enuios romieu,
que quier e quier, quar de la freja nieu
nais lo cristals, don hom trai fuec arden;
e per esfortz venson li bon sufren.

Against my will I love exclusively and entirely
the one who does not deign to see or hear me.
What then shall I do, since I cannot leave her,
and pity or mercy are of no avail?
I shall keep to the custom of the importunate pilgrim
who begs and begs, for from the cold snow is born
the crystal from which one derives burning fire:
and through their efforts the good triumph through
 endurance. (lines 25–32)[37]

Similar to Thibaut's gemstone as a material and poetic witness of his conversion, Peire's earthly love is crystallized into a gemstone of spiritual love. Like a crystal, his enduring attachment to his love emits its own energy and fire. Like Jaufre's contradictory movement, crystal embodies the time of his pilgrimage. His idiomatic trace becomes the purity of his love born from his constant service.[38] According to classical and Christian cosmologists, natural crystal had particular performative powers because of its heavenly origin and the belief in the presence of cold and heat in the firmament. Because the cold *crystallinum* supports the hot empyrean, it could preserve and generate cold as well as emit light like other gems.[39] In his appraisal of the usefulness and value of stones and minerals in his day, Pliny the Elder values rock crystal above all because of its fragility: "a kind of ice . . . formed of moisture from the sky falling as pure snow."[40] Jerome, Augustine, Isidore, Bede, and Raba-

nus Maurus give the same explanation about its formation.[41] Crystal appealed to Peire and other poets like him because unrequited love could be seen as powerful and agentive through its comparison. This image of the cosmos depicts crystal as manifesting transcendence, a purity that preserves the eternal light of the empyrean.[42] Drawing from these classical and medieval conceptions of rock crystal, Peire's image records his pilgrimage of love as a process of elemental transformation through time, one that ends in the crystallization of his pure love.

Both Thibaut's and Peire's songs follow the topos of divine and pure love as a transparent gemstone. But their stones retain the material traces of their conversion from earthly to spiritual love: Peire is a pilgrim in search of his lady in a song ultimately directed "over there" ("lai") "to the Heavenly King" ("Lai vir mon chan, al rei celestial"; line 49), but his movement is more complicated than a mere turn, and he records the time of his service through the process of crystallization. The stanzas concerning Peire's love service as a crystal and the references to the Holy Land (IV and VII in Avalle's edition) are not in all manuscripts; since the crystal and crusade stanzas are transmitted in the same manuscripts, it is tempting to consider that the crystallization of the poet's unrequited love might have been attached to the image of Peire as a crusader.[43]

Similarly, the troubadour Gaucelm Faidit composed songs about his involvement in the Fourth Crusade, and in one departure lyric, "Mas la bella" ("But the beauty"), he emphasizes the time and movement of his departure for crusade. His song articulates distance through a material sign, but one associated with pilgrimage rituals rather than a spiritualized unrequited love. Parallel to Peire's translation of faraway love into a gemstone, he transforms his hesitation into a material sign of his public commitment to undertake the journey, the "entresenh":

> E quar estauc que ades no·m empenh
> ves Suria? Dieus sap per que m'ave:

que ma domna e·l reys engles mi te,
l'us per amor e l'autre per pauc faire
del gran secors que m'avia en coven.
Ges non remanh, mas ben iray plus len;
quar d'anar ai bon cor, don ges no·m vaire,
qu'e nom de Dieu ai levat entresenh.

But why do I still delay spurring
to Syria? God knows why this befalls me:
because my lady and the English king hold me back,
the one through love and the other for doing little
about the great assistance he had promised me.
I am not in fact staying behind, but I shall certainly
 go more slowly;
I have the firm intention of going and am not being
 irresolute about it,
for I have raised the sign in God's name. (lines 33–40)[44]

Not conflicting desire but the neglect of the king and his love for his lady slow his pace toward Syria. This departure song affirms his piety and intention but lends context to his hesitation to go to Syria: he translates the delay into a slow pace. The "entresenh" was one of the signs assumed by pilgrims when they made a public commitment to undertake the journey. Liturgical texts describe a rite after the blessing of the cross presented to the crusader, accompanied by the words "Lord, bless this ensign of the holy cross that it may help toward the salvation of Thy servant." The crusader then attached the cross to his shoulder and was given the pilgrim's insignia of staff and scrip.[45] Both departure songs of Peire and Gaucelm trouble an unequivocal departure through the idiom of distant love (here, Gaucelm's unwillingness to separate from his lady). The neglect of the English king compounds Gaucelm's delay caused by his love for his lady. These verses embody conflicting desires and the struggle to undertake their pious duty as crusading pilgrims, and the movement that

path entails. At the same time they also affirm their commitment and intention by invoking material testimonies of ritual signs (the "entresenh") or physical embodiments of purity (crystal).

If we view departure songs as analogues to public rituals, then we can also say that they foreground the psychological process and sacrifice toward the commitment. The material embodiment of time and distance will occur in another way in female crusade songs discussed later: for instance, when the lady left behind feels her lover's tunic against her skin. In his new life as a penitent, the first troubadour Guilhem IX ends his penitential song possibly about crusade, "Pos de chantar m'es pres talenz" ("Since a desire to sing has come over me"), with a declaration that he will "throw away joy and pleasure / and squirrel, vair, and sable."[46] The conspicuous disavowal of material possessions goes beyond the departure from his past life as a penitential sacrifice: like Gaucelm's "entresenh," it leaves a material trace of his former life of luxury and commemorates his new life (and perhaps regret in leaving such objects behind). Moreover, especially in Guilhem's case, the poets control the memory of their conversion in their own idiom. They illuminate the effort that goes into reconfiguring earthly desire as pious service. As material and physical records of conversion and pilgrimage, these songs register the movement of the courtly crusader in various witnesses: from lyric to gemstones to ensigns.

Songs that problematize the movement of conversion and leave such material traces amid the reconfiguration of earthly to spiritual love suggest performances to ready the crusader-pilgrim. Adapting Victor Turner's study of pilgrimage, Nichols describes how crusade was different from other kinds of pilgrimages that were about the spatial and temporal "liminoid" absorption of sacred sites: escaping from everyday life through a transitional voyage to a sacred site, pilgrims enact or perform the sacred texts and thereby make authentic—in a different space—their own religious knowledge through this personal experience. In contrast to this discrete sacred experience, crusaders "impose a permanent European social, religious, and political structure on the liminal space of pilgrimage . . . in other

words ... make individual liminality the basis for a collective spatio-temporal hegemony."[47]

In parallel to this culture of crusade, perhaps we can view these songs as a secular version of the "liminal," "transitional," and personal experience of pilgrimage that refuses the hegemonic collective appropriation of time and space. These songs perform competing spiritualities of earthly and celestial chivalry to personalize an ethics of crusade. This imaginative and poetic practice—vivid figures of desire and self-exile from the beloved—troubles a mode where individual experiences of loss and desire, shaped by multiple and localized places both in Europe and abroad, are translated into a unified narrative of crusader pilgrimage. This narrative dictates an accord between spiritual and real topography as well as an unequivocal movement of pilgrimage to the Holy Land based on foundational texts of scripture lavishly illustrated in works such as the Morgan Crusader Bible and preached in sermons. In short, these poets resist and trouble the ideology of the collective crusade movement preached by churchmen: what Nichols describes as the crusaders' setting "out to impose decisive cultural change . . . to bring to the multicultural environment of Palestine and the Eastern Mediterranean the same single, dominant religious culture they knew in Europe."[48] These songs suggest a resistance to this cultural change through a poetic idiom of a wavering heart and a fragmented body.

CONCLUSION

Departure songs ready the pilgrim to appropriate an unknown Outremer by adapting bodily fragmentation and crusader movement—both internal and external—to poetry. The songs leave traces of conversion as the poets hesitate, reflect, and struggle toward crusade. In the *Minnesang* tradition, poets such as Friedrich von Hausen, Hartmann von Aue, and Albrecht von Johansdorf produce their own right intention by using bodily fragmentation (the tongue and calling to the heart) to dramatize their conversion toward a true calling. They articulate the conflict between *Minne* and crusade through

the intervention of a female voice and through syntax that foregrounds the transformation of the will. Johansdorf performs the process and practice of good loving in the continuum of the Good. Occitan songs refuse the unequivocal movement of pilgrimage to the Holy Land. Troubadours find ways to record a vexed movement that enhances their spiritual status through figural movements of the heart that commemorate the process of restraining and reshaping desire. They also commemorate the process of their departure from earthly love through material objects such as crystals and ensigns. Crusader-poets speak an idiomatic self-taught discipline and school. Through the mode of lyric, the subject of crusade "practices love lovingly," and we follow that practice of the idiom through its turns, hesitations, and transformations of desire into precious objects that symbolize spiritual purity.

The Heart as Witness: Lyric and Romance

"Va, cancons, si t'en croie" (Song, go and bear witness)
JAKEMÉS, *Roman du Castelain de Couci et de la dame de Fayel*, line 7395[1]

THE COURTLY CRUSADE SONG AS WITNESS

Poets create an idiom through the figure of the separated heart, re-sulting in the reconfiguration of confessional memory and a notation of ambivalence. I now follow the figure from lyric to romance. How does romance translate this idiom? In the *Roman du Castelain de Couci et de la dame de Fayel* (c. 1280), the insertion of the Châtelain de Couci's crusade departure lyric "A vous, amant" ("To all you lovers") into the romance materializes the figure of the separate heart. A version of the eaten-heart legend, the romance famously ends with the lady unknowingly served the heart of her lover by the cuckolded husband as an act of revenge. Here the Castelain de Couci (I will use this name for the figure in the eponymous romance) is the courtly crusader who valiantly serves God and remains loyal to the lady.[2] After proving himself a martyr for Christ by fighting for Richard Lionheart, wounded by a poisoned Saracen arrow, he requests on his deathbed that his heart be embalmed and returned to his lady when he dies. As a secular relic symbolic of their love, the separated heart is in dialogue with the contemporary practice of crusader hearts being sent back home or buried in a separate place from the body.[3]

The Castelain shows himself to be a warrior for Christ and re-mains loyal to his beloved: so the *Roman du Castelain de Couci* would seem to reconcile courtly love with Christian faith. Yet, as in the lyric examples, the romance portrays his conversion as an unrepen-tant idiom, particularly in its self-conscious mode of bearing wit-ness to the earthly love that inspires his crusade. At the end of the

song that appears in the romance, the poet asks the song to act as a witness of his service for his Lord and lady if he should return ("Va, cancons, si t'en croie," Song, go and bear witness; line 7395).[4] The idiom appears in this address to his song and extends my previous discussion of *recorder* and lyric in chapter 2. Romances preserved lyrics and thematized songs as texts either learned by heart (e.g., as remembered improvisation) or written down; as seen in words such as *noter*, *ramembrance*, and *recorder*, the romance mediates between performance and writing.[5] Indeed, it is ambiguous whether or not he sings or interprets the song from his memory because "cant" and "dist" (line 7344) are used interchangeably in lyric. However, this is the first time in the romance that Jakemés uses the word *dist* to introduce a song. Further, the Castelain recalls a song in order to keep in his heart the image of his lady ("d'avoir en coer la semblance / De sa dame"; lines 7341–42) that he says is now well known ("c'on a recordé moult souvent"; line 7345). The recording (remembering as an act and interpreting the song as a textual object) of the unrepentant idiom in Jakemés's text introduces another complex layer of professed sincerity. There is a double gesture of remembering a song that itself announces its status as a claim of sincere love: both performance and notation, it bears witness to a crusader's intention.

The romance demonstrates a concern with material witnesses, both through physical objects and through the lady's protest as a witness of true love. The Castelain's explicit act of making his song a "witness" affirms that, stated in the lyric, he has left his heart behind. In Manuscript B the poet regrets that he cannot take his heart away from his lady, so it is fitting that he leaves it with her: "Ne je ne puis de li mon coer oster, / Si me couvient que je ma dame lais" (lines 7376–77). It is notable that in other versions of this song transmitted independently of the romance, it is only "l'amour" that the poet leaves behind.[6] Following the trope in the lyrics, directly before the separation of his heart, he recalls her sweet words ("recorc"; line 7366) and wonders how his heart can stay in his body (lines 7366–69). Could this inability to take his heart at the moment he sings his song, along with the request that his song act as witness in the ro-

mance, anticipate the famous ending in which his heart is sent home to his lady *after* his proper death as crusader? The romance newly adapts this figure to maintain the idiom in a mobile status between the love for God and for the lady: here the separated heart and body require material proof, not just his lyrical word of his true love—the song as witness (as a record) becomes the heart as relic.

The romance abounds with material articulations of the idiom that justify this view of the need for the song to stand as a witness and later realized in the heart sent home. In her important study, Helen Solterer succinctly notes that the romance actualizes poetic figures.[7] I agree with Solterer's reading that the romance sets its readers up for the "fulfillment of the poetic paradigm ... the physical act confirms what has already been projected poetically, both by the tradition and the narrative itself."[8] Various objects invoke material exchanges and function as physical signs of verbal promises: specifically, letters and tokens exchanged between the separated lovers attest to the crusader's verbal reluctance upon departure. The heart becomes a secular relic as the culmination of a story about material witnesses: from the lyrical suggestion of leaving his heart behind, of asking his song to be a witness, to the removal of his heart as a memento for his lady. Upon his deathbed, the moment of *ars moriendi* (art of dying) that testifies to his accomplishments as a crusader and lover, the Castelain dictates a letter to his lady. He writes that as he has always carried her heart and tresses with him, he now literally sends his heart along with the letter and her tresses that rightly belong to her ("c'est vos, s'est drois que vous l'aiiés"; lines 7667–68). With this gift, he dies as a sincere lover ("vrais amans"; line 7670), sad and chagrined that he will no longer be able to speak to her. He then compares her heart to a pure seed that lacks blemish ("vos coers est li fins grains sans paille"; line 7679), reminding us that in this state of having proven himself a good crusader (unlike the "before" state of Thibaut de Champagne and the Châtelain d'Arras), he can proclaim his earthly love as pure rather than attributing purity to Christ. He writes these wishes in a letter and throws the seal away, a gesture that makes his letter authentic. The letter describes his love

in various states: he writes that he has carried his heart with him (meant figuratively) and in reality he carried the tresses that she gave him. Finally he gives a token of himself to her along with this letter of testimony—collapsing the figure and the literally real gift, his heart.[9] In content and as material witness, the letter translates the figure of the separated heart for the narrative form of the romance in which different states of the separated heart exist to propel the narrative forward toward the actual physical heart as gift, the realization of the figure. The letter tracks the process from lyrical figure to secular relic.

This emphasis on the material witness of the idiom parallels the "cultural shift" during this period concerning relics. As Claire Taylor Jones explains in her study of the *Herzmaere*, the German analogue to the *Roman du Castelain de Couci*, following the fall of Constantinople and the increased availability of relics, "crusading was unavoidably associated with anxiety over circulation authenticity, display, and veneration of relics."[10] Jones describes the concern with "authenticity" in the "progression of exposures and enclosures" of the heart enclosed in the relic, with documents and seals (in the *Herzmaere*, the ring) to signify the proof of the relic.[11] Both the *Roman* and the *Herzmaere* create the authenticity of the heart as relic in a way that responds to theological discussions about visual veneration and authenticity of relics, including proper confession of true repentance codified in the Fourth Lateran Council's doctrines of transubstantiation and the relationship between communion and confession. In this romance, the idiom makes the relic authentic through the figure of the separated heart, the dual performance of the *ars moriendi* by both the Castelain and the Dame, and finally the lady's eating the relic—all of these factors register the new concern over external signs of the heart in religious discourse, both visually and verbally.[12] Just as we previously saw poets respond to the homiletic concern for sincere confession, here the romance responds to the concern for authentic relics.

Moving to the perspective of the Dame de Fayel, we see that her grief over her beloved constitutes another kind of witnessing

through her lyrical lamentation. Examined more closely, the last scene of the *Roman* permits us to see how female suffering over the departed crusader creates a version of the idiom in both lyric and romance.

THE FEMALE LAMENTATION: THE UNDIGESTED HEART AND THE TRANSLATION OF THE IDIOM IN THE SENSUAL FEMALE VOICE

> Ha! Com doleureus envoi a
> De son coer quë il m'envoia!
> Bien me moustra qu'il estoit miens!
> Li miens devoit bien iestre siens!
> Si est il ! Bien le mousterai,
> Car pour soi amour finnerai!

> Alas! What doleful message
> of his heart he has sent me!
> How he shows me that he is mine!
> And so I will also be his!
> So it is! I will show him
> because by love I will die for him.

> JAKEMÉS, *Roman du Castelain de Couci et la
> dame de Fayel*, lines 8143–47

The consumption of the heart by the Dame de Fayel at the end of the romance may be viewed as sublimating and cleansing the lovers' illicit love: it brings the bodies together as a culmination of topoi (lovesickness, internal and external woundedness, the heart/body dynamic) developed throughout the romance.[13] As a secular analogue of the Eucharist in which Christ's bodily sacrifice becomes a symbol of eternal love through the ritual act of communion, the eaten heart symbolizes the Castelain's good works as a crusader inspired by his love for the lady. When the secular relic becomes spiritual nourishment through consumption, cardiophagy commemorates the Castelain as a pious crusader and devoted courtly lover but also neutralizes the earthly desire through the spiritualization of a

physical organ. That is, the heart becomes a symbol of a true conversion to pure love. This reading follows other moral interpretations of fatal lovers in medieval romance—for instance, the charitable death of Iseut in the romance *Tristan et Iseut* who dies in the arms of her lover out of *caritas* rather than carnal love in the Thomas version. From an anthropological perspective, the act of cardiophagy also indicates archaic taboos and transgression: the disturbance of conjugal relations and sexual difference; the blood crime of the assassination of the rival by the betrayed husband; and the consumption of human flesh.[14] The conversion of earthly to spiritual love by means of the eaten heart neutralizes these taboos. The lovers' death embodies *fin'amor* and the Castelain's redemption.

However, another reading of the eaten heart is possible: perhaps the lyrical presence of the Dame de Fayel's voice at the end resists this conversion, a view echoed in crusade lyrics in a woman's voice. The Dame's lamentation affirms the idea that the "envoi" of the heart authenticates the Castelain as a courtly crusader and by extension his song that bears witness to his sincerity: *envoi* is a technical term for the ending of a lyric that announces itself to an addressee. Likewise, the Dame's lamentation acts as a witness, an *envoi* that authenticates their love in the romance. In the final section of this chapter I develop this idea through a discussion of this ending and the notion of the eaten heart. My point of departure is Catherine Gaullier-Bougassa's thesis that the romance ending relates an unassimilated "undigested" heart because the lady refuses to allow her body to become a passive tomb for her lover's organ.[15] Rather than dying immediately, she continues to suffer, lamenting her lover and blaming herself for his departure. These laments translate and reconfigure the idiom through the voiced desire of the lady. Here she responds to the news that she has eaten the heart of her lover:

> Dame, or creés sans faille
> Que vous son coer mengié aves,
> De ciertain savoir le poés.
> Sa dame atant li respondi:

"Par Dieu, sire, ce poise mi
Et puis qu'il est si faitement,
Je vous affi ciertainnement
K'a nul jour mes ne mangerai
N'autre morsiel ne metterai
Deseure si gentil vïande.
Or est ma vie trop pesande
A porter, je ne voel plus vivre.
Mors de ma vie me delivre!"

Lors est a ycel mot pasmee,
[…]
Et quant a li pot revenir,
Si gieta mierveillous souspir
Et dist: "He! Que m'est avenu?
Sire Dieus, qu'est ce devenu?
Bien me doi plaindre et dire 'ay mi!'"
Quant j'ai pierdu men douc ami,
Qui tant fu sages et discrès,
Et sour tous loiaus et secrés,
Qu'en toute France n'en Rommaigne
Croi que plus loiaus ne remaigne.
Et c'est çou qui au coer m'afole
Que par moi, qui ouvrai que fole,
Esploitai qu'il passa la mer,
Dont au coer ai grief doel amer
Et plainne en sui de desconfort.
[…]

Ha! Com doleureus envoi a
De son coer quë il m'envoia!
Bien me moustra qu'il estoit miens!
Li miens devoit bien iestre siens!
Si est il ! Bien le mousterai,
Car pour soi amour finnerai!
 (lines 8099–8147)

"Lady, now you can be sure and certain that you have eaten his heart." The lady responded, "By God, Lord, I am grieved indeed. But, as it is so, I promise you with all certainty, that I will never eat anything again: no food could be added to such noble nourishment. Life has become unsupportable for me, and I no longer want to live. Death! Come to deliver me!" And so she fainted . . . and when she came to, she let out a profound sigh and said, "Alas, what has happened to me? Lord God, how did this come about? Well should I lament and proclaim my despair and say "Woe is me!," I who have lost a sweet friend, so wise, discreet, and more loyal and sincere than any other. In all of France and in the whole Empire of the East, there is no man more faithful than him, I am sure of it. What really breaks my heart is that I am myself responsible for his voyage overseas, by my foolish error; my heart is tortured by grief, and bitterness consumes me . . . Alas! What doleful message of his heart he has sent me! How he shows me that he is mine! And so I will also be his! So it is! I will show him, because for the sake of his love I will die!

In her emphasis on how the heart "moustra," or exhibits, his love for her, the Dame's lamentation resists the full digestion of the heart as symbol of the spiritual transcendence of the crusader's body. That is, I see lamentation as the process of lamenting, or *plaindre*, and its effects; this is the speaking of the idiom—here the lament actualizes a resistance through the undigested heart. She blames herself for his departure and proclaims that his heart shows that they belong to each other. Or more specifically, whereas the Castelain makes his song his witness, and his offer of his heart as relic serves as the idiom that authenticates his love for his lady through an accumulation of witnesses, here the idiom is transformed into the lamentation of the Dame de Fayel. At the point where she should die at the horror of eating her lover's heart, her heart suffers and cries out against his sacrifice. Her laments act as a living witness, a new voice through this strange, suspended realization of what she ate. A kind of protest, the indigestion of the heart through lamentation is the

moment when the idiom crystallizes. The fact that she gives voice to the material testimony of the eaten heart rather than simply dying is key: in other versions of the eaten heart legend we find a silent death of the lady, the lack of an *ars moriendi* in which the knight's feats and courtly love are affirmed as in our romance, or two hearts joined together in death—all of these endings follow the transcendence of erotic love seen in works such as *Tristan et Iseut*.[16] But here the laments resist the immediate sublimation and give voice to the idiom. Moreover, the revenge of the cuckolded husband is unsuccessful: he despairs seeing the suffering of his wife, and when the affair is made public, the lovers are celebrated as exemplary "vrais amans" and the cuckold is judged as overly vengeful in his act of serving the heart. He lives the rest of his life without joy or pleasure.

The unassimilated presence of the idiom is visible in one miniature in a fourteenth-century manuscript of the *Castelain de Couci* (fig. 1). It depicts on the left the Lord of Fayel presenting the sealed letter of the Castelain to his wife. Before them is a table with a pitcher, platter, and casket with the lady's locks spilling out. The servant of the Lord of Fayel presents the casket with its contents as proof that she has eaten her lover's heart. To the right of this image is the Dame's servants and the Lord's servant attending her, on her deathbed after she has eaten the heart of her lover. The visual attention to these material witnesses and the double testimonies of the Castelain and the Dame in both letter and lament suggest that readers were attentive to these articulations of courtly and professional avowals. The Castelain's casket and the tresses bear witness to his courtly and pious sacrifice for crusade and his enduring love for his lady. Moreover, plentiful descriptions of activities such as jousting tournaments affirm the values of an aristocratic martial class with reference to people and places of the twelfth century, a certain elite class invested in both earthly and celestial chivalry.[17] The adaptation of the idiom in this romance reflects how aristocratic nobles wanted to profess crusade in their own way and have material objects (such as the objects in the romance or the manuscript illumination that foregrounds those objects) that reify this profession. Following

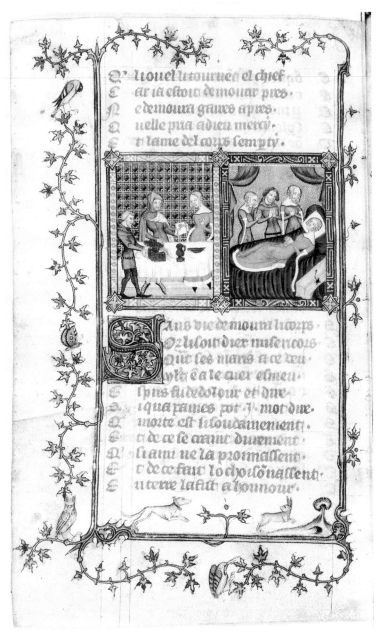

FIGURE I. *Roman du Castelain de Couci* (fourteenth century). BN fr. 15098, fol. 157v. Photograph: Bibliothèque nationale de France.

the changing circumstances of the aristocracy, the culture of crusade relics, and the changing horizons of readers of courtly literature, these texts memorialize the idiom in a manner that asserts, independently of ecclesiastical discourse, the spiritual worthiness of going on crusade. The romance's investment in the art of professing crusade responds to the theological and homiletic scripting of confession, whether through an ambivalent profession or through the reification of the crusader-lovers' body as a secular relic unassimilated into the pure spiritual love of right intention.

THE TRACE OF FEMALE CRUSADE LYRICS: POPULAR PERSPECTIVES, SENSUAL SURROGATES, AND VOICES OF PROTEST

> Sa chemise qu'ot vestue
> M'envoia por embracier:
> La nuit, quant s'amor m'argüe,
> La met delez moi couchier
> Mout estroit a ma char nue
> Por mes malz assoagier.

> The tunic that he wore,
> He sent it so that I could embrace it
> At night when his love goads me
> I place it next to me as I sleep
> very close against my bare skin
> to soothe my suffering.
> GUIOT DE DIJON "Chanterai por mon corage"
> ("I will sing for the sake of my heart"), lines 51–56[8]

The lamentation of the Dame de Fayel finds analogues in crusade lyrics in the voices of women left behind. Instead of asking the lover to remember her and accepting death, like the Dame de Fayel, the lady of these lyrics protests: she rejects the call for crusade, and even when she does accept his departure (either reluctantly or as a good Christian), she compensates for his absence with a material token or demands a textual memento.

Certain female laments (*chansons de femme*) support what Simon Gaunt has observed as the underlying homosociality of the courtly lyric tradition in which men measure their lyric prowess against other men, and women either are silent or judge the narcissistic self-display in this masculine arena.[19] In crusade lyric written from the perspective of the woman, this homosocial reading can be seen in departure songs where after her lover leaves, the lady curses God or the secular leaders of crusading expeditions and silently suffers and wishes to die, reluctantly accepting the higher spiritual calling of crusade. While it is true that these songs are either anonymous or attributed to male poets, the female voice allows another kind of idiom to emerge: she is more than a catalyst for the male poet to affirm his avowal (the siren lady of "Aler m'estuet") or a figure for moral reflections (the God-song versus lady-song, or *Gottesminne-Frauenminne*, conflict in *Minnesang*). The significance of her voice lies in its substantive, poetic qualities (how she speaks) rather than its signifying, denotative ones. In their particular sensual diction, the laments register a protest. For example, this anonymous crusade lyric in the Old French tradition combines the sea as sign of the crusade voyage with the romance image of salty tears in the sea that separates lovers such as the lovers in *Tristan et Iseut* crossing the *mer salee*:

> Biauz dous amis, con porroiz endurer
> la grant painne por moi en mer salee,
> quant rienz qui soit ne porroit deviser
> la grant dolor qui m'est el cuer entree?
> Quant me remembre del douz viaire cler
> qui soloie baisier et acoler,
> granz merveille est que je ne sui dervee.
>
> Si m'aït Dex, ne puis pas eschaper ;
> morir m'estuet! Teus est ma destinee,
> Si sai de voir que qui muert por amer

trusques a Deu n'a pas c'une jornee.
lasse! mieuz vueil en tel jornee entrer!
Que je puisse mon douz ami trover,
que je ne vueill ci remaindre esguaree.
 (lines 15–28)

Fair sweet love, how can you endure the great pain you feel for love of me on the salt sea, when nothing in the world could describe the great grief that has entered my heart? When I remember the sweet bright face I used to kiss and caress, it is a miracle I have not gone mad.

God help me, I cannot escape: I shall die, it is my destiny. But I know well that anyone who dies for love doesn't have a day's journey to God, and I, alas! would rather start on the journey towards my sweet love than remain here alone and abandoned. "Jherusalem, grant damage me fais" (Jerusalem, you do me great harm).[20]

Although after cursing Jerusalem, she accepts his departure, her sensual longing for "the sweet bright face I used to kiss and caress" (lines 19–20) articulates a resistance to crusade that appears more forcefully in other female laments. Like the male poet in crusade lyrics who remembers the lady instead of repenting inwardly, this sensual memory leaves a residue of unrepentance that ultimately culminates in the lyrical presence of the undigested heart in the *Roman de Castelain de Couci*.

A similar trace of refusal occurs in the woman's lament of the troubadour Marcabru (fl. 1130–50). One can interpret this song as advocating that the lady must accept her lover's turning away from her and toward the Holy Land:

> A la fontana del vergier,
> On l'erb'es vertz josta-l gravier,
> A l'ombra d'un fust domesgier,

En aiziment de blancas flors
A de novelh chant costumier,
Trobey sola, ses companhier,
Selha que no vol mon solatz.
(lines 1–7)

By the spring in the orchard, where the grass is green beside the bank, in the shade of the fruit tree, with its pretty white flowers and the usual spring birdsong, I came across that young woman who, alone and without companion, does not want my company.[21]

The lady's lover has departed for the Second Crusade under Louis VII, and Marcabru depicts her resisting the advances of a knight and wanting to be alone. Her refusal could be the troubadour's disdain for the less virtuous knights who are reluctant to join the French contingent: rather than going on crusade, this cowardly knight courts ladies who have been left behind by their crusading lovers. Although she curses the king and God for taking away her lover, she ultimately accepts this separation. Her suffering signifies the absent crusader's virtue superior to hers because she has not completely accepted his holy mission, and it also implies Maracabru's criticism of the courting knight who also remains attached to earthly love:

"Senher," dis elha, "ben o crey
que Dieus aya de mi mercey
en l'autre segle per jassey,
quon assatz d'autres peccadors;
mas say mi tolh aquelha rey
don joy mi cred; mas pauc mi tey,
que trop s'es de mi alonhatz."
(lines 36–42)

"Sir," she said, "I do believe that God will have mercy on me forever in the next world, as He will on many other sinners; but here He is taking away from me the one person who gave me joy (literally

"through whom my joy increased"), but he thinks little of me, for he has gone so far away from me."

In response to the knight's effort to comfort her in the previous stanza, where he says in essence that she should live in the present and believe in God's power to heal despair over time, the lady replies that her departed knight was the only source of her increasing joy. Physical and mental separation has halted that growth of joy from their love, and all she can ask is mercy for her attachment and suffering. Through the lady's refusal of courtship and her plea for mercy as a sinner, Marcabru affirms the true love of the crusader for his spiritual vocation. As Nichols concludes in his careful analysis of this lyric, "for Marcabru, the ethical response to the intervention of history in one's life demands the suppression of *fin'amors* and its aesthetics. His poem thereby becomes an example of the crusader ascesis he advocates."[22]

However, while I agree that the lady's suffering exalts the departed crusader, the lyric may be more equivocal if we are attentive to how the lady's voice sounds. Her voice refuses merely to advocate the service of her lover, and she speaks in a way that makes us remember the singularity of someone left behind. Marcabru gives this highborn lady's voice (she is a "filha d'un senhor de castelh"; line 9) a particular localized accent with the rhyme endings of "-ey" in the words "rey" and "tey" (lines 40–42). At the very moment she concedes that she must accept her lover's higher calling and his turn away from her, this sound registers a disruption in that we note a confected end rhyme. Rather than a semantic or musical difference (unfortunately, no music is transmitted in the single manuscript), the pronunciation foregrounds a different accent to fit the rhyme scheme. While her words denote her acceptance of her lover's departure, Marcabru's use of a different Occitan (perhaps Poitevin) diphthong (the "-ey" rhyme) articulates her refusal to accept the crusade project. The editors of Marcabru's corpus see this rhyme as an authorial (rather than scribal) intervention that recalls the songs of Guilhem IX and gives the rhyme words in this stanza an "old-

fashioned or *popularisant*" flavor.[23] Further, Marcabru was known to deliberately deviate from the language norm of the early troubadours, using "non-normative forms" of a stable "performance dialect" of music and poetry ten times as frequently as the average of other earlier texts.[24] While the linguistic analysis is controversial, Marcabru deliberately uses this rhyme in the voice of the neglected lady to articulate a sound of protest, or at very least ambivalence about crusade. The "-ey" reminds the listener of another idiom, a shift in register. It could be a regional sound, a rhyme that recalls an archaic form of Occitan, or even a reference to Guilhem IX and his deliberately crude-sounding lyric as a critique of the lady's attachment to her departed lover. Whatever the case may be, it produces a disruptive sound and a singular perspective at the very moment that she should submit to collective crusade ideology and embody a silent Logos.[25]

In this concept of this lady's vocality—her idiom—as one defined by the foregrounding of a certain sound, I draw from recent soundscape studies and the work of Michel Serres on "noise."[26] While we will probably never definitively ascertain whether the shift to the "-ey" is a scribal or authorial intervention, or a translation of a Poitevin accent, what is clear is that it is a different sound that articulates something at the very moment when the abandoned woman expresses her continual attachment to her lover who now thinks little of her. The fragmentary diphthong sounds something left behind, what Serres would call a noise outside of the meaningful voice of crusade—here adapted by Marcabru into the courtly mode. In a recent collection of essays on soundscapes, the essays of François Noudelmann, Sarah Kay, and Judith Peraino focus on the different ways sound can carry the fabric of thought rather than an idea.[27] An "acousmatic reading," argues Noudelmann, displaces a unified subject with a variable voice, one with "regional accidents, vocal accidents." Serres's work on noise supports their analysis of sound in the history of metaphysics: sounds not subordinated to sense are feared and relegated to the domain of noise, to insignificance, to nature and to animality. If we listen to what Noudelmann calls "sonic sub-

strates," we can view the noise of "A la Fontana" in the "-ey" rhyme as a sound that doesn't fall into a decipherable system—a noisy sound within the context of philological uncertainty (its transmission in a single chansonnier, the uncertainty of the diphthong) and within the hermeneutic system of crusade and courtly lyric conventions.[28] According to Serres, this noise can be a productive interference; rather than communicating a message, a meaning, this noise of the "-ey" rhyme produces something else that shifts the envoicing of crusade in new ways through lyric: the sound indicates a resistance to the sense of crusade, the suffering noise of women and people left behind disrupts a moralistic courtly adaptation of crusade, which is how female laments are often described.

Likewise in his study of Middle High German lyric, Markus Stock notes how the repetition of sounds and words in medieval courtly lyric reinforces not only the repetition of a concept, and that concept's connection to sound, but rather that "in the sound dimension the individual rhetorical figure is blurred and a total acoustic impression emerges."[29] We can imagine this happening in an example such as Jaufre Rudel's well-known "amor de lonh" repetition in "Lanquan li jorn" ("When the days") that creates such an acoustic dimension of faraway love. Faraway love is a concept that acoustically melds love and distance even as Jaufre rhetorically changes his subject position and the conditions of this faraway love throughout the song. We should view the lady's disruptive end rhyme within the total acoustic dimension of the crusade song: even as this rhyme signifies acceptance in keeping within this dimension, it registers something else through sound.

A disruptive sound within statements that denote silent acceptance makes sense in the context of silent female suffering in this genre. In another version of this courtly suffering for a departed crusader, Johansdorf depicts the lady left behind as suffering silently ("stille"):

> swenne sî gedénkèt stille an sîne nôt,
> "lebt mîn herzeliep, od ist er tôt"

sprichet sî, "sô müezè sîn der pflegen
durch den er süezer lîp sich dirre werlde hât bewegen."

whenever she silently broods over his fate,
"does my love live, or is he dead,"
she speaks, "then he must take care of him
for whom he, dear one, left this world." (4.7-10)[30]

Here we see the lady accept her role as a suffering lover for the greater spiritual cause, an example that aligns with versions of the eaten-heart tale wherein the lady silently dies for her lover after eating the heart. It is telling that the "Guote liute" indicates that the lady is supposed to be "stille"—silent in her suffering. Just before this image, Johansdorf leaves the perspective of the lady more ambiguous about whether she accepts his departure. All we know is that to the departing crusader, her suffering makes her love genuine:

Wol si saelic wîp
diu mit ir wîbes güete daz gemachen kan
Daz man si vüeret über sê.
ir vil guoten lîp
den sol er loben, swer ie herzeliep gewan,
wand ir hie heime tuot alsô wê.

Blessed be the lady
whose goodness makes it possible
to take her along across the sea.
Whoever was the recipient of love
should praise her,
for here at home she suffers. (4.1-6)[31]

In contrast to the siren lady of the "Aler m'estuet," here the silent suffering of the lady allows her to be taken overseas in spirit rather than through an exchange of hearts: her silence signifies that she accepts that she must suffer at home without her lover. But the closing

stanza gives us a glimpse of what she is thinking as she silently broods, something that becomes manifest as a protest in the Dame de Fayel's lament.

The laments of the Dame de Fayel and the lady of "A la fontana" refuse to wholeheartedly accept this spiritual devotion and silent suffering. This is also the case with the lady in "Chanterai por mon corage" attributed to Guiot de Dijon. She begins her lament by explaining that her song has a purpose: to comfort her heart, "chanterai por mon corage / que je vueill reconforter" (I will sing for the sake of my heart which I want to console). As she sees no one returning from their pilgrimage, including her lover, she vows not to marry anyone else and includes a refrain after every strophe, the crusade chant of pilgrims since the time of Charlemagne:[32]

> Dex, qant crieront Outree,
> Sire, aidiés au pelerin
> Por cui sui espoentee,
> Car felon sunt Sarrazin.

> God! When they will cry "Onward!"
> Lord, help the pilgrims
> for whom I tremble,
> because the Sarrasins are traitors.
> (lines 45–48)[33]

The lyric records leave-taking rituals. Like the lady of "A la fontana," this lady of "Chanterai" laments her lover's absence in Beauvais and the fact that she did not witness the removal of his tunic, or "chemise," the ritual that signifies his pilgrimage.[34] She now holds it as a cherished memento of him:

> De ce sui mout deceüe
> Que ne fui au convoier;
> Sa chemise qu'ot vestue
> M'envoia por embracier:

La nuit, quant s'amor m'argüe,
La met delez moi couchier
Mout estroit a ma char nue
Por mes malz assoagier.
 Dex, quant crieront Outree ...

It disappoints me
that I did not escort him at his departure
The tunic that he wore,
He sent it so that I could embrace it
At night when his love goads me
I place it next to me as I sleep
very close against my bare skin
to soothe my suffering.
 God, when they will cry "Onward!" ...
 (lines 49–57)

With the realistic interventions of popular rituals and chants, "Chanterai" not only registers the female lament. It also at least partially records the lay perspective of family and loved ones left behind. As the "chemise" was something the crusader wore over everyday clothes that symbolized the vow of the crusader pilgrim, the lady's wearing it at night next to her skin inverts the spiritualization of the body: the sensual memento as surrogate of her lord makes present the memory of her lover as a material body. She places it "against her skin to assuage her pain." All these elements of the song resist the idea of silent suffering. In her cogent analysis of "A la fontana" and "Chanterai por mon corage," Matilda Tomaryn Bruckner sees the tunic as a double love that unites the separated lovers in contrast to the *here* and *there* separation invoked by the male and female personas of "A la fontana." Bruckner argues that "Chanterai" creates an earthly, sensual "center" among the "diaspora" of the here-and-there structure of crusade love songs, one that comforts ("assoagier") the lovers who are "separated but not divided."[35] The tunic

enacts an earthly presence that revises this song's protest: even as it avows Christian piety, the song grants sensual compensation. I view these two crusade songs with female voices as another version of the Dame de Fayel's outcry: where the Dame's protest manifests the undigested, unassimilated figure of the separated heart, the popular disruptive sound of Marcabru's lady articulates protest even as she accepts his departure. Likewise, the tunic of "Chanterai" coupled with popular crusade chants ("Dex, quant crieront Outree") produces the absent lover through hope and memory. The tunic at night intensifies the breeze that comes from the sweet land where her lover is, a breeze that she feels under her gray coat ("par desuz mon mantel gris"; line 44). The breeze and the tunic make him present, touching her bare skin even as she remembers him, and his absence tortures her ("si sovent me tormente"; line 27).

In the manuscript of Bern, "Chanterai" is attributed to "Lai dame dou Faiel," the heroine of our romance.[36] This attribution suggests that readers of the *Roman* and the audience of "Chanterai" saw the same outcry and refusal of the crusade orthodoxy through the female lamentation. Further, the Bern source has staff lines for music but no music entered. Like the disruptive sound of Marcabru's lady and the surrogate tunic, this invisible music articulates embodied absence— empty staff lines. Both the Bern source of "Chanterai" and the tunic as surrogate embody and record the departure and absence of the lover and the grief of the abandoned lady. While we can reconstruct the melody of the song though other manuscript sources that provide the music, such occurrences in manuscripts remind us of the unwritten and invisible practices that make songs about abandonment particularly resonant. These songs that contain sounds and poetic figures of female ambivalence must be heard otherwise, whether through Noudelmann's "sonic substrates" of unassimilated sounds that transmit the sensual texture of loss, the sonic translation of the tunic against the abandoned lady's skin, or by respecting the fragmentary transmission of oral practices and rituals that constitute the contingent nature of medieval song practice as we reconstruct these songs of departure.

Through its overt sensuality and references to popular perspective through rituals and crusade chants, "Chanterai por mon corage" articulates collective and personal loss in a lyric of multiple voices. The communal voice and the particular female lover's view of loss and desire come together in protest. This combination disrupts a courtly genre from the male perspective that should speak the female's silent acceptance as a sign of her lover's conversion. Like the sensual remorse of the lady with the tunic in "Chanterai," in "Jherusalem, grant damage me fais," the lady's interaction with the memory of her lover's face, acting as a surrogate, makes the absent lover present.

These songs suggest that the exchange between God and the lady, or the lady and the lover through a surrogate, continues when the crusader departs. Love continues through multivocal protest, lamentation, and material surrogates. Another song that supports this residual ambivalence occurs in "Già mai non mi conforto" ("I shall nevermore take comfort") of Rinaldo d'Aquino, who was a member of the Sicilian School under Frederick II. If other examples record the woman left behind as an active, desiring vocal presence rather than a silent sign of passive suffering, the woman in "Già mai non" takes a different tactic in her refusal of crusade orthodoxy. Recalling themes of memory and material witnesses in the *Roman de Castelain de Couci* and "Chanterai," she demands something from her lover in return for his departure and spiritual mission, as she says at the end of the song:

> Però ti priego, Duccetto
> che sai la pena mia,
> che me ne faci un sonetto
> e mandilo, in Soria,
> ch'io non posso abentare
> la notte nè la dia.
> In terra d'oltre mare
> sta la vita mia.

And I beg you, my Duccetto,
who know my grief,
write a song of this for me,
and send it when you are in Syria.
For I cannot rest
night or day.
My life is now
in a land beyond the sea. (lines 56–63)[37]

First, she laments that her lover must depart beyond the sea ("oltra-mare"; line 6), in keeping with the genre, but adds bitterly that in his departure he "does not send to let me know, and I stay on back here, deceived" (lines 9–11; "ingannata," deceived; line 11). She then manipulates and subverts the spiritual and moral topography of crusade discourse:

tanti sono li sospiri
che mi fanno gran guerra
la notte co la dia.
Nè 'n cielo ned in terra
non mi par ch'io sia.

How many are the sighs
at war in me
night and day.
I don't feel in heaven, or
on earth. (lines 12–16)[38]

While her sighs seem to depict the conventional war between vices and virtues as anticipating her acceptance of his departure, the internal "guerra" contradicts the real war in the "altra contrata"—the other country, where her lover departed. Her internal war takes precedence over that external one: to emphasize this resistance to the crusade topography, as she awaits word from him and wonders what

she must do, it seems to her that she is in a state between earthly attachment and her recognition of his spiritual duty. Her lament thus records the time of waiting and her internal conflicted state: it subverts the spiritual topography of crusade by foregrounding her personal and emotional state. In praying to God, she manages her despair by transforming her lover into a cross: "Oi croce pellegrina" ("O pilgrim cross"; line 29). In this grand gesture of poetic condensation, one can see how this rhetorical move parallels the poets of male-voiced departure lyrics discussed earlier, where poetic figures such as the separated heart or tongue succinctly generate the configuration of earthly to spiritual love. After lamenting that the "pilgrim cross has destroyed her" ("Oi croce pellegrina / perchè m'ài sì distrutta?" lines 29–30), leaving her burning and all consumed ("tapina / chi ardo e 'ncendo tutta"; lines 29–32), she accepts the fate of her lover with others who serve the cross.

However, this lament does not signal her acceptance of separation. While the lady in "Chanterai" copes with a "chemise," reliving the memory of her lover through its sensual presence next to her body, the woman in "Già mai non mi conforto" ends her song by asking her lover to send her a "sonetto" from Syria as consolation (lines 59–60). What is striking about her request is how it constructs a continuing dialogic relationship between her and her lover abroad, whom she addresses using a term of endearment, "my Duccetto," derived from the poet's name. She requests that he write a song "of this ["ne"] for me and send it when you are in Syria" (line 60). What is the subject matter of this song, the "of this"? Although the pronoun is ambiguous, it could be his acknowledgment of her grief mentioned in the line before. She declares that her life is now beyond the sea (lines 63–64), implying that they are essentially together and kept alive through the exchange of verse. When she says that her life ("la vita mia"; line 64) is now overseas, she describes a shared love rather than a separated body and heart. Rinaldo offers another model for maintaining a distant love through song.

Two songs of the 1170s by the troubadour Peire Bremon lo Tort not only confirm that such exchange of songs took place between

lovers but also remind us that some departure songs, composed as the crusader pilgrim prepares to return to the West, lament a lady left behind in the Latin East:

> Qu'era roman en Suria
> mos jois et eu tenc ma via
> en las terras on nasquei.
> Jamais midonz non veirei.
> Gran mal mi fan li sospir
> que per lei m'aven a far,
> que la nuoch non posc dormir
> e·l jorn m'aven a veillar.

> For now my joy stays in Syria
> and I'm taking the road to the lands
> where I was born.
> I'll never see my lady again.
> The sighs I must sigh
> for her give me great pain,
> so that I can't sleep at night
> and yet must stay awake during the day.
> (lines 9–16)[39]

Peire was active in the administration of Philip of Montreal in Syria. When he returned to the West, he asked William Longsword of Montferrat and his song ("chanzos") to comfort his lady after their separation:

> Chanzos, tu·t n'iras oltra mar
> e per Deu vai a midonz dir
> q'e gran dolor et en conssir
> me fai la nuoich e·l jorn estar.
> Di·m a'N Guillem Longaespia,
> Bona chanzos, qu'el li dia
> e que·i an per lei confortar,

qe Filippe de Monreal
me tren pres en sa bailia,
et am tan sa compagnia
qe sens lui no m'en puesc tornar.

Song, you will go away over the sea
and for God's sake tell my lady
that day and night I am in great pain and anguish.
Good song, tell Lord William Longsword
for me that he should go to her
to comfort her and tell her

that Philip of Montreal
keeps me close in his administration,
and I so love his company
that I cannot return without him. (lines 43–53)[40]

Peire composed this song between 1175 and 1177, the dates of
William's offer of the Kingdom of Jerusalem and his death in Sidon.
He sends it to his lady as a sign of his status in the administration
of Philip and close association with Lord William. In contrast to
Rinaldo's song, wherein the lady demands dialogue between separated lovers, the song functions as a sign of Peire's importance in
France and in the crusader states: he needs to be separated from
her because of his administrative role rather than a crusading duty.
Although it was crusade and the expansion of the Latin East that
separated the lovers, when the crusader avowal is not in question,
the taking leave of a lady or leaving her behind seems to become a
question of earthly matters.

CONCLUSION

In conclusion, female lamentations demand continual devotion: as
seen in the songs of Albrecht von Johansdorf and the anonymous
"Jherusalem," the complex female voice refuses to fall silent or to

passively accept the departure of her beloved. Rinaldo d'Aquino's lady goes further than the Dame de Fayel, Marcabru's lady, and the lady of "Chanterai" who all speak out defiantly against loss and cope through material substitution, sensual evocations, and vocal protest. Rinaldo's lady demands a continuing partnership and poetic activity—an active presence beyond the sensual surrogate of the other ladies. Rinaldo's lady converts her suffering into an ongoing engagement with her lover through poetic activity. As lamentations that refuse the translation of crusade orthodoxy into a teleological path of conversion based on right intention, these songs and the example of the Dame de Fayel produce creative and productive adaptations of departure and loss. While they affirm the male crusader's sacrifice, they represent a complex female voice and in many cases a popular perspective on crusade departure. They change the paradigm of remembering: for the lady, the act of remembering is an ongoing exchange between two people who remain apart—through the refusal of lamentation that commemorates togetherness, dialogic and disruptive songs that recover different voices, or sensual engagement with a surrogate. Rather than a discourse of separation seen in Peire's direction to his song that proclaims his social status among patrons in the West and Syria, the "sonetto" of Rinaldo's lady creates the conditions for the continuation of love and future dialogue despite separation.

Lancelot as Unrepentant Crusader
in the Perlesvaus

[Lancelot to the hermit]: Sire . . . icel pechié vos jehira[i] je hors de la
boche dont je ne puis estre repentanz el cuer. Je aim bien ma dame, qui
roïne est, plus que nulle rien qui vive . . . la volenté me senble si bone et
si haute que je ne la puis lessier, et sil m'est enracinee el cuer qu'ele ne s'em
puet partir. La gregnor valor que est en moi si me vient par la volenté.

Sire . . . my tongue will tell of the sin that my heart cannot repent.
My lady, who is a queen, I dearly love more than anything in the
world . . . my desire for her seems to me so fine and noble that I
cannot abandon it, and it is now so rooted in my heart that it can
never leave me. And whatever is of most worth in me comes from
that desire.

PERLESVAUS (lines 3656–61)[1]

In the first chapter, I discussed how the Châtelain d'Arras compares
himself to Lancelot, the exceptional but paradoxical lover who is
at once the perfect knight of King Arthur's Round Table and the
lover of Queen Guinevere. For the chatelain, if he carries the heart
of his lady with him while he is overseas, he will be another Lance-
lot, a valiant knight who wins a doubled reward of earthly and spiri-
tual love. The notion of Lancelot as an ethical model for a courtly
crusader brings us to the unrepentant Lancelot in the *Perlesvaus*
(c. 1200–1210, or *Perceval*), a prose romance significant for this study
for two reasons: first, Lancelot is represented as a crusader who ad-
vances the New Law despite lacking access to the Grail, as in the
Vulgate Cycle; and second, in a confessional scene with a hermit,
he is explicitly depicted as unrepentant for his sin of loving Guine-
vere. The *Perlesvaus* develops the potential of Lancelot seen in lyric.
Without deflating the lyrical suspension of the lover caught between

two models of chivalry, it extends his professional avowal by asking how his competing loves for God and the lady can be sustained through a romance that advocates holy warfare.

The unwavering performance of a nonconfession as a profession: Lancelot's unrepentance and his status as a crusader without complete conversion speaks the idiom that I treat in this chapter. By making Lancelot explicitly unrepentant, the militant Grail romance advances a new idiom of *volenté*, or desire, seen in lyric.[2] Unwavering in his refusal to repent his earthly love for his lady, Lancelot professes his love within the context of a confession. This scene refuses the penitential discourse of the period discussed earlier, and as I will explain in the course of this chapter, it also explicitly contradicts the confessional scene of a repentant Lancelot in *Queste del Saint Graal* (*Quest of the Holy Grail*). An analysis of the unrepentant Lancelot in the *Perlesvaus* demonstrates what I have described as the professional version of Michel Foucault's "aveu" as a vow to advance crusade. Lancelot's refusal to confess as a Grail knight shows how a profession of earthly allegiances can also act as a profession of faith.

Among readers of Arthurian romance, it is well known that Lancelot is a contradictory figure in that his status as the foremost knight is inseparable from his adulterous love for Guinevere. His love for her inspires remarkable acts of prowess.[3] When the Châtelain d'Arras compares himself to Lancelot, it is possible that we see a Lancelot not yet associated with the Grail quest.[4] That is to say, his Lancelot shares an affinity with Chrétien de Troyes's *Chevalier de la Charrette* and the thirteenth-century noncyclic (non–Grail quest) *Prose Lancelot* or *Lancelot Proper* of the *Lancelot-Graal* (or Vulgate) Cycle. In these works Lancelot's love for Guinevere and the pains he undergoes on her behalf are not yet imbued by the moral condemnation of his sin; later branches of the cycle will make explicit this aspect of his nature, such as his repentance in the *Queste del Saint Graal* that advocates chivalry inspired by spiritual rather than worldly love, Lancelot's displacement as the perfect knight by his son Galahad, and Lancelot and Guinevere's adulterous, sinful re-

lationship as setting in motion the events that will ultimately lead to the downfall of the Arthurian kingdom.

While the *Perlesvaus* keeps this positive view of Lancelot as a courtly lover, it transforms him into a militant crusader. Lancelot's knightly mission is adapted for his role as a Grail knight in imitation of Christ: he is willing to endure pain and suffering, "painne e travaille," as he undertakes acts done for the advancement of the New Law (*Perlesvaus*, lines 1–7) as well as for Guinevere. Known for its militant crusading spirit, the *Perlesvaus* goes further than the *Charrette* and the noncyclic *Lancelot* by presenting the tension among competing chivalries inspired by earthly versus spiritual love through Lancelot's paradoxical status as a courtly crusader. One of the earliest romances to narrate the completion of the Grail quest, the *Perlesvaus* follows the tradition of Chrétien de Troyes and his successors by showing Perceval as the Grailwinner.[5] Because the dating of the *Perlesvaus* in relation to the *Prose Lancelot* is uncertain, it is difficult to ascertain how the *Perlesvaus*'s audience would have perceived Lancelot, but it is considered earlier than the *Queste del Saint Graal* that features the penitent Lancelot. In keeping with other chivalric literature of the twelfth and thirteenth centuries, the *Perlesvaus* valorizes knightly warfare and suffering as spiritually meritorious, even when undertaken for a cause other than crusade.[6] Yet unlike earlier crusade epics of the twelfth century, or the contemporary *Lancelot-Graal* Cycle, the *Perlesvaus* contains a confessional scene with a hermit wherein Lancelot refuses to renounce his adulterous earthly love for Guinevere.[7] This engagement with the penitential discourse of crusade creates a new articulation of the idiom.

The trouvère draws on the image of Lancelot as an exceptional Arthurian knight inspired by his adulterous love.[8] With the exception of the *Queste del Saint Graal* in which his "avowal of love" is "transformed into a reluctant confession to a hermit of the sinfulness of his love,"[9] in the popular *Lancelot-Graal* Cycle, Lancelot's love is presented in mainly positive terms until his installation as knight of the Round Table, although scenes foreshadow his ulti-

mate repentance in the *Queste*.[10] It seems that two models of Lancelot were available by the time of "Aler m'estuet": an earthly Lancelot seen in the pre-Grail prose *Lancelot* in which moral condemnation is avoided, and a spiritualized Lancelot whose sin will bring the downfall of Arthur's kingdom and the coming of the redemptive Christlike Galahad—son of Lancelot—seen in the *Queste*.

Throughout the *Lancelot-Graal* Lancelot's exceptional status is based on his desire or will (*volenté*) to apply his heart and body for the sake of Guinevere. In the first part of the *Lancelot*, he emphatically declares this intention and conscious effort to be a proper knight when the Lady of the Lake instructs her young charge on the meaning of knighthood:

> se Diex i veut mettre les boines teches, biau m'en sera, mais je i oserai bien mettre cuer et cors et paine et travail . . . Dame, fait il, ge n'ai de rien nule si grant talant, se ge truis qui ma volenté m'an acomplisse.

> If God wants to grant these fine qualities within me, so much the better! But I dare say that I will apply myself in heart and body, suffering and labor . . . Lady, I have no greater wish to do this, if I can find someone who will grant these wishes.[11]

In describing his God-given "teches"—"qualities" that lead to work or tasks to be completed, as well as a spiritual mission and sense of responsibility that enable him to prove his worth—Lancelot is aware of his special standing as a knight even before he encounters Guinevere. We see the knight intentionally cultivate his heart according to his own understanding of good qualities. He will accomplish good works according to the directives of the Lady of the Lake:

> Mais les teches del cuer m'est il avis qe chascuns les poroit avoir, se pereche ne li toloit, car chascuns puet avoir cortoisie et debonareté et les autres biens qui del cuer muevent, che m'est avis; por che quit je que l'en nel pert se par pereche non a estre preus, car a vos

meismes ai je oï dire pluseurs fois que riens ne fait le preudome se li cuers non.

But the qualities of the heart, it seems to me that anyone could have them, if laziness did not get in the way. Because anyone can have courtliness, graciousness, and other traits from the heart, I'd wager. But I believe one can lack the will to be noble. You yourself, I have heard you say many times that nothing makes a worthy man if not the heart.[12]

In these discussions with the Lady of the Lake, Lancelot is keenly aware of the relation between his "cuer" and intentions: his heart undergirds his intentions and structures his own sense of "teches." He is determined to apply his "cuer" willfully as a proper chevalier, a moral stance that will be indelibly linked to his love for Guinevere, a love that will inflict suffering ("paine et travail") through the love and chivalric prowess she inspires.

My focus on Lancelot in the *Perlesvaus* takes a different approach from internal readings of the romance in relation to the Vulgate Cycle — notably, those readings that emphasize "sens" within the structure of the text and within the Arthurian romance tradition.[13] While in those readings the crusading violence is explained through the internal logic of the romance (e.g., the narrative technique of severed heads), I focus on Lancelot because he provides another significant iteration of the idiom seen in other genres. Thus I analyze how this romance crafts the idiom through the explicitly unrepentant Lancelot and focus on what aesthetic and literary strategies it deploys to deflect the contritionist model of crusade avowal seen in religious and moral texts of the period.[14] As readers of the *Perlesvaus* have noted, the confessional scene in which Lancelot refuses to repent his love of Guinevere yet is allowed to advance the "New Law" against the "Old Law" (*La Nouvelle et L'Ancienne Loi*) as a crusader is particularly remarkable because it occurs in a militant Grail romance that glorifies brutal violence as enemies of the Roman Catholic Church are mercilessly dispatched. Scholarly attention

has focused on the pagan elements of violence depicted in the Grail knight's crusade to promote the New Law against non-Christians. In Branch VIII, for example, Perlesvaus exercises justice on behalf of the New Law by hanging the Lord of the Fens by his feet up to his shoulders in a vat of blood drawn from his knights until he drowns to death. Peggy McCracken and Anne Berthelot have commented on the "sacrificial logic" of divine justice seen in the archaic "homicidal violence" and in particular the symbolic circulation of severed heads that supersedes royal justice and the chivalric code that enforces it.[15] Barbara Newman aptly comments that the "*Perlesvaus* offers a radically uncanonical Grail quest, its pagan antecedents competing keenly with its Christian destiny."[16] As a crusading romance that exhibits extreme, "pagan" violence in the name of advancing Christianity, the *Perlesvaus* upholds Lancelot's status as a good Arthurian knight and a violent crusader despite his being explicitly unrepentant of his love for Guinevere. Although Arthur, Gawain, Lancelot, and Perceval encounter the Grail, Lancelot is barred because of his love for the queen. Nevertheless, the *Perlesvaus* is perhaps the first romance to place Lancelot in proximity to a holy object. In this peculiar configuration of crusader violence, unrepentance, and courtly love, the romance reconciles Lancelot's implicit sin with spiritual chivalry.

THE PLACE OF *PERLESVAUS* AND THE COURTLY CRUSADE IDIOM IN THE DEVELOPMENT OF ROMANCE

Why does the Lancelot of the *Perlesvaus* emerge as a figure resistant to penitential discourse? Why not Tristan or other heroes of Arthurian romance that gained in popularity from the end of the twelfth century onward? Unlike the speakers of most exhortative crusade lyric or the chansons de geste that use chivalry to promote holy war, the *Perlesvaus* Lancelot shows a moment of ambivalence about crusade articulated through romance. This moment becomes visible when we read it against the penitential discourse in genres

such as epics and chronicles from which romances adopt styles and narrative techniques.

The violent articulation of the idiom in the *Perlesvaus* represents a significant development in chivalric literature: in short, a courtly crusade idiom that adapted penitential discourse in a new way to advance violence. Does Lancelot's unrepentant piety in this text advance a particular form of violence? Does the *Perlesvaus* show the extent to which the idiom can motivate a merciless religious violence that does away with internal reflection? These questions reveal the imaginative force of this idiom at this moment of history: the historical circumstances I discussed earlier, such as the participation of secular leaders in conflicts and their competing political loyalties, as well as the rise of confessional discourse around the time of the Fourth Lateran Council, perhaps shape this stage of prose romance and the stakes concerning the moral status of Lancelot.

The romance advocates pious violence through knightly independence: it grants Lancelot a spiritual efficacy of penitential action without internal repentance. In my view—and this is why the Lancelot of the *Perlesvaus* seems crucial for the translation of the idiom into romance —this adaptation seems possible only because of Lancelot's extraordinary love for Guinevere. Unlike the *Lancelot* that tacitly upholds his love, the *Perlesvaus* has Lancelot explicitly choose Guinevere over the Grail (*Perlesvaus*, 3863–67). As a version of Foucault's preconfessional "aveu," then, Lancelot's *volenté* in the *Perlesvaus* extends the crusade lyric's reconfiguration of internal repentance: the romance combines the lyric response to the penitential discourse (courtly love replacing internal penance) with Lancelot's confident faith in the redemptive power of crusading acts motivated by his love for Guinevere. That is to say, he professes crusade through declaring his desire and will (*volenté*) for her.

The literary prehistory of this courtly unrepentance is clear in twelfth-century verse romances, in which authors such as Chrétien de Troyes and Béroul treat adultery and guilt as a question of shame (*honte*) rather than sin (*péchié*).[17] These romances are punctuated by verbal ruses in which, from a formal and legal perspec-

tive, what the accused says cannot be condemned as long as there is no physical evidence or witness to contradict the sworn oath. One thinks of Iseut's famous oath (*escondit*) before King Arthur and the people of Cornwall in which she can honestly say that she has never had anyone between her thighs other than a leper (the disguised Tristan) and King Mark, as described by Béroul in *Tristan et Iseut* (lines 4201–16).[18] Likewise, public oaths that precede judicial duels in Chrétien's romances present truths in misleading forms, such as Lunete's use of the *serment* to trick her lady into marrying Yvain. Both authors are concerned with the reconciliation of lovers and society rather than of an individual to God. Tristan lies about having any amorous relation with Iseut (lines 2223–35) because he knows that no one will challenge him to a judicial duel in which he might fail and God's judgment of his sin might be perceived. But the latter is not of interest to Béroul, and in any case the characters are convinced of Tristan's superior prowess and that he cannot fail in such situations. As Alberto Varvaro explains Béroul's *Tristan et Iseut*, this author's preference for a formal and legalistic analysis of adultery over a moral one makes clear that "juridical forms . . . presuppose a relationship between the law and God," and the romance turns "from the moral to the social plane, or at least from the plane of transcendental morality to that of the ethics of social life, close to, and almost coinciding with, legal considerations."[19] In place of an analysis of inner feelings and guilty conscience in these romances, we see analyses of "escondire" (in which an accused responds with a public oath that constitutes a juridical act) and "desraisnier" (juridical self-defense). Even in the confessional scenes with the hermit in Béroul's *Tristan*, where one might expect the repentance of the sinners, the focus is rather on the social and ethical implications of their affair on the community, the depravity of their life because of their devotion, and the need to reconcile with Mark. The moral judgment of adulterous love is never questioned; it remains only to justify it through ruses against their accusers who are always seen in a negative light. Thus the analysis of adulterous love resides in a specific juridical

rather than moral discourse that focuses on the social and ethical effects of an unquestioned *fine amour.*

Matilda Tomaryn Bruckner reads the figure of Lancelot in Chrétien's *Chevalier de la Charrete* in a different but related light that concerns twelfth-century romance fictionality. As the "nexus of desire" whose singularity of "paradox and hyperbole" drives the romance because his feats and disappearance create a "pattern of suspended action" in the tournament scene, for example, Lancelot is at the center of narrative deferrals, displacements, and recalls as he suspends the marriages, does his best and worst, is desired by all but out of reach.[20] In the thirteenth century, the *Perlesvaus* adapts these social and juridical discourses and changes this internal fictionality of romance through the penitential discourse of crusade. It justifies Lancelot's *volenté* for Guinevere as a penitential act that has a positive impact from a moral (crusade) and social perspective: *volenté* permits him to be a Grail knight in the service of Arthur. But just as the words *escondire* and *desraisnier* reveal the fundamental importance of juridical and feudal discourses for judging adulterous love, so Lancelot's *volenté* in the *Perlesvaus* arises from a later combined courtly-penitential discourse. Like Béroul's *Tristan,* the *Perlesvaus* maintains the positive value of Lancelot and Guinevere's *fine amour* within a crusading ideology of repentance.

Because the *Perlesvaus* foregrounds ascetic requirements, however, it questions the status of Lancelot as an adulterous lover and crusader. When we investigate the conditions by which Lancelot as a courtly lover and chivalric crusader in the *Perlesvaus* emerges against the backdrop of penitential discourse, we notice how this Lancelot offers a *volenté* different from both the contritionist intention to repent inwardly and confess and the secular "volonté" of Tristan in the courtly version of Thomas d'Angleterre.[21] In the memorable passage in *Tristan et Iseut* wherein Tristan debates whether or not he should marry Iseut aux Blanches Mains (lines 548–89), he feels a psychological conflict: he feels *volonté* (impulsion) without a true *desir* (erotic desire) for her. His true *amor* (love) for Iseut la Blonde

prevents ("vainc") his natural tendencies ("le voleir de sun cors"), and love and reason restrict ("destraint") his nature. In Thomas's psychological evaluation and moralistic view, he must inevitably detest his desire for Iseut aux Blanches Mains because his true desire is for Iseut la Blonde.

How is this *volonté* in Thomas's *Tristan* different from the *volenté* in the *Perlesvaus*? Crusade and confession change the moral framework of *desir*, *volenté*, and *amor*. *Voleir* in Lancelot's case is measured by his capacity as an Arthurian knight, his fidelity to Guinevere, and, in the case of the *Perlesvaus*, his good works as a crusader that can redeem his sins. Not contradictory, his *desir* and *volenté* for Guinevere therefore affirm his knightly prowess and assure his redemption as a crusader. In the *Lancelot-Graal* Cycle, the ethical problem comes in *La Mort du roi Arthur* (*Mort Artu*)[22] where Lancelot's *volenté* is against Arthur and announces the end of the Arthurian kingdom. However, what is clear throughout the Vulgate Cycle and the *Perlesvaus* is the extent to which the dominance of the penitential crusade discourse shapes the value systems of sincere confession, redemption, and chivalry in romances. Unlike Thomas's *Tristan*, Lancelot's love of Guinevere unites *volenté* with *desir* and *amor*, and the *Perlesvaus* shows him to be redeemed through his crusading works inspired by his love for his lady, King Arthur, and God.

Indeed, like the *Perlesvaus*, the later prose *Tristan* (contemporaneous with the *Lancelot-Graal*) maintains the adultery of Tristan, who also serves as a Grail knight; both works avoid the question of repentance. The conflict between sin and serving Arthur's court omits conversion as a requirement. A comparison of Tristan and Lancelot in these two thirteenth-century romances suggests why Lancelot is the more appropriate choice as a courtly crusader. Although Tristan becomes a member of the Arthurian Round Table and takes part in the quest for the Holy Grail, and his prowess and worth are often compared to that of Lancelot, his love for Iseut is of a different nature. Rather than Lancelot's declarations of love inspired by noble sentiment that form his *volenté*, Tristan's love for Iseut is inspired by rivalry and pride, such as his love for Iseut when

he discerns Palamedes's desire for her. Furthermore, the complicated feudal loyalty to Mark (versus the political independence of Lancelot, discussed later in this chapter) and the courtly disenchantment of Kaherdin complicate Tristan's potential as a Grail hero who could be enlisted for spiritual quests and penitential discourse. The psychological realism of Tristan's love in the prose *Tristan*, conditioned by earthly rivalries and feudal loyalties, contrasts with Lancelot's *volenté* in the *Perlesvaus* whose singular earthly desire inspires Lancelot to holy acts that converge with his love for both Arthur and Guinevere.

While in the *Lancelot-Graal* the possibility of Lancelot as an unrepentant crusader is implied in the deferral of sinful relations with Guinevere, other chivalric romances of this period developed strategies for reconciling earthly love and crusade. Through many adventures and feats that win him earthly renown and glory, the knight can, as in departure lyric, eventually turn toward spiritual salvation and leave the lady and sinful love behind. Heroes such as Gui in the thirteenth-century Anglo-Norman romance *Gui de Warewic* and Gille in the thirteenth-century Old French verse biographical romance *L'histoire de Gille de Chyn* eventually repent their earthly loves by turning to warfare in the name of Christianity rather than personal glory. Following his combats in Europe and abroad that prove his prowess and prestige to his beloved, Gui does not take up the cross but as a pilgrim engages in combats in the Holy Land.[23] He does these acts as a reformed knight ashamed of his search for fame and devotion to Felice. When Gui decides to serve God and leave the life of earthly chivalry, he repents the chivalric feats that he accomplished for his wife and his personal glory as well as the destruction of lives and property that came as a result of this chivalry. He must expiate his sins by going on a pilgrimage to the Holy Land, as he says:

> Pur vus ai fait maing grant desrei,
> Homes ocis, destruites citez,
> Arses abbeies de plusurs regnez,

[...]
E quanque ai mun cors pené
E quanque ai fait e doné
Pur vus l'ai fait, ben le sacez,
E asez plus que ci n'oez.
[...]
Mais pur lui unc rien ne fis,
Pur ço sui las e chaitif.
Tant francs homes ai oscis
En mei sunt li pecché remis;
El servise Deu desore irrai,
Mes peccez espenir voldrai.
 (lines 7608–29)

For you I have caused great havoc, killed men, destroyed cities, and
burned abbeys in many kingdoms … all that I have exerted my body
for, and all that I've done and given, I've done for you, you can be
certain, and much more than you've heard here.… but I have done
nothing for him, and so I am wretched and despicable. I've killed so
many honorable men that the sins remain with me. From now on I
shall go in God's service. I would like to expiate my sins.

The rhetorical repetition of "pur vus" emphasizes his confession to
his lady as an act of repentance: in listing his acts as sins, he can now
turn toward God and serve him, recognizing that he has never done
anything "pur lui." Unlike the Castelain in the *Roman du Castelain
de Couci* who is inspired by his lady to be a good crusader, in these
chivalric stories the knight must repent his past life in order to start
a new life serving God in the Holy Land. The chivalric feats in the
Holy Land in the second part of *Gui de Warewic* parallel the first
part, but now there is a spiritual progression: he does these acts in
the name of Christianity and the Lord rather than his lady. Like-
wise, D. A. Trotter notes how *Gilles de Chyn* combines historical
material with elements of romance and epic to idealize the hero, a
generic hybridity easily found in other works such as the chronicles

of Robert de Clair and the Middle English *Richard Coer de Lion* as well as *Gui de Warewic*.[24] Stefan Vander Elst has shown that such romances of courtly love and chivalric adventure in faraway places were fertile material for the incorporation of crusade themes of repentance and salvation.[25]

This "salvific structure" of repentance and conversion from earthly to celestial chivalry reflects the concern of churchmen from the end of the eleventh century onward that sin—especially the concept of *fine amour* celebrated by the courtly literature of aristocratic circles and likewise familiar to clerics—was a threat to the success of crusading. As I discussed earlier, Pope Innocent III and his followers attributed past failures to the sinful disposition and dissension among Christians and therefore saw the task of recruiters to lead crusaders to moral purity and repentance through prayers and sermons widely preached to large groups of people. Conversion tales of chivalric adventure were instrumental in advocating crusading piety, similar to prayers and sermons.[26]

However, like the *Castelain de Couci* that documents the values of the nobility of northern France, these romances could serve the interests of the aristocracy by establishing their ancestry and commemorating pious or patriotic acts of their families. As Trotter notes, *Gui de Warewic* establishes the "praiseworthy ancestry for the Counts of Warwick" as "Gui the reformed knight returns from the Holy Land to defend England against a pagan enemy"[27] in the defense of England before the Conquest. Gilles experiences divine visitations: his exploits have the amazing quality of feats related in chansons de geste. Unlike these heroes, Lancelot in the *Perlesvaus* maintains his autonomy as an earthly lord—advancing feudal values shared with romances such as *Gui de Warewic* even as he refuses to repent and become a reformed knight as Gui does. Therefore, his good works as a Grail knight make him available for redemption without the same kind of spiritual progression as in these biographical romances. Within this context, one can see how the *Perlesvaus* Lancelot converges with the idiomatic quality of my lyric examples in its exceptional ambivalence about crusade and repentance.

SINCERE *VOLENTÉ* LACKS
CONTRITIONIST HESITATION

From the perspective of a medieval reader familiar with peniten-
tial discourse and courtly romance, at first glance Lancelot appears
to express sincere contrition for his sins as a proper pious soldier
of Christ during his confession in the Grail Castle (Branch VIII).
However, his refusal to renounce his love for Guinevere and his will-
ingness to do penance for it with the belief that God can be merciful
(*Perlesvaus*, line 3686) allow him to shape his own crusade intention
based on his *volenté* for Guinevere. When the hermit asks him what
was the sin that he could not repent, Lancelot responds:

> Sire, fait Lanceloz, icel pechié vos jehira[i] je hors de *la boche* dont je
> ne puis estre repentanz el cuer. Je aim bien ma dame, qui roïne est,
> plus que nulle rien qui vive, et si l'a .i. des meillors rois del mont a
> feme. La *volenté* me senble si bone et si haute que je ne la puis les-
> sier, et si n'est enracinee el cuer qu'ele ne s'em puet partir. La gregnor
> valor que est en moi si me vient par la *volenté*.

> [Lancelot]: Sire . . . my tongue [lit. mouth or lips, *boche*] will tell
> of the sin that my heart cannot repent. My lady, who is a queen, I
> dearly love more than anything in the world, and one of the finest
> kings alive has her for his wife. *My desire* for her seems to me so fine
> and noble that I cannot abandon it, and it is now so rooted in my
> heart that it can never leave me. And whatever is of most worth in
> me comes from that *desire*. (*Perlesvaus*, lines 3656–61, my emphasis)

Lancelot defends his *volenté* but agrees to do penance for his sin:

> Je ne sui mie entalentez de guerpir le, ne je ne vos voil dire chose a
> coi li cuers ne s'acort. Je voil bien *fere la penitance* si grant com ele est
> establie a tel pechié, car je voil servir ma dame la roïne tant com li
> plera que je soie ses bien voillanz.

[Lancelot:] I have no desire to abandon my love, nor do I wish to say anything to you that my heart would deny. I will gladly do as great a *penance* as is laid down for this sin, for I wish to serve my lady the queen as long as she will have me as her love. (*Perlesvaus*, lines 3681–85, my emphasis)

Thomas Kelly and Jean-Charles Payen each observe that the hermit does not contradict Lancelot's statement but merely indicates that there is a high price to pay for the sin of adultery. Lancelot freely agrees to be a traitor to his king and a murderer of Christ because he cannot refuse such a good love bestowed upon him (*Perlesvaus*, lines 3663–71).[28] I agree with the scholarly consensus that in this "romance of Redemption,"[29] Lancelot's expiatory penance as a soldier of Christ and especially the suffering he endures in enforcing an unwanted marriage redeem his sin of adultery and make him available for salvation.[30] Kelly suggests that toward the end of the romance it is Lancelot who replaces the chaste Perlesvaus as the leading Christian knight, especially when Perlesvaus retires from worldly chivalry.[31] Nevertheless, an awareness of the confessional discourse within which the scene is inscribed and of how the *Perlesvaus* deploys martial penance to deflect internal contrition reveals that Lancelot promotes both piety and chivalric values for noble crusaders. That is, his *volenté* deflects interiority.

Lancelot's unrepentant, unwavering confession explicitly challenges the ecclesiastical prescriptions concerning sincere confession and in this way displays what Richard Kaeuper calls the "aristocratic capacity" for adapting penitential ideology and confessional practices.[32] To repent his love for Guinevere would make Lancelot insincere and a hypocrite: what comes from his lips must accord with his heart. Lancelot's unhesitating defense of his *volenté* as a *sincere* expression of true love advances a spiritual autonomy from the proper internal cultivation of contrition. His focus on the accord between his heart and tongue transforms the courtly and confessional commonplace, as he reconfigures that relation to accord with his love

and will. From the perspective of the romance's courtly audience, this change proves that his refusal to repent his *volenté* makes his confession sincere rather than a theological failure. In view of the Abelardian conception of sin, Lancelot consents to what he knows is a sin: he acknowledges his love for Guinevere as sinful and shows no proper shame or tears.

Whereas in "Aler m'estuet" we saw the construction of a courtly wavering about departure that responded to the unwavering of God's love, in the *Perlesvaus* we see a different configuration and resistance to confession and repentance: Lancelot does not waver in his refusal to repent Guinevere, nor in his willingness to do penance for this sin. His hesitation to confess his love before Guinevere in the *Lancelot*—an elaboration of his hesitation to step into the cart and his constant sighs in the *Chevalier de la charrette*—conforms with the difficulty of his sincere confession in the *Queste del Saint Graal*. Elspeth Kennedy argues that if part of the *Lancelot* did precede the *Perlesvaus*, then the confessional scene in *Perlesvaus* would have "greater depth and power" for readers who recall his confession of love to Guinevere in the *Lancelot*.[33] As a corrective to courtly romance, the *Queste* has Lancelot hesitate as he repents his sin of adulterous love, turning toward penance and the right spiritual path symbolized by the quest for the Grail. In the *Perlesvaus*, Lancelot's immediate refusal to repent is thus notable because it does not portray the hesitation of a contritionist or courtly confession.

How should Lancelot's confession appear and sound? Although he is excused from confessing the "sin that he cannot repent" as long as he is willing to do a "great penance" for his sin as instrument of the New Law, the romance nevertheless features a confession. Lancelot's refusal to repent foregrounds the idea that he *should* confess.

Lancelot's *non*confession and agreement to do penance for his sin provide a solution for dispensing with confession that responds to confessional discourse of the period apparent in both courtly and homiletic literature. Despite his being a crusader, Lancelot is not excused from confession.

Indeed, apart from the confessional manuals and sermons I discussed previously, moral and chivalric literature such as the *Queste* instructs an elite lay class on what sincere contrition should look like. This is what *Perlesvaus* readers anticipate: internal torment, the struggle to come to terms with sin that painfully emerges from the lips. The courtly crusader reluctant to leave his lady in love lyric as profession becomes in the *Queste* a reluctant confessor of earthly sin. The painful confession follows the contritionist emphasis on the difficulty and bitterness of pronouncing a sincere, heartfelt confession. During his confession in the *Queste*:

> Lanceloz pense .i. petit, com cil qui onques mes ne reconut l'afere de lui la roine, [ne ne le dira ja tant come il vive, se trop granz amonestemenz ne le meine a ce]. Il jete .i. sospir de parfont cuer, si est tex atornez qu'il ne pot mot dire de boche. Si le diroit il volentiers, mes il n'ose, [come cil qui plus est couart que hardis]. Et li prodons le semont [toutevoies] de regehir son pechié et de guerpir del tot, car autrement est il honiz [s'il ne fet ce qu'il li amoneste]. Il li promet [la] vie pardurable por le geh[i]r et la poine d'enfer por le celer. Si le moine tant par bones paroles et par sermon et par buenes autoritez que Lanceloz li comence a dire:
>
> —Sire, fet il, il est einsi que je sui morz de pechié d'une moie dame que j'ai amee tote ma vie, c'est la roine Guinievre, la feme mon seignor lo roi Artur.

Lancelot hesitated, for he had never avowed the matter concerning himself and the queen, nor would he while he lived, unless the moral pressure proved too great. His torment wrung a deep sigh from his breast, but not one word could he force from his lips. Yet he would gladly have spoken, but he dared not, for fear was stronger in him than courage. And still the hermit urged him to confess his sin and renounce it utterly, for if he refused, confusion would overtake him; he promised him eternal life if he made a clean breast and hell as the price of concealment. In short, he plied him with so many sermons and good authorities that Lancelot at last began:

"Sire, it is this way. I have sinned unto death with my lady, she whom I have loved all my life, Queen Guinevere, the wife of King Arthur..."[34]

Theologians and priests alike were aware that a sincere regret for one's sins could be neither forced nor legislated, which suggests why vernacular literature foregrounds the internal struggles of knights such as Lancelot. Another example of sincere contrition appears in the unrepentant knight of the late twelfth-century or early thirteenth-century anonymous tale *Le Chevalier au Barisel*, who comes to a painful remorse through the compassion and charity of a hermit. The story reflects the clerical view of how an unrepentant proud knight, only after struggling and confronting his unrepentant inner self with the help of a holy man in the same kind of torment as Lancelot in the confessional scene of the *Queste*, should come to an unforced and spontaneous true repentance. It describes the metamorphosis of the knight who by chance confesses to a hermit. The knight is motivated only by a care for his vassals (as he says to them, "vostre compaignie m'i maine" [your company leads me there (to confess)]; line 125) rather than a desire to repent.[35] The knight thoroughly confesses his sins without any grief and even relishes his sinful behavior. He accepts what he thinks to be an easy expiatory act, filling a barrel with water. When the knight returns from his long, arduous journeys after failing in his task because, as the hermit says, his penance is without true contrition ("Te penitance riens ne set, / car tu l'as fait sans repentance, / et sains amour et sans pitance" [your penance is without value, you have done it without repentance nor love and holy piety]; lines 780–82), the hermit wonders whether the knight's lack of remorse points to his inadequacy as a man of God. Crying out with tears, the hermit is violently taken with sorrow as he addresses God, asking him for pardon (lines 783–808). The knight, witnessing the grief of this man unrelated to him as a "merveille" (miracle; line 813), is himself moved to tears, and his first tear fills the barrel. This image illustrates the penitential meta-

phors of tears as cleansing the soul in a "bath of repentance" ("laver en repentance").[36]

Just as Lancelot in the *Queste* hesitates as he inwardly confronts his sin and then confesses after he feels the pain of remorse, in *Barisel* once the hermit's anguish softens the knight's heart and moves him to his first tear of repentance, the knight is able to narrate his sins: "de cuer vrai/toute sa vie li conta / c'onques de mot n'i mesconta, / a mains jointes, tout en plourant" (with sincerity he narrated his whole life without mistaking a single word in his account, with clasped hands, weeping; lines 940–43). Similarly, the hermit instructs Arthur in *Lancelot* to make a public confession in which "de tous les pechiés dont langue se porra descovrir par la ramembrance del cuer; et si garde que tu portes ton cuer avoec toi et ta bouce (all the sins that tongue can reveal through the recollection of the heart; and be sure that you carry your heart with you and your mouth)."[37] These texts link sincere contrition with tears and a complete, perfect confession that does not miss a single word. Further, they emphasize the necessary relation between heart, mouth, and tongue. The use of different words for tongue (*langue*) and mouth (*bouce*) in the scene of Arthur's confession suggests that the heart should be in the mouth before the tongue speaks.

Like these contritionist depictions of confession, the *Perlesvaus* portrays the concern with the accord between heart and tongue/ mouth, and it shares the same emphasis on representing the heart accurately by means of a verbal instrument (lips, tongue) to the extent that the heart and tongue should be together in the act of "ramembrance." In contrast to both the *Barisel* and the *Queste*, however, it is striking that Lancelot in the *Perlesvaus* emphasizes his confessional sincerity or accordance of tongue and heart by not hesitating as he declares his *volenté*. Unmoved by the hermit's willingness to do penance on his behalf as in *Barisel* and *Queste*, Lancelot does not cry as he declares his willingness to do penance.

In other words, not only does Lancelot demonstrate a refusal of the contritionist doctrine prescribed by twelfth-century theolo-

gians and literary texts for the elite, but he also advances a spiritual self-sufficiency in which the structural efficacy of penitential action challenges interiority as a means to redemption. In believing that his penitential acts of crusading will cleanse his sin as expiatory penance, making him available for salvation, Lancelot circumvents what would become during the thirteenth century the growing focus on the ritual of the sacrament and the sacerdotal absolution of the priest-confessor as advocated by Thomas Aquinas in his *Summa Theologica*. With greater reflection on how to evaluate sincere contrition came the significant issue of sacramental efficacy promoted by Aquinas in his commentary on Peter Lombard's *Sentences*. Aquinas argues that priestly absolution formalizes the sacrament: absolution causes the sinner's acts of confession and satisfaction to be infused with grace.[38] The priest's absolution, his "absolvo te," was necessary as a guarantee of the sinner's sorrow, and it made priestly administration essential in the structure of the sacrament formulated by Peter Abelard. The sacrament consisted of contrition, oral confession, and the performance of penance. Even though Kelly argues that Lancelot will suffer more for his sin in his unjust imprisonment by Arthur later on, the explicit nature of Lancelot's unrepentance and willingness to do penance for his sin through action proposes a different kind of crusader morality and ethic: a combined moral autonomy and efficacy of penitential action. Doing good deeds on behalf of the New Law atones for his sin and makes him available for spiritual redemption.

Lancelot, and not the priest, chooses his penance. Thus, going back to my reassessment of Foucault's confessional subjectivity and what I posit is the social aspect of "aveu," here is another version of the professional quality of the idiom: Lancelot asserts his professional courtly sincerity over penitential self-reflection and internal repentance. His admission to being at once repentant for his sins and unable to renounce the most important one makes him willfully sinful in the Abelardian sense, yet heroic and courtly from the romancer's point of view in that we see him reconcile competing spiritualities in his willingness to do penance for his sin.

FROM INTERNAL CONTRITION
TO WARRIOR PENANCE

In light of these debates about confession and the priests' role in the sacrament, Lancelot's unrepentant *volenté* is significant as an independently crafted idiom. Because Lancelot rather than the priest chooses his penance, the *Perlesvaus* formulates and authorizes an unrepentant courtly sincerity as redeemable through chivalric action. In its monologic quality—as Payen calls it, a "dialogue des sourds"[39]—the scene illuminates the process by which Lancelot fashions a chivalric piety within a confessional discourse concerned with the authentic expression of the love of God. The very monologic character of this scene indicates Lancelot's independent recognition, diagnosis, and judgment of his sin.

The deflection of contritionist interiority seen in Lancelot's refusal to repent his love for Guinevere correlates with other literary models in which we see Foucault's "aveu" as a social affirmation or courtly attribution of status. *Perlesvaus* shapes a different kind of chivalric piety by drawing from the tradition of the heroic confession in chansons de geste such as *La Chanson de Roland* (c. 1100) and the late twelfth-century *Chanson d'Aspremont*. By relying on the warrior ethos of the chanson de geste, the *Perlesvaus* reflects how such a scene provided a competing model of crusading piety independent from increasingly prescriptive pastoral models.

Scholars have recognized how early thirteenth-century chansons de geste find ways to deflect the call for complete conversion espoused in contemporary sermons. The writer of the *Perlesvaus* most likely drew from the new ways these works reconciled chivalric prowess with crusade. In her study of the discourse of war in Arthurian romance and chansons de geste, Marion Bonansea argues that in *Aspremont*, like the *Chanson d'Antioche*, the knights benefit from a "relation of contiguity with the divine" without having to renounce aristocratic and feudal values. In *Aspremont* the field of battle against the infidels becomes the place to win earthly glory, the knight Girart comparing himself to Charlemagne even as he wins

this glory in the service of God.[40] Bonansea notes well that such "contiguity" is far from (and I would venture, rejects) the Pauline dualism of the conversion of souls seen in the sermons of contemporary preachers such as Eudes of Châteauroux and James of Vitry. Eudes advocates a complete conversion to Christ for the crusader, a complete renunciation of the world based on the conversion of Saint Paul.[41]

From the confessional scene, we see that the *Perlesvaus* recognizes that the internalization of physical acts matters but also privileges a warrior ethos in which chivalric acts of strength and conquest constitute the good.[42] The knight's obligations to the lady and God count as chivalric service, and they are more important than internal grief and regret for his sin. Lancelot's *volenté* is ultimately evaluated by his crusading acts and their advancement of the New Law and God's ecclesia. This ethos of action permits him to be redeemed. Lancelot's nonconfession enacts his self-redemption. By adapting the epic stoicism of penance, Lancelot in the *Perlesvaus* departs from the confessional hesitations in the *Lancelot* and *Queste* which demonstrate the moral dilemma of his love for Guinevere, as well as the lyrical oscillations between joy and sadness in "Aler m'estuet" that feature the reference to Lancelot. In short, Lancelot's immediate speaking of his *volenté* develops a different kind of sincerity appropriate for a romance. He trusts that, despite an internal unrepentance, his acts to advance the New Law will reconcile him to God.

When Lancelot enacts the dispensation from confession, it recalls the same blessing obtained by crusading knights in the *Chanson d'Aspremont*. As long as Lancelot is willing to do a "great penance" for his sin as instrument of the New Law, he is excused from confessing the "sin that he cannot repent." But unlike the epic situation, Lancelot no longer depends on an ecclesiastical authority that grants dispensation from confession and blesses meritorious suffering during a moment of battle. In the *Aspremont*, the pope blesses knightly fighting for crusade and bestows spiritual reward, demonstrating how chivalric literature creates the blessing that knightly

crusaders wanted. As Kaeuper describes it, "the ahistorical chronology and the suprahistorical crusade benefits mix powerfully in a blessing descending on the grateful chivalric *ordo*":[43]

> Je sui uns om qui ne vos doi mentir;
> Ki or ira sor Sarrasins ferir
> Et le martire volra por Deu sofrir,
> Dex li fera paradis aovrir;
> La nos fera coroner et florir
> Et a sa destre nos fera aseïr
> Tos vos pechiés, *sans boce regehir*,
> Vuel hui sor moi de par Deu recueillir;
> La penitance sera del bien ferir.

> I am a man who does not deal in lies;
> He who goes now against this foe to fight
> And for God's sake should lose his mortal life,
> God waits already for him in Paradise
> With crowns and laurels [for the soldier of Christ];
> He shall sit us at his own right-hand side;
> *Without confession*, all the sins of your lives
> On God's behalf I now collect and shrive;
> Your penance is to fight with all your might!
> (laisse 236, my emphasis)[44]

The pope assumes that the soldiers of Christ will have the pure conscience and right intention preached by Bernard of Clairvaux, and that they will not fight for a cause other than Christ.[45] But if the pope of *Aspremont* assumes this internal disposition of the soldiers of Christ, he also makes it clear that their confession is not required for spiritual redemption so long as they succeed in fighting on God's behalf. The spiritual redemption of fighting and the omission of explicit confession are noteworthy when compared with the chronicle of Henry of Valenciennes of the Fourth Crusade. While we can as-

sume the speaker collects indirect confession ("sor moi") in *Aspre-mont*, Henry reports that crusaders participated in penitential activities directed by clerics before battle:

> Car confiesions o vraie conpunction de cuer si est eslavement de tos visses ... e pour chou commandons nous a toz que *cascuns confiés selon son pooir* ... et li chapelain qui estoient en l'ost on celebré li siervice nostre Segneur en l'ounour dou Saint Esprit, pour chou que Dex lor donnast hounour et victoire contre leur anemis. Apriès che *se confiessierent* li preudome par l'ost, et puis rechurchent corpus Domini ... *vous iestes tout confiessés et mondé de toz pechiés et de toutes ordures de vilenie* ... Je vous commanc a toz, en non de penitence que vous poigniés econtre les anemis Jhesu Crist.

Because confession and true compunction of the heart washes away all sins ... and that is why we order you right away *each of you to confess* according to your ability ... and the chaplains who were on the field celebrated the service of our Lord in honor of the Holy Spirit, so that God would give them honor and victory against the enemies. After the soldiers on the field *confessed* and received the body of the Lord [to the chaplain Philip, he addressed them again] *you have all confessed and are purified of all sins and all kinds of wickedness.* ... I command you all, in the name of penitence that you fight against the enemies of Jesus Christ. (my emphasis)[46]

Here Henry explains how divine aid comes to those who are sincerely repentant, who confess, and who "in the name of penitence" "fight against the enemies of Jesus Christ." Attacking the enemy is viewed as a form of penance only for those who have taken these important steps before battle.

Lancelot's combination of courtly *volenté* and piety also differs from Roland's version of chivalric piety in the *Chanson de Roland.* The *Perlesvaus* adapts Roland's martial pride for a contritionist discourse. On his deathbed, Roland performs the ritualistic gestures

and asks for forgiveness of his sins, but he does not humble himself before God nor ask for forgiveness for any particular sin:

> Ço sent Rollant que la mort le tresprent,
> Devers la teste sur le quer li descent ;
> Desuz un pin i est alét curant,
> Sur l'erbe verte s'i est culchét adenz,
> Desuz lui met s'espee e l'olifan.
> Turnat sa teste vers la paiene gent:
> Pur ço l'at fait quë il voelt veirement
> Que Carles dïet e trestute sa gent,
> Li gentilz quens, qu'il fut mort cunquerant.
> Cleimat sa culpe e menut e suvent,
> Pur ses pecchez Deu puroffrid lo guant.

> When Roland felt death take hold of him,
> descending from his head to his heart,
> he went quickly to a place underneath the pine
> and lay down on the green grass, his face against
> the earth,
> beneath him he placed his sword and horn.
> He turned his head toward the pagan enemy
> So that Charles and all his followers would say
> Of the noble count that he died a defiant death
> He confessed his sins multiple times,
> And for his sins he proffered his glove to God.
> (laisse 174)[47]

Here Roland professes generic guilt rather than confessing specific sins. As Linda Marie Rouillard remarks of this scene, "rather than provoking a profound change in the individual's relationship with his God, penance and clerical authority in the case of the *Roland*, the role of Turpin here maintain and validate warrior culture as a way to serve God."[48] Indeed, the expression "cleimat sa culpe" is

used repeatedly throughout the *Roland* (as it will be in laisse 176, for instance), and in this sense invokes a ritualized expression of guilt for the collectivity of holy warriors in the poem. Some editors translate this phrase as he "proclaimed his *mea culpa*," confessing his sins in a mode that could possibly refer to the Confiteor, the penitential prayer where one acknowledges sinfulness and seeks God's mercy and forgiveness.[49] Still, here penance is a professional proclamation of the pious warrior rather than a personal repentance of a sin that requires a confessional evaluation of sincerity. In contrast, Lancelot's refusal to renounce Guinevere seems to aspire to the epic stoicism of *Roland*, which validates his unchanging status as a pious knight in martial culture, but the romance also reconfigures the sincerity of contrition to serve courtly values. Lancelot not only refuses personal transformation in the affirmation of his *volenté* but also does more. His pious sincerity to serve God does not depend on ecclesiastical or royal authority such as Turpin, the pope, chaplains, or Philip, as in the other examples, for the dispensation and recognition of his meritorious suffering. Thus for Lancelot, the crusade to advance the New Law is a penitential pilgrimage undergirded by a personalized earthly *volenté*. Furthermore, his *volenté* and professional "aveu" remain independent of ecclesiastical blessing, the nonconfession as self-blessing: Lancelot shapes his courtly piety as a sincere unrepentance that avoids hypocrisy and claims the spiritual merit of crusading without the confession seen in these epics.

Clearly this new framework for spiritual redemption responds to the penitential discourse seen in contemporary sermons and Innocent's encyclicals, which linked the reform movement and a call to crusade. From the *Chanson de Roland* and *Aspremont*, it is evident that the idea of the remission of sins for fighting the infidel had been central to the movement since Pope Urban preached the First Crusade at the council of Clermont in 1095.[50] The historical writings on the First Crusade by Robert the Monk, Guibert of Nogent, and Baldric of Borgueil developed an ideology about crusade that was providential and focused on crusade as a movement toward heavenly Jerusalem for the elect.[51] Although writing for a monastic audience,

these historians gave theological refinement to crusading as a chival-
rous act for lay knights, reinforcing Urban's exhortation (echoed in
chansons de geste such as *Roland* and *Aspremont*) that soldiers of
Christ defend the Holy Church.

As part of the development of a popular ideology of crusade from
the First Crusade to the Fourth Lateran Council, laymen in the late
twelfth and thirteenth century form their own idiom of crusading,
one that professes the achievement of salvation in their own way.
This idiom draws from a language of churchmen that adapts courtly
and chivalric language to advocate holy war. The idiomatic Lance-
lot in the *Perlesvaus* demonstrates how during this period the idiom
is affected by the new theology of penance, especially by the early
thirteenth-century focus on sincere, internal contrition as the foun-
dation of crusading acts.

Critics argue that the *Perlesvaus* "humanizes" Lancelot within
an ideology of crusade that celebrates violent conversion and retri-
bution. The courtly yet violent aesthetic of the *Perlesvaus* might be
productively compared to the ubiquitous scenes of beheadings and
destructive force seen in the Morgan Crusade Bible that I discussed
earlier.[52] However, I suggest what is imprecisely called humaniza-
tion is a ritualized professional response to a penitential discourse.
In other words, this response reflects a defense of typically "medi-
eval" externalized social codes rather than a shift to a prehuman-
ist individualism and interiority memorably characterized by Colin
Morris.[53] While Morris is right to argue that social and cultural
changes in the twelfth century brought about new reflections on
consciousness and sincerity, seen especially in the romances of Chré-
tien de Troyes and the lyrics of the troubadours, as the thirteenth
century progresses, Lancelot's attachment to the ethics of courtly
love in the *Perlesvaus* tilts toward a pragmatic ethics of social life
adapted for crusade. Lancelot represents a courtly translation of the
necessity of redemptive violence in place of a transcendent, moral
condemnation of earthly values. This idiomatic Lancelot advances in
a new way the spirit of Varvaro's characterization of Béroul's *Tristan*:
the capacity of adulterous love to serve as a force for the Good over

Thomas' passionate love that leads to social and spiritual destruction. Here, however, the Good served is crusade. The *Perlesvaus* Lancelot demonstrates how the crusade avowal was a carefully crafted articulation of feudal and aesthetic codes that represented the ideals of the aristocratic martial class. Even if seen as an exceptional example, the confession makes evident the possibilities Lancelot had for shaping the language of crusade. He responds to the pastoral demand for more internal self-reflection with a warrior ethos and feudal codes. Such a figure in a crusade romance signals a heightened awareness of codified notions of what constitutes an authentic confession. In the end Lancelot is barred from the Grail because he loves the queen without repentance: "il amoit sanz repentir" (*Perlesvaus*, line 3751), an expression used by the trouvères.[54] I have shown, however, that the manner in which he justifies his *volenté*, arguing for its inherent goodness and by agreeing to do "penitance si grant" (*Perlesvaus*, line 3683) for his sin, advances an independent idiom that is as important as his inability to see the Grail. Lancelot is willing to endure pain and suffering, "painne e travaille," as he undertakes acts for the advancement of the New Law. But more important for this lay idiom of crusade, he fashions his own earthly intentionality as a professional "aveu" through the moral and aesthetic protocols available to him. That is to say, he speaks crusades for his times and needs.

LANCELOT AS MODEL FOR PROFESSING CRUSADE: THE CASE OF JEAN II DE NESLE, CASTELLAN OF BRUGES

How might this unrepentant Lancelot serve as a model for an aristocratic crusader? Just as the Châtelain d'Arras was inspired by Lancelot, there is evidence that another lord who went on crusade was inspired by the *Perlesvaus* Lancelot in particular. Scholars have identified Lord Jean II de Nesle, castellan of Bruges, as the patron of the *Perlesvaus*, according to the colophon of one manuscript held in Brussels (Brussels MS 11145) dated to the second half of the thir-

teenth century.[55] In the chronicle of Geoffroy Villehardouin, *La Conquête de Constantinople*, Jean departed for the Fourth Crusade in 1200.[56] In addition to this account, from the scholarship of W. M. Newman we know that Jean played a significant role in the internal politics of Flanders.[57] It is intriguing to speculate that an idiomatic Lancelot would have appealed to this lord whose crusading activities and political affiliations are well documented.

The editor of the *Perlesvaus* William A. Nitze first identified "seingnor de neele" as Jean in this manuscript and argued for a dating of the *Perlesvaus* based on the known biography of the dedicatee, a terminus ad quem of the first forty years of the thirteenth century.[58] The colophon reads:

> Por lo seingnor de neele fist li seingnor de cambrein cest liure escrire q'onques mes ne fu troitiez que une seule foiz auec cestui en roumenz et cil qui auant cestui fu fez e[s]t si anteus qu'a grant poine an peust lan choissir la lestre et sache bien misires johan de neele que lan doit tenir cest contes cheir ne lan ne doit mie dire a ient malantendable quar bone chosse qui ert espendue outre mauueses gens nest onques en bien recordee par cels.

> The lord of Cambrein had this book written for the lord of Neele. It has only once been written down in the vernacular and that copy is so ancient that the letters can be read only with great difficulty. And let my lord Johan de Neele know that this tale should be cherished and should not be told to men of little understanding, for a good word spread amongst bad people is never properly remembered and passed on by them.[59]

In revisiting Nitze's presentation of the colophon in relation to the romance, Tony Grand has thoroughly analyzed the historical evidence concerning Jean, asking whether his political pragmatism or religious idealism influenced the Lord of Cambrein's motives for the gift. Information on the Lord of Cambrein remains uncertain. After reviewing the status of the town of Cambr(e)in (Pas-de-Calais) dur-

ing 1191–1212, Grand contradicts Nitze's conclusion that the Lord of Cambrein would have come from an area under the Count of Flanders, as it remained subject to the French crown. He also questions whether Jean II was a patron of the Lord of Cambrein. Drawing on the work of Newman, Grand concludes that the gift was appropriate insofar as the Lord of Cambrein might have been aware of Jean's "religious feelings" and his patronage of poetry.[60] Most important, Grand concludes that the Lord of Cambrein did not dedicate a copy of the *Perlesvaus* "because of the bond created by their mutual adherence to Flanders."[61] Yet the gift of the *Perlesvaus* might be perceived as a political act in another way if we review Jean's biography as a crusading lord and how it constitutes *volenté*.

For our discussion in terms of Lancelot, the pertinent aspects of Jean's biography concern his known assertions of autonomy from ecclesiastical authorities and his political calculations. For instance, in 1226 he reserved the right to take back his gifts to the church upon his safe return from the Albigensian crusade (Acte 147). In 1229 Pope Gregory IX admonished him for infringing on ecclesiastical authority in a dispute concerning the priory of Lihons. He was known to have written a letter with other noblemen to Innocent III, demanding permission to hold tournaments without fear of excommunication.[62] From 1224 on he was known as a powerful baron of the French royal court, a faithful servant to Philippe Auguste in particular. When it was politically expedient in his career, he sought support from France as a baron of the French king. Perhaps the theme of the Grail with Christ's blood would have had special significance for a Flemish lord after he returned from the Fourth Crusade. Certainly the Lord of Cambrein would have known of Jean's close proximity to the blood relic of Bruges supposedly brought back by Thierry of Alsace. Although Jean's behavior as a crusader and baron are not exceptional for the period (as Grand writes, he was a "political animal" of any time[63]), the knowledge of Jean's life helps us imagine how he might have seen political autonomy and crusade piety as intimately intertwined.

Lancelot's assertion of his earthly *volenté* in the confessional scene and in his relations with Arthur likewise reconciles political calculation with his higher calling as a crusader: while he safeguards his personal intentions by couching them in courtly and chivalric terms, he acknowledges his king as well as a higher power beyond barons and kings. His profession of *volenté* as an independent idiom aligns with his political status in the *Lancelot-Graal* as an independent vassal of mysterious origins.[64] The political status and idiomatic speech of Lancelot might have resonated with someone like Jean. The use of *volenté* as a different kind of professional avowal in the *Perlesvaus* suggests more than the importance of feudal relations as a motivating force for crusade. *Volenté* embodies an idiom of autonomy also manifested in the archival documents that make up Jean's crusading existence.

An ethos of martial action would have appealed to aristocratic crusaders who, despite their piety, were concerned about their material holdings and their clan. Lancelot's assertion of a worldly *volenté* reflects what Jonathan Riley-Smith has called the "increasing secularization of the crusading movement."[65] Worldly cares were as important as—if not more important than—the personal piety and conscience urged in contemporary sermons: relations between lord and vassal, especially among nobility in northeastern France and Flanders, shaped recruitment; imperial and papal politics influenced the goals of expeditions as in the Fourth Crusade, or decisions to turn crusading expeditions toward Constantinople rather than the Holy Land. Lancelot's *volenté* might be understood as valorizing the various secular—chivalric and courtly—intentions that motivated crusading as penance. These intentions are maintained but cleansed through the ideology of chivalric literature.

The scene in the *Perlesvaus* when Lancelot is freed after having being unjustly imprisoned by Arthur reflects how *volenté* allows Lancelot to shape both his crusade piety and the terms of his feudal obligations. Lancelot uses the same word that he used in confession, *volenté*, to describe his attachment to the feudal code of service:

"Lanceloz, fet li rois, ge sui repentanz de ce que ge vos i é fet, e ge me sui porpensez des bons services que g'é trové en vos; si le vos amenderai a vostre *volenté*, mes que l'amor i soit ausint enterinne com ele ert devant.

Sire, fet Lanceloz, vostre amende aim ge molt, e vostre amor plus que de nului; mes ja, se Dex plest, por chose que vos m'aiez fete, mal ne vos ferai; quar l'en set bien que ge n'é mie esté en la prison por traïson ne por felenie que vos aie fete, mes por ce que vostre *volenté* i fu, si ne m'ert mie reprochié en vilenie; e puis que vos ne m'avez fete chose de coi j'oie blasme ne reproche, ge me doi trere arrieres de vos haïr; quar vos estes mes sires, e se vos me fetes mal, li blasmes en iert vostres. Mes, se Diex plest, por rien que vos m'aiez fet, m'aide ne vos faudra, ainz metré mon cors partout en aventure por vostre amor maintenir, autresi com g'é fet maintes foiz."

[After he wrongly imprisoned Lancelot, Arthur confesses:] "Lancelot," said the king, "I am deeply sorry for what I did to you, and I have been thinking about the great services you have done me. I will now make amends *as you wish*, but let our love be as complete as it was before."

[Lancelot:] "Sire," said Lancelot, "I would be glad to have you make amends; but I value your love more than anyone's, and if it please God, I will never do you any harm, whatever you may have done. For it is well known that I was not imprisoned for any treason or crime I committed against you, but because you *wished* it. I shall not be reproached with any crime; and since you have done nothing to me for which I could earn blame or reproach, I should refrain from bearing you ill-will; for you are my lord, and if you do me harm, it is you who will be reproached for it. But if it please God, whatever you may have done to me, my aid you will always have: my life I shall always risk to uphold your honour, as I have often done."
(*Perlesvaus*, lines 9489–9504, my emphasis)

Apart from the discourse of earthly love that we have seen, *volenté* is conventionally used to signify service in lord-vassal relations in

courtly literature and customary law.[66] Lancelot's use of the word here connects back to the confessional scene of the *Perlesvaus* because Arthur confesses to be "repentanz" just as Lancelot respects the feudal code of freely submitting to Arthur's *volenté*. More crucially, while Lancelot maintains his moral autonomy in the confessional scene by refusing to renounce his *volenté* and choosing to do penance for his sin, here he maintains his political autonomy by choosing to submit to Arthur as a vassal even though he comes from a clan that Arthur betrayed and therefore owes him no allegiance, a theme that runs throughout the *Lancelot-Graal*.[67] Throughout the cycle he embodies the effort and exercise of will (*volenté*) needed to attain the knightly ideal rather than inherited qualities of beauty, strength, and nobility.

As Elspeth Kennedy and David Hult have each argued in their respective studies of the *Lancelot* and *La Mort du roi Arthur*, Lancelot's mysterious origins and complicated feudal relation to Arthur as a vassal make him a figure in which the limits of knighthood are tested, as his love and *volenté* reveal tensions in the chivalric ideal and feudal customs of the Arthurian world.[68] Unlike Roland in *Chanson de Roland* or Tristan in *Tristan et Iseut*, he is unrelated by blood to his king, and as an unknown dispossessed knight, he owes Arthur neither land nor homage. In the course of the *Lancelot-Graal* it becomes clear that Arthur caused him to be dispossessed of his inheritance as a member of the lineage of Ban. Membership in a competing familial clan despite his being a vassal to Arthur becomes more important in *La Mort du roi Arthur*.[69] As Hult explains, in the *Mort du roi* we are meant to note the extent to which his heart makes him the best knight who at once embodies and threatens the social good: for instance, Lancelot decides not to claim the kingdom of Gaul when he wins the *Joyeuse Garde*, a gesture that would threaten Arthur's power.[70] In the exercise of his *volenté* for both Guinevere and Arthur as knight, lover, and loyal vassal, he remains a politically autonomous figure who inherently threatens Arthur's kingship. Throughout the cycle, then, Lancelot's political independence correlates with his first loyalty to the queen: it is the

queen rather than the king who performs the final act of the knighting ceremony. The *Perlesvaus* affirms this double political and courtly *volenté* in Branch X when Lancelot visits the tomb of Guinevere that reminds the reader of this first loyalty to the queen. Lancelot's intention ("cuers") and physical suffering ("painne e travaille") as a good knight and courtly lover are inseparable from his status as a vassal of Arthur through the concept of *volenté*.

In the final analysis, the scene between Arthur and Lancelot, like the confessional scene's explicit refusal of repentance, makes repentance an earthly arrangement between lord and vassal, and leaves out any mention of Lancelot's adultery. The use of *repentanz* and *volenté* to indicate Arthur's repentant state and Lancelot's free submission to his lord indicates a quasi sacralization of feudal custom that supersedes Lancelot's internal repentance of his sin. Through two appearances of *volenté*, then, we see how Lancelot's professional courtly avowal not only accords with but constitutes his political status, making him a model for an idiom that supports an independent lay theology for noble crusaders. While both Arthur and Lancelot are successful defenders of the New Law, and a divine justice seems to operate above Arthurian law,[71] *Perlesvaus* affirms the autonomy of a feudal code between Arthur and Lancelot as a motivating force of crusade ideology. In the scene with Arthur, Lancelot's *volenté* reveals the extent to which earthly intention of feudal custom allows for agency among the knightly defenders of the New Law. It is well known that courtly and feudal language often coincide, the idea of the knight's submission to the lady (*domna/femna* in troubadour terms) modeled on the vassal's submission to his lord. But what is striking in the *Perlesvaus* is how Lancelot's unrepentant *volenté* aligns with his feudal *volenté* to advance Lancelot's spiritual and moral autonomy as both crusader and vassal.

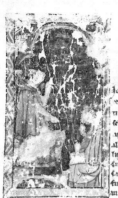

MEMORIALIZING CRUSADE PIETY
IN THE *PERLESVAUS*

The opening image of Jean's manuscript supports the appeal of piety and feudal independence for Jean: a much-effaced miniature in which an angel (or Christ?) dictates the work to Josephus (fig. 2) sacralizes the notion of *volenté* in the *Perlesvaus* that I have described in this chapter. Other manuscripts that transmit the *Perlesvaus* affirm the holy and sacred nature of the work in a related manner. For instance, two fragments (BN fr. 120, 14th c.; Arsenal 3480, 15th c.) of the *Perlesvaus* interpolated into *Lancelot-Graal* manuscripts instruct the reader to contemplate Lancelot's ultimate redemption in the wider context of the Vulgate Cycle. These manuscripts feature Crucifixion scenes above the incipits (in BN fr. 120, fol. 520, and in Arsenal, fol. 483). The images recall the invocations to the Trinity (*O non du Pere e du Fill e du Saint Esperit*) at the beginning of each branch and frequent use of the adjective *haut* (noble, or high) in the *Perlesvaus* that vigorously remind the reader of the sacred and holy nature of the work.[72] The Crucifixion scene invites a meditation on Christ's suffering. It is meritorious suffering in imitation of Christ that Lancelot adapts and transforms into suffering motivated by courtly *volenté*. In considering these other manuscripts of the *Perlesvaus* with the opening image of Jean's manuscript, we can assume that such readings and compilations would have appealed to a would-be or returning crusader such as Jean: he would look favorably upon such assemblages that valorize his sacrifice professed and packaged in his own terms.

Based on the Oxford manuscript, Nitze's critical edition of the *Perlesvaus* begins with the common crusading rhetoric of Christ's suffering present in contemporary sermons as well as crusade lyric, and now linked to the Grail:[73]

> Li estoires du saintisme vessel que on apele Graal, o quel li precieus
> sans au Sauveeur fu receüz au jor qu'il fu crucefiez por le pueple
> fachater d'enfer: Joesphes le mist en remenbrance par la mencion

de la voiz d'un angle, por ce que la veritez fust seüe par son escrite
et par son tesmoignange, de chevaliers e de preudomes, coment li
voldrent soffrir painne e travaill de la loi Jhesu Crist essaucier, que il
volst renoveler par sa mort e par son crucefiement.

Hear the story of that holy vessel which is called the Grail, in which
the precious blood of the Saviour was gathered on the day when He
was crucified to redeem mankind from Hell; Josephus recorded it
at the behest [lit. the voice] of an angel, so that by his writing and
testimony the truth might be known of how knights and worthy
men were willing to suffer toil and hardship to exalt the Law of Jesus
Christ, which He had aimed to renew by His Death and crucifixion.
(*Perlesvaus*, lines 1–7)

Jean's version of the text in the Brussels manuscript begins, "ojes
lestoire du seintisme veissel que le apele graal. En quoi li precious
sanc au sauveor fu receuz" (Hear the story of the holy vessel which
is called the Grail, in which the precious blood of the Saviour was
gathered). Addressed as listeners to the angel, we listen ("ojes") to
this story and remember its sacred nature transmitted by divine au-
thority. By extension, this image blesses the unrepentant Lancelot
by authorizing his nonconfession within a written prose testimony
of divine inspiration ("la voiz d'un angle") and by associating his *vo-
lenté* with the image of Christ's blood gathered in the Grail. Taken
together, the colophon and the opening image of divine authority
convey the spiritual truth of crusade (advancing the New Law)
through the performance of a feudal relation—the ritual of the gift
(the manuscript book) given by vassal to lord. The colophon ensures
that the reader sees the book as a symbolic "aveu" of social status,
and as such it valorizes Lancelot's redemption "not limited to deeds
performed in direct service of advancing the New Law,"[74] accord-
ing to what I have been describing as the earthly, personalized idiom
of Lancelot's *volenté*. In short, Lancelot's unrepentance within the
confessional discourse of the period forms a distinct idiom worthy
of memorialization in a noble book ("liure"; Brussels colophon).[75]

And a romance in prose attests to its historical veracity as a self-authorized testimony of crusade based on the profession of *volenté*.[76]

CONCLUSION

A romance that features Lancelot as a crusader, a colophon dedicated to a politically savvy lord attached to a holy romance of the Grail: these textual elements at first appear to affirm the transformation of twelfth-century courtly romances of earthly matters into the spiritual quests of thirteenth-century Arthurian romance, seen especially in the *Queste del Saint Graal*. Yet Lancelot's unwavering refusal to repent his love of Guinevere in the *Perlesvaus* constitutes an idiomatic moment that illuminates the compelling ambiguity of his status as an unrepentant crusader, exemplary Arthurian knight, and courtly lover, especially for someone such as Lord Jean de Nesle. My analysis of this romance among other genres of texts related to crusade and confession suggests why readers of the *Perlesvaus* found an unrepentant Lancelot appealing even if morally questionable. How might Lancelot have served as a moral, ethical, and political model for Jean de Nesle? Through the *Perlesvaus* Lancelot, we see how *volenté* asserts crusade piety and maintains political independence, two things that would have appealed to Jean based on his biography as an autonomous Flemish lord after he returned from crusade. In taking such an approach, I read the romance's construction of idiomatic unrepentance as one that affords personal autonomy from the changing spiritual and physical demands of the crusade movement. This idiom responds to and perhaps actively works against significant ideologies emerging during the pastoral reform movement regarding the codification of confession and clerical concerns about sincere internal contrition.

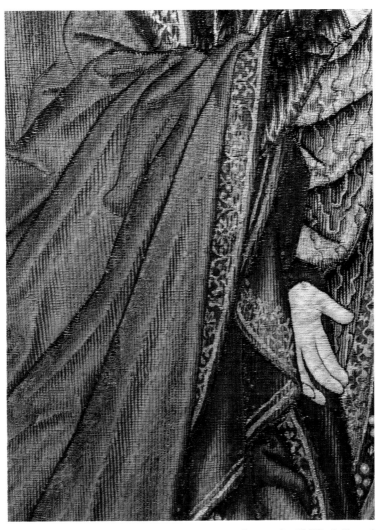

PLATE 1. *Emperor Vespasian Cured by Veronica's Veil* (c. 1510, detail). Wool silk, and gilt-metal-strip-wrapped silk in slit. Flemish, Brussels. The Metropolitan Museum of Art, New York. Robert Lehman Collection (1975). Photograph: Marisa Galvez.

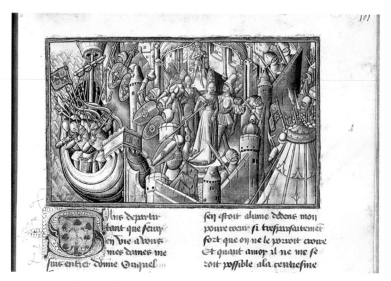

PLATE 2. Giovanni Boccaccio, *Le Livre de Troilus et Brisaida* (fourteenth century). Arsenal 3326, fol. 101. Photograph: Bibliothèque nationale de France.

PLATE 3. Raoul Lefèvre, *Recueil des Troiennes histoires* (fifteenth century). Arsenal 3692, fol. 95. Photograph: Bibliothèque nationale de France.

PLATE 4. Raoul Lefèvre, *L'Histoire de Jason* (fifteenth century).
Arsenal 5067, fol. 105. Photograph: Bibliothèque nationale de France.

PLATE 5. Raoul Lefèvre, *L'Histoire de Jason* (fifteenth century).
Arsenal 5067, fol. 117v. Photograph: Bibliothèque nationale de France.

PLATE 6. Raoul Lefèvre, *L'Histoire de Jason* (fifteenth century). Morgan MS 119, fol. 66v. Purchased by J. Pierpont Morgan, 1902. The Morgan Library and Museum. Photograph: Marisa Galvez.

PLATE 7. Book of Hours (fifteenth century). MS Lewis E. M. 18.4. Photograph:
Rare Book Department, Free Library of Philadelphia.

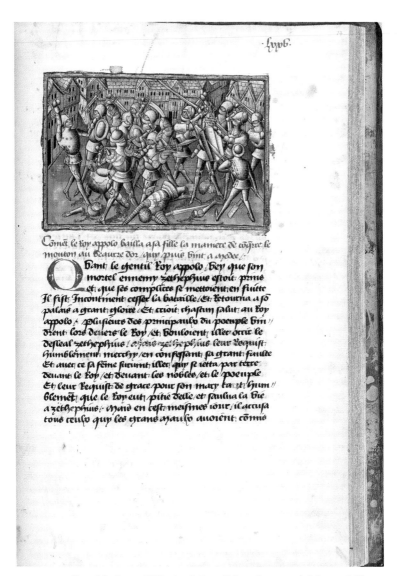

Comēt le Roy appolo baillia a sa fille la maniere de cōquerre le
mouton au beaurze dor / qui / puis bint a medee /

Quant le gentil Roy appolo / Bey que son
mortel ennemy zethephius estoit / pris
et que ses complices se mettoient en fuitte
Il fist Incontinent cesser la bataille / Et retourna a so
palais a grant gloire / Et crioit chascun salut au Roy
appolo / Plusieurs des principaulx du poenple Bin //
rent lors denuers le Roy / Et Boulioient tuer ortre le
desleal zethephius / cppere zethephius leur requist
humblement mercep / en confessant sa grant faulte
Et auec ce sa feme surunt illec / qui se retta par terre
deuant le Roy / et deuant les nobles / et le poenple
Et leur requist de grace pour son mary tant humi //
blement que le Roy euth pitié delle / et saulua la Bie
a zethephius / mais en cest mesmes iour / il accusa
tous ceulx qui les tyrans maulx auoient comis

PLATE 8. Raoul Lefèvre, *L'Histoire de Jason* (fifteenth century). Morgan MS 119, fol. 74. Purchased by J. Pierpont Morgan, 1902. The Morgan Library and Museum. Photograph: The Morgan Library and Museum, New York.

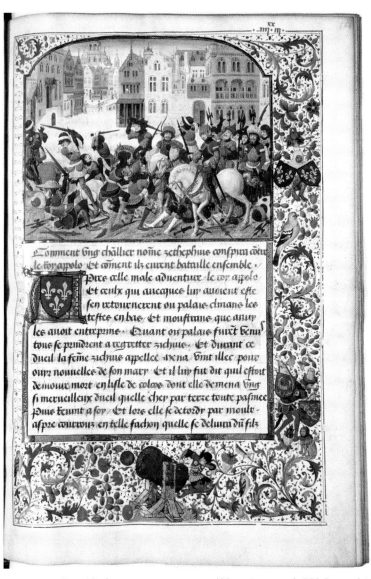

PLATE 9. Raoul Lefèvre, *L'Histoire de Jason* (fifteenth century). BN fr. 331, fol. 83. Photograph: Bibliothèque nationale de France.

que fil voulott aler en oliferne accompaigme de fes pa
rene et anne que tant fevoient enuers fa dame quelle
lefpoufevoit et quelle le couronneroit roy de fon pais·
Et pour ce dift Iafon que ie prens bonne fiance en la pro
meffe de ces deux damoifelles Ie men pzar en mon pais
affambler mes parene et anne au plus toft que ie poiur
Et ne ceffevar Iamaie Iufquee a tant que ie fevar venu
au deffue de mes amoure· en quoy Iay bonne efpevance·

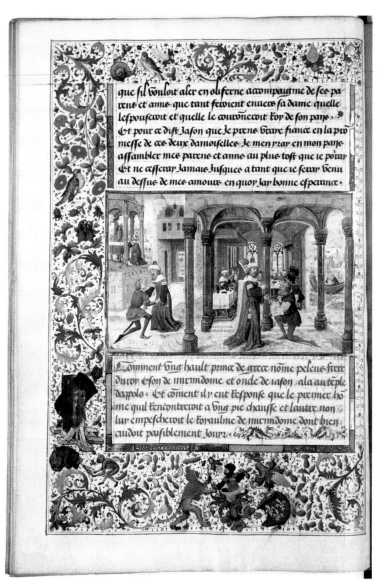

Comment vne hault prince de grece nome peleue frere
du roy efon de mirmidome et onde de iafon; ala au teple
daipolo· Et coment il y eut refponfe que le premier ho
ime quil rencontreroit a vne pie chauffe et lautre non
luy empefcheroit le royaulme de mirmidome dont bien
cuidoit paifiblement iouir·

PLATE 10. Raoul Lefèvre, *L'Histoire de Jason* (fifteenth century). BN fr. 331, fol. 52v. Photograph: Bibliothèque nationale de France.

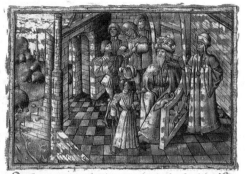

Cōmēt capit, fitz du roy Espū de mirmadōnie fuit fait chlr /
Et cōmēt hercules luy a saulluer cōment dune pucelle /·

Mehremēmēt les roys et les princes de
haulte felicite attandoient quant la leur
semence leur apportoit generation · Ayās
quant a ce ne paruenoient quelque prof /
perite quilz eussent / leur vie estoit trauersee de con
tinuel regret / Et visitoient temples et oracles, Jusqe
a la consūmation de leurs iours · ou Jusques a leuance /
ment de leurs oroysōs · Le roy espū dont est faite
ou prologue mention, Entre tous biens et prosperitez
mondaines fut moult noblemēt regnant · Certes il
eust Fortune maintenu en paix · Il eut par maria /
ge vne tresbelle dame ayās ilz furent longuemēt
ensemble sans auoir generation / Dont leurs iours
furent plains de regrew · Et, pou de plaisire prenoi /
ent es biens de fortune / Ainchois estoit cōtinuellemē

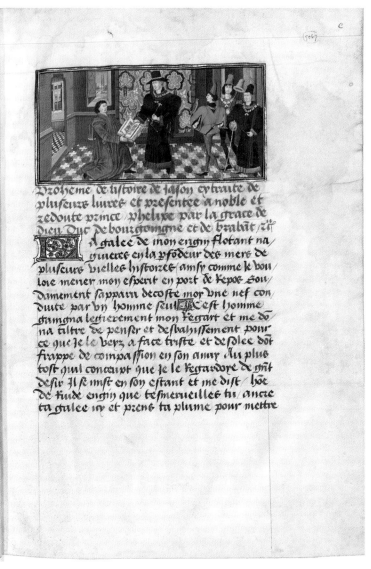

Proheme de listoire de Jason extraite de
plusieurs livres et presentee a noble et
redonte prince phelipe par la grace de
dieu duc de bourgongne et de brabant / &c

A galee de mon engin flotant na
vineres en la pfodeur des mers de
plusieurs vielles histores amsy comme le vou
loie mener mon esperit en port de repos sou
damement sapparu decoste moy une nef con
duite par un homme seul Cest homme
estrangma legierement mon regart et me do
na tiltre de penser et desbahissement pour
ce que le le vers a face triste et desplee dot
frappe de compassion en son amy Au plus
tost quil conceupt que le le regardope de grit
desir Il se mist en son estant et me dist home
de rude engin que tesmerueilles tu arrere
ta galee ic et prens ta plume pour mettre

PLATE 12. Raoul Lefèvre, *L'Histoire de Jason* (fifteenth century). Arsenal 5067, fol. C. Photograph: Bibliothèque nationale de France.

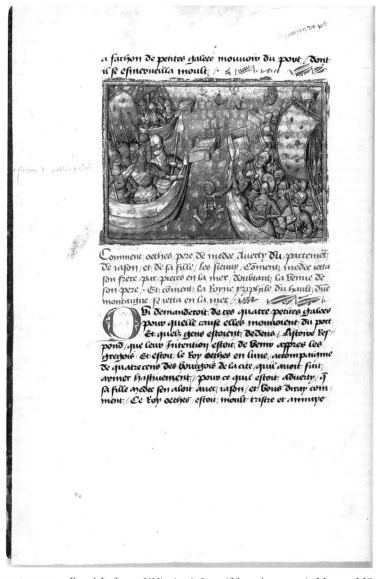

PLATE 13. Raoul Lefèvre, *L'Histoire de Jason* (fifteenth century). Morgan MS 119, fol. 102v. Purchased by J. Pierpont Morgan, 1902. The Morgan Library and Museum. Photograph: The Morgan Library and Museum, New York.

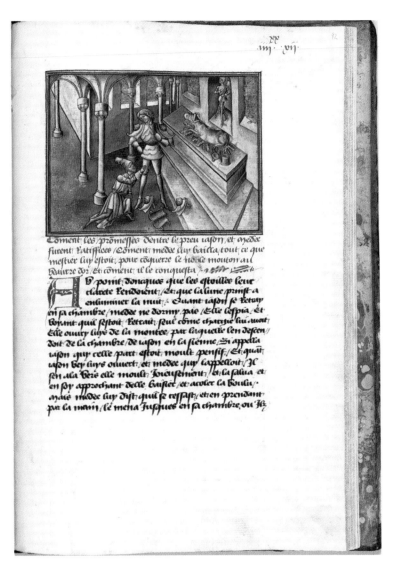

PLATE 14. Raoul Lefèvre, *L'Histoire de Jason* (fifteenth century). Morgan MS 119, fol. 92. Purchased by J. Pierpont Morgan, 1902. The Morgan Library and Museum. Photograph: The Morgan Library and Museum, New York.

Three Ways of Describing a Crusader-Poet: Adjacency, Genre-Existence, and Performative Reconfigurations

COURTLY CRUSADE IDIOM AND DESCRIPTIVE HISTORICAL POETICS

In the previous chapters I described an idiom that emerges in courtly lyric and romance in resistance to a penitential discourse about crusade, inward repentance, and external signs of the heart. The reconfiguration of the penitential discourse produces a speaking crusades and right intention in a language that articulated a certain ambivalence about these concepts as prescribed or preached by churchmen or in homiletic literature.

This chapter advances another way of formulating the idiom by constructing the subject of three crusader-poets. A study of various manuscripts permits us to track the movement of the idiom from lyric phenomenon to material archive. This descriptive historical poetics is an effort to expand the temporal constellations of the idiom and multiply the complexity of relations through which we can describe the crusader subject speaking it. As we have seen, the reconfiguration of confession to profession might be fleeting and transient when put in the context of a corpus of manuscripts like the examples of the figure of the fragmented body in the crusade lyric corpus and the unrepentant Lancelot in the romance tradition. In this chapter I show fleeting idiomatic crystallizations that are concrete and singular in the radical synchronicity of witnesses or the complex *Nachleben* (afterlife, in the sense of the survival of anachronistic forms and phenomena) of genres that structure people and places associated with crusading poets.[1]

Studies of crusader art and literature of Europe and the Latin East during this period have emphasized the complexity of cultural exchange among Christians and non-Christians at the intersection of "poetic places and real spaces."[2] First, there is the complex question of what we should consider "crusader art" in general. Art produced in cultural and artistic centers before, during, and after the establishment of the Latin Kingdom is variable; much of the material has been lost; and architecture was the central medium in which one could see the engagement of diverse religious and ethnic cultures and major military and artistic changes.[3] Such exchanges result, for instance, in different modes of stylistic incorporation of foreign cultures, such as Christian buildings in the Levant. These exchanges also produce modes of citation and artistic cross-fertilization in the Latin East and the Holy Land in which style is more important than function, and multicultural buildings that do not necessarily result in harmonious relations among various ethnic, religious, and social groups. Precious metal objects such as gifts made from local materials embody variegated aesthetic styles shared by Latin Christians and Muslims in the Holy Land and artisans working across cultures.[4] Further, pilgrimage texts and travel diaries of merchants have their own discourse of itineraries, encounters, and pragmatic realities intersecting with the *in illo tempore* of Christian narrative, where places visited in the present connect the pilgrim with holy events of the past.[5]

When I speak of "idiom" in this chapter, I advance a way of thinking about crusade in which modes of speaking crusades are constructed by frames and constellations. Whereas earlier I analyzed the penitential discourse, in this chapter I analyze how courtly manuscripts create a "crusader-poet." In the Western European tradition, how is this subject constituted through its material environment? What idioms are produced through a configuration of various witnesses?

TWO CONCRETE EXAMPLES OF DESCRIPTIVE
HISTORICAL POETICS: THE CHINESE SWORD
OF JEAN D'ALLUYE AND THE EPITAPH
OF BARTHÉLMY CAÏN

Before moving to how manuscripts produce the crusader subject, I
illustrate my approach of descriptive historical poetics with two ob-
jects that in several ways embody typical monuments of the crusader
and whose meanings seem clear in their respective disciplines of study
(e.g., epigraphy, art history, the study of armory). Funerary sculptures
such as effigies and steles of crusaders often provide with precision the
year and location of death, as well as the crusader's origin and status
in life. With these objects I attempt something different from these
practices that I will apply later to the descriptive historical poetics of
the manuscripts: I search for the idiom in movement by identifying
historical frameworks of people and places through moments of in-
determinacy, in order to assess the value of this idiom as a particular
speaking crusades, as a mobile phrase that occurs when certain pos-
sibilities appear. These moments multiply ontological frameworks for
describing a crusader-poet's existence or show how much a subject of
crusade depends on disciplinary practices.

First, the sword of Jean d'Alluye (fig. 3) converses with my meth-
odological approach and the concept of idiom deployed in this chap-
ter. Among the sculptures at the Cloisters of the Metropolitan Mu-
seum of Art, the armored gisant of Jean d'Alluye from the Abbey
of La Clarté-Dieu, which he founded in 1239 and where he was
entombed about 1248, represents the idealized image of a crusader
in the classical age of chivalry. In this type of funerary monument,
an armored figure reclines on a horizontal surface that may consti-
tute the top of a pseudosarcophagus or the projection of a subterra-
nean tomb. Inscriptions often appear on the slabs of subterranean
tombs, identifying the deceased and indicating his rank as nobility
or knight. Such monuments are found all over Europe but are most
common in France, England, and Germany dating from about 1220
to 1400. In the case of Jean d'Alluye, the figure measuring 6 feet, 11.5

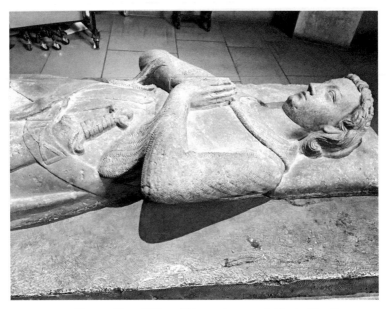

FIGURE 3. Gisant of Jean d'Alluye (thirteenth century). Tomb effigy, limestone. Loire Valley, France. The Cloisters Collection (1925). Photograph: Marisa Galvez.

inches in length by 2 feet, 10.25 inches in width, is sculpted in high relief. His hands devoutly joined in prayer, the larger-than-life-size sepulchral effigy illustrates the equipment typical of a knight of the first half of the thirteenth century. His feet rest against a small lion, symbolic of courage. In addition to wearing the expected long-sleeved mail shirt with a hood, surcoat, shield, spurs, and mail chausses over his legs, the knight depicted in early manhood bears a surprising object. As first noted by Helmut Nickel, Jean d'Alluye's sword has a trilobate pommel that is different from the standard ovals or disks found in swords of Western Europe at this period. Using manuscript illustrations and surviving examples of medieval swords, Nickel convincingly argues that the sword was most likely forged in China, as it resembles archaic Chinese swords and their representations in Chinese art prevalent by the twelfth century.[6]

Judith Hurtig has reflected on the appearance and then prevalence of the armored gisant during the thirteenth and fourteenth

centuries: on the one hand, one sees the changing status of knights—the older and lower classes of aristocratic knights were merging into one class—manifested in the new importance placed on dubbing ceremonies, heraldry, titles, and artistic representations of chivalry as an affirmation of status and social advancement.[7] Illuminated manuscripts of Arthurian literature and funerary sculpture affirmed Christian knightly status (*miles Christi*) and promoted chivalric culture at the same time that the nobility was losing its primacy in warfare. Such celebration of knighthood through secular and funerary art coincided with a liberalization of burial practices; further, the period sees an increase in the emergence of lay craftworkers and professional ateliers for the production of manuscripts and other objects such as ivories commissioned by secular patrons of the aristocratic and mercantile classes. All these factors point to the function of the armored gisant as not only a religious monument, representing the pious hope for salvation, but also an articulation of wealth and power.

Although the original paint on the shield that indicated the arms of the knight has long since disappeared, information on the knight and on the provenance of the gisant was eventually discovered. Biographical information about Jean d'Alluye gives a few possible scenarios for his acquisition of the sword. It is known that Jean took the cross and went to the Holy Land in 1241. He returned home in 1244 with a relic of the True Cross given to him by the bishop of Hiera Petra in Crete. By carefully representing the Chinese sword with a scabbard and sword belt in the Western European style on his gisant, Jean shows that the object was a cherished possession brought back from Outremer, important enough to be portrayed with him for posterity. Nickel proposes that Jean acquired the sword in a peaceful trade along the Silk Road, through an encounter with "a raider in the conquering hordes of the Mongols," as an "exotic collector's item in the bazaar of some Levantine port" or as "booty on a Syrian battlefield."[8]

One can speculate further on the cultural value of this sword for a thirteenth-century French crusader. The Chinese sword pro-

vides an opportunity to reflect on a Western—specifically French—encounter with an "Other" that fits neither in the category of Saracen seen in chansons de geste of the twelfth and thirteenth centuries, nor in the "marvels of the East" (e.g., the legend of Prester John) that emerged with the rise of Mongol power in the East during the thirteenth century. More likely the acquisition of the sword is the result of contacts and exchanges between European crusaders and the Mediterranean commercial elite. As Sharon Kinoshita explains, "despite their religious differences ... Byzantine, Islamic, and Mongol [empires] were linked by their ways of articulating power relations through a constellation of ceremonial practices ... often marked by the exchange of beautiful precious objects rendered as a tribute, bestowed as favours, or given as diplomatic gifts."[9] The ceremonial display of Jean's sword on his gisant makes us wonder what kind of cultural value it held for him: was it a ritual presentation of booty, like the prized horses of San Marco acquired in the sack of Constantinople? Might it signify a new awareness of Eastern cultures after the Mongols' expansion of power, and by the 1240s, the possibility of Latin Christendom's alliance with them? Even if the sword resulted from commercial exchange, it still avows a fascination with the marvels of the East. However as an idiom, if we are attentive to how it speaks, this professional avowal must be described in its specificity.

As an idealized image of the crusader, the effigy embodies the substance of the language of crusade, but the untranslatable quality of the idiom occurs in the presence of the Chinese sword. That usage is a moment that crystallizes a frame of reference: we can guess where this crusader has been (a bazaar in the Levant, a raid in a Mongol horde), but the point is that we will never know how or why he has this sword. What we can do is develop a frame of reference that includes a complex of relations that intertwines the "subject of crusade" with various cultures, at the same time personalizing or speaking crusades in his own way, as when he ascribed enough value to this foreign object to be buried with it as a proper crusader. The gesture of being buried with this sword constitutes his "idiom." The

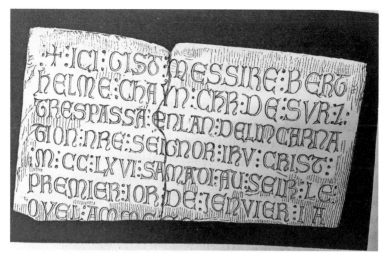

FIGURE 4. Frankish stele of the knight Barthélmy Caïn. From Johann N. Sepp, *Meerfahrt nach Tyrus zur Ausgrabung der Kathedrale mit Barbarossas Grab* (Leipzig, 1879), 264.

work of historical poetics is to describe such a network of relations and to multiply our frames of reference.

My second example of descriptive poetics creates a crusader subject through the multiple frames of relations made possible through indeterminacies of epigraphy. The Frankish stele of the knight Barthélmy Caïn (fig. 4) was found in the cathedral of Tyre[10] and reads:

⋮ + ⋮ICI ⋮ GIST ⋮ MESSIRE ⋮ BERT/HELME ⋮ CHA⋮N ⋮ CH(EVALIE)R ⋮DE ⋮ SUR ⋮ ET ⋮ / TRESPASSA ⋮ EN LAN ⋮ DE LINCARNA/TION ⋮ N(OST)RE ⋮ SEIGNOR ⋮ JH(ES)U ⋮ CRIST ⋮ M ⋮ CC ⋮ LXVI ⋮ SAMADI ⋮ AU ⋮ SEIR ⋮LE ⋮ / PRE-MIER ⋮ JOR ⋮ DE ⋮ JENVIER ⋮ LA/QUEL AMME ⋮ SO[IT MISE ⋮ EN PARADIS]

Here lies sir Berthelme Chayn, knight of Sur, who passed the year of the incarnation of our Lord Jesus Christ 1266, Saturday in the evening of the first day of January. Let it be this soul was sent to paradise.

As a funerary monument, the stele with a French epitaph sup-
posedly provides precise historical facts: the date of Caïn's death
and his status and identity as a Frankish knight. However, Pierre-
Vincent Claverie has corrected the date of the actual death to 1267,
as it was that year that the first of January fell on a Saturday. Cla-
verie concludes that a different calendar was in use in this King-
dom of Acre. Further, the present-day location of the stele remains
uncertain. Supposedly reported to be in the Louvre but now cur-
rently lost, epigraphers must rely on the facsimile of the archaeolo-
gist who first discovered it and others who transcribed the inscrip-
tion.[11] The language of the epitaph tells us that Caïn was a speaker
of French living in the Holy Land, and his name is certainly French,
but after that the interpretation becomes more diffuse. While the
majority of inscriptions were in Latin, the use of French for such
epitaphs has been an invaluable source for understanding the par-
ticular kind of written French in the Latin Kingdoms of Outremer;
indeed, scholars have recently argued for the status of the language
as a "supraregional" mixture of Western and Middle Eastern lan-
guages, and as a written language it reflects the practical and cultural
life of the Holy Land at the time of the Crusader States as well as
political visions that shaped and transmitted French scripta in vari-
ous Francophone regions during the thirteenth and fourteenth cen-
turies. For instance, Laura Minervini argues for the supraregional
mixity of Outremer scripta, while Fabio Zinelli demonstrates the
dissemination of Outremer French in French manuscripts of Nea-
politan origin—evidence that cultural exchange between Outre-
mer and Angevin Italy shaped the textual traditions of Neapolitan
manuscripts.[12]

 To the questionable existence of this stele as an institutional ob-
ject and the mobile status of Outremer French, we must also add
the vagaries concerning the identification of the name. While Hans
Prutz argues for a Berthelme Chayn as a Venetian of French ori-
gins because a report of 1243 that mentions this name as a receiver
of two *casalia* in Tyre, Claverie argues for the reading of a branch

of Caïn from Montréal-en-Auxois, long present in the regions of Avallon and Dijon.[13] A member of that family was connected to the entourage of Hugues II of Burgundy, who went on the First Crusade (1103–43). Moreover, while only one noble branch in France seems to have used this name as a surname, other documents attest to the use of "Chayn" as a first name: "Caina de Montergali" and a "chevalier Chayn," expanding the range of identification (surnames and first names as "Caïn"). Although it is difficult to ascertain when the Caïn established themselves in the Holy Land, the name "Caïn le Roux" appears in the registers of Cyprus in the first quarter of the thirteenth century, which leads Claverie to consider the existence of this Frankish family in the Holy Land around that time.[14]

The evidence leads us to two possible frames of reference for constituting the subject of crusade: either a Venetian chevalier about whom we know very little except for his possessions bestowed by the king, or a Burgundian chevalier from a noble family in which at least one member went on crusade. For Claverie to consider the stele's connection to a crusading family from Burgundy, he reads "Chayn" as "Caïn" with the diphthong. The interpretations of the stele create different Frankish subjects in Tyre: one a property holder from Venice, another a "crusader subject" by way of his genealogy. In Tyre, two Frankish spaces of Outremer emerge through this stele— Venice and the Holy Land; France and the Holy Land—and much depends on the weight one puts on certain documents and the interpretation of a diphthong. The point is that the stele foregrounds a descriptive poetics that shows how disciplinary discourses such as epigraphy create knowledge. Assuming that a reliable translation of the inscription exists as a document even if the object can no longer be located, epigraphy can create "subjects" depending on how one produces frameworks of relations: the connections between real places, interpretive spaces (e.g., France/Tyre through a name), and diplomatic documents. This differential view of epigraphy obliges us to reflect on the weighing of sources and on the process from transcription to translation. Sword and epitaph call for a differ-

ent kind of poetics to describe the idiom: from the sword, multiple frameworks of exchange are possible, and from the name "Chayn" in stone, at least two different "subjects" are possible. The facticity of an effigy and a stele as monuments is called into question—that is to say, the truth claims of information transmitted by these objects appear incomplete. The process of translation shows information displaced or diverted in order to produce information about the crusader. What emerges is a poetics of description that produces the subject. This approach moves the focus from the objects of study to the fields of knowledge that create relations between places, times, and proper names.

Understanding the Chinese sword and epitaph as two versions of speaking crusades, we can locate lyrical translations of crusades within and across texts and various possible situations through time and space. Two objects commemorate the "crusader subject"—what he did, where he was from, where he went, and so on—but we are left contemplating the unexplainable details (the Chinese sword) and the disciplinary practices (e.g., epigraphy) through which these subjects speak. Previously we saw how lyrical modalities and postures of crusade resist hermeneutic paradigms (e.g., confession, the theological and historical discourse of holy war) through poetic reconfigurations of figures, people, places, and objects. Now I submit descriptions of these constellations in manuscripts through what I call modes of *adjacency*, *genre-existence*, and *performative reconfigurations* (and reverberations). As in the case of the effigy and stele, the idiom becomes visible through descriptions strategically situated within historical discourses of language, culture, and materiality.

THIBAUT DE CHAMPAGNE AND THE ADJACENCY
OF THE "TROUVÈRE-CRUSADER-LORD"

Adjacent: having a common boundary, abutting, touching, contiguous, nearest in space or position, immediately adjoining without intervening space; or, near or close but not necessarily touching, from Latin, adjacere—*"to lie near"*

Thibaut de Champagne IV's role as a crusader and rich lord of Champagne during the thirteenth century is well documented. He was also a celebrated trouvère, having composed courtly lyrics on moral and amorous themes, including a number treating crusade. The adjacency of archival material concerning Thibaut as a trouvère-crusader-lord helps us construct possibilities about our subject of crusade; these mobile frameworks make visible an idiom that might not be disclosed when "Thibaut de Champagne" is interpreted from separate domains of the literary and the historical or relegated to a historical existence who composed a lyric corpus. There are two ways that adjacency occurs in Thibaut's work. The first is within the thirteenth-century French compendium of mostly prose works in the Bibliothèque Nationale (BN français 12581), dated 1288 in a colophon, in which Thibaut's lyric texts occur next to a listing of Champagne's *foires*, or fairs ("Feodorum Campanie Rotuli", in the manuscript as "La devisions des foires de Champaigne," fol. 312r–312v), and the second is in his commissioned *Rôles des fiefs de Champagne* that documents annual incomes, components of the fiefs, names, titles, and possessions of fief holders.[15] I define *adjacency* as a quality of nearness outside conventions of manuscript compilation and analogue.[16] Adjacency happens precisely because it does not follow the conventions of compilation nor acknowledge the status of poetic texts. What occurs is a quality of archival nearness that seems almost arbitrary except for the bringing together of texts having to do with Thibaut de Champagne in some way (poetry of Thibaut and *foires* of Champagne). In his study of this manuscript, Daniel O'Sullivan has noted that Thibaut's songs in the first section of the compendium (folios 1–22) follow the grouping of the known *libellum* of Thibaut but with a different succession. He also argues that Thibaut's placement at the beginning of this "collection arrageoise" indicates that he was considered a vernacular authority of Arras, where the manuscript was compiled.[17] In addition to works by Thibaut, BN fr. 12581 also includes a treaty on falconry, a long fragment of the *Roman du Saint Graal*, and *Le Livres dou Trésor* of Brunetto Latini. The colocation in this compendium of the fairs and lyric texts oc-

curs on folio 312v (fig. 5). The listing of *foires* indicates the place and time of the fairs that depend on localized context. For example, "La foire de Laingni est livrée landemain de l'an reneuf" means that the Laingni fair takes place the day after the New Year. This listing of fairs might be seen as the conventional medieval scholarly practice of *ordinatio* and *compilatio* in which texts are ordered, collated, and glossed together under a conceptual framework. Yet the gathering of people, places, and lyric that occurs in relation to Thibaut does not follow the conventional generic organization; instead, the identity of "trouvère–crusader–Lord of Champagne" comes about through what we might call a contingent, localized bureaucratic listing of names and places next to his lyric corpus.

As the lyric texts are unattributed, readers must provide this loose organizing principle. While the choice to record the fairs and songs is certainly related to Thibaut or Champagne, with these two lists together we find events, places, and lyric texts that form an association without a gesture toward signification that we might find in scholastic texts or even a songbook devoted to lyric texts that promotes artistic hierarchies and clear genres. The list of fair locations and times near a list of his songs are two kinds of "lists": the first is a documentation that ostensibly records a calendar of places, events, and people in Champagne, the feudal domain of Thibaut; the other is a list that records the artistic works of a poet, a series of songs, a lyric corpus as Thibaut. Through adjacency—again a nearness in which one list does not define the other but remains provisionally related to the other in some way—these lists come together as overlapping existences of Thibaut in the "real" (extratextual) world and the commemorative world of the compendium. Through this mode of adjacency, people, places, and texts come together to produce a poet's identity that can be adapted in real time according to a reader's engagement with these particular kinds of lists and contingent contiguities.

As far as I know, this is the only compendium that lists fairs of Champagne adjacent to a lyric corpus. The fairs occur next to Thi-

FIGURE 5. Songs of Thibaut de Champagne following *foires*, or fairs (thirteenth century). BN fr. 12581, fol. 312v. Photograph: Bibliothèque nationale de France.

baut's lyric texts, literally sharing a manuscript folio, but I would argue they are not "compiled" with his lyric corpus for the reasons I have described. One might say the fairs are "collated" with his lyric, but that also implies an ordering principle that goes beyond collecting things about Thibaut and Champagne. In contrast, these two lists concerning the trouvère come from separate discursive domains and are next to each other but do not form a relation with a meaning beyond the shared nominal identity of a poet who is associated with lyric works and Champagne. That is to say, I take seriously and literally the fact that the list of fairs *is a list that lies near a lyric corpus*, as will become clear in my handling of the inquest in relation to the compendium. To understand adjacency here and the mode in which it produces his crusader identity, one must look to Thibaut's other documentation as lord and how adjacency operates there. Two things to note: first, the lyric corpus of Thibaut in the manuscript includes his crusade departure song "Dame, ensi est q'il m'en couvient aler," which I discussed in chapter 1.[18] Second, Emmanuèle Baumgartner limited her comments to observing that the compilation of the fairs and Thibaut's corpus in BN fr. 12581 shows that his poetry was esteemed as much as Champagne's prestige as a rich trade area.[19] But can more be said? Can we expand upon this mode of adjacency as poetic description?

Through the mode of adjacency, we can describe an appearance of the idiom within the manuscript corpus of Thibaut and the trouvère lyric corpus. But within this philological context we might attempt something else: a recognition of speaking crusades in a discrete instance of manuscripts seen adjacently, an instance that attests to Thibaut's "subject" as crusader in two professional modes as a poet and as a feudal lord.[20] Thibaut's interest in compiling his own songs is attested in the *Grandes Chroniques*, where it is stated that he composed the loveliest songs and "les fist escrire en sa sale à Provins et en celle de Troyes, et son appellées *Les Chançons au Roy de Navarre*" (he had them written down in his hall in Provins and in the one in Troyes, and they are called *The Songs by the King of Navarre*).[21] The fact that they appear in almost exactly the same order in nearly

every manuscript suggests that an early authoritative compilation was made, if not a personal songbook (the aforementioned *libellum*) compiled by Thibaut himself. Sylvia Huot observes that in addition to his high social standing, Thibaut's descent from the first troubadour Guilhem IX might have encouraged him to preserve his songs as a compilation in imitation of his illustrious ancestor.[22]

Much important scholarship since the late twentieth century has recognized how the particular transmission of trouvère versus troubadour lyric anthologies has shaped the corpuses of these texts. For instance, Luca Barbieri makes a convincing case that the preference for a more monothematic canon in the manuscript tradition of the trouvères, focusing on love songs, the social hierarchy of poets, and distinct genres, explains the proliferation of *chansons de départie* where crusading is adapted to the theme of love. More diverse assemblages of lyric texts similar to Occitan chansonniers are exceptional in the trouvère corpus, and Thibaut's so-called songbook is included as one of these outlier collections that contain more varied genres extraneous to courtly love song (*grand chant courtois*).[23] If we follow Barbieri's thesis that Thibaut's songbook is more of a "work in progress" among the chansonniers, in which texts were added in a step-wise fashion and modified according to different internal ordinations, then this view contributes to the modality of adjacency in a compendium such as BN fr. 12581.[24] In addition to the location of his songs next to the fairs of Champagne in this manuscript, his songs and a few other lyric pieces elsewhere by other poets also appear transcribed in the fourteenth century without music or attribution. They appear on the empty leaves whenever there was space at the end of a gathering after the completion of a text.[25] According to Huot, this appearance suggests the ongoing popularity of his songs and their circulation independent of the chansonniers. In sum, the particular manuscript tradition of Thibaut and the transmission of his songs attested in the compendium after his death in 1253 increases possibilities for describing Thibaut as a subject of crusade through adjacency. The status of his song collection enabled a modality of gathering within compendia such as BN fr. 12581 and permits us to

see other possibilities of adjacency when placed near other collections associated with him.

The adjacency of fairs and lyric in the chansonnier is not surprising when we consider both the economic importance of the fairs in Champagne and Thibaut's self-documentation. Under Thibaut's tenure, Champagne emerged as a vital trade region at the crossroads of Flanders, England, and France. The fairs were an important economic resource for Thibaut. Merchants exchanged raw materials such as linens, and, according to custom, they had to obtain licenses through the lord. Lists such as the one in the manuscript usually occur in municipal records and indicate the time and place of various fairs. Further, Thibaut controlled and shaped his idiom through various material witnesses. In addition to his initiative to compile his own songs reported in the *Grandes Chroniques*, the passage gives anecdotal evidence that he probably oversaw scriptoria in which his songs were preserved in manuscript form.[26]

Thibaut was apparently concerned with the preservation of his lyrics in written form—whether in manuscripts or in his halls—and this awareness of self-documentation as a lord also extends to how he collected and preserved information about inhabitants who held property in his region. He commissioned a register of all fief holders and their holdings in his region, considered to be "the most complete and systematic collection of data on an entire medieval aristocracy."[27] This inquest of 1249–52 was drawn up by two "enquêteurs," or commissioners: a knight and a canon. Impressively thorough, the inquest contains "registers for twenty-three (62 percent) of the thirty-seven castellanies."[28] While most of the holders' testimonies are recorded in the third person in Latin, absentees were represented by the testimonies of wives or close acquaintances in the vernacular and the first person. The reports could also be emended. Changes that occurred during the inquest were added at the end of the register for each castellany (fig. 6).

In its material aspect that allowed for real-time in situ emendations as the commissioners went out and collected testimonies, the *Rôles* offers a model for adjacency that correlates with the adjacency

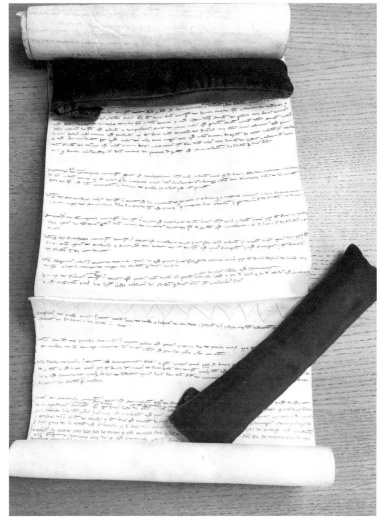

FIGURE 6. Roll of fiefs for Pont-sur-Seine (1249). J196, nos. 47 and 50. Membranes sewn together. Archives Nationales, France. Photograph: Marisa Galvez.

of the fairs and lyric texts in our compendium. The inquest produced new classes of fief holders at the same time that it provided the documentation necessary for the "territorial expansion and administrative consolidation" of Thibaut's Champagne. Historians such as Theodore Evergates have analyzed how the inquest created distinct statuses of fief holders that had never existed before. In the twelfth century, a title meant membership in a distinct social, genealogical, and economic class. Through the inquest, there now emerged a class of "nonknighted" such as the "armigers," or squires (sons of knights who postponed knighthood, deemed too expensive a profession for those who could not afford the ceremonial dubbing and the upkeep of knighthood). Women became much more visible as fief holders, as their vernacular testimonies on behalf of themselves or in lieu of their husbands attest. Twenty-four percent of fief holders in the *Rôles* lacked a title: for example, people who remained untitled but had property, or those who delayed acquiring titles or acquired titles later on. Such social mobility through the shifting meaning of titles and nontitled people, new for this period, was made possible by more thorough inquests that documented new practices of landholding and status.

This change in social mobility through inquest extends my description of a compendium that transmits Champagne's fairs and poetic corpus by shifting the frame of reference. The adjacency of Thibaut's fairs and songs shows an association of places and names through which the idiom exists—a gathering that we should see as contingent despite its occurring in a parchment compendium usually interpreted as a more fixed archive than a cartulary roll that allows for in situ emendation. Adjacency reveals an idiom of crusade adapting to changing conditions that concern lists of fief holders and mercantile holdings, and a calendar of fairs. The idiom also shifts in appearance according to its medium: whether a large compendium with literary works or a cartulary roll meant to record fief holders as accurately as possible. From a larger perspective, seen next to the inquest, the compendium records how the identity of a crusader-lord is maintained in social and economic domains. Produced in the

final decade of Thibaut's life after he had returned from his failed crusade expeditions in the mid-thirteenth century or shortly after his death, the lyric texts, the list of fairs, and the inquest together produce his crusade identity as trouvère–crusader–Lord of Champagne. In short, adjacency shows how the translation of his poetic idiom to a compendium by means of the *Rôles* assembles a persona that is in flux: the lyric corpus shares nearness to the fairs but is not determined by them as it retains its cultural status as lyric. Thinking back to Baumgartner's cautious assessment, we can view the compendium as correlative with the inquest *in process*: BN fr. 12581 disrupts the genre of a chansonnier that organizes by author and lyric genre and thus demonstrates the active process of creating Thibaut as trouvère–crusader–Lord of Champagne through the archive.

RAIMBAUT DE VAQUEIRAS AND GENRE-EXISTENCE

Genre-existence: connections between texts made possible through the making of a new literary genre within and across manuscripts, this active description constitutes a mobile "troubadour-crusader-vassal"

"testimoni, cavalier e jocglar," a witness, a knight and a poet
 Epic Letter, chansonnier C, BN français 856, laisse III, line 118[29]

During the twelfth century, European noble and knightly families in northeastern France such as that of Thibaut of Champagne developed a tradition of crusading that would benefit the crusade movement in the thirteenth.[30] The troubadours of the same period who composed crusade lyric were for the most part not of this rank and were not expected to go on crusade. This might explain why many lyrics treat requests for patronage to fulfill a crusade vow, or contain praise of a crusading lord.[31] Raimbaut de Vaqueiras was active in the courts of southern France and northern Italy in the second half of the twelfth century and went on crusade with his friend and patron the Marquis Boniface I of Montferrat, a leader of the Fourth Crusade of 1202. When Raimbaut was not present at the Italian courts of Montferrat, Malaspina, Este, and Savoy, or in Thessalo-

nica, he participated in events such as the siege of Constantinople in 1204 with Boniface. Raimbaut is known for his celebrated multilingual descorts and for inventing new hybrid genres such as the *Epic Letter* (*EL*), a narrative poem in monorhymed decasyllabic laisses, and the "procession of ladies" known as the "Carros" song or "Truan, mala guerra."[32] The *EL* makes visible a crusader-poet in constant transformation through two temporalities: on the one hand, the material context and tradition of the chansonnier, and on the other hand, "Raimbaut" as a troubadour-vassal within the political network of people and places from northern Italy to Thessalonica and the Latin East named and interacting in his lyrics. Unlike other troubadours or trouvères of aristocratic status or active in southern France, as an Occitan troubadour Raimbaut was closer to the northern Italian courtly milieu that first created a written tradition of the troubadours through the chansonniers. The *EL* not only shows Raimbaut as conscious of his self-fashioning; it also becomes an active node that drives the movement of the constellation "troubadour-crusader-vassal" through its transmission in songbooks. Raimbaut as crusading subject emerges in the associative movement within various genres that treat the names and places of his life as a crusader. What I call the *genre-existence* of Raimbaut then operates in several temporalities—spaces such as archives, and real or poetic places. These places include the performance of lyric in northern Italian courts and the myriad places evoked in Raimbaut's *EL* as a professional troubadour-crusader-vassal under Boniface. After the conquest of Constantinople in 1204, Boniface was given the kingdom of Thessalonica together with the neighboring territories of Macedonia and Greece. Genre-existence offers a mode for viewing the constructive principles of this active and fluid process of reception and re-creation of the idiom to create Raimbaut as a troubadour-crusader-vassal.

Compared to Thibaut's compendium, the Occitan songbook that transmits the lyric of Raimbaut de Vaqueiras, BN français 856, offers a translation of the idiom within the framework of the chansonnier genre. Therefore, we must look to its principles of organization. BN

FIGURE 7. Chansonnier (fourteenth century). BN fr. 856, fol. 5v. Index. Photograph: Bibliothèque nationale de France.

fr. 856 contains exclusively troubadour poets, their works grouped by name. In its index, Raimbaut's crusade song "Ara pot hom conoisser" ("Now men may know"), a song that honors Boniface as a pious lord, occurs just before the *EL* (fig. 7). In the *EL* Raimbaut requests recognition and reward for loyal service rendered to the marquis as the letter testifies to events in both the Latin East and West. The letter has long been recognized as original in genre and style, com-

bining eyewitness testimony with personal anecdotes and heroic flourishes in the epic style of a work such as *La Chanson de Roland*.[33] Unlike the compendium featuring Thibaut that creates a contingent adjacency in the mode of the *Rôles*, Raimbaut's chansonnier creates a relation between poetry as service and an account of that service in the *EL* among a heterogeneous network of places and events that constitutes his milieu. Raimbaut is his own *enquêteur*, or commissioner, who recognizes the material and social opportunities of a traveling professional troubadour. Even as we can see that Raimbaut created this genre for the specific purpose of social elevation, genre-existence emerges through the songbook that orders his crusade song next to the *EL*, producing the troubadour-crusader-vassal. It is important to see that the chansonnier produces a new social status for Raimbaut—in the crusade lyric (his work) and then the account of his works throughout the years—according to a configuration entirely different from the inquest and the compendium of Thibaut. If through adjacency we apply a synchronicity to the compendium and inquest to describe the "subject" of Thibaut, a crusader adapting to his times and people in Champagne, in *EL* we have a different framework for describing the "subject" Raimbaut as one producing a record of his works.

As a new genre placed within the material context of the chansonnier and its ordering, the *EL* directs readers to see his record of events in relation to his crusade lyric, "Ara pot." In the *EL* to Boniface in BN fr. 856, Raimbaut details his service throughout the years in a new genre specially made for the task. The genre combines the historical truth of the chronicle, the heroic seriousness of a chanson de geste, and the personal affection of a courtly letter. He also thanks his lord for elevating him to knighthood and explicitly admits that he took the cross and made confession only for his lord's sake: "E quant anetz per crozar a Saysso, / ieu non avia en cor, Dieus m'o perdo, / que passes mar, mas per vostre resso / levey la crotz e pris confessio" (When you went to Soissons to take the cross, I had no mind, [may God forgive me] to cross the sea, but for the sake of

your glory I took the cross and made (literally, took) confession [*EL*, laisse II, lines 26–29]).[34] Rather than assuming the position of the repentant crusader, Raimbaut explicitly states that he confesses for the sake of his lord—in other words, his role as a crusader is professional. His statement is a pragmatic professional decision to confess; that is, a decision based on worldly cares rather than a pious confession. The profession is emphasized by the verb he uses as "take," *pris*, rather than "make," *far*—Raimbaut's version here closer to *dare*, the verb used normally by the clergy. This profession changes our framework for describing the poetics of the crusade lyric that precedes the *EL*.[35] It constitutes an earthly *affirmation* in line with the *EL*'s request for material recognition of his services. Rather than confessing an interior self for a spiritual quest, he affirms that he did something for someone. Further, he requests external signs of earthly rather than spiritual recognition.

While the *EL* adapts the courtly rhetoric of praise and devotion to include a detailed and heroic chronicle of Raimbaut's presence in major events, the crusade lyric that precedes it, "Ara pot," shows the troubadour's professional position as vassal through epideictic conventions that praise his crusading lord.[36] "Ara pot" mentions the word *honor* and its derivative six times in a single stanza, verbally heaping praise on Raimbaut's patron as much as exalting crusade in his description of his patron's sacrifice:

> Tant a d'onor e vol honratz estar
> q'el honra Dieu e pretz e mession
> e si mezeis, que s'eron mil baron
> ensems ab lui, de totz si sap honrar,
> q'el honra·ls sieus et honra gen estraigna
> . . .
> c'a tal honor a levada la crotz (lines 12–16, 18)

So great is his honour and his wish to be honoured that he honours God and worth and munificence and himself, and were there

a thousand barons in his company, he would know how to be hon-
oured by all, for he honours his own and he honours strangers. . . .
With such honour has he taken the cross.[37]

Comparing the *EL* and this lyric, I focus on the idiom—how one
speaks and professes crusades, as service, as piety, as glorified heroic
action in the assemblage of the chansonnier. "Ara pot" is more con-
ventional in its extravagant praise of the marquis as a crusader leader.
Through the chansonnier, the *EL* as a new genre next to this exhor-
tative lyric makes clear that the subject of crusade and the idiom
reside within spiritual and feudal devotion and one's status as vas-
sal. In other words, service to God and Boniface is linked in the
chansonnier to create a professional crusade idiom—Raimbaut
as troubadour ("Ara pot"), crusader, and recorder of his feats as a
troubadour-vassal (*EL*). We see the poetic work he does, his ac-
counting or inquest of it in the *EL*, and finally the public's recog-
nition of this through the songbook. The mode of genre-existence
allows us to see the subject and its idiom in movement, in the lyric
context and the chansonnier. Put otherwise, the genre-existence of
Raimbaut is possible through his historical and performative con-
text: as an active troubadour and vassal in courts and through his
reception in the songbook that has developed and regenerated that
milieu in a different medium. These two temporalities of diachrony
and synchrony produce the "crusader-poet"—Raimbaut consciously
producing his inquest, his *EL* compiled with his crusade lyrics—to
show Raimbaut as a specific kind of crusader-poet.

The ending of the *EL* makes clear the collapsing of different
temporalities of lyric composition, account of deeds, and finally the
archive of lyric and *EL* as crusader subject. Raimbaut ends his letter
in BN fr. 856 by stressing that he is an official witness of the great
deeds of his lord as well as a knight and a poet:

> E pus, senher, sai tan de vostr' afar
> per tres dels autres me devetz de be far,
> et es razos, qu'en mi mi podetz trobar

testimoni, cavalier e jocglar,
senher marques.
(laisse III, lines 115–19)

And since, my lord, I know so much of your affairs, you must reward
me as for three of the others, and this is just, for in me you may find
a witness, a knight and a poet, my Lord Marquis.[38]

Raimbaut defines his profession as "testimoni, cavalier e jocglar,"
someone who in his service acts as juridical witness but also docu-
ments for posterity the noble deeds of the marquis.[39] Moreover, the
word *jocglar* defines his status as both a poet and a courtly enter-
tainer or craftsman of words. While I agree with the editor Joseph
Linskill that Raimbaut's use of this word for his status "shows that
the distinction between the troubadour and *jongleur* was disappear-
ing at this time," it is also possible that Raimbaut deliberately uses
this word to create a flexible category of "subject" as troubadour
(performer/poet)-crusader-vassal which he defines through his lyric
and *EL*. He wants to be recognized for his feudal and chivalric status
earned through noble deeds in the service of his lord. At the same
time he demands to be rewarded three times more than others—
placing a metric on his worth in his self-defined role as troubadour
and professional player. From composition to chansonnier, archival
frameworks produce social mobility and the crusader subject as it
emerges in various modes of "testimony," and according to tempo-
ralities of notation and reception.[40]

Chansonnier BN fr. 856 produces a network of people and places
through the idiom of Raimbaut that is at once lyrical ("Ara pot")
and historically specific (*EL*). To further see how genre-existence
works within a constellation of names and people, we must con-
sider other manuscripts that transmit Raimbaut's lyric texts. As
another invented genre, "Truan, mala guerra" ("A cruel, base war")
also describes people and places in relation to Raimbaut's status as
a troubadour-vassal in northern Italy during the late twelfth cen-
tury.[41] With "Truan, mala" Raimbaut invented a new genre that

names women preparing for warfare in order to record the political tensions of the region. As a mock epic and collective panegyric that depicts an armed conflict between aristocratic ladies, "Truan, mala" uses ladies' names as metonymies for Italian city-states and courts. We have already seen how Raimbaut's social class determines his intention to go on crusade as a professional act recorded in the *EL*. While the *Rôles* and the fairs in the compendium represent Thibaut's control over his crusader-lord persona through documentation of fief holders and places under his domain, "Truan mala" represents the autonomy of actors and places within the courtly network of Raimbaut's social sphere. As that of a troubadour-vassal, Raimbaut's lyric gives us the perspective of someone who is an independent observer of the political realities of his courtly environment:

> Truan, mala guerra
> sai volon compensar
> domnas d'esta terra
> e *villas* contrafar:
> en plan o en serra
> volon *ciutat* levar
> ab tors,
> quar tan pueja l'onors
> de leis que sotzterra
> lur pretz e·l sieu ten car,
> qu'es flors
> de totas las melhors;
> na Biatriz, quar tan lur es sobreira
> qu'encontra leis faran totas seinheira
> e guerr'e fuec e fum e polvereira.
> (lines 1–15, my emphasis)

The ladies of this land wish to begin here a base, cruel war and imitate the *peasants* [or *communes?*]. In the plain or on the hill they

plan to raise a *city* with towers, so exalted is the honour of her who casts their worth into oblivion and prizes highly her own, being the flower of all the best: Lady Beatrice; for she surpasses them that they will all raise their standards and wage war against her, with fire and smoke and dust.[42]

In "Truan, mala," Raimbaut praises his lady Beatrice, the daughter of his patron Boniface, and holds her up as a model to mock the city-states of the region about their erection of a citadel and fortified city. Much depends on whether one interprets "villas" as peasants or city-states related to "ciutat." If the latter, it would give the poem a much more political viewpoint in its critique of independent city-states; the ambiguity of this word shows how lyric was a means to create and shape civic or feudal entities by obscuring the distinction between names for civic states and feudal classes (*villas* as peasants). As a troubadour, he creates a genre that enables mobile associations in order to show how the political entities of his domain as a troubadour were contested among various people and places. Through a new genre, he not only registers the autonomy of the cities of the region and how they are in tension with courts such as Boniface's but also records economic transactions between the political entities of the region. Among the many other ladies and daughters associated with lords of the Montferrat region, he mentions the mother and daughter of the Marquis of Incisa, who were known to have been given as donations to the commune of Asti from Montaldo and other districts:[43]

> Domnas de Versilha
> volon venir en l'ost
> Sebeli e Guilha
> e na Riqueta tost
> la mair' e la filha
> d'Amsiza, can que cost.
> (lines 31–36)

Ladies from Versilia hasten to enter the army, Isobel and Willa and
Lady Henrietta, so too the mother and daughter from Incisa, cost
what it may.[44]

Compared with Thibaut's use of "terra" in his declaration of the in-
quest, the "terra" of "Truan, mala guerra" is negotiated among au-
tonomous cities and their political representatives—various ladies'
names rather than fief holders under the lordship of Thibaut. If we
view the inquest and the documentation around Thibaut as a new
genre of activity that emerges through adjacency to make his iden-
tity as trouvère-crusader-lord, it is useful to consider Raimbaut as
an inventor of genres that produce a specific kind of social mobility
for himself and those in his courtly milieu. Even though names re-
lated to fiefs are also in flux in the inquest, adjacency creates new
associations of names and holdings (new names emerging as prop-
erty owners and a new class of landholders such as women and
the unknighted), and these names still come into being and exist
as documentation concerning Thibaut's feudal domain of Cham-
pagne. In contrast, here Raimbaut reproduces the political nego-
tiation of social mobility and transactions by inventing a new genre
appropriate for his milieu, and his *EL* in turn witnesses his mobile
status as a troubadour-crusader-vassal within this productive mode
of invention. Names exist under the *EL*, but the genre shows how
those names and places are in political flux independent of Raim-
baut, who as troubadour-vassal records them in a poetic situation
different from the inquest. In short, just as Raimbaut's *EL* and
"Ara pot" document his self-elevation and profession respectively
as troubadour-crusader-vassal, the mock epic depicts independent
warring political entities within his courtly network. The names and
places exist under Raimbaut, yet the genre permits us to see their
independent status in flux, whereas in the inquest the names re-
main categorically under Thibaut as social and economic entities.
And as Thibaut's idiom shows the mobile status of people and places
under his name that constitute his identity as trouvère-crusader-
lord, so "Truan, mala" shows Raimbaut's status, milieu, and capacity

for self-fashioning in the *EL*. By extension, the songbook tradition takes Raimbaut's name in relation to these names, places, and genres into account. Finally, the *Rôles* make women visible in their status as fief holders. Likewise, "Truan, mala guerra" makes women political players within a poetic world that discloses people and places in transactional relations. Thus, adjacency and genre-existence illuminate social and economic configurations through the "crusader-poet" and the documents and genres produced through that subject.

Genre-Existence and the Transmission of *EL*

Languedoc-Provençal and Catalan manuscripts that transmit the *Epic Letter* can be summarized via the abbreviation CEJRSgcv, with the following meaning:

> *C: BN fr. 856, 14th c.*
> *E: BN fr. 1749, 14th c.*
> *J: Florence, Biblioteca Nazionale, Conv. Supp F, 4, 776, 14th c.*
> *R: BN fr. 22543, 14th c.*
> *Sg: Barcelona, Biblioteca de Catalunya 146, 14th c.*
> *cv: Catania, Biblioteca Ventimiliana 92 (Catalan), 15th c.*

Descriptive Summary of Appearance of *EL* in the Manuscripts

In CE and J, the *EL* is in *liminal* positions either at the beginning or end of Raimbaut's corpus; C has crusade song "Ara pot hom conoisser" directly preceding ending position of *EL*; CJ form a consistent group of a complete text of the *EL*. In Sg, canso-sirventes "No m'agrad' iverns ni pascors" directly precedes *EL*. In Sg, *EL* is at *center* of two homogeneous groups of cansos/mixed genres, all by Raimbaut, and serves as biographical principle to a minisongbook.[45]

Through its relation to Raimbaut's lyric texts, the *EL* invites later compilers to form different versions of a troubadour-crusader-vassal. Like BN fr. 856 (chansonnier C), the fourteenth-century

Languedoc-Provençal Biblioteca de Catalunya 146 (chansonnier Sg) places a crusade song, the *canso-sirventes* "No m'agrad' iverns ni pascors" ("Neither winter nor spring delights me"), before the *EL*. In this last extant song of Raimbaut, probably composed in Thessalonica, he yearns for the days in Montferrat. He reflects on the precarious situation of the crusaders in the Latin East after the Adrianople disaster of 1205, which resulted in the capture of Emperor Baldwin, who had been elected after the conquest of Constantinople in 1204. Raimbaut ends the poem on a hopeful note, noting the military triumphs of the Latin conquerors and expressing a firm conviction that the crusade will be ultimately fulfilled.

Both Federico Saviotti and Simone Ventura have observed how Sg makes *EL* the ordinating principle at the center of the troubadour's corpus, in contrast to the chansonniers CEJ that place *EL* in a liminal position of the corpus. This liminal position could be due to its character as a nonlyric text, as well as its bellicose content.[46] According to Ventura, the *EL* is at center of two groups of cansos with mixed genres and serves as a biographical principle for a minisongbook in this chansonnier.[47] Sg gives further attention to *EL* in that it is the only text in verse format apart from a fragment of the *Roman de Troie* (c. 1165) by Benoît de Sainte-Maure.[48] The text appears in a verse format of two columns rather than a single column of prose.[49] This variant on the placement of *EL* and a crusade song tells us a number of things about *EL* as a textual node for producing the subject of the idiom. First, the popular "No m'agrad' iverns" transmitted in numerous chansonniers attests to Raimbaut's material reward for his services detailed in the *EL* even though the troubadour makes the gifts from his lord appear as rewards for his knightly prowess. Second, in contrast to "Ara pot," as a *canso-sirventes* "No m'agrad" begins as a typical canso in which Raimbaut laments an unrequited love, but despite being forlorn on the battlefield, he reluctantly turns to the pursuit of valor and glory in stanza 5. After praising the triumphs of the marquis and his companions and chastising deserters ("perjurs fraiditz pellegris"; line 89), he ends with the hope that Latins and Greeks will conquer Damascus and

liberate Syria, and that Jerusalem will be conquered. Composed a few months after the *EL* and the last of his datable compositions, the song occurs before the *EL* in Sg but does not necessarily mean a chronological orientation. Its proximity to the *EL* illuminates how genres shape the transactional quality of the relationship between Raimbaut and the marquis, and the manner in which the *canso-sirventes* with the *EL* can shape his narrative as a crusader-poet: the rewards he received for his service in the *EL* reinforce his chivalrous acts in "No m'agrad," increasing his authority to criticize those who deserted the crusade cause. In Sg, the *EL* allows for multiple ways to create the crusader subject in relation to lyric texts. Finally, the militant exhortations to continue crusade at the end of "No m'agrad" come during a difficult period for the Latin Empire with new attacks on Thessalonica and the marquis from the Wallacians and Drogobites. This rallying call to fight and the promise of new victories complement the potential of *EL* to serve as propaganda through witnessing the feats of both the marquis and Raimbaut.

As a node for constructing multiple versions of Raimbaut as a crusader subject, *EL* makes him an important figure in the Catalan literary tradition. It is striking that the *EL* is transmitted exclusively in the so-called Languedoc-Provençal-Catalan (and not Venetan) tradition of chansonniers. How can one explain this bias? There is strong evidence of perhaps a late thirteenth-century Catalan songbook tradition of Raimbaut's corpus that incorporated the *EL*.[50] In contrast to the Venetan songbook tradition bias for a more traditional and homogenous selection of courtly lyric, the Languedoc-Provençal-Catalan tradition favors the mixed genres of Raimbaut seen in works such as the *EL*, the *Carros*, and plurilingual descort.[51]

Perhaps we can also speculate on the relation between its transmission and importance in fourteenth-century Catalonia, the time of Sg's compilation. Saviotti's study complements Ventura's description of Sg in that he shows how the circulation and afterlife of Raimbaut as a subject depends on a configuration of his lyric texts, *vida* (biography) and *EL* in Sg. These configurations testify to his

diverse output under the marquis and the awareness of his poetic experimentation in the Provençal-Catalonia ambit where a corpus of his texts circulated. Saviotti remarks that this Western tradition of Raimbaut's corpus shows a strong Catalan afterlife in the early fourteenth century, judging from the prominence of the *EL* in Sg and the Catalan chansonnier Barcelona Biblioteca de Catalunya 7 and 8 (chansonnier VeAg) that places three works of Raimbaut in a florilegium of French, Catalan, and Occitan texts.[52] The importance of the *EL* in the Catalan tradition is reinforced by the Catalan songbook cv, as this chansonnier contains the *Sermò* of Ramón Muntaner (chapter 272 of his *Crónica*) that resembles the *EL* in form and content as a polymorphic epic that gives advice to a future sovereign, combining lyrical effusion and military accounts.[53] Indeed, the presence of the *EL* in cv attests to the intense circulation of literary texts among southern France and Catalonia in the fourteenth and fifteenth centuries and the importance granted to Raimbaut represented in Sg.[54]

Further, we can consider two other issues related to the global importance and political significance of the *EL* in its transmission between northern Italy and Catalonia: first, that scholars speculate that the fragment of the *Roman de Troie* in Sg (associated with the *EL* in its same format) was perhaps a deliberate decision reflecting contemporary political events related to Count Pere II (r. 1347–1408) of the Catalan comital house of Urgell who were known to be patrons of troubadours, Pere considered the patron of the manuscript; second, that the transmission of Raimbaut's works in the second half of the twelfth century from Italian Occitan courts to Catalan royal courts via the Tolosan Consistory was shaped by the upheaval of the Albigensian Crusade.[55] Taking these matters into account, we can regard the *EL* as a testimony of a troubadour whose mobile biography mirrors the multidirectional itinerary of his works shaped by external and internal crusades, by local political events, and by a transmission among various courts spanning the Latin East, Northern Italy, and the courtly ambit of Languedoc-Provençal-Catalan courts.[56]

Might the strong Catalan reception of Raimbaut have to do with the various constellations formed from the *EL* and his lyric corpus, a genre-existence that gained momentum through the manuscript tradition and after the Albigensian Crusade that influenced the transmission of the Occitan tradition in the Occitan-Catalan cultural and linguistic space?[57] At the very least, perhaps the *EL* gives compilers and editors of Catalan songbooks with varied material and of texts by Muntaner a biographical framework in which to order his work and to produce iterations of the troubadour-crusader-vassal in a more elaborate manner than the conventional *vida* and lyric texts in most Italian chansonniers. In his detailed study of Sg, Ventura argues that texts of dubious attribution are reaffirmed or reconstituted through this biographical framework. Moreover, places and locations in dubious texts are attributed to Raimbaut by way of texts such as the *EL* that provide such details. Texts of doubtful attribution in the Sg Raimbaut corpus, Ventura writes, are primarily identifiable as those of "Raimbaut" through the places and people of a specific milieu identified in texts such as the *EL* and "Truan, mala" (also transmitted in Sg), the court of Montferrat during the twelfth and thirteenth centuries.[58] The Malaspina anthology by Gilda Caïta-Russo that includes Raimbaut and other troubadours is another example of this awareness of the distinctive network of people and places of the northern Italian troubadour courts.

Thus a kind of centripetal accretion occurs through the genre-existence of Raimbaut: while he defines his lyric works and his status as vassal and troubadour under the marquis in the *EL*, compilers use the *EL* in relation to his lyric texts to create their own versions of him as a moral voice of crusade as a professional crusader, or both. Perhaps this flexible genre-existence of Raimbaut was particularly important when his work was transmitted in the Catalan political environment after the Albigensian Crusade and royal houses were using French and Occitan texts in deliberate ways to affirm their power (as in the Sg's *Roman de Troie*), and troubadour texts were transmitted in a fragmentary way different from the long-standing written tradition of the Italian chansonniers, as Ventura suggests.[59]

Finally, compilers from the thirteenth century onward use Raimbaut's genres to reconstruct a court: the *EL* provides a historical narrative of events, and lyrical texts such as "Truan, mala" give real places and people a poetic framework that demonstrates dynamic political and economic relations among the courts of northern Italy. In sum, through adjacency and genre-existence, I reconstruct crusader-poets not as fixed but mobile existences through specific configurations of witnesses. Like the Chinese sword of Jean d'Alluye or the diphthong of Caïn, the nearness of the fairs and the lyric texts of Thibaut in a compendium and the inquest invite us to assemble Thibaut as a "trouvère-crusader–Lord of Champagne" with all those hyphenated elements in flux. Adjacency makes visible shifting frames of people and places through the material archive and through the phenomenological situation of a list. The inquest roll emended in real time and the fairs near lyric texts are two kinds of lists that inform but are not determined by each other—they maintain their specific qualities and in their nearness constitute a particular speaking of the idiom. Like the strangeness of the Chinese sword that suggests multiple scenarios for Jean d'Alluye as a crusader, Raimbaut's invention of new genres seen through the chansonniers enables a mobility of people and places, including himself. To go farther, genre-existence perhaps served as impetus for Raimbaut to spur the Catalan literary tradition.

RECONFIGURATIONS OF THE CRUSADER-POET
IN THE LATIN EAST

Performative Reconfigurations:
Jehan de Journi of Cyprus and Contrafactum

Contrafactum: In musical terminology, when a melody or composition is reused, the result is a contrafactum.

Or prïons dont Dieu finement
Qu'il maint au roi delivrement

Si com il set qu'il est mestiers,
Secours de gens et de deniers

Now let us pray sincerely that God
send quickly to the king
as he knows it is necessary,
the aid of people and money

JEHAN DE JOURNI, *Disme de Penitanche*,
lines 3195–98[60]

My final example of descriptive poetics emphasizes that medieval texts were adapted for their new contexts according to their media of transmission: words within a performative context such as liturgy were adapted in a confessional manuscript composed in Cyprus. Away from home, crusaders remember and recast songs and prayers through techniques of adaptation that leave traces in written texts, and these discursive practices are in turn shaped by a local culture in a constant state of change. In 1288 the elderly Frankish Cypriot Jehan de Journi, during a period of illness in Nicosia, composed the *Disme de Penitanche* as an act of penance.[61] Jehan hopes to give his last confessional "tithe" and return to France. At the end of his treatise, in response to the dire situation of Cyprus at the end of the thirteenth century, he adapts liturgical prayers from his home in northeastern France, vernacular Prône prayers from the parish *Rituale*. Invariably in the vernacular (the transition from the Latin ritual heralded by "Oremus" or "Deprecemur"), the celebrant typically read aloud petitions for the state of the church and the faithful, and this communal prayer took place during the Offertory service of Sunday Mass.[62]

As the only versified adaptation of the Prône, Jehan's contrafacture of these prayers produces yet another version of the poet-crusader. Here I deliberately expand upon the term *contrafacture* beyond its usual definition as a reuse of a composition or a melody. I see Jehan's performative adaptation of the Prône prayer—as Keith Sinclair has argued, identifiable by its rhetorical repetition of "Let us

pray," or "Prïons," and pattern of intentions—as an adaptation of a communal practice of vernacular prayer for the laity that was sometime spoken, murmured, or sung.[63] While the structure of prayers might vary, in France the list of intentions in the Prône remains consistent during the Middle Ages, and often included a Pater and Ave recited in common or the appropriate Psalms and orations for the living and the dead.[64] In the German tradition, the structure and form of the Prône are more varied, and there would be a command to raise a cry after the prayers, perhaps referring to songs in the vernacular that had developed out of the Kyrie-eleison.[65] As Katherine Lualdi has argued, the Prône's content and oral mode of delivery between priest and the laity made it an explicitly communal rite, and in the later Middle Ages it became an important mode of catechesis and for defining orthodox beliefs.[66] The priests exhorted the laity to affirm their faith in concerns here and abroad, and it served as a forum for transmitting the basic tenets of the Roman Catholic Church during the Sunday Mass while also reaffirming the social hierarchy in which they were bound.[67] As extant versions in French from the thirteenth century attest, they might include prayers for religious and secular leaders of the immediate community, and for the state of the church in the local area as well as the Holy Land. Thus Jehan's adaptation of the Prône in his confessional text is significant as a case of a crusader-poet idiom in the mode of unwritten contrafacture: not only would his prayers have registered for his community in both Cyprus and France, but as the only versified recension of the vernacular Prône prayers, the *Disme de Penitanche* demonstrates a case of unwritten liturgical and devotional practices alongside written political or contingent content.

Through an adaptation of liturgical prayer at the end of his confessional text, Jehan invokes an aspiration to be closer to God, but he also includes a political and personal perspective of Outremer. This gesture is consistent with the Prône as a communal prayer that constitutes his own idiom. While scholars such as J. B. Molin and Sinclair have found versions of this prayer in missals and discussed in a limited manner the performance of these prayers during the Mass,

emphasizing their content and transmission, I stress that we should think about Jehan's contrafacture as more than the adaptation of structure and content of the prayer. He adapts liturgical practice in a manner that combines the personal and the political in a new mode specific to an Outremer situation.

The *Disme* belongs to the thirteenth-century genre of moral literature concerning religious instruction, works designed to help the laity prepare themselves for confession. We can situate this work among the proliferation of vernacular texts connected to the Reformist movement of the Fourth Lateran Council in 1215. A poem of 3,296 verses, the *Disme* is transmitted in a single manuscript, British Library MS Add. 10015. A knight of considerable education, Jehan de Journi belonged to a well-known crusading family whose alliances are detailed in the *Lignages d'Outremer*.[68] Present in the eastern Mediterranean as the crusades drew to their close, he notably mentions at the end of his poem events and people connected to the Latin East at the end of the 1280s. As for the subject of his poem, the penitential "tithe" that Jehan wishes to pay for God, he borrows partially from traditional sources such as the *Summae* of Raymond of Peñafort and Thomas of Cobham, and, adopting scholastic methodology, engages in the technical details of confession, contrition, and penance as they were being debated among theologians. He presents taxonomies such as the seven deadly sins, and cites proverbs from among university textbooks of the day, attesting to the availability of either primary sources or, more likely, secondary compendia in Cyprus. His use of these sources indicates the transmission and diffusion of high religious culture among the Frankish laity.

In the *Disme* we can think about contrafacture and the crusader-poet as another example of performative reconfiguration and reverberation: the activity of translation involves various temporalities through sound (recitation, murmuring, or singing in response to the priest) and ritualistic performance. Not only is prayer adapted within a confessional text to give a different configuration of places and people in relation to Jehan de Journi (from a Mass in France to a Frankish confessional text in Cyprus), but his reconfiguration rever-

berates—in the sense of ritual practices of the Mass going beyond the manuscript and its present space and time toward future audiences and places. Jehan's adaptation of parish prayers, supplications for local lords to save the Holy Land during the time of his composition of the *Disme*, connects the people and places of Cyprus with his homeland in Artois as in fact he bids for a return after paying the confessional tithe that is the work. Here are his adapted verses of the parish *Rituale*, petitions from Cyprus through the medium of a prayer from home.

> Aprés requerons humlement
> A Dieu qu'il maint acroissement
> De gens, d'ounour et de tous biens
> Celestïens et terrïens
> A monsegneur le roi Henri
> Que Sarrasin ont amenri
> De toute la gregneur partie
> Qui affiert a sa segnourie,
> [. . .]
> Car Jerusalem ont comquise
> Et trestoute la tere prinse
> Qui a son roiaume apartient,
> Fors Acre qui encor se tient,
> Saiete et Castiau Pelerin,
> Sur et Barur dont enterin
> Ne sont li mur que par frankise;
> En ches[t] conté est Cayfas mise.
> [. . .]
> Dont est il bien cose certaine
> Que grant despens et moult grant paine
> Couvient a ces cités deffendre;
> Pour che couvient au roi despendre—
> Et il le fait mout volentiers—
> Quamqu'amasser puet de deniers
> En Chipre dont est rois et sire,

Et a paines puet che souffire.
Or prïons dont Dieu finement
Qu'il maint au roi delivrement
Si com il set qu'il est mestiers,
Secours de gens et de deniers,
Par cui Jherusalem soit mise
Ens ou pöoir de sainte Eglise.
(lines 3163–3200)

Next we request humbly that God support the increase of people, honor, and of all goods heavenly and earthly for our lord king Henry [II of Lusignan], as the Saracens have robbed [him] of all the greater part that is proper to his domain/authority, [. . .] Because Jerusalem has been conquered and every princely land that belongs to his kingdom, except Acre which he still holds, Saiete [Sidon] and Castiau Pelerin [Athlit, between Haifa and Caesarea], Sur [Tyre] and Barur [Beirut] whose walls are only standing as a result of noble actions and in this country Cayfa [Haifa] is situated. [. . .] thus it is certain that great cost and with great pain it is necessary to defend these cities. And that is why it is necessary for the king to spend and he does this willingly, as much as he can, he collects deniers in Cyprus of which he is king and lord, hardly can that suffice. Now let us pray sincerely that God send quickly to the king as he knows it is necessary, the aid of people and money; through which Jerusalem would be placed within the power of the holy Church.[69]

The use of "let us pray," a formula from *Rituale*, indicates petitions that are adapted to the situation of Cyprus—the urgent request that secular lords defend these cities ("cités") in danger. The request for help aligns with the explicit request for material support: "Après requerons" and "or prïons" indicating a list of petitions and the urgency of the requests for Henry II. Jehan's prayer becomes a critique of inaction.[70] The naming of the cities that are falling as he speaks evokes a situation starkly different from the cities of Montferrat or the domain and fiefs of Champagne. Contrafacture

of prayer makes us aware of the Holy Land as a politically unstable place rather than an abstract entity; contemporary liturgical petitions in France address the Holy Land as a distant land that can still be saved, as when "we pray for the Holy Land of Outremer that is in [or in earlier versions, about to be] in the hands of the Saracens."[71] Jehan is a vassal to the lords he addresses, but like Raimbaut, he is confident in his position and thus his plea is also an urgent reminder, which might be seen as criticism of their incapacity to act.

Further, Jehan purposefully invokes and adapts the liturgical ritual of the priest inviting the faithful to pray with him, usually during the Offertory, or after the aspersion and during the procession in the nave. By replacing the priest who invites the faithful to offer supplications for the state of the church, secular rulers, and the Holy Land, Jehan creates his own community of faithful through his confessional text, one that depends on his experience of Outremer as a Frankish Cypriot, that exists in both France and Outremer and creates a movement between those two poles as his text embodies a bid for a return to France. That is to say, the contrafacture activates an association of places, Cyprus and France, specific to the Latin East and the situation of crusades at two points in time—the present and the future. Here the transmission and adaptive re-creation of prayer across time and space and in different genres are essential to the production of the crusader-poet.

As a mode of descriptive poetics, this version of contrafacture permits a movement of Jehan's idiom through modalities of prayer (including time and space) and manuscripts, including the transmission of Jehan's text in a single manuscript, and the French witnesses of Prône prayers that help us reconstruct the ritual of the Prône during his time.[72] It is also useful in this sense for observing configurations of time, place, and people different from what we have seen with the crusader-poets such as Thibaut and Raimbaut. The adaptation of the Prône harnesses the performative energies of a moment in the Mass when the community of the faithful affirmed their faith within the context of the people they knew and places that were meaningful: for instance, a French missal from the fourteenth cen-

tury includes thirteenth-century prayers for the king and queen of France and their family, to the local merchants, to the deliverance of Constantinople.[73] We can compare this version of contrafacture to other versions that reconfigure performance and the topic of crusade in another way, as in the translation of the first troubadour Guilhem IX's penitential song to the religious play the *Jeu de St. Agnes*. In that play, the form and melody of Guilhem IX's song, "Pos de chantar m'es pres talenz," which may refer to crusade, were taken over for a hymn of praise sung in the play by converts. Created through songbooks, the troubadour's persona (like Thibaut and Raimbaut) is in turn translated and reassembled as a penitent song and persona for a different audience and textual situation. The *contrafacta* of liturgical practice and a crusade song rely on a structure of names and places determined by their genres, transmission, and performative situation. These aspects are in turn reconfigured into penitential works of different genres that take into account orality and performance otherwise—for example, a troubadour song taken over by a religious play depends on songbook transmission of the troubadours, while the adaptation of the Prône does not necessarily rely on written transmission but rather the ritual practice of liturgy. In Jehan's version of the Prône, the exhortation of a priest to a responsive congregation is taken over as a personal performance of confession addressed to the Frankish elite located in Outremer and France. Both the ritual of the Prône and its contingent content are significant here.

Jehan's lyrical reconfiguration of the Prône makes possible a spiritual and geographic mobility. His confessional tithe cleanses him for the return home, and the prayers at the end call forth his return. This mobility is realized precisely because of the unified cultural milieu of the elite Frankish aristocracy living in the Latin East and the northeastern region of France, the same area associated with Thibaut de Champagne and the Châtelain de Couci.

The Conditions of an Outremer Crusader Subject:
The New Status of *Historia*

Por ce que je voy treschanger
Mout de choses de blanc en ner
A se tens d'ores ou je sus
Selonc les biens que je ais veü,

Je suy par .i. talant tremis
D'escrire a rime aucuns dis
Sur ce siecle et sur la saison
Qui fait son cors par mesprizon.

Because I witness many things changing
From light to darkness
In my own time,
Before my very eyes,

I am overcome by the need
To put down my thoughts in rhyme [verse]—
Thoughts on the age and the season
In which have befallen so many ill things.
Chronique du Templier de Tyr
from the *Gestes des Chiprois*[74]

Jehan de Journi's adaptation of liturgical verses for a new kind of confessional treatise creates a crusader subject conditioned by the circumstances of Franks in Outremer. The lyric verses (*rime*) from the *Chronique du Templier de Tyr* illuminate the extent to which literary genres familiar to the Frankish aristocracy overseas were being shaped by events that Jehan mentions in the *Disme*. In this section, I examine these verses in the narrative by the Templar of Tyre (treating the period 1243–1309), the third chronicle in the longer *Gestes des Chiprois*, or *Deeds of the Cypriots*, compiled in the 1310s. A comparison of these verses to Rutebeuf's "La Complainte d'outre-mer," or "Lament of the Holy Land," a nonnarrative Old French text (*dit*) composed in the late thirteenth century on the theme of crusade, shows how literary genres about crusade were being redefined.[75] What was "crusade" to these two poets who in their service to vari-

ous secular lords had witnessed failures and hypocrisies over saving the Holy Land? How do they rally secular lords in dire times and criticize the moral failures of others? Evaluating the present situation, the Templar and Rutebeuf propose solutions through a common heritage of moral satire. Just as we see Jehan writing verses as a penitential bid to return home, these poets call upon the crusader to see things anew: events in the current moment require the crusader subject to form himself according to new times or *historia*—a word that could mean "story," "epic," or "chronological history."

Both the Templar and Rutebeuf use the crusade theme as a means of criticizing the moral laxity and corruption before them and as a way to mourn a past age of honor and chivalry. The difference in their laments is shaped by their environments: Rutebeuf, a jongleur immersed in the university milieu of Paris, composed occasional and satirical poetry for patrons such as Alphonse of Poitiers and Charles of Anjou. He wrote the "Complainte d'outre-mer" sometime after 1265, when holy war in the east was being preached in France and sermons responded to the growing criticism of crusade. The first part of the *Gestes* is a version of the Latin text known as the *Annals of the Holy Land*, which concerns the years 1132-1218. The second part, consisting of the memoirs of Philip of Novara, recounts the wars between Frederick and the Ibelins and deals with the period 1219-43. The third part, the Templar's long prose narrative, treats the period 1243-1309 and is the only surviving Christian eyewitness account of the siege and conquest of Acre in 1291. In this interpolated poem, the unknown chronicler who lived in Cyprus and Tyre criticizes the transformation of Syrio-Cypriot society from a chivalric crusading society into a mercantile one after the fall of Acre. In describing how "Righteousness fails, / and Truth expires on all sides" (lines 153-54), he reproaches all classes of Cypriot society for the decline of courtliness among the feudal class, the simony of the clergy, the bad government of princes and barons, and the evil ways of crusader knights. The verse section occurs toward the end of the *Chronique*, where he shifts his focus to Cyprus and analyzes the political situation on the island that leads to the fall of Acre.[76]

In many respects the poem follows the conventions of satirical lyric lamenting the "world-upside down," seen in middle Latin Goliard lyric, and the verses of Continental contemporaries such as the troubadour Peire Cardenal and Rutebeuf. Yet by comparing the Templar's verses to the "Complainte d'outre-mer," one can see how the dramatic unfolding of events that the Templar witnesses defines his satirical text. More than merely strengthening his disgust and moral outrage (or as Gilles Grivaud describes it, "employing a more literary form" that permits the author to "lose the historian's reserve in order to adopt the impassioned style of a witness"), the Templar reserves the use of verse in this section—it is the only place that it occurs—to indicate a limit situation of crusade as subject matter.[77] He responds to the particular historical circumstances of Outremer and implicitly questions the usefulness of lyric. Witnessing and experiencing the destruction of the Latin East and the crumbling of Cypriot society, the Templar chronicler shows how tropes and rhetorical devices used by Western poets no longer have the same symbolic purchase. One sees this quality through a comparison of the verses of the Templar and Rutebeuf, which demonstrates new conceptions of *historia* after the fall of Acre. To exhort crusade and criticize moral laxity, Rutebeuf depends on an idealized past of mythic heroes from the first crusade and epics, and he is inspired by biblical references in sermons of his day. In contrast, the Templar's *rime* lack the bid to a distant past and references to scripture; his deliberate use of lyric in this section of the chronicle offers another kind of truth claim shaped by the conditions in the Latin East at that time and the Frankish loss of power in the Holy Land.

When the Templar chronicler chooses to compose a poem, "escrire par rime," on the bad state of affairs after the fall of Acre and Syria, what might have been the literary models available to him?[78] We know little about "the Templar of Tyre" except that he was probably born in Cyprus around 1255, served as a page of Margaret of Lusignan, the wife of John of Montfort, lord of Tyre, and lived in Tyre between 1269 and 1283. Although there is no evidence

that he was a Templar, he says that he served as a scribe for William of Beaujeu, master of the Templars. He seems to have been a Cypriot of knightly rank who later lived in Acre during most of the siege. Scholars have shown the diffusion of French literature among the Latin Crusader States and the extent to which the Lusignan kingdom was dominated by major genres such as history, law, and morals.[79] Cypriot historiography composed in the thirteenth century, such as the *Continuations* of William of Tyre and the works of Philip of Novara, represents the literary culture of the noble class residing in the Latin Crusader States at this time. Its characteristics include annalistic accounts with the direct intervention of the author, a conception of history based on Christian and chivalric values. For example, Philip represents the Holy Roman Emperor Frederick II and Philip of Ibelin as Manichean dramatis personae rather than contingent political opposition. His satirical depiction of Cypriot factions uses characters from the *Roman de Renart* and exempla drawn from romances such as *Alexandre le Grand*, the *Roman de Troie*, and *Lancelot*. And finally he uses prosimetra, especially "rime," to amplify satirical invective or emotional expression.

The historical writings inspired by William of Tyre and Philip of Novara show an unsurprising taste for the matters of antiquity and Bretagne among the Frankish nobility in the Latin East, as manuscripts came directly from France or via the Angevin court of Sicily. Further, as John Haines has demonstrated, this French diaspora brought with it parchment anthologies of songs, such as a chansonnier compiled in the thirteenth century for William of Villehardouin, prince of the Morea.[80] Such luxurious manuscripts attest to the French diaspora's devotion to art song collections as a sign of refinement and high culture, in addition to its interest in other genres of a moral or historical nature and romances such as *Roman d'Alexandre* as well as those that treated Arthurian material.[81]

Given this cultural environment, the verses of the Templar chronicler present a distinctive moment in the literary and historical

tradition of French texts produced Outremer because his verses are informed by his experience with political life at the turn of the fourteenth century. Moreover, the chronicler's position as a secretary to William of Beaujeu, and later his service to Philip of Ibelin, the king's uncle, gave him privileged access to documents. His position as eyewitness to the dramatic unfolding of events in the Latin East and his proximity to the king's household influenced the use of verse in his chronicle. The fall of Acre was an epistemological and hermeneutic turning point for crusade in Western thought. Even before 1291, "crusade," David Jacoby argues, was a quotidian reality for the nobility of this region, and if it made the ideals of chivalry and the feudal code of ethics all the more cherished, crusade as an on-the-ground reality diffused its marvelous aspects as seen in courtly literature. Here the struggle against the Muslims was stripped of its fantastical elements.[82] Now with the collapse of the crusade ideal, we find that the Templar's verses are invested with a pathos as they are divested of powerful tropes and rhetorical forms formerly associated with the crusade ideal. Nichols has discussed how after Saladin captured Jerusalem in 1187, when prose was replacing poetry as the vehicle of history, crusade poetry by the troubadours gave a sense of the "critical dialectic regarding crusades that was developing in Europe." For instance, the troubadour Peirol (fl. 1188–1222) "articulates a strategic analysis that situates the failure of the crusades in the present state of European politics."[83]

The Templar chronicler relates this new situation in the beginning quatrains of the only verse section of the *Chronique de Templier de Tyr*. He says that after Syria and Acre were lost, he feared that no mention would be made of the noble people who were "abased and so dishonoured" ("abayssés et si avillés"), and thus is he so moved to pity that he composes verses, or "rime," in his book so that "in times to come it may always be preserved and remembered" ("por ce que elle set tous jours trovee et remembree"). In addition to emphasizing the veracity of his eyewitness account, he foregrounds how the circumstances of the present age make his account new:

Por ce que je voy treschanger
Mout de choses de blanc en ner
A se tens d'ores ou je sus
Selonc les biens que je ais veü,

Je suy par .i. talant tremis
D'escrire a rime aucuns dis
Sur ce siecle et sur la saison
Qui fait son cors par mesprizon.
…

Et se nul dit: "Que m'apartient"
D'oÿr tel chose que pro vient"
Facent rayson, que .i. *fabliau*
Ont oÿ quy est fait *nouviau*.
…

Sur ce ciecle coumenseray
Et aucune chose diray
Que a chascun deuvra sembler
Que [ce] que je diray est vers.
…

Tes sont tout le plus de la gent
Treschangés sont trop malement,
Et ja soit ce que sans mes dis
Chascun en est bien avertys.

Because I witness many things changing
From light to darkness
In my own time,
Before my very eyes,

I am overcome by the need
To put down my thoughts in rhyme [verse]—
Thoughts on the age and the season
In which have befallen so many ill things.

...

And if anyone should say: "What has this to do
 with me?
What profit is there in the hearing of these things?"
Let them be assured that they are hearing
A tale which is quite new.

...

I shall begin with the present age
And tell of certain things.
It ought to be plain to everyone
That what I say is true.

...

So the greater part of men
Are changed for the worse,
And perhaps without my verses
No one would stop and take notice. (my emphasis)[84]

His insistence on the veracity of this eyewitness account ("je ais
veü") supplements the model of *historia* that privileges written or
oral sources. While this view of eyewitnesses as authorities is present
in romances of antiquity such as Benoît de Sainte-Maure's *Roman
de Troie*, unlike the prologue of the *Troie*, the Templar is not con-
cerned with translating into French a Greek or Roman history from
a reliable source such as Dares, who was born and raised in Troy: "En
une estoire comencier, / Que de latin, ou jo la tuis, / Se j'ai le sen e
se jo puis, / La voudrai si en romanz metre / Que cil qui n'entendent
la letre" (So I begin a history from the Latin where I took it, if I
have the good sense and I can, I would like to put it in the vernacu-
lar for those who can not understand those letters; lines 34–37).[85]
Rather, his use of the phrase "noviau fabliau" indicates a new kind
of account for a different time and situation, Outremer or the Latin
East/Cyprus at the end of the thirteenth century. As a chronicler, he
stresses the unprecedented situation of the "present age" and events
"in his own time." Moreover, his use of *fabliau* as a "new kind of story
or tale" occurs in a lyric section toward the end of a prose chronicle:

he feels the need to express his "thoughts" ("aucuns dis") in verses ("rime") so that people take notice. The "nouviau fabliau" presents a different kind of truth claim than the chronicle in which it is embedded.

Rather than referring to a short comic tale, the Templar's use of the word *fabliau* seems closer to the verb *fablier*, which means simply telling or speaking. Or in idiomatic terms, he attempts to develop a new kind of telling. Indeed, the words *novele*, *conte*, *dit*, and *fabliau* could be used interchangeably for various moral and satirical texts. While not being bawdy or comic in the same vein as those short medieval tales that would lead to the work of Chaucer and Boccaccio, the Templar's new "fabliau" shares with other tales of that name the moral purpose of criticizing all classes of society through literary devices that exaggerate moral failings—in some cases grotesque, so-called realist exaggeration or comedy.[86] Here the Templar uses verse in a prosimetric format to foreground a universal fable about political circumstances. While he uses *dis* interchangeably to mean "verse" and "thoughts," the act of writing in verse (*escrire a rime*) seems to doubly authorize his *dis* that record the sad events he has witnessed. The poet recalibrates these words about storytelling and authority in the context of his experiences: What does it mean to speak the truth? In what manner can he tell a story that emphasizes the veracity of his truth claims?

The Templar chronicler was perhaps influenced by Philip of Novara's prosimetric narrative of the war between Frederick and the Ibelins, where he interpolates five poems (*rime*) in various episodes. Philip also evidently recognized the value of poetic language. Just as the Templar breaks from his prose narrative, Philip breaks from epic narration for rhetorical effect. However, reading the Templar's verses next to Rutebeuf's "Complainte d'outre-mer" reveals the significance of his lyrical emphasis on time and witnessing. Like the chronicler, Rutebeuf uses the theme of crusade as an opportunity to criticize the moral laxity of his society, combining satirical criticism of clergy and higher social classes with crusade propaganda. He exhorts "kings and counts and dukes and princes" to emulate the great

crusading deeds of exemplary forebears, epic heroes such Roland
from the Old French epic and legendary heroes from the distant past
of the First Crusade such as Godfrey of Bouillon. As scholars have
noted, Rutebeuf often takes the position of a preacher, borrowing
motifs from contemporaneous sermons and didactic works. How-
ever, even as he judges others and morally condemns people's frail-
ties, he reminds his audience throughout his poetry that he seeks to
prove his moral humility and contrition amid events of the time and
to share common human battles over virtue and vice. For example,
at the end of the "Complainte," Rutebeuf implies that the purpose
of his sermonizing is to make things better even though they get
worse (lines 171–72). This is a typical gesture of the poet where, in a
self-deprecating tone, he acknowledges his work as a poet and the
function of his poetry.[87]

In stark contrast to the Templar chronicler, Rutebeuf explic-
itly invites his audience to "reconmenciez" (recommence) a "novele
estoire" (a new battle, history, or epic) to save the Promised Land.
He purposefully plays with the word *estoire* (line 16), which derives
from the Latin *historia* and Greek *stolia* (military expedition, sea
voyage).[88] He invites his listeners to imitate the first generation of
crusader heroes who fought for God and skillfully interweaves anti-
clerical criticism into this exhortation. He exhorts rulers to under-
take military action (*historia*) and see themselves as part of common
history (*historia*):

> Ha! Antioche! terre sainte!
> Con ci at doleureuse plainte
> Quant tu n'as mais nuns Godefrois!
> Li feux de charitei est frois
> En chacun cuer de crestiien;
> Ne jone home ne ancien
> N'ont por Dieu cure de combatre.
> Asseiz se porroit ja debatre
> Et Jacobins et Cordeliers
> Qu'il trovassent nuns Angeliers,

Nuns Tangreiz ne nuns Baudüyns.
Ansois lairons aux Bedüyns
Maintenir la Terre absolue
Qui par defaut nos est tolue.
 (lines 144–58)

Oh, Antioch! Holy Land! How painful and lamentable it is that
that you no longer have any Godfreys! The fire of charity has gone
cold in every Christian heart; no men, be they young or old, can be
bothered to fight for God. The Dominicans and Franciscans could
struggle for a long time to find any Angeliers, Tancreds, or Bald-
wins. Instead, they will allow the Bedouins to hold the Holy Land,
which has been taken from us through our failings.[89]

Along with Godfrey, Tancred, and Baldwin, celebrated heroes of
the triumphant First Crusade, Rutebeuf includes in his lamentation
Angelier of Gascony, a peer of Charlemagne who fell in the battle of
Roncevaux. Bewailing the present lack of moral courage in contrast
to these forebears, he attacks the Mendicant orders for contributing
to the failure of the crusade.

Typical of other exhortative songs in the second half of the thir-
teenth century, this complaint exhibits a convergence of propaganda
(drawn from sermons and other moral writings responding to criti-
cism of the crusades) and satire that cultivated a closed historical
and epic past. With "closed" I mean that words such as *estoire* and
conte (line 2) refer to a narrative of events, not to the events them-
selves. Rutebeuf would have drawn from crusader sermons and their
plentiful scriptural references that call upon listeners to imitate past
heroes in stories such as the *Chronique de Turpin*, *La Chanson d'Anti-
oche*, and *L'Histoire transmarine*. Satirical crusade poetry depends
on these exemplary narratives, not only to preach crusade but be-
cause satirical poetry by definition perceives a discrepancy between
reality and the moral ideal it wishes to exhort. Both the Templar and
Rutebeuf employ octosyllabic rhyming couplets that they identify as
poems, as opposed to an epic, a chanson, or a prose *historia*, a flex-

ible *dit* and *rime*. Appropriate for reflection and vivid rhetoric, these forms absorb historical change and articulate what cannot be said in other genres such as the epic and chronicle. Through *rime*, the Templar conveys a condition of "newness": without the possibility of recommencing Rutebeuf's new epic tale of history (*reconmenciez novele estoire*), there comes a new contingent "telling" (*nouviau fabliau*) born from the experience of the Latin East at the end of the thirteenth century—a new speaking crusades. This new situation divests the Templar's *rime* of the symbolic usefulness of a legendary past or the image of God's martyrdom. Now that the fall of Acre has come about as divine judgment for the evil actions of crusader knights, all that is left for the Templar to do is to reflect upon contemporary society, using compact proverbs about the dominance of "Lord Money" and allegorical figures such as Righteousness and Truth to depict more vividly the depravity of his age. Compared with crusade rhetoric and tropes extended over several strophes, such proverbs can also be applied to historical situations and those concerning money and class. The hope of God's intervention is earthly and localized rather than eschatological, and seeing the division of the aristocracy following the deposition of Henry II, he ends his *rime* hoping that God will bring his land into "agreement," from "discorde" to "acorde."

In sum, while some scholars have dismissed the prosaic nature of the Templar's *rime* as the work of a poet less gifted than Rutebeuf, a comparison of these lyric works demonstrates two perceptions of crusade and the role of the poet in relation to contemporary events and milieux. The Templar's composing a "new tale" in verse, given his personal experience and "the present age," represents an important development in satirical crusade lyric—the formation of the subject of crusade in a new temporality and *historia*. Comparing Rutebeuf's preaching of a *novele estoire*, or "new history," to the Templar's *nouviau fabliau*, or "new tale," reveals a significant shift in the perception of "estoire" according to the chronicler's experience, perhaps suggestive of a particular moment in French literary history: a new concept of crusade divested of its symbolic past, a new present seen as the outcome of moral laxity and the contemporary situation

Outremer, rather than an opportunity for a new "estoire" that imitates the deeds of past forebears.

Through a descriptive poetics of crusader-poets, we have seen several configurations of the idiom's mobility. First, the social and economic mobility of Thibaut as Lord of Champagne seen in the *Rôles* and compendium allows for a mode of description that accounts for the changing status of people and places under Thibaut's name as trouvère-crusader-lord. Second, from a synchronic perspective, Raimbaut's invention of new genres makes visible a network of people and places that can shift status (*villas* as city-states or peasants) correlative to his changing status as vassal to knight in the *Epic Letter*, and the ambiguity of confession by a professional troubadour-crusader-vassal. From a diachronic perspective, his status as a crusader is a professional one that exists through the genre of the chansonnier and the organization of his songs in manuscripts by editors or scribes. Judging from the centrality of the *EL* in the Catalan Sg chansonnier, it is clear that the biographical letter becomes a node for the production of the crusader-poet through the medium of the chansonnier. In the case of Jehan de Journi, through contrafacture we see in his bid for a return to France a spiritual and temporal mobility and the reconfiguration of song for a localized situation (falling cities, the Holy Land). Although in the *Disme de Penitanche* his pious intentions and confession are sincere, his act of contrafacture makes more visible his status as a crusader knight between two places and the situation of the Latin East. Finally, the Templar's *rime* in comparison with Rutebeuf's lament announce a new horizon of lyric and *historia* that informs our view of Jehan de Journi and other possible subjects of crusade in the second half of the thirteenth century. Contrafacture and the transformation of genres grant a wider lens in which to locate the idiom emerging from France and Outremer.

I began this chapter with objects in order to demonstrate my

method of descriptive historical poetics. Through the Chinese sword we discern Jean d'Alluye's sphere of cultural contacts without a fixed meaning through a valued, personalized object. The sword embodies a particular usage of the idiom (the idealized crusader image of the effigy) in which we can trace a constellation of places and people. The Frankish epitaph of Barthélmy Caïn illuminates how disciplines such as epigraphy shape the "crusader subject" through the deciphering of a monument such as a stele. By letting the uncertain diphthong of "Caïn" speak, we see a fluctuating idiom conditioned by the practice of epigraphy rather than a single identity of the crusader from a certain place and family. Finally, through distinct modalities of descriptive poetics in manuscripts, I offer multiple views of crusade texts by making mobile associations through archives such as compendia, cartulary rolls, and chansonniers, as well as the phenomenon of contrafacture. With it, crusader subjects emerge to testify to the complexity of speaking crusade at particular moments and in various forms and media across time and space.

The Feast of the Pheasant as Courtly Crusade Idiom

The room in which the banquet was held was a large one, and finely hung with a tapestry in which the life of Hercules was depicted … when their fanfare was over, the curtain was suddenly pulled back, and there, on the platform, could be seen the figure of Jason, armed to the teeth, walking about, looking all around him, as if he had arrived in a strange land.

OLIVIER DE LA MARCHE, *Mémoires*[1]

puis l'escorça et mist le veaurre, qui avoit la laine de fin or, a une part, et le corps il despieça par menbres et l'apporta sus un autel assiz au dehors du temple

Then he (Jason) stripped away the fleece that had wool made of fine gold on the one part, and the body he dismembered into pieces and carried it to the altar placed before the temple.

RAOUL LEFÈVRE, *L'histoire de Jason*[2]

Tapestry collection of Philip the Bold, Duke of Burgundy (r. 1363–1404).
- Hector of Troy, Cyprus Gold thread, 200 francs
- Jason ("how he conquered the golden fleece" two tapestries), 1, 125 francs[3]

The songbirds are sitting in the trees, hardly touching the fruit, for they are spending most of their time singing. Their voices, I believe, will announce that all will be better now that the queen of the seasons is here … everything moves more freely, even the smallest animals … some of these have just emerged from their hives, others have barely been born.… Thus, the art of weaving smiles at us and offers the onlooker deep pleasure.

EMPEROR MANUEL II PALAEOLOGUS OF BYZANTIUM (written in 1400 in contemplation of a tapestry)[4]

JASON AS UNREPENTANT CRUSADER:
THE LYRICAL OBSESSION WITH MATTER
AND THE LIFE OF THE IDIOM

My last example jumps to the fifteenth century because a spectacular feast features another crusade hero of ambiguous status and permits a study of the figure of the unrepentant crusader in multiple media. As a case for descriptive historical poetics, the particular qualities of the Feast of the Pheasant extend the methods of description advanced in chapter 5 by asking how the idiom can collectively occur in performances and media of which we have only fragmentary knowledge or that we have to reconstruct with attention to specific material or aesthetic effects. According to the courtier and chronicler Olivier de la Marche, on February 17, 1454, the Burgundian duke Philip the Good gathered more than a hundred courtiers in Lille for a sumptuous banquet called the Feast of the Pheasant. During the period of 1419 to 1477, Dukes Philip the Good and Charles the Bold presided over a dynamic and rapidly expanding realm. As they entertained growing political ambitions of territorial expansion, these Burgundian nobles hosted lavish court ceremonies of increasing pageantry to represent ducal magnificence and enhance political projects. The public demonstration of power and wealth through sumptuous yet tasteful expenditure and generosity derived from Aristotle's *Nicomachean Ethics*. In the fourteenth century it received renewed attention through contemporary translations, including one dated 1370–77 by Nicolas Oresme, a councillor and chaplain to King Charles V of France.[5] Diners participated in ceremonial activities that engaged multiple senses. Chronicles like the one of Olivier de la Marche, literary accounts, tapestries, and manuscript illuminations depict such feasts as involving song, dance, and ritual. Elite diners wore luxurious materials such as velvet and fur, cloths of fine brocade were draped on the tables, and tapestries hung on the walls, depicting mythological and biblical scenes. The table would have had objects of fine metalwork such as salt containers or water pitchers, or sometimes mechanical water fountains that moved; servants attended to

the proper regulation of the table and the service of the courses. We see many of these elements in the feasting scene from the Feast of the Duke of Berry from *Les Très Riches Heures du Duc de Berry* (1416) by Jean de Limbourg. Our eyes are drawn to the visual splendor of the silk brocaded clothing of the duke and the cleric in animated conversation; the royal emblems of the swan and bear suspended in the background along with tapestries depicting the heroic battle of the Trojan war, the sumptuous dress of the courtiers, and the table decoration and instruments for serving. In addition to music and other elements, all these features related both the power and the restraint of the host: he offered his guests a sumptuous feast in a ritualized performance that encouraged moral and virtuous behavior even as they indulged various sensual pleasures.

The Feast of the Pheasant actualized a kind of idiom different from my previous examples, one that enlists the wealth and historical situation of the Burgundian dukes and the artistic production of the feasts. Consistent with the other examples in this book however, the Feast of the Pheasant speaks a refusal of penitence and a preoccupation with worldly concerns such as wealth and erotic desire. It speaks these things even as it avows the pious goals of spiritual pilgrimage and holy war.

I organize the chapter in the following manner. First, I explain Jason as an unrepentant crusader within the context of the Feast of the Pheasant and how he constitutes the idiom. I also include in this section a brief introduction to the media that will be treated in the chapter. Second, I explain the phenomenon of the entremets at the feast. Finally, as a practice of descriptive poetics I treat separately the tapestry, play, and manuscript and how they embody the idiom in their material and aesthetic qualities. Jason is featured in both the play and the manuscript, and I will analyze his idiomatic function within the context of these media in these final sections.

While scholarship has focused on the religious and political narratives advanced by the figure of Jason in the context of the Feast of the Pheasant, I focus on how three seemingly minor or decorative aspects work together to produce an idiom through the aes-

thetics and effects of discrete media: tapestry, play, and manuscript. As Christina Normore has observed, scholars have revised the "frivolity" of medieval banquets and instead see them as "a sign of power and tool for community formation" as well as an opportunity for "provocation and questioning of the senses" that was "integral to the political life of the courts." This questioning not only asks guests to "reflect on the meanings that lay beneath pleasant surfaces," as Normore suggests, but also makes us inquire into the nature of these surfaces and their effects, not to mention their ability to produce an idiom of crusade.[6] Thus my object of inquiry concerns the lyrical obsession with matter at this feast—the atmosphere, effects, and surfaces that prompt both questioning and pleasure—which constitutes the life of the idiom.

At the Feast of the Pheasant, the courtiers made a vow to go on crusade and rescue Constantinople, which had fallen to the Turks eight months earlier. Although Philip's call at the feast did not result in crusade, scholars have long noted its extravagance as a communal avowal. Modern historians interpret the account of the spectacles and performances of this event variously as political propaganda and as building community, to shore up Duke Philip's political power among the Burgundian nobles by demonstrating his subservience to the French crown and the crusading tradition. By this time in his career, crusade was Philip's primary interest, and the feast cultivated his ambition to take part in all Western crusading initiatives as well as to form a Burgundian Christian community.[7] As part of their ducal demonstration of wealth and power, the Burgundian nobility took as models, or claimed as their ancestors, heroes and knights such as Alexander, Hector, and Saint George. These mythical characters had great appeal because the noblemen were trying to affirm chivalry and recreate its rituals. They were the subjects of the arts and entertainments featured at events such as the Feast.[8] The Burgundian library was known to hold many manuscripts of narratives of the "historico-realist," or non-Arthurian, type, especially stories of chivalric and classical heroes who were the putative ances-

tors of Burgundian families. Philip the Good's library contained numerous works attesting to his crusade and political ambitions. Like crusaders of old, Philip wanted to undertake his own quest to save Jerusalem.[9]

Named after the symbol of religious and royal authority obtained by the legendary Greek hero Jason, the Order of the Golden Fleece was a prestigious order of knights founded by Philip the Good. Assembled at the Feast of the Pheasant, what did this order see in Jason? A more crucial question for this account of the feast might be further, how does this story serve as an idiom? Moralized from twelfth-century vernacular sources (*romans antiques*), Jason was well known throughout the High Middle Ages as the Greek Argonaut who conquered the Golden Fleece with the help of the sorceress Medea. Drawing from Ovid's version, which portrays Medea as a sorceress who is betrayed by Jason when he abandons her for Mirro, the daughter of the King of Corinth, medieval authors emphasized Jason's ingratitude and infidelity in contrast to Medea's suffering. Benoît de Sainte-Maure's *Roman de Troie* portrays Jason as a disloyal figure who betrays his homeland and, having been seduced by the powers of Medea, foretells the destruction of Troy. Yet by the time of the feast, Jason had regained his reputation as a model of chivalry enough for him to be taken as the one of the patron heroes of the Order of the Golden Fleece. In the late Middle Ages, the myth was allegorized to depict Jason as a crusading Christ figure. After defeating Medea, who is considered to be the devil presenting the fruit, Jason seizes the Golden Fleece just as Christ took on human form to redeem humankind. This allegorization of the Jason and Medea myth enabled Philip the Good in 1430 to take Jason as an appropriate crusading patron of his order and the marvelous fleece as symbol of royal authority and his crusading piety. Jason's voyage on the *Argo* with his companions, his journey to Colchis, and his chivalric feats in search of the Golden Fleece justified crusading expeditions. The fleece symbolized the treasures of the Orient, while the Argonauts were viewed as crusaders who aimed to save the Chris-

tian faith through the capture of the fleece.[10] I argue that the story of Jason and the Golden Fleece advanced Burgundy as an independent polity through a narrative featuring an unrepentant crusader.[11]

Like Lancelot, then, it is Jason's ambiguous status as a hero of chivalry with an underlying carnality and willingness to break promises for material conquest that attracted Burgundian nobility. As many have noted, Jason's conquest of the Golden Fleece and its symbolic link to the ducal ambitions of crusade surpassed the negative judgment that accumulated around Jason as a hypocrite and traitor, a view advanced by authors such as Jean de Meun, Guillaume de Machaut, Eustache Deschamps, and Christine de Pisan.[12] Although by the fourteenth century we find attempts to rehabilitate Jason as a Christ figure in the *Ovide Moralisé* and elsewhere, the process by which he is refashioned in the Feast of the Pheasant is a creative adaptation that preserves his ambiguous status as chivalric hero and traitor to Medea. When represented within the phenomenological framework of the feast as a multimedia event, from this ambiguous quality of Jason emerges a speaking crusades.

A letter about the feast written by de la Marche around 1500 suggests the idiomatic elements of this unrepentant crusader and the story of the fleece. Addressed to Philip the Fair, the dedicatee of the *Mémoires*, the letter links Jason's dependency and betrayal of Medea to the acquisition of the Golden Fleece in a manner that highlights, on the one hand, his refusal to marry her (contrary to the legend in Ovid's *Metamorphoses*) and, on the other hand, the heft and quality of the fleece. Although the emphasis on the betrayal and the fleece might seem strange, de la Marche then goes on to describe a "poeterie" of Jason based on these two qualities that undergird the order:

> Icelle Médée se enamoura dudit Jason, et tant traictèrent ensemble, qu'il luy prommist de l'emmener et de la prendre à feme; et elle luy aprist les sors qu'il convenoit faire contre les dragons et les boeufs, et aultres enchantements qui moult *estoient contraires à ung chevalier qui voulloit le mouton conquérir.* Jason crut Médée et fist ce qu'elle luy

enseigna, et fist tellement qu'il vint à son dessirs de toutes les sorcer-
ies dessusdictes, et parvint jusques au mouton et l'occit. *Mais pour ce*
qu'il trouva ledit mouton si grand et si pesant qu'il ne le povoit apporter,
il escorcha ledit mouton, et apporta la peau et le vyaire qui estoit d'or, et
à celle peau pendoit la teste, les cornes, les quatre piedz et la queue dudit
mouton. Et pour ce fut-il dit que Jason avoit conquis la Thoison d'or;
et ne parle-l'on point du mouton. Et s'en retourna atoute ladicte Thoi-
son; mais il trompa Médée et ne l'emmena ou espousa.

This Medea was in love with the said Jason, and they were so drawn
together that he promised to take her as his wife; and she taught
him magic so that he could conquer the dragons and the bulls, and
other sorceries *that were very contrary to a knight who wanted to con-*
quer the sheep. Jason believed Medea and what she had taught him,
and accomplished his desires with the said sorceries and came to
the sheep and killed it. *But because the sheep was so big and heavy that*
he could not carry it, he flayed the said sheep and carried the skin and the
fleece that was of gold, and from this skin was attached the head, the horns,
and the four feet and tail of the said sheep. And for this it is said that
Jason conquered the Golden Fleece, *and we do not speak at all of the*
sheep. And he returned with the said Fleece, but he betrayed Medea
and neither took nor married her. (my emphasis)[13]

Jason's dependency on Medea's magic to accomplish chivalric tasks
remains vexed: while he ultimately conquers the Golden Fleece, the
physical separation of the fleece from the heavy beast calls atten-
tion to itself. De la Marche seems to deliberately want to counter
Jason's troublesome dependency on Medea and the betrayal that
threatens his status as a hero by emphasizing the physical qualities
of the feat. Again departing from Ovidian legend, de la Marche de-
picts in startling detail the heft of the beast and how the sheep is
composed of skin and fleece. The fleece becomes a separate thing
of gold, while the skin carries the remnants of the once whole crea-
ture of which "we do not speak." This heft of the sheep and separa-
tion of the fleshly inanimate thing from the beast that needs to be

forgotten seem almost to distract us from the problematic status of the worldly Jason. This passage points to the imaginative work required to rehabilitate Jason as a proper hero who through the capture of the Golden Fleece will be fully converted and cleansed of his sins. The contiguity of material and symbolic qualities of the sheep, skin, and fleece returns us to Jason's persistent ambiguous status because it inadvertently reminds us of what the sheep once was before it became a powerful symbol. Still attached to the skin of the sacrificed animal, the fleece held by Jason embodies the fleshy residue of unresolved worldly issues—namely, his attachment to and betrayal of Medea, which make him an unrepentant crusader. Even as the idealized Jason story tries to reconcile and overcome the problematic status of our hero, this letter speaks of an idiomatic Jason who will appear in other media such as the mimed play at the Feast of the Pheasant and the Jason manuscript.

The account of Jason's betrayal of Medea and conquest of the Golden Fleece directly precedes de la Marche's explanation that Jason was eventually coupled with Gideon, who was a proper biblical model for the order. The Order of the Golden Fleece had three foundational figures: Jason, Hercules, and Gideon. As Rolf Strøm-Olsen has correctly argued, the "scripturally-grounded" figure of Gideon, who Christianized the pagan and deviant actions of Jason in his relations with Medea, was notably absent at the Feast of the Pheasant, while Jason was very much present.[14] I dwell on how the multimedia nature of the feast permits the Burgundian elite to adapt Jason according to their needs—something compelling in Jason's questionable status was perfect for the Burgundian crusading agenda, and his status appears in all its complexity through the idiom. As in my earlier examples of the crusade departure song and Lancelot in the *Perlesvaus*, I describe situations in which the idiom is most inventive and provocative in its speaking crusades in a particular context, medium, or form.

The play about Jason's adventures on Colchis was complemented by a rich tapestry, prominently hung on the wall behind the duke, which featured the travails of Hercules. As the ancestor of the Bur-

gundian princes, Hercules was also appropriate as "an Argonaut and classical archetype popular at the Burgundian court."[15] It is possible that Jason was featured in the tapestry, as the two were known to be depicted together in late medieval artworks concerning the *History of Troy*.[16] In addition to the proximity of the two heroes as Argonauts and Burgundian ancestors, there is another reason why we must consider the Hercules tapestry as part of the idiom at the feast. Widely known in the court of Burgundy, the Jason myth was first circulated among the Burgundians in tapestry form. Philip the Bold commissioned two pieces depicting Jason and the conquest of the Golden Fleece from his tapissier Pierre Beaumetz of Paris.[17] It is also known that the story of Jason existed in other forms in places associated with the Burgundian dukes. William Caxton tells of the Golden Fleece wall paintings in the Hesdin castle based on Raoul Lefèvre's *Histoire de Jason*, while manuscripts about Jason in the ducal library are known to have existed by 1430.

Finally, another element that comprises the idiom of the feast is a late fifteenth-century manuscript (Morgan MS 119) of *L'histoire de Jason* by Lefèvre, chaplain to Philip. The manuscript produces surface effects of gold and red color applied over grisaille miniatures that correlate to the effects of the tapestry and mimed play that engage the viewer to experience the material nature of the Jason story through another medium.[18] A technique often used in fourteenth- and fifteenth-century Northern European luxury manuscripts, grisaille involves rendering images in monochromatic tones of gray, black, and white. Grisaille manuscripts became popular at the Burgundian court in the second half of the fifteenth century under the patronage of Philip the Good. In a payment order dated April 3, 1455, made out to the miniaturist Jean le Tavernier through Jehan le Doulx, the ducal treasurer of Lille, Philip commissioned various works, including 230 grisaille miniatures.[19] In her study of Burgundian grisaille manuscripts, Sophia Rochmes argues that Philip cultivated grisaille as his own courtly style, drawing from French manuscripts but creating a form of "visual self-identification" similar to his preference for black clothing.[20] The grisaille miniatures of the

Morgan manuscript (and by extension those of BN fr. 12570) by the Maître du Champion des Dames belong to Philip's carefully cultivated visual idiom of manuscripts. Both BN fr. 12570 and Morgan MS 119 also reflect a style of grisaille in paper manuscripts particular to Lille during this period.

Taken together, play, tapestry, and manuscript embody the idiom that speaks Jason's status as an unrepentant crusader with both worldly and pious interests. Taken separately, the specific modes in which they speak demonstrate how descriptive poetics reconstructs a multimedia phenomenon such as the Feast of the Pheasant.

Indeed, whereas other studies have treated the "interwoven strands" of the feast's "enigmatic entertainment" that "create a political and religious narrative," I focus on the quiddity of the material texture of the tapestry, on the interactive ambiguity of the mimed play, and on the raised surface of manuscript miniatures that invite readers to engage with the texture of gold and red color on a folio page. In these features, an idiom emerges in tension with a pious and repentant narrative of crusade.[21] How would these things have been experienced in multiple modes and in relation to one another as a version of the idiom? This book has considered the idiom as situated in language and art objects; here I describe it in a phenomenon of the feast, where it emerges not from the conventions of lyric, romance, or art, but from performance.

THE ENTREMET AS COURTLY CRUSADE IDIOM

Entremets, literally "between" (*entre*) "dishes" (*mes*), were entertainments composed of elaborate table decorations and spectacles involving painted animals and people. The mimed play of Jason was an entremet, and manuscripts such as the *Grandes Chroniques de France* owned by King Charles V (fig. 8) depict such theatrical entremets. The between-course entertainment tableside shows the reenactment of the crusaders' capture of Jerusalem in the eleventh century in order to engage the guests to think about their duties as military leaders. Edible artworks and other table objects (such as the boat-

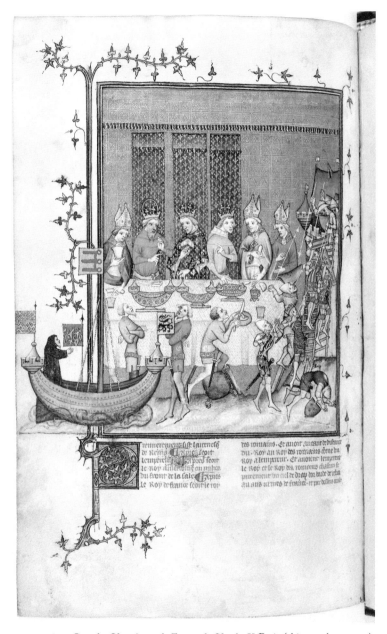

FIGURE 8. *Grandes Chroniques de France de Charles V*, Paris (thirteenth century). BN fr. 2813, fol. 473v. Photograph: Bibliothèque nationale de France.

shaped aquamaniles for washing hands depicted in the manuscript miniature) produced by a host of artisans working at the court provoked wonder. Medieval recipe collections, chronicles, and visual representations from manuscripts and tapestries give a sense of these entremets.[22]

As Normore's studies have shown, entremets traversed boundaries between reality and fiction, spectator and spectacle, animate and inanimate, and the material and the figural by engaging the diners' multiple senses of sight, sound, touch, and smell. In the climax of the Feast of the Pheasant, the entremet of the Holy Church is begun by an armed giant in a long green silk robe with the turban of a Saracen, who enters a room leading an elephant covered in silk. Riding the elephant is a lady with a white robe and the white headdress of a Beguine; both otherworldly and holy in her garb, she stops at the ducal table to reveal that she is the Holy Church, and she delivers a complaint poem to the duke and other nobles present describing her fallen state after the Turkish capture of Constantinople, ending her poem with a plea for their aid. After this the herald Toison d'Or calls for all assembled noblemen to swear on the pheasant held by two ladies to aid Lady Church. Philip the Good then enters into the entremet, pretending to be moved by this plea; he draws out a letter promising aid to his fellow Christians, which the herald reads aloud to the assembled guests.[23] Normore rightly points out that the pretension is "made explicit" in de la Marche's account as the duke "savoit à quelle intencion il avoit fait ce banquet"; that is to say, the entremets were "carefully calibrated display[s]" of emotions used as political tools in a cultural environment where "affective exchange played an important role in both political and devotional discourses."[24]

Extending Normore's account of other entremets that involve senses such as taste, sound, and gesture, I apply theoretical concepts of fluidity and mixture to the materials and objects concerning Jason to show how they embodied the idiom as what Normore describes as a liminal phenomenon.[25] For example, one gustatory entremet in a fifteenth-century cookbook, the *Viandier* is the *coqz heau-*

mez: a stuffed roasted old hen or cock, seated astride a piglet, wears "a helmet of glued paper and a lance" that "should be couched at the breast of the bird, and these [the helmet and lance] should be covered with gold-or silver-leaf for lords, or with white, red or green tin-leaf."[26] Just as in animal tales and manuscript marginalia, animals here are used to satirize the chivalric code and social norms, the old cock as perhaps an aging knight who is past his prime, the dish visually communicating the decadence of the chivalric order. Normore notes that this entremet "imitates" but "does not follow a single model" of topsy-turvy worlds such as animal jousts and foodstuffs of Cockaigne. Recalling the chivalric cock in *Le Roman de Renart* and Chaucer's "Nun's Priest Tale,"[27] the entremet depends on the use of lowly poultry (rather than noble poultry such as a pheasant or a swan) as a mockery of a knight on his steed. The *coqz heumez* pokes fun at male aristocratic pride and prowess as well as the chivalric rituals of dress codes used to distinguish social classes. Moreover, as Normore argues, the complex, sensual gustatory experience blurs the boundaries between abundance and ostentation, moderation and excess, in order to depict this upside-down world of chivalry. In sharing parts of this dish, chewing and digesting morsels, diners absorbed satire while they were masticating, digesting and incorporating these portions into their bodies. In my view, they remain fluidly between sensual modes, a state that permits various receptions and interpretations of the entremets. The multisensory experience and ingestion of an elaborate, static artwork in a lifelike pose offers a good example of the experience of the edible entremet: it constitutes a concoction—a delicious mixture—that, as neither purely inanimate visual object nor consumable food, remains something *in-between*.

The Feast of the Pheasant was exceptional in late medieval feasting culture and might explain its idiomatic nature.[28] While the affective aspect of the entremets was not contradictory to the intention of crusade, it is the contingent mode of performing sincerity that is my interest—a mode analogous to both the performance of sincerity in departure lyric and the *Perlesvaus* and particular mobile assemblages of crusader-poets.

TAPESTRY AS DEEP SURFACE

How did guests experience the Hercules tapestry in the context of the Feast of the Pheasant? How can we view such tapestries in the same liminal mode as other entremets mentioned in the previous section, and why does our way of seeing them matter for interpreting Jason as an unrepentant crusader? How does the tapestry speak crusades? As the object described by Olivier de la Marche no longer exists, to answer these questions at least provisionally, we need to inquire into the aesthetic and material qualities of such a tapestry.

In his monumental catalog of late medieval and Renaissance tapestries, Thomas Campbell describes how in this kind of work,

> far more than any number of paintings or even sculptures, the scale and richness of tapestry provided a dramatic physical demonstration of the wealth and power of the patron, and as such, it was much more highly valued as a material possession. Tapestry also provided a monumental figurative medium on which the patron could parade images of ancestors, of military conquests, or of the historical and mythological heroes with whom he wished to be associated.[29]

In addition to its figurative capacities for representing forebears, Campbell notes the monumentality and value of such a tapestry at the Feast of the Pheasant. Through the interaction of specific media, the visual design and texture of tapestry, the role playing of Jason, and the surface effects of manuscript illumination, Burgundians performed their own idiom distinct from contemporaneous courtly and artistic cultures of Europe. It was an idiom that combined a specific Burgundian artistic style present across media and experienced through events such as the feast. In the case of tapestry, the idiom emerges through a dramatic figurative medium of textile art; however, I argue that the particular surface and improvisatory aesthetics of such a monumental object maintained Jason as an unrepentant crusader by competing with the figural allegory that would have been depicted and reinforced by other spectacles at the

feast. If we consider that according to records, tapestry was a primary medium through which the story of Hercules and Jason was transmitted to the Burgundian public, we can reflect on how this medium was essential to the idiom at the feast.[30] That is to say, the particular aesthetic and material qualities of tapestry challenge us to reconstruct and reimagine the idiom through the various modes and situations in which it was produced, created, and experienced by the feasting participants.

Entremets required the participation of various kinds of people: a chronicler-planner such as de la Marche, cooks, artisans, and finally feasting participants, actors, and spectators. Similarly, as an art form distinguished from other decorative fabrics, tapestry was "born of the collaboration between the artist who creates the cartoon and the weaver who translates the cartoon into textile matter—not with the cold precision of a machine but with his own personal understanding and skill at bringing into play all the resources of his craft."[31] It is through an account of this collaborative and artisanal nature of tapestry and entremets at the Feast of the Pheasant, and the performative nature of participants with these objects, that the figure of Jason as an unrepentant crusader appears as part of an idiom. As a pagan and Christian hero of the Order of the Golden Fleece, Jason in the story of the fleece was symbolically linked to the recovery of Christian lands in the eastern Mediterranean. However, in this instance the effects and atmosphere of the feast produced the idiom. Jason's position as an unrepentant crusader functions through the aesthetics of the feast that realizes devotional and political meaning through bodily affect, gestures, and surface effects. Further, the luxury of objects such as tapestries woven with gold-wrapped silk thread from the Latin East registers the chivalric feat of capturing the Golden Fleece as both material and spiritual conquest.

Taking a tapestry that usually lies in the background as a conceptual node rather than a singular primary source, I direct our attention to what I call the "deep surfaces" of the Feast of the Pheasant that, like the entremets, are crucial to the success of the idiom. As a speculative response to how the tapestry would have been experi-

enced at the feast, and why this matters for Jason and his idiom, I propose the following: while Hercules and (most likely) Jason might have been the figurative crusader "subjects" of the tapestry, the courtly crusade idiom happens in the shimmering effects of the wool weft wrapped in silk thread and in its highly ornamental flattened but textured surface plane, just as it will occur in another way in the mimed play of Jason acted out during the feast. Like Philomela, who weaves herself *into* (*intextuit*) a cloth background as an illustration rather than a deep piece of embroidery ("purpureasque notas filis intexuit albis"; Ovid, *Metamorphoses* v. 577), someone like de la Marche or a member of the Order of the Golden Fleece was present in the tapestry as they took on roles depicted in it; participants in the economic, social, and political networks of gold silk from Venice or Cyprus are also present; and finally, viewers at the feast are interwoven into the tapestry in another sense in their pleasurable engagement in the surface effects of the shimmering silk threads.

This descriptive poetics of deep surface responds to the need to historicize and enrich recent critical approaches.[32] I maintain that the tapestry of Hercules serves not only as a case study of but also as an analogy for the historical, medium-specific, and speculative mode of descriptive poetics. Although it no longer exists, I grant the autonomy of an art object through its possible existence in the feast: as at once a movable wall covering that creates a mood of luxury and celebration, as a text of narrative allegory, and as an object that exists only in documents such as a chronicle or inventory from which we can trace various social and economic relations.

With this in mind, a descriptive poetics of the idiom should also consider the labor and other social relations that went into making the tapestry. For instance, the fact that the Burgundian ducal inventories list the most valuable tapestries as containing gold and silk thread from Venice and Cyprus speaks of the work of artisans who smelted gold and silver and beat it into very fine leaves, which were then cut in long, thin strips and patiently wound around a thread of silk by female workers. It speaks of the trade between Burgun-

dian dukes and the merchants who supplied such valuable metallic silk to their noble patrons. Scholars such as Peter Stabel note that during the fourteenth and fifteenth centuries, the mercantile network created by the long-standing taste and trade for Oriental luxury items by European nobility was being transformed by the rise of Italian merchants with access to Mediterranean goods and markets that could compete with the gold silk producers of Cyprus—the inventory listing of the tapestries at the beginning of this chapter gives an indication of a moment in the production of this kind of silk thread.[33] Finally, the tapestry speaks of the community of artisans—designers, weavers, and cartoonists—commissioned to make it. The activity and movement of the luxury silk fabric interwoven into the tapestry enliven the idiom as a speaking network of labor and materials.[34]

These qualities of participatory embodiment—the commercial and artisanal network of the tapestry-silk trade as inseparable from the aesthetic and tactile qualities of the tapestry—constitute the deep surfaces of the idiom. Its depth is found not in the hermeneutic sense of interpreting the meaning or symbolism of a tapestry or an empirical description of social and economic networks from documentary evidence, but in the mode in which past and current writers, artists, and historians activate the tapestry and by extension the idiom through a historical reconstruction of the event that called for the engagement of these surfaces.

Like the edible entremets and animated table objects at the feast, then, the tapestry of Hercules allowed for many forms of engagement; this aspect is important for understanding how the idiom could exist at the feast as a speaking of at once secular and spiritual objectives concerning crusade. Illuminated manuscripts, extant cartoons, tapestries of the same period, regional workshops, and finally descriptions of such tapestries all provide information on how these works would have functioned as part of the feast's idiom. In the January image from Jean Limbourg's *Les Très Riches Heures du Duc de Berry* (1416; fig. 9), we see how diners could blend into the fiction of the tapestry hanging in the background.[35] The dynastic arms and

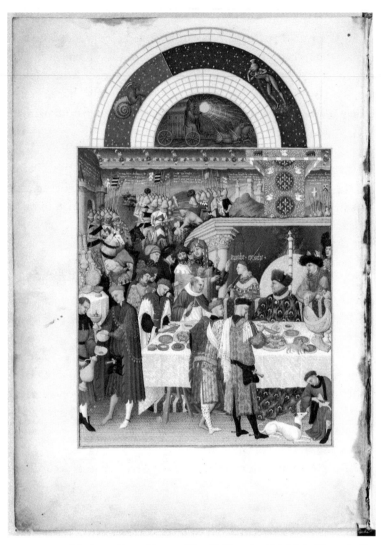

FIGURE 9. Limbourg Bros., "January" (1416). From *Les Très Riches Heures du Duc de Berry*. MS 65, fol. IV. Musée Condé, Chantilly, France. Photography by René-Gabriel Ojéda. Photograph: © RMN-Grand Palais, Paris / Art Resource, New York.

personal emblems merge with the Trojan War scenes depicted in the tapestry and link the court seated at the banquet with the past. This kind of liminality blurred boundaries between reality and fiction in what was, according to de la Marche's account, already a staged feast following certain conventions. As a story and an object, such a tapestry would invite the diners to engage with the woven fabric from various vantage points of closeness, such as in this image from a fifteenth-century manuscript, "The Banquet of Charles the Bold and Frederick III at Trier" (fig. 10) from *Chronik der Burgunderkriege* (1480). This image is illuminating not for what the wall hangings depict but for how they cover the walls on all sides of the diners. We can imagine myriad possibilities of experiencing them in this room—for example, viewed from different angles as they wrapped around the walls, from up close or far away.

In his discussion of Philip's patronage of tapestries, Campbell describes the ducal collection consisting of one hundred sets, some of which numbered ten or more pieces. The most valuable were related to dynastic and political claims, such as the now lost set of the *Story of Gideon* that Philip commissioned in 1449 to provide a backdrop to ceremonies of the Golden Fleece. Completed in 1453, the tapestry was designed by Bauduin (Badouin) de Bailleul, the leading artist in Arras at the time, and was composed of eight pieces with a height of 5.6 meters and a total length of 98 meters.[36] It was richly woven in silver and gilt metal-wrapped thread, wool, and silk, and it cost the enormous sum of 8,960 écus d'or (the cost of a something like a warship).[37] According to the chronicler Georges Chastellain, when the *Story of Gideon* tapestries were first shown in 1456 at the Golden Fleece chapter meeting held in the Binnenhof in The Hague, it was declared the finest weaving ever seen, and when Philip hosted banquets in Paris featuring the tapestries among other riches, Parisians of all ranks who lined up to visit his residence were impressed most of all by the *Story of Gideon*, which the chronicler described as "the richest and largest that had ever been made."[38] From contemporary weavings we can get a sense of the richness and appearance of tapestries such as the *Gideon* and by extension the Hercules tapes-

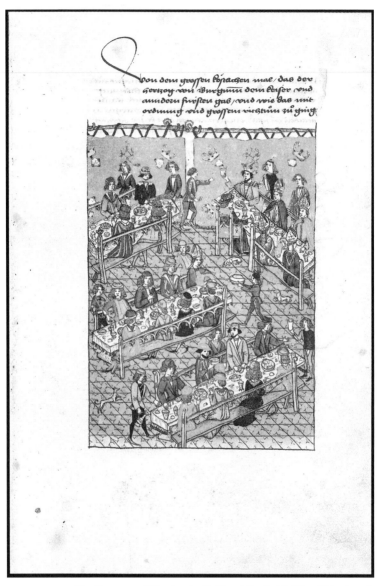

FIGURE 10. The Banquet of Charles the Bold and Frederick III at Trier (1480). From *Chronik der Burgunderkriege*. MS A5, fol. 121. Photograph: Zentralbibliothek, Zurich.

try mentioned by de la Marche. For instance, we can see contemporaneous weavings commissioned from Philip's principal supplier, Pasquier Grenier, the same Tournai-based merchant from whom Philip commissioned a *Story of Alexander* tapestry with which the *Story of Gideon* tapestries were displayed, such as this tapestry that depicts "The Battle Scene with the Sagittary and the Conference at Achilles' Tent" from *Scenes from the Story of the Trojan War* (fig. 11).

Understanding the flat surface of these existing tapestries is essential to understanding the vibrancy of the idiom in the tapestries that would have been at the Feast of the Pheasant. Such a plane offers the viewer multiple perceptions simultaneously, which, as Adolf Cavallo says, "when expertly combined, can offer an agreeably rich experience."[39] Campbell describes how such designs keep the eye "moving across the patterned surface of the tapestry, rather than lingering and exploring spatial depth."[40] These rich designs were technically difficult to execute and were limited by the cost of labor and materials. Because gradations of color available to the artist working in paint were not available to the weaver and designers, "from an early date tapestry designers opted instead for designs that emphasized ornament, line, pattern, and richness over perspectival or atmospheric effects."[41] Changes that were made in the preparatory process indicate the flattening effect and decorative detailing that compromised spatial illusion.[42] For instance, as Campbell notes, when one compares the drawing with the cartoon made in preparation for the *Sack of Troy* in the Museu Catedralicio in Zamora, one notices the elaboration of Polyxena's dress with the intricate pattern of brocade, and the reduced perspective from the linear emphasis of the mortar between the stones.[43]

In an account written around 1400, the emperor Manuel II Palaeologus of Byzantium contemplated a tapestry, and the description gives us a good idea of how flattened perspective and patterned surface enable a roaming eye and conditioned a particular experience conducive for the formulation of the idiom. One's gaze never settles on one object but keeps moving like the springtime creatures in the tapestry: "everything moves more freely, even the smallest

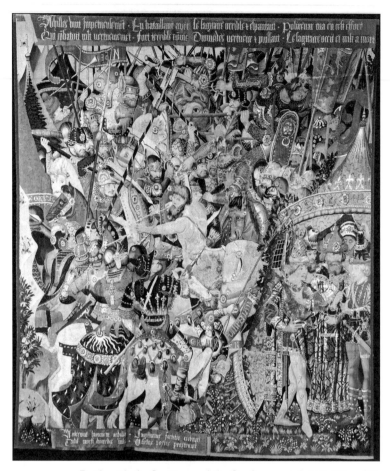

FIGURE II. Battle with the Sagittary and the Conference at Achilles' Tent (fif-
teenth century). From *Scenes from the Story of the Trojan War*. Wool warp, wool wefts
with silk. Tournai, South Netherlands. The Fletcher Fund (1952). Photograph:
Metropolitan Museum of Art, New York.

animals . . . some of these have just emerged from their hives, others
have barely been born." As a kind of surface reading specific to this
medium, the tapestries offer an experience of material richness and
visual abundance that coexisted with the allegorical narrative. En-
joyment and pleasure would have come from the eye moving across,
and at variable distances from, the surface plane; and from the shim-

mering effect of the material, such as silver- or gold-metal-wrapped thread. Close or distant, gold- or silver-wrapped thread draws the eye to pause or focus on a detail such as the folds of a dress, giving the moving eye a different rhythm separate but continuous with reflection on a whole image or person. One can stand farther back and take in the different effects of the metal and wool threads: the light refracts from threads wrapped in metal while wool threads absorb the light, as in this detail from an early sixteenth-century Flemish tapestry showing *Emperor Vespasian Cured by Veronica's Veil*, made from wool, silk, and gilt-metal-strip-wrapped silk thread (plate 1).

Records indicate that sets from the ducal collection served the dual purpose of spectacle and diplomacy: like his father and grandfather, Philip used tapestries as a form of diplomatic gift, and they often served as reminders of negotiations, such as those between France and England in the case of the *Battle of Liège* tapestries, or the *Life of the Virgin* tapestries given to Pope Martin V in 1423 "so that his holiness would maintain the duke in his favor."[44] Thus the presence of tapestries as objects of both nonnarrative richness and texture and diplomatic importance was inseparable from the narrative depicted. Diners become classical subjects.

If we consider the "deep surface" aesthetic of this tapestry as part of the experience of the Feast of the Pheasant's idiom, we should take into account the localized social and economic networks interwoven into the fabric. Katherine Anne Wilson focuses on the "extensive evidence for medieval tapestry"—records that indicate purpose, upkeep, and transport—rather than the aesthetic and stylistic qualities of surviving medieval tapestries that she argues are often "revered" over the documentary evidence.[45] Wilson responds to what she terms the "object-centered approach" of scholars such as Cavallo and develops the work of Léon Laborde in describing the networks of weavers, patrons, cartoonists, and merchants involved in making such a tapestry. Her material study of documentary evidence is in line with other recent historical investigations into the movement of objects, artisans, and raw materials in luxury industries such as silk.[46] In her work on Byzantine silk and Mediterranean visual cul-

ture, Cecily Hilsdale relies on the formulation of "rooted cosmopolitanism" elaborated by Amanda Anderson, Bruce Robbins, and James Clifford to describe how Byzantine silks, as arts of the medieval Mediterranean, were rooted in local cultures as well as positioned in global networks. This view attempts to avoid the view of particularist cultural relativism and the idealized globalized vision of a technocratic or capitalistic universal culture.[47] The documentary evidence of tapestries as mobile, diplomatic objects also coincides with but is distinct from mercantile and crusade networks of gold and silk thread from Venice and Cyprus.

While studies have shown how luxury materials and objects depicted in literary texts shape fiction in complex ways, my study of the Feast of the Pheasant examines a different issue: how things such as tapestries that have their own power and agency and depict narratives are in dialogue with other phenomena at the feast. I adapt the approaches of ethnography such as Clifford Geertz's concept of "thick description" of a sign that increases dialogue among cultures, as well as Bruno Latour's assemblages to tapestry.[48] Tapestries' signs may signify various narratives to their audience, but the physical qualities of these signs and the local networks that make them possible factor into their idiomatic function at the feast.

As a point of comparison, many medieval romances feature luxury materials such as saddles and clothing textiles as a visual commentary on the narrative or to negotiate social class and desire in a rhetorical deployment that may draw from classical ekphrasis but also addresses the concerns of a ruling elite.[49] Although de la Marche's description of the tapestry is limited, historical tapestries such as the one present at the feast offer an aesthetic of a *horror vacui*, a flat ornamental surface plane with crowded figures that fill up the space. This aesthetic and the use of the tapestry (as a usage of the idiom) prompt us to reflect on how such figural narratives were perceived at the feast and in this medium (refer back to fig. 11). The depiction of luxurious cloths in romances can help us only to a certain point: the textiles depicted in the famous Grail banquet of Wolfram von Eshenbach's *Parzival* possess the narrative function of provoking wonder and em-

phasize how Parzival forgets to ask about the Grail. In their exotic quality and fine craftsmanship, they are part of his stupefaction that leads to his grave mistake. In the same way, we can imagine that the artistic detail in a tapestry creates a sensual, nonnarrative effect that we can relate to the atmosphere of the feast even as viewers understood the Christian and political agendas—in Hercules, for instance, as ancestor of the Burgundian nobility. As my main concern is how these phenomenal effects and the narrative of political allegory work together to produce the idiom, the examples we have today that relate to tapestry recorded in de la Marche's account can nevertheless give us a mode of descriptive poetics. In other words, we cannot analyze an extant object, but we can assess its performative mode and apply it to other media at the feast. Is there a difference between experiencing the tapestries in a superficial manner (as deep surface reading) and reading through the tapestries (a figural narrative shaped by the medium of woven threads and its form as a tapestry)? Ultimately the two types of reading are distinct but not mutually exclusive; both modes are essential to the life of the idiom.

As movable objects and diplomatic gifts, tapestries embody networks of people and communal craftwork, but through their aesthetic qualities, they also elicit certain emotive affects for the participants in the feast. Where the idiom is concerned, social and economic relations must be seen with aesthetic qualities. That is to say, the specificity of the tapestry medium accounts for notions of mobility (as an object in movement, wrapped around walls, and woven from material assembled by people from various places) and for modes of reading so that Jason can speak ambivalently as an unrepentant crusader.

THE *MISTERE* OF JASON

So far I have described how the materiality of the tapestry and the political-Christian allegory of Jason exist in the Feast of the Pheasant in a continuum of surface effects, embodied social and economic networks, and allegory that is crucial for articulating the idiom. I

now return to the story of the unrepentant Jason and analyze how he was portrayed in a play that was part of a series of entremets. Although the privileged place of Jason at the feast was not surprising, it was not without controversy: since the founding of the Order of the Golden Fleece, several members of his court spoke out against Philip's choice of an immoral Jason as patron.[50] The poet and "varlet de chambre" Michaut Taillevent, author of the poems "Le Songe de la Thoison d'Or" (1431) and "Le Congé d'amour" (1440), states in the latter that Jason ought to be burned as a disloyal lover. Jason was tarnished by his cruel treatment of Medea: "La desloyauté de Jason / Contre Medee qui l'ayda" (lines 23–24).[51] According to Danielle Quéruel, by the end of the fifteenth century, Jason and Gideon coexisted as two necessary patrons, one secular, who attached the order's crusading expeditions to the history of Troy and the expedition of the Argonauts, and the other a moral and biblical exemplum. In the later accounts of Jason, his expedition to Colchis was moralized as a story of Jason's penitence and redemption, including the acquisition of the fleece as a victory over the enemies of the soul; Medea as a symbol of Christian faith; the island of Colchis a paradise where, like the Holy Land, the sinner can find redemption; and the temple of Jupiter the Church Triumphant.

The series of entremets concerning Jason maintain the Greek hero in his contradictory roles as crusader, chivalric hero, and courtly lover. They take place among other entremets (such as the one of the Holy Church) and are given a special stage. In the first episode, a curtain is drawn back after the sounds of clarions have subsided. The armed Jason suddenly appears walking about in a strange land. He reads a letter from Medea and then does battle with giant bulls, dousing the flames from their nostrils with the help of liquid from a vial given to him by Medea. The chronicle emphasizes his physical prowess and "contenance d'homme de bien" (the appearance of a good man)[52] during a battle that ensues. In the second episode, the curtains are drawn back to show Jason fighting a serpent so fiercely that, as de la Marche comments, it "did not resemble a play [*mistere*] but an all too bitter and mortal battle;"[53] Jason defeats this mar-

velous creature with a ring given to him by Medea. He then cuts off its head and extracts the teeth. In the final episode, the curtains are once more drawn back from the special stage designated for the *mistere* and Jason plows the land, sowing the seeds with the serpent's teeth. Armed men spring from these sown teeth and fight each other. As the imperfect tense indicates, this action continues until all the men have killed one another, as Jason looks on:

> Sourdoient et naissoint gens armez et embastonnez; et regarderent l'ung l'aultre et s'entrecourrurent sus si fierement, qu'ils se firent le sang couler, et en la fin s'entretuerent en la presence de Jason, qui les regarda quant il eust semé les dens; et prestement qu'ilz se furent tous abatuz et occiz devant luy, la courtine fut retiree.

> Armed men were rising up and being born ready for battle; they look at each other and run towards each other fiercely, so that they make blood shed and in the end kill each other. Jason looks at them as they had arisen from the sowed teeth, and presently they were defeated and killed before him, and the curtain was drawn.[54]

Normore notes that the curtain creates boundaries for the play as an "object of contemplation": it transforms the transgressive nature of the "unstable propositions" of unstable bodies as "violently threatening" into a "pleasurable frisson."[55] Studied closely, the fragmentation of bodies and various magical objects are essential to Jason's valor as a knight because his physical powers and the usefulness of his conventional weapons are limited. He needs the vial of liquid that puts out the flames from the bulls' nostrils, the ring to kill the serpent whose head then becomes a talisman. The power of these magical objects culminates in the inanimate teeth that are brought to life by the death of the serpent; inanimate objects become in turn living creatures that then return into lifeless bodies. If the performance of animacy by the powers of magical objects such as vials and rings is contained as an "object of contemplation," then it also suggests Jason's status as a hero within this play of propositions. As an

animated "personnaige,"[56] Jason is the enabling node that allows the animate and inanimate to be in flux. Moreover, whoever plays Jason at the feast as "personnaige" enables the continuum of the idiom, empowered to act out these scenes as he wants, despite the script of Medea's instruction. The script permits variability within the structure of the scenes: the player can act out Jason as a hero of chivalry and prowess, playing up the battle scenes; he can be a dependent lover who reads the instructions of Medea and emphasizes his dependency on her magical devices; or finally the actor can extend the scene of being a contemplative observer who looks upon the men springing forth from the sown teeth and then dying again. Even if the script can be allegorized in terms of the destruction of the warring knights and Jason's decision to leave Medea and his obtaining of the fleece, his role within these scenes and the play within a play (the staging of the curtains within a ritualized feast, etc.) speaks crusade idiomatically. The pleasurable entertainment comes from the oscillation between propositions of life and death, animate and inanimate, courtly lover and valiant knight. Yet it is important to remember that Jason as an unrepentant crusader grounds this frisson as speaking crusades, as a potentiality. Rather than representing Jason morally as a crusader knight who was at the center of the courtly debates around this myth, the play at the Feast of the Pheasant defers this matter and reinforces the ambiguity of what makes Jason a crusader knight. Like the crusader departure lyric and Lancelot in the *Perlesvaus*, then, the *mistere* reconfigures Jason by evading crusader repentance through a certain idiom of prowess, replacing it with powerful acts of love and magic that limn the otherworldly and the earthly, classical myth and Christian allegory.

Thus the entremets of Jason convey the chivalric and allegorical meaning appropriate for the feast but allow for ambiguity as a performance. Jason as entremet enables would-be crusaders to appear to be physically valiant even when they are dependent on external material or magical sources. They appear to be courtly and dependent on the lady and at the same time have the power to transform lifeless things into tools of war. What better way to endorse crusade then

as an object of contemplation, where things can come to life "as if it were a real battle" but then can recede into a fiction? The affective possibilities of the play activate Jason's potential as a crusader-lover and in this way maintain that continuum of the Good as an artistic production resistant to extant moralizing texts with which this *mistere* would have been in dialogue.

TEXTURAL READING: FROM TAPESTRY TEXTURE TO MANUSCRIPT SURFACE

In my last example of a descriptive historical poetics of the Feast of the Pheasant, I examine the paper manuscript of *L'histoire de Jason*, in New York's Pierpont Morgan Library, MS 119, dated to around 1470. Raoul Lefèvre wrote the *Histoire* between 1452 and 1467. The Morgan exemplar is an incomplete version of the parchment manuscript offered to Philip (Arsenal 5067). After the death of the duke, numerous versions were circulated (the parchment BN fr. 331, the paper BN fr. 12570, and Morgan MS 119). The Morgan manuscript contains twelve grisaille miniatures most likely painted by the same artist as BN fr. 12570, known as the Maître du Champion des Dames.[57] Although the Morgan manuscript is dated later than the feast and was not the source of the entremets of Jason, the manuscripts that contain the romances of Lefèvre were commissioned by Philip and reflect significant mentalities and sensibilities regarding the Greek hero that relate to the feast.[58]

I argue that the particular use of grisaille in the Morgan manuscript—the illustrations in pen and ink are overlaid with gold and red colored ink—suggests more than a personal style in figural elaborations of the Jason romance. The absence or limitation of color in grisaille miniatures makes the textural luster and form of the gold and red over the monochromatic color particularly prominent. As Rochmes notes, the use of gold with silver in monochromatic grisaille miniatures of the ducal library indicates an appreciation for the monetary and aesthetic value of these metals at a time when the value of craft in illusionistic paintings should surpass the value of the

material.[59] The elaborated density of gold and red details with this technique of colorlessness renders the idiom as a color texture that sits on the monochromatic surface of the page. In short, the colors of these grisaille manuscripts constitute an idiom as texture.

When comparing grisaille and semigrisaille paper and parchment, Burgundian manuscripts in the artistic milieu of the Morgan manuscript, the gold and red details, flattened perspective, and monochromatic figures of MS 119 are qualities found in other illustrations of paper manuscripts by the Maître, such as this image of the attack of Troy from *Le Livre de Troilus et Brisaida* by Giovanni Boccaccio (plate 2).[60] In a grisaille parchment manuscript of Lefèvre's *Recueil des histoires de Troie* (c. 1468), another Flemish artist called Le Maître aux Grisailles Fleurdelisées heavily applies dark colors so that the grisaille absorbs light and casts all the figures in a shadow, contrasting especially with the gold border details that reflect light (plate 3). Compared to these grisaille manuscripts, the use of gold and red to illustrate the story of Jason in MS 119 is distinctive: the use of gold to signify the Golden Fleece and red for the blood in the Battle of Jacointe, for example, produce the idiom in their textural excessiveness within the genre. Moreover, the reflective qualities of colors used in grisaille paper or parchment manuscripts correlate with the various reflective qualities of thread used in contemporaneous Burgundian tapestries, metal thread reflecting light more than other threads to produce illuminating details. In this way tapestry and manuscript miniatures produce surface effects that compete with, rather than merely serve, mimetic representations. The mode in which colors are perceived, are applied, or interact with various media (wool, silk, paper, parchment) mediates our reading of figures that represent a crusade narrative. In the case of the Morgan manuscript, the rendering of grisaille leads to the apprehension of something other than figural or mimetic representation.

It makes sense that the idiom emerges in the paper rather than the more luxurious parchment manuscripts of the Jason romance: grisaille was an experimental medium in the late medieval culture of France and Burgundy, and the paper medium seems to exaggerate

its qualities. Colorlessness in certain media (tapestries, manuscript illustrations) was a way to "think through knowledge and otherness," to use color experimentally in a world of color taxonomies and labels, as Rochmes describes it.[61] The Burgundian audience was attuned to colors as signifying varying degrees of natural and artificial wonder, as in one entremet of the Feast of the Pheasant where a pie releases live sheep dyed blue with gilded horns.[62] Grisaille as a color could be used to signal otherworldliness or "ontological otherness."[63] Moreover, colors possessed a material nature: in the ducal inventories that list tapestries and manuscripts, the black and white ("de blanc et de noir") of grisaille and the gold of manuscript illustrations refer predominantly to material and technique: the material gold or gold strips wound around silk thread rather than the color gold; white as meaning "left blank," or the lighter side of parchment.[64]

If grisaille was used in altarpieces, wall paintings, and textiles to signify otherness or to question how the senses access the knowledge of the unrepresentable (e.g., angels and other marvels, as in the Getty Museum's *Miroir historial*'s depiction of marvelous creatures such as Sirens and the Virgin Mary with a gold crown), scholars of the technique have remarked that there is no consistent use of grisaille in the various degrees of achromatism. I see this color experimentation as fertile ground from which an idiom can emerge, just as in the situation of the Feast of the Pheasant and its entremets. The choice of monochromatic color indicates a decision not to use other color, for a variety of reasons. For instance, grisaille suggests a certain genre: miniatures commissioned by Philip the Good executed in grisaille or semigrisaille are illustrations of historical texts such as Jean le Tavernier's renowned illustrations for the *Chroniques et conquestes de Charlemagne* transcribed by David Aubert for Philip.[65]

The distinctiveness of the Morgan MS 119's grisaille within the context of the Jason corpus becomes even more striking when one considers how grisaille reflects Philip's efforts to assert his power in the Burgundian artistic and political milieu. Till-Holger Borchert suggests a number of reasons for the "rediscovery of grisaille as a

creative form in manuscript illumination" at this time, including the widespread popularity of grisaille among royal courts and the Duke of Burgundy's efforts to reinforce his power and leadership of the crusades and to claim territorial and dynastic consolidation of his territories. Striving to reinforce their own style within a prestigious medium, the Burgundian dukes made their grisaille manuscripts distinctive and cultivated artists accordingly. Thus the aesthetic and political interests that undergird the Morgan MS 119 relate closely to the Feast of the Pheasant and its particular idiom of crusade and political power. Borchert also suggests that grisaille reinforces the duke's affiliation with his bibliophile father John the Fearless and grandfather Philip the Bold: we can assume that scribes and court secretaries were granted access to historical texts such as the *Jason* and manuscripts with Franco-Flemish grisaille miniature illustrations that were commissioned in the late fourteenth century by Philip the Good's forebears or received from relatives in the context of courtly gift culture.[66] Given these ducal ambitions, and the rich artistic resources of scribes and illuminators from the Burgundian-Netherlandish territories given commissions by the duke, we can imagine how grisaille became an important medium for artistic experimentation and an expression of ducal magnificence.

The visual idiom in Morgan MS 119 exhibits a personal style within the genre of grisaille miniatures for historical texts. It also demonstrates reflection on the art of creating manuscript illustrations—a process of speaking crusades through a specific medium and story. As Rochmes and Georges Didi-Huberman each have discussed, far from being a unified illustrative monochrome and sculptural style (for instance, the use of single colors allowing for greater nuance of three-dimensional figures), grisaille "signifies an experience."[67] Didi-Huberman sees grisaille as a process of *decoloration*, "a process where through time, the color of things lose color."[68] Rochmes extends this reflection that attempts to get away from stable taxonomies and a symbolism of grisaille. She argues that grisaille might be seen not only as a "decoloration or coloration" but also as "decomposition or, instead, as becoming."[69]

In Morgan MS 119, the gold and red color details exist as surface excretions over monochromatic illustrations that foreground process. Here I use the word *excretions* ontologically in that they refer toward signification (the otherworldliness of gold, the sacrificial violence of blood) but also exceed those meanings: in their material and technical nature as gold and red surfaces on the monochromatic page, they refer to the three-dimensionality of sculpture and metalwork related to grisaille. The grisaille in the Morgan manuscript embodies the material framework in which red and gold colors speak something else: an idiom that utters an unconceptualized, vaguely formed mode out of colorlessness, a coming into being of sacrificial violence and desire for monetary luxury bound to the ducal crusade ambition through the application and material surface of gold and red.

The technical application of these colors and the theoretical nature of grisaille in Burgundian visual and material culture support this speaking crusades through the red and gold details. If one compares the Morgan miniatures with the full colored miniatures of the autographed manuscript of *L'histoire de Jason*, the parchment manuscript Arsenal 5067, the use of noncolor in 5067 clearly signifies flesh, as in the miniature of Jason flaying the sheep on folio 105, and Medea throwing body parts into the sea on folio 117v (plates 4 and 5). In contrast to this representation of living flesh and bodies that exist versus nonliving objects or things in a hermeneutic of sacrifice, the grisaille of Morgan MS 119 gives the colors of gold and red a different status. The noncoloredness of grisaille manifests the material nature of the colors: for instance, the miniature in MS 119 depicts the Golden Fleece as an animal with thickly laid gold rather than a flayed creature with bare parchment as flesh in Arsenal 5067 (plate 6). One of the first stages in creating a miniature, gold leaf was applied after the drawn outline made of a common type of dark ink (as well as possibly other tinted inks, including white for highlights) but before the other colors, so grisailles with gold can resemble an unfinished manuscript such as in a Book of Hours in the Free Library of Philadelphia (plate 7). While the Morgan miniature

does not have this same kind of unfinished appearance, the particular application of gold foregrounds the process of representing the Golden Fleece as a symbol of crusade and its status as a sensual thing represented through costly material. In MS 119, the Golden Fleece exists as a fleece that results from a sacrificial act of flaying, but it also exists as gold material. Probably painted first after the initial outline, it has a primary existence in the miniature; without the narrative of flaying depicted in the full-color manuscripts, the Golden Fleece floats among a chaotic, violent scene of bulls and warriors as a fleece that speaks rather than symbolizes gold. Rather than a Golden Fleece, the gold fleece emerges from the page as a material substance detached from any fixed meaning.

Unlike the gold details, red in MS 119 is not contained within the ink lines and is deliberately unformed as bodily excretions of fire from beasts' nostrils, as in the Battle of Jacointe on folio 74 and the image of the fire-breathing bulls on folio 66v (plate 8, earlier plate 6). In the color parchment manuscripts, the color red as blood is carefully integrated into a coherent representation that uses colors for perspective (e.g., grisaille for architectural volume) and narration, as in the scene with Medea as she places her dismembered brother into the sea in the full-colored Arsenal 5067 fol. 117v, red representing blood and parchment the flesh of the figures (earlier plate 5). In another way, red represents regalia or decorative details rather than blood in the battle of Jacointe in BN fr. 331, folio 83, or in the tent and standard of Arsenal 3326, folio 101 (plate 9, earlier plate 2). These color manuscripts attenuate violence because the color details are absorbed into a narrative of mythological sacrifice and Christian piety. They call attention to themselves not as surface details but rather as ornamental effects interpreted within the larger color scheme and figural representation. In contrast, the unbounded use of color against the grisaille background and insistence of detail in Ms. 119 articulates an immediate desire, the quest for carnal rather than spiritual goods.

Further, when comparing Morgan MS 119 to the other manuscripts of *L'Histoire de Jason*, its use of grisaille is distinctive in that

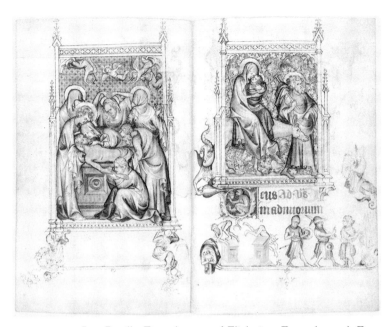

FIGURE 12. Jean Pucelle, Entombment and Flight into Egypt (c. 1330). From *Book of Hours of Jeanne d'Evreux* (fols. 82v–83). Grisaille, tempera, and ink on vellum. Paris, France. The Cloisters Collection (1954). Photograph: Metropolitan Museum of Art, New York.

it de-emphasizes the architectural qualities used in the parchment miniatures, where the technique reinforces sculptural volume and spatial perspective: for instance, in the semigrisaille BN fr. 331, grisaille is used effectively to illustrate the sculptural details of buildings. In contrast, the use of gold and red in MS 119 emphasizes how grisaille flattens the perception of volume and mass. To understand the creativity of MS 119's artist, it is helpful to compare his work to others. For instance, the Maître of MS 119 might have used the flattened plane of grisaille to maximize the textural surface effects of the colors. The delicate gray grisaille in the fourteenth-century Book of Hours of Jeanne d'Evreux by Jean Pucelle demonstrates the two styles of grisaille seen in BN fr. 331 versus MS 119: on folio 83 (fig. 12), we see sculptural qualities similar to the grisaille of BN fr. 331, but the artist also uses the technique to work against three-

dimensionality.[70] In her discussion, Rochmes argues that Pucelle's miniature "test[s] the limits of his medium of manuscript illumination through unusual configurations of color and space."[71] The execution of the architectural frame as ink lines in contrast to the voluminous figures and their colored background within the frame allows the artist to play with different perceptions of space: the figures represent three-dimensional space while the frame insists on flat surface. Joseph's foot in the bottom right corner seems to advance out of the frame but also recedes behind it. The grisaille flatness of the frame competes with another kind of grisaille where shading and colors of the figures give them three-dimensional volume. Further, as Rochmes observes, this miniature demonstrates the use of grisaille to evoke other media—as where the bluish accents of the grisaille background of the miniature suggest enamel. Here the grisaille also reflects the contemporary visual culture of reliquaries, glass roundels, tableware, and metalwork. In one striking example, the sixteenth-century silver-and-gold clasp of a fifteenth-century Book of Hours made in Bruges, now held in the Royal Library of Belgium (KBR MS 145, fols. 75v–76), echoes the silvery appearance of grisaille.[72] These examples of various uses of grisaille and the proximity of the style to other media suggest that readers of Morgan MS 119 were attuned to this experimental use of grisaille as a particularly Burgundian idiom under Philip.

This close aesthetic relation to other media and the experimental use of grisaille support the Morgan miniatures' resistance to a figural or hermeneutic of color; that is to say, the gold and red do something more than signify otherworldliness and sacrifice. These colors evoke monetary value and sensory perception of violence in a stage of being represented as an image—in the red's formlessness over a flattened background and the gold's thickness. Pascal Schandel explains that because the Maître was very likely an artist working in other media such as tapestry, his technique as a painter of grisaille miniatures with surface effects converges with the interwoven surface of the Hercules tapestry. Schandel sees the Maître's hand in a tapestry, *La Tenture des Sauvages* (*Tapestry of the Wild*), now housed

at the museum of the Château de Saumur.[73] In the style of the Maître, Schandel comments that

> si la tenture offre une densité et une prolifération de motifs conformes aux tapisseries de l'époque, ne laissant aucun espace vide, chacun d'eux, pris isolément, révèle le répertoire formel et les exagérations du Maître du Champion des Dames. Cartonnier, le peintre put livrer les producteurs de tapisserie, dont on sait qu'ils étaient nombreux à Lille.

> if wall coverings offer a density and proliferation of motifs conforming to other tapestries of the period, not leaving any space empty, each of the [two fragments of the *Bal*] taken separately, reveals the formal repertory and exaggerations of the Maître du Champion des Dames. As a cartoonist he could render [his services] to tapestry producers of which there were many at Lille.[74]

As this master was "polyvalent" and solicited by bibliophiles, he could make cartoons of tapestries but also engage his talents in other pictorial activities.[75] While sharing the aesthetic of a flattened surface plane with the *Tenture des Sauvages* and the tapestries related to the Hercules tapestry of the Feast, the grisaille of Morgan MS 119 speaks crusade differently from the tapestry medium. Yet both media rely on the attenuation of perspective and volume that would support a historical or figural narrative, or a representation of a hypotactic text with a before, during, and after—that is to say, a visual hierarchy of information that coheres into a unified narrative. Looking at these miniatures was perhaps a similar experience to that of the Emperor Manuel looking at a tapestry, his eye moving from one pleasurable detail to the next. If Manuel's experience becomes lyrical "springtime" mediated by the form of the tapestry, the grisaille of MS 119 embodies this lyrical experience of crusade.

TEXTURAL DESCRIPTION: TAPESTRY AND
GRISAILLE AS COURTLY CRUSADE IDIOM

Gold-wrapped silk thread in the tapestry of Hercules produced sur-
face effects of shimmering luminosity that elaborated the design of
the flat surface patterns without creating perspectival depth. As an
analogue of what I call a *textural surface elaboration*, the gold and red
details of Morgan MS 119 are raised from the surface of the page,
making us more aware of the density of these colors in relation to the
flat plane of monochromatic illustrations. This color texture creates
outward effects in a different way from the deep surface of the tap-
estry. A surface materiality of ink rises upward from the monochro-
matic page, inverting the interwoven "deep" texture of the tapestry's
shimmering gold silk thread.

The surface quality of the miniatures in MS 119 directs our at-
tention to materiality and wealth—blood and gold—in a way that
is not phenomenally subsumed by the narrative and compositional
frames of the other, more costly parchment manuscripts of *L'His-
toire de Jason*. In Arsenal 5067 and BN fr. 331, the full-color minia-
tures contrast background with foreground and represent surfaces
rather than manifesting them from the page as MS 119 does. For
instance, on folio 52v of BN fr. 331 (plate 10), we see many diverse
scenes in the foreground and background and material surfaces. In
contrast, the graphic flatness of MS 119 collapses background and
foreground in a way that does not permit the narrative temporality
of BN fr. 331, and the gold and red act as the architectural surface of
the manuscript page rather than the surface of a visual representa-
tion of a building. One can see how this flatness functions in another
comparison: folio 2 of Morgan MS 119 that depicts Jason and King
Aeson (plate 11) and the dedicatory page folio C of Arsenal MS
5067 (plate 12). The miniature of MS 119 shows the Maître's famil-
iarity with tapestry such as the *Story of the Trojan War*, which I dis-
cussed earlier, as he gives the same checked pattern to the costume,
floor, and throne. While the miniature does not contain the same
crowding of figures and architecture as that tapestry, the uniform

pattern creates a flattened effect similar to those tapestries in which the mortar in the walls of the palace is continuous with the figures and the furniture. This grisaille effect of architecture and figures on the same plane contrasts with the opening miniature of Arsenal 5067 that depicts the presentation of the romance. The figures stand out from the floor and architectural details through their dark clothing; spatial perspective creates a contrast between the interior room and the outside scene. Moreover, a tapestry hangs in the background with a graphic design as a separate object, another feature that gives perspective and depth different from the flatness seen in MS 119.

Like the entremet of Jason, MS 119 contains scenes that underscore Jason's chivalry and courtliness, such as his fight with the giant Corfus, his gesture of vassalage to King Aeëtes of Colchis on folio 78v, and his public vow to fight the King of Esclavonie before Queen Mirro and other knights on folio 24. There are only two miniatures in BN fr. 12570 and MS 119 that differ: the illustration of Apollo informing Mena about the death of her husband Zechius in BN fr. 12570 (fol. 108) has been replaced by the marriage of Apollo and Mena, in MS 119 (fol. 70v); and instead of the promises exchanged by Jason and Medea in BN fr. 12570 (fol. 139), MS 119 features a scene that depicts a priest applying unguent to Jason's leg in a temple where an ox is sacrificed before a statue of Mars (fol. 92).

The replacement of the exchanged promises in the bedroom scene with the temple scene suggests that the artist wanted to deflect our attention from Jason's betrayal of Medea with his piety and chivalry (his determination to go on the quest anyway and the ritual sacrifice). MS 119 reinforces Jason's love for Queen Mirro rather than Medea: his continual devotion to her despite having to depart for crusade is appropriate for the idiom. This difference of scenes in the two paper grisaille manuscripts, seen with the excretions of blood and gold in the miniatures that treat crusading sacrifice and violence, collectively articulates a material residue of Jason's betrayal of Medea for the sake of his crusade for the Golden Fleece, despite mimetic efforts to demonstrate his spiritual conversion through the acquisition of the fleece.

Like the association of Jason with Gideon, his devotion to Mirro corrects his betrayal of Medea as an appropriate self-exile of erotic sacrifice. This movement of conversion occurs in the crusade departure songs I discussed earlier. Like the crusader-poets who leave their ladies behind, Jason leaves Medea behind as an explicit professional avowal of his "vocation" as a crusader knight reformulated to fit the narrative of the Greek Argonauts. And like those departure lyrics, the discrepancy between the manuscripts articulates the residual consciousness of his self-exile and departure, the trace of his turn. He professes to Mirro:

Ma dame, vous m'avez fait assez de courtoisiez . . . je ne demande point les grans tresors qui sont es habismes des mers, ne ceulx qui sont es montaignes enclose. Mon desir s'arreste en deux choses singulieres; l'une a conquerre nom en armes, qui doit estre l'appetit de *la vocacion* de tous nobles cuers, l'autre obeyr aux commandemens et plaisances d'Amours qui me lye et obleige a estre vostre, a vous penser, a tendre a vostre bienvoeillance, a faire chose qui plaise a vos yeux et a vostre hault cuer.

My lady, you have given me enough courtesies . . . I do not ask for great treasures that inhabit the sea, or for those that are hidden in the mountains. My desire is settled on two singular things; one is to conquer a name in arms, that must be the hunger of *the vocation* of all noble hearts, and the other is to obey the commandments and pleasure of Love that leads me and obliges me to be yours, and to think of you, and to tend to your goodness, and to do something that is pleasing to your eyes and your noble heart.[76]

Here Jason avows his double dedication to "two singular things": first, he must make a name for himself through chivalrous acts that are the "vocacion" of those with noble hearts, and second, he must serve the commandments of Love. This double dedication recalls the figure of Lancelot in "Aler m'estuet" who has the "doubled reward"

of his beloved and spiritual redemption. While Jason does not say these two goals are contradictory (indeed, they seem complementary because both can be seen as worldly objectives), his continual dependency on and love for Medea after this declaration make them contradictory as this necessary relationship compromises the allegory of the Golden Fleece as spiritual redemption.

Further, while Jason's professional avowal—his "vocacion"—follows the courtly convention of the knight who adapts the service of love to inspire and valorize his chivalrous and pious acts (as Mirro falls in love with him by virtue of his prowess), the blood and gold effects of the MS 119 miniatures disrupt this conversion story. These effects remind us that the two goals of chivalry and love might be in competition for the courtly crusader as we experience them through the manuscript effects as "two singular things." The grisaille texture translates Jason's vocation for these two things. The visual narrative of MS 119 emphasizes Jason's love for Mirro over Medea, a move that would seemingly defer the troublesome depiction of Jason as a traitor to his lover. However, the gold of the Golden Fleece and the blood of battle scenes and sacrifice lie on the page as a material excess that emerges from the "vocational" speaking of Jason. That is to say, the conversion is incomplete, and the experience of the reconfiguration from earthly to spiritual love leaves a textural residue. For example, in the miniature of King Apollo of Colchis and Mars on folio 66v (earlier plate 6), we see the bodies of the soldiers scattered on the field, flames emerging from their armor as they burn from the fires out of the bulls and a triple-tongued dragon. Without a perspective to frame the action, our gaze is drawn to a golden beast in the upper-right corner, the sheep with the Golden Fleece. The luminosity and thickness of the gold paint is of the same substance as the gold framing of the miniature, and it also appears in several miniatures, such as the gold crown that appears on an altar in the wedding of King Apollo and Mena on folio 70v. But here we notice the excessiveness of the gold ink here as a thick surface on the paper. This surface thickness, the texture, demonstrates how

the Golden Fleece—as not just a figure or emblem but a material, untranslatable *thing*—is the obsession of the romance that erupts at this narrative moment.

Likewise in the miniature of the civil war in Jacointe on folio 74 (earlier plate 8): red blood spurts out of dismembered armed bodies and has a thickness over the gray colors of the grisaille miniature. Examined closely, the blood has a texture different from the rubrication just beneath the miniature. While the paper absorbs the red ink there, in the miniature the red ink sits on top of the drawing, an excessive substance that emerges from the mimetic representation of violence. Both the gold of the Golden Fleece and the blood of the civil war embody the textural idiom that is the speaking of Jason's desire as at once "deux choses singulieres" (two singular things) that are never resolved—his vocational appetite as crusading knight and his service to the commandments and pleasures of Love. They are also the gestural phrases of the unstable nature of crusade as a thing outside of rational, rule-bound laws and ideological justification. Fragmented bodies spew substances that are not contained by political or moral boundaries visually and verbally represented in the miniature and text.

Substances emerging from the page, and from fragmented bodies: we saw this idiom occur in another mode in the *mistere* of Jason, where he functions as a node between animate and inanimate things. It occurs in yet another mode in the miniature of Medea throwing her brother's body in pieces into the sea on folio 102v in Ms. 119 (plate 13). In a boat across from her we see her father Aeëtes with his golden crown. Compared to the depiction of this same scene in Arsenal 5067 on folio 117v (earlier plate 5), the use of red in Morgan MS 119 draws our attention to the decapitated head spewing blood over partial limbs in the sea with similar blood gushes. The Arsenal manuscript gives less emphasis to the blood and bodily parts than to the two ships facing each other, with people in contrasting colors and finely detailed dress. Again the perspective and gradations of multiple colors in the landscape that narrate a moment of sacrifice—Jason must leave Medea because of her treacher-

ous act against her brother—contrast with the minimalist red and gold effects of the Morgan manuscript (BN fr. 12570 has the same blood effects in the miniature of the same scene). In MS 119, gold is used for the Golden Fleece and for royal crowns; the use of gold and red together, and few other colors, starkly renders the human cost in making these objects of power. Further, this use of color renders the physical and spiritual costs in making political entities such as the Burgundian state and of investing in a crusade ideology. However one reads or registers them in the story of Jason, one notices these "stray details" of color as textural effects of the idiom.[77]

Together the tapestry and MS 119 embody the idiom through an emphasis on surface effects in different media. In concert with the entremets of Jason, these effects convey the material luxury and exoticism of the Orient and the bloody violence implicit in the crusading ambitions of the Burgundian court. In the specific case of the Morgan grisaille, the colors that represent the physical acts and bodily excretions of violence and sacrifice erupt as textural surface. The translation of the Jason romance in the Morgan miniatures cannot contain these irreducible material particularities of speaking crusades through the Jason story, seen especially in the moment of Jason stripping away the fleece in Lefèvre's text:

> puis l'escorça et mist le veaurre, qui avoit la laine de fin or, a une part, et le corps il despieça par menbres et l'apporta sus un autel assiz au dehors du temple

> Then he (Jason) stripped it and put aside the fleece that had wool made of fine gold, and the body he dismembered into pieces and carried it to the altar placed before the temple[78]

Rather than illustrating this scene as the color manuscripts do (see earlier plate 4), by depicting the Golden Fleece as a solid gold object, the Maître registers the fascination with crusade—its material and sensual qualities—in the thickness of gold and unbounded red excretions. Even when in MS 119 we see a supposed rehabilitation

of Jason's soul and body such as on folio 92 (plate 14), where a priest heals Jason in the Temple of Diana, and flames emerge from the burning ox on the altar, the spare use of red recalls the flames emerging from the nostrils of the bulls with the Golden Fleece and the sacrifice of the men in that scene on folio 66v (earlier plate 6). Thus the sacrificial fire of the ox in this miniature recalls the blood of human sacrifice in pursuit of the Golden Fleece in the other miniature. Finally, a comparison of narrative representation in the manuscript corpus—complementary to the analysis of illustrations—supports the idiom of MS 119 and the ambiguity concerning Jason as a model crusader. Is Jason completely converted and healed, as the application of unguent by the priest suggests? The fact that BN fr. 12570 shows Jason and Medea together instead of Jason in a pious and healing moment in the temple with a priest suggests an uncertainty among the artists about Jason's status as a hero.

CONCLUSION

These surface descriptions of tapestry, *mistere*, and manuscript should make us more attentive to the specific aesthetic situations and media in which a text, the romance of Jason, is experienced by its Burgundian public. Surface description of the idiom as texture and deep surface suggests how and in what forms and modes this "text" comes to life. Such context-specific descriptive practice is necessary when we consider that many crusade romances were probably performed as depicted in the *Grandes chroniques de France* (earlier fig. 8). During the thirteenth century, chronicles attest to how Arthurian prose romances such as *Lancelot* were performed at courtly festivals from England to the Latin East. The Templar of Tyre relates such courtly performances among the Frankish aristocracy in Outremer, such as the festivities after the coronation of Henry II of Lusignan as King of Jerusalem in 1286 in Acre. These performances drew from Arthurian texts liberally, as certain scenes and episodes might come from versions either produced in Europe or overseas for an elite Frankish audience.[79] They included social satire that resonated for

the local audience, such as jousting knights dressed as women (from the *Realm of Femenie* or *Realm of the Amazons*, well known in the thirteenth century), perhaps ridiculing the effeminacy of knightly values.[80] In the celebration related by the Templar, knights impersonated nuns who were with monks and played characters from the Round Table such as Lancelot, Tristan, and Palamède. These festivities of the Round Table involved regulated jousting with blunt instruments, music, dancing, and feasting. The chivalric game of the Round Table evoked the spirit of Arthurian literature, but without the spiritual implications of the quest for the Holy Grail. In addition to this festival in Acre, we know of a Round Table held in England in 1252 recorded by Matthew of Paris.[81] Just these few examples suggest the complexity of these performances in which knights impersonated heroes. Performed as satire, affirmation of knightly values, or practice tournaments, they recall the liminality of the entremets in the Feast of the Pheasant.

Like the Burgundian situation, these performances of knightly values and collective self-identification were likely important in areas of political contingency such as Burgundy and of multiple linguistic, ethnic, and religious groups such as the Latin East. Suggesting that multimedia festivities were a significant mode of transmission of these texts, the Outremer and Burgundian situations prompt us to consider versions of such an idiom in similar modes. If dramatic spectacles and sensuous material textures were essential to these courtly situations, we need to inquire into their nature as something other than instruments for conveying representations of romances and chronicles. The case of the Feast of the Pheasant demonstrates that the idiom becomes visible when we apply imaginative and capacious methods of reading objects and texts, including ones that we must reconstruct from archival records.[82]

Toward a More Complex View of Crusade

IN THIS BOOK, I hope to have shown that the courtly crusade idiom, embodied in various forms of speaking, manifests complex responses to holy war and to becoming a holy warrior. It proposes a method that can be applied to a variety of cultures and traditions.[1] Literary figures resist the simple instrumentalization of ideas. Through its figural resilience and what I have been calling *textural residues* in diverse media, the idiom maintains conflicting value systems and resists orthodox ideologies that flatten multiple perspectives of human action and history. In attempting to recover the complexity of the idiom, I assemble a critical community of readers that poses questions, refuses given narratives, and shifts the focus from historical events under the rubric "crusade" to the speaking particular that asks: What is the event? What is the subject? I ask not whether the courtly crusade idiom resulted in crusade. Rather, I ask: What did these songs, objects, and events such as the fall of the Latin East and the Feast of the Pheasant embody? What were lyric and art working through? To render the moment of departure before crusade more complex—that is, to see a "crusader-poet" in various cultural and material milieux, the unrepentant crusader as responding to something or someone in a way that we can only partially recover through poetic language—is to offer an account of crusade that refuses to be easily appropriated by successive ideological movements, especially those that depend on fantasies that create a collective identity through the exclusion of and violence against others.

Poets adapted the language of courtly love and feudal knighthood to ready themselves for crusades: "crusades" might be the act of going overseas for a spiritual cause, or a mixture of feudal and

political ambitions, and a belief in Christian redemption. The idiom registered in diverse ways practical concerns for one's own well-being, regretful departures from loved ones, and concern for things left behind—through the lyrical voice of the abandoned woman, or the manuscript transmission of a professional troubadour such as Raimbaut de Vaqueiras. Showing how a subject speaks ambivalently about crusade via poetic language, art, and song can contribute to the cause of making modern communities that embrace social justice and diversity in religion and race. Descriptive historical poetics recovers personal voices that are in the process of reaching out to communal goals. We can apply this poetics to many places and times (including studies that involve various cultures and their literary idiom), thereby paying attention to the language and artistic conventions in which people think through religious beliefs and political acts. This procedure demands a critical awareness and historical consciousness that precludes our judging past and current movements solely by their political and physical actions, even if ethically we are bound to do so in some way. It resists being drawn into the interpretive mode that simplifies ideas to summon fear, cultivate ignorance, and commit violence. The idiom is a resilient medium through which conflicting personal beliefs must pass in order to come to a common view. It cultivates debate and dialogue—between the lady left behind and the man leaving, among various selves that constitute personhood, and among readers, viewers, and participants. Through this common poetic language that is constantly refigured into new constellations, we trace the formation of broad ideologies and their dissemination developed from divergent and personalized worldviews.

The personal path to conversion and how people write that path, no matter the empirical starting and ending point, such as departure from the West or religious holy war enacted in another place, deserve particular attention through description. On the one hand, the hesitant movement of the pilgrim that we saw lyric capture so well; on the other hand, the unwavering confession of Lancelot's *volenté* as a form of right intention against contritionist models—these

moments complicate the crusader intention. Likewise, the method of adjacency makes us pause as readers: we become aware of how we read the documents of crusaders, and how those documents make the crusader. Should we morally and ethically judge past and present holy warriors by those end points that align with dominant narratives of crusade such as the Holy Grail or the ideology of militant knighthood that advocates violence against the Other at all costs? Perhaps we must, but nevertheless we should pay attention to these stories and lyrical moments — not only what they say but how they say (tapestries, grisaille details, and entremets included) — and the imaginative energies they release and nourish. Despite teleological points that create tension between literary interpretation and ethical concerns, in this book I argue that if we mean to approach the question of how people are drawn to certain spiritual orders and resist ambivalence, the equivocal movement and modes of the subject ought to be brought to light. This study hopes to turn the creative energies inherent in the idiom away from these simplified narratives and toward better political and moral ends. The process of constructing piety through literary language and art takes paths that we must acknowledge and describe. We do this in order to come to a common ground of talking about the subject of crusade, both in its past forms and in its contemporary versions.

ACKNOWLEDGMENTS

This book would not have been possible without the intellectual, spiritual, and moral support of many colleagues and friends. Many people offered advice, observations, and criticisms that crucially shaped the direction of this book, notably Susan Boynton, R. Howard Bloch, Matilda Tomaryn Bruckner, Bill Burgwinkle, Mary Channen Caldwell, Markus Cruse, Topher Davis, Daisy Delogu, Marilyn Desmond, Mary Franklin-Brown, Simon Gaunt, Jane Gilbert, Miranda Griffin, Noah Guynn, Bruce Holsinger, Sarah Kay, Bill Kennedy, Sharon Kinoshita, Irit Kleiman, Patrick Kozey, Niklaus Largier, David Lummus, Tom O'Donnell, Peggy McCracken, Bob Mills, Barbara Newman, Steve Nichols, Julie Orlemanski, Linda Paterson, Nicholas Paul, Jürgen Pieters, Dan Reeve, Zrinka Stahuljak, Jesús Rodríguez-Velasco, Luke Sunderland, JoAnn Taricani, Simone Ventura, Julian Weiss, Courtney Wells, and Michel Zink. Invigorating collaborations with Martin Aurell and Estelle Ingrand-Varenne gave me the opportunity to present elements of this project to diverse audiences and expand the scope of the book. Anonymous readers for the University of Chicago Press understood the project and gave me concise and thorough criticisms. I appreciate the continual support and common sense of my editor, Randy Petilos, the careful eye of Lori Meek Schuldt, and the staff at the press. I am indebted to the friendship and lively conversation of my community in the Bay Area past and present, especially Dominic Brookshaw, Jin Chow, Justin Daniels, Kathryn Dickason, Chloe Edmondson, David Hult, T. S. Dawson Lee, Sepp Gumbrecht, Robert Pogue Harrison, Gavin Jones, Alexander Key, Shawn Lee, Mae Lyons-Penner, Christine Onorato, Tom Owens, Heath Rojas,

Johannes Junge Ruhland, and Nariman Skakov. I am thankful to my family—Christina Galvez, Paul Galvez, Marietta Galvez, and Domingo Java—as well as to my dance circle: S. Jean Lee, Daisy Wang, Divya Sharma, Cythia Solis, and Yu-Wen Chen. John Bullock, Stephanie Choi, Paul Levine, and Noam and Sarah Pines have also supported me through the years. The musical and familial conversations with Gérard Zuchetto, Sandra Hurtado-Rós, Thierry Gomar, and all of the Troubadours Art Ensemble have kept me close to the essence of medieval culture. The Spin City community centered around Maricar kept me caffeinated and grounded in the most essential way, at the most crucial stage of the project.

The Stanford Humanities Center gave me a productive year to formulate the argument of this book, and a week at the Camargo Foundation allowed me to connect with dear colleagues who offered advice and encouragement that proved invaluable. The France-Stanford Center for Interdisciplinary Studies and Center for Medieval and Early Modern Studies at Stanford supported conferences with the University of Poitiers that made interdisciplinary thinking an integral part of the project. I presented portions of this book at the following forums: the Center for Late Antique and Medieval Studies at King's College London, the Group for Early Modern Studies Graduate Seminar at the University of Ghent, the Medieval Studies Workshop at the University of Chicago, the Medieval Lecture Series at University of Virginia, the Institute for Cultural Inquiry in Berlin, the Seminario di Filologia Romanza at the Fondazione Ezio Franceschini in Florence, the Mediterranean Studies Seminar at Center for Medieval and Renaissance Studies at the University of California, Los Angeles, the Poetics Workshop at Stanford University; the annual meetings of the International Congress on Medieval Studies, the Modern Language Association, and the Medieval Academy of America; and conferences at Binghamton University, Fordham University, and Northwestern University. I was honored by these invitations, each of which gave me the occasion to rethink parts of the book with engaging audiences.

For use of their archives and materials, I thank these institutions

and their curators: the Bibliothèque nationale de France; the Archives Nationales (France); Bibliothèque royale de Belgique, Brussels; the Morgan Library and Museum; the Zentralbibliothek, Zurich; the British Library; and the Rare Book Department of the Free Library of Philadelphia.

The memory of my father, Alberto Galvez, undergirds this book. My best interlocutor and intellectual partner is my husband, Roland Greene, who saw this book through to its conclusion. His persistent support and encouragement helped me find my resilience. *The Subject of Crusade* is for him and our daughter, Eleanor.

Portions of chapter 1 appeared in earlier form in my article "The Voice of the Unrepentant Crusader: 'Aler m'estuet' by the Châtelain d'Arras," in *Voice and Voicelessness in Medieval Europe*, ed. Irit Kleinman (New York: Palgrave, 2015), 101–22, and is reproduced with permission of Palgrave Macmillan.

NOTES

INTRODUCTION

1. Scholars have rightly complicated this term in recent years from various angles, depending on sources and cultural contexts, and the bibliography on crusades from a historical perspective is vast; recent titles include Philippe Buc, *Holy War, Martyrdom, and Terror: Christianity, Violence, and West, ca. 70 C.E. to the Iraq War* (Philadelphia: University of Pennsylvania Press, 2015); Christopher MacEvitt, *The Crusades and the Christian World of the East: Rough Tolerance* (Philadelphia: University of Pennsylvania Press, 2008); Megan Cassidy-Welch, ed., *Remembering Crusades and Crusading* (London: Routledge, 2017). For studies on crusades and their historiography, see Jonathan Riley-Smith, *The Crusades: A History* (New Haven, CT: Yale University Press, 1987); Steven Runciman, *A History of the Crusades*, 3 vols. (Cambridge: Cambridge University Press, 1951–54); Elizabeth Siberry, *Criticism of Crusading: 1095–1274* (Oxford: Clarendon Press, 1985); Christopher Tyerman, *The Invention of the Crusades* (London: Macmillan, 1998). Finally, David A. Wack's *Medieval Iberian Crusade Fiction and the Mediterranean World* (Toronto: University of Toronto Press, 2019) provides an important study of crusade culture and fiction in the Iberian context.

2. See Richard W. Kaeuper, *Holy Warriors: The Religious Ideology of Chivalry* (Philadelphia: University of Pennsylvania Press, 2009); see also Simon Thomas Parsons and Linda M. Paterson, eds., *Literature of the Crusades* (Cambridge: D.S. Brewer, 2018).

3. Gilles of Rome, *De regimine principium* (Frankfurt: Minerva, 1968), 2.2.c.7; quoted and translated in Charles F. Briggs, *Giles of Rome of Rome's "De Regimine Principum": Reading and Writing Politics at Court and University, c. 1275–c. 1525* (Cambridge: Cambridge University Press, 1999), 74.

4. Paul Alphandéry and Alphonse Dupront, *La Chrétienté et l'idée de croisade*, 2 vols. (vol. 1 1954, vol. 2 1959; repr., Paris: Albin Michel, 1995), Postface, Michel Balard, 580.

5. Roger Bacon, *"The Greek Grammar of Roger Bacon," and a Fragment of His Hebrew Grammar, Edited from the MSS with Introduction and Notes*, ed. Edmond Nolan and S. A. Hirsch (Cambridge: Cambridge University Press, 1902), 27. See also Barbara Cassin, ed., *Dictionary of Untranslatables: A Philosophical Lexicon* (Princeton, NJ: Princeton University Press, 2014), "For Bacon, a substantially unified *lingua* is diversified accidentally into different *idiomata* (for example Greek splits into Attic Greek, Aeolian, Doric, Ionian) . . . each idiom has its own distinct traits (*proprietas*), which is precisely why it is called *idioma*, from *idion* (proper), from which the word *idiota* is derived" ("Language," 548). For Aquinas's use of locution, see Christopher M. Brown,

"Thomas Aquinas (1224/6–1274)," in *Internet Encyclopedia of Philosophy*, accessed January 17, 2019, https://www.iep.utm.edu/aquinas/.

6. Bacon, *Greek Grammar*, 26.

7. Cassin, *Dictionary of Untranslatables*, 548.

8. Verbal categories such as to reason, to know, to describe, to narrate, to question, to show, and to order. See Jean-François Lyotard, *Le Différend* (Paris: Les Éditions de Minuit, 1983), 10.

9. Lyotard, *Le Différend*, 24–25.

10. Lyotard, *Le Différend*, 29.

11. The courtly crusade idiom's formulation within these discourses of crusade, penance, and courtly love during this historical moment may be productively compared to David Lawton's idea of "public interiorities" as a "process of revoicing" (9), and Mary Carruthers's idea of memory as a "socializing" practice that uses oral and written texts to create community (10–13); I acknowledge the influence of these works throughout my discussions of voice, textuality, and memory, especially in chapters 1 and 6 where I specifically address voice and confession, and then tapestry and manuscript as a certain type of textuality ("deep surface" and "texture"). See David Lawton, *Voice in Later Medieval English Literature: Public Interiorities* (Oxford: Oxford University Press, 2017); Mary Carruthers, *The Book of Memory: A Study of Memory in Medieval Culture* (Cambridge: Cambridge University Press, 1990).

12. Cecilia Gaposchkin, *Invisible Weapons* (Philadelphia: University of Pennsylvania Press, 2017).

13. William Chester Jordan, "The Rituals of War: Departure for Crusade in Thirteenth-Century France," in *The Book of Kings: Art, War, and the Morgan Library's Medieval Picture Bible*, ed. William Noel and Daniel Weiss (London: Third Millennium, 2002), 98–105; Jonathan Phillips, *The Fourth Crusade and the Sack of Constantinople* (London: Jonathan Cape, 2004).

14. See Kaeuper, *Holy Warriors*; John W. Baldwin, *Aristocratic Life in Medieval France: The Romances of Jean Renart and Gerbert de Montreuil, 1190–1230* (Baltimore: Johns Hopkins University Press, 2000), esp. 194–247. For military religion among crusaders, see David S. Bachrach, *Religion and the Conduct of War c. 300–1215* (Woodbridge, UK: Boydell Press, 2003). For homiletic literature in Old French, see Michel Zink, *La Prédication en langue romane avant 1300* (Paris: Champion, 1976). The foundational study of penance in medieval French texts is Jean-Charles Payen, *Le Motif du repentir dans la littérature française médiévale (des origines à 1230)* (Geneva: Droz, 1967).

15. Louise Riley-Smith and Jonathan Riley-Smith, *The Crusades: Idea and Reality, 1095–1274* (London: Edward Arnold, 1981), 64–67; Runciman, *History of the Crusades*, 2:471–72.

16. Linda Paterson, in collaboration with Luca Barbieri, Ruth Harvey, and Anna Radaelli, *Singing the Crusades: French and Occitan Lyric Responses to the Crusading Movements, 1137–1336* (Cambridge: D. S. Brewer, 2018), 103. I will also refer to the University of Warwick website of crusade lyrics titled "Troubadours, Trouvères and the Crusades," edited by Paterson, Asperti, et al., last revised November 20, 2017, https://

warwick.ac.uk/fac/arts/modernlanguages/research/french/crusades/texts/ (hereafter cited as Warwick site).

17. Paterson, *Singing the Crusades*; D. A. Trotter, *Medieval French Literature and the Crusades (1100–1300)* (Geneva: Droz, 1987); C. T. J. Dijkstra, *La Chanson de croisade: Etude thématique d'un genre hybride* (Amsterdam: Schiphouwer en Brinkman, 1995); Suzanne Schöber, *Die altfranzösische Kreuzzugslyrik des 12. Jahrhunderts* (Vienna: VWGÖ, 1976), 13–24; Friedrich-Wilhelm Wentzlaff-Eggebert, *Kreuzzugsdichtung des Mittelalters: Studien zu ihrer geschichtlichen und dichterischen Wirklichkeit* (Berlin: de Gruyter, 1960); Dorothea Carolyn Martin, "The Crusade Lyrics: Old Provençal, Old French and Middle High German, 1100–1280" (PhD diss., University of Michigan, 1984); a study on Occitan crusade lyric by the musicologist Rachel Golden is forthcoming. For a recent overview of crusade songs in the Old French literary canon and its integration into the courtly love theme, including a comparison with the Occitan tradition and an account of the Old French crusade songs in the manuscript tradition, see Luca Barbieri, "Crusade Songs and the Old French Literary Canon," in Parsons and Paterson, *Literature of the Crusades*, 75–95.

18. Conon de Béthune, *Les Chansons de Conon de Béthune*, ed. Axel Wallensköld (Paris: Champion, 1921), 7.

19. For a discussion of social status and audience of poets, see Paterson, *Singing the Crusades*, 11–20.

20. See Charmaine Lee, "Richard the Lionheart: The Background to *Ja nus hom pris*," in Parsons and Paterson, *Literature of the Crusades*, 134–49.

21. Paterson, *Singing the Crusades*, 15, 131.

22. Giraut de Borneil, *The Cansos and Sirventes of the Troubadour Giraut de Borneil: A Critical Edition*, ed. Ruth Verity Sharman (Cambridge, UK: Cambridge University Press, 1989), 454–55; edition and translation with a few modifications from Paterson, *Singing the Crusades*, 67–68.

23. Bernard of Clairvaux, *Sancti Bernardi Opera*, ed. J. Leclercq and H. M. Rochais, 8 vols. (Rome: Editiones Cistercienses, 1957–78), 3:215.

24. See Siberry, *Criticism of Crusading*, 96; E. O. Blake, "The Formation of the 'Crusade Idea,'" *Journal of Ecclesiastical History* 21 (January 1970): 25–30; Bernard, *Opera*, 3:213–39; Ralph Niger, *De Re Militari et Triplici Via Peregrinationis Ierosolimitane*, ed. Ludwig Schmugge (Berlin: de Gruyter, 1977), 92, lines 18–25.

25. Bernard, *Opera*, 3:215.

26. Jessalyn Bird, "James of Vitry's Sermons to Pilgrims," *Essays in Medieval Studies* 25 (2008): 81–113, esp. 82.

27. J. Riley-Smith, *Crusades: A History*, 176; James M. Powell, *Anatomy of a Crusade: 1213–1221* (Philadelphia: University of Pennsylvania Press, 1986), 56–57. For a discussion on the importance of how the promulgations of the Lateran IV were transmitted and locally received, see Jeffrey M. Wayno, "Rethinking the Fourth Lateran Council of 1215," *Speculum* 93, no. 3 (2018): 611–37. In this study, I consider homiletic and courtly literature as an integral part of the transmission history of the council's decrees.

28. See, for example, the crusade lyric "Vos qui ameis de vraie amor" (1150–1200), in Joseph Bédier and Pierre Aubry, eds., *Les Chansons de croisade* (1909; repr., New York: Burt Franklin, 1971), and "Aler m'estuet" by the Châtelain d'Arras, which will be discussed in chapter 1.

29. In addition to the previously cited works by Paterson, Trotter, and Dijkstra, see also Stefan Vander Elst's comparison of chansons de geste and chivalric romance of the thirteenth century in *The Knight, the Cross, and the Song: Crusade Propaganda and Chivalric Literature, 1100–1400* (Philadelphia: University of Pennsylvania Press, 2017).

30. Stephen G. Nichols, "Urgent Voices: The Vengeance of Images in Medieval Poetry," in *France and the Holy Land: Frankish Culture at the End of the Crusades*, ed. Daniel H. Weiss and Lisa Mahoney (Baltimore: Johns Hopkins University Press, 2004), 23.

31. Colin Morris, *The Discovery of the Individual 1050–1200* (1972; repr., Toronto: University of Toronto Press, 2012); Caroline Walker Byum, "Did the Twelfth Century Discover the Individual?," in *Jesus as Mother: Studies in the Spirituality of the High Middle Ages* (Berkeley: University of California Press, 1984). For another counterargument of courtly language as an interiorization of the law and politics of the church, see Suzanne Verderber, *The Medieval Fold: Power, Repression, and the Emergence of the Individual* (New York: Palgrave Macmillan, 2013). See also Lawton's helpful introduction (*Voice*, 1–11) wherein he reviews the major discussions of voice, text, and authority pertinent to medieval works (including debates in New Criticism, structuralism, and orality).

32. Thibaut de Champagne, *Les Chansons de Thibaut de Champagne: Roi de Navarre*, ed. A. Wallensköld (Paris: Champion, 1925), "Au tens plain de felonnie," line 40; "Dame, ensi," lines 22–25; translations (with some modifications) from Kathleen J. Brahney, ed. and trans., *The Lyrics of Thibaut de Champagne* (New York: Garland, 1989). I have also consulted the most recent edition of Thibaut's lyrics, Thibaut de Champagne, *Thibaut de Champagne: Les Chansons, Textes et mélodies*, ed. Christopher Callahan, Marie-Geneviève Grossel, and Daniel E. O'Sullivan (Paris: Éditions Honoré Champion, 2018).

33. See Jonathan Riley-Smith, "Crusading as an Act of Love," *History* 65, no. 214 (June 1980): 177–92; "Vos qui ameis," line 22.

34. For crusades and confession in the aristocratic context see Baldwin, *Aristocratic Life*, 194–247. Baldwin discusses how the new sacrament of penance influenced courtly romance in the French context (223–34). See also Payen, *Le Motif du repentir*; Zink, *La Prédication*; Mary C. Mansfield, *The Humiliation of Sinners: Public Penance in Thirteenth-Century France* (Ithaca, NY: Cornell University Press, 1995).

35. Aden Kumler, *Translating Truth: Ambitious Images and Religious Knowledge in Late Medieval France and England* (New Haven, CT: Yale University Press, 2011), 46–50. For a discussion of Anglo-Norman confessional manuals such as the *Manuel des Péchés* of William of Waddington, see Payen, *Le Motif du repentir*, 558–69; Claire M. Waters, *Translating Clergie: Status, Education and Salvation in Thirteenth-Century Vernacular Texts* (Philadelphia: University of Pennsylvania Press, 2016), Zink, *La Prédication en langue romane avant 1300*.

36. Michel Foucault, *Histoire de la sexualité*, vol. 1, *La volonté du savoir* ([Paris]: Gallimard, 1976), 78–84. Responses to this account include Lee Patterson, *Negotiating the Past: The Historical Understanding of Medieval Literature* (Madison: University of Wisconsin Press, 1987), esp. 64–74; Carolyn Dinshaw, "Getting Medieval: *Pulp Fiction*, Gawain and Foucault" in *The Book and the Body*, ed. Dolores Warwick Frese and Katherine O'Brien O'Keeffe (Notre Dame, IN: University of Notre Dame Press, 1997), 116–63, esp. 140–49. See also Verderber, *Medieval Fold*.

37. Foucault, *Histoire de la sexualité*, 79; translation from Michel Foucault, *The History of Sexuality: An Introduction*, vol. 1, trans. Robert Hurley (New York: Vintage, 1990), 59.

38. Foucault, *History of Sexuality*, 58.

39. Foucault, *Histoire de la sexualité*, 79; Foucault, *History of Sexuality*, 59 (with some modification).

40. Mansfield discusses the practice of public penance versus private penance in her *Humiliation of Sinners*.

41. Foucault, *Histoire de la sexualité*, 78.

42. This Alto Pascio manuscript is held in the Capponi archive in Florence. I am thankful to Count Capponi, who allowed me to access the archive.

43. J. Riley-Smith, "Crusading as an Act of Love," 177–92, quotation at 177. My study aims to complement his work by analyzing how the poetics of crusade love song responds to this thinking.

44. Bird, "James of Vitry's Sermons," 85.

45. Innocent III, *Opera Omnia*, (*Quia Maior*), *Patrologiae Cursus Completus*, in *Patrologia Latina*, ed. J. P Migne, Series Latina, 221 vols. (Paris: Garnier, 1844–1905), 216:817–822 (hereafter cited as *PL*).

46. Penny J. Cole, *The Preaching of the Crusades to the Holy Land, 1095–1270* (Cambridge, MA: Medieval Academy of America, 1991), 139.

47. *PL*, 216:818–19; translation from L. Riley-Smith and J. Riley-Smith, *Crusades: Idea and Reality*, 121–22.

48. Innocent, *PL*, 216:817–822; J. Riley-Smith, *Crusades: A History*, 174. See Cole's discussion of Pope Gregory IX's *Rachel suum videns*, which clarified the indulgence for those who go east and do not participate in crusade and to those who aid the crusade effort with advice (*Preaching of the Crusades*, 161). Jessalyn Bird, "Reform or Crusade? Anti-Usury and Crusade Preaching during the Pontificate of Innocent III," in *Pope Innocent III and his World*, ed. John C. Moore (Brookfield, VT: Ashgate, 1999), 173, discusses how the *Quia Maior* and other bulls "directed crusade preachers to target urban centers, and to stress in their preaching that those who gave money, useful advice or aid were to share in the crusade indulgence according to the quantity of their aid and the degree of their devotion," including shipbuilders or those who contributed ships, and devout and wealthy wives, who were "prime sources for vow commutations and devotions."

49. Michael Lower, *The Barons' Crusade: A Call to Arms and Its Consequences* (Philadelphia: University of Pennsylvania Press, 2005), 109–11.

50. Tyerman, *Invention of the Crusades*, 67.

51. Cole, *Preaching of the Crusades*, 138.

52. Waltraud Verlaguet, "Crusade Sermons as a Factor of European Unity," in *War Sermons*, ed. Gilles Teulié and Laurence Lux-Sterritt (Newcastle, UK: Cambridge Scholars, 2009), 1–13, at 7; James of Vitry, "Sermo II," reproduced in Christoph T. Maier, *Crusade Propaganda and Ideology: Model Sermons for the Preaching of the Cross* (Cambridge: Cambridge University Press, 2000), 121 (edition of *ad status* crusade model sermons).

53. Caesarius of Heisterbach, *Dialogus miraculorum*, ed. J. Strange (Cologne, 1851).

54. Rutebeuf, "La Complainte de Constantinople" and "La Disputation du croisé et du décroisé," esp. lines 57–72, 90–104, in *Onze poèmes de Rutebeuf: Concernant la croisade*, ed. Julia Bastin and Edmond Faral (Paris: P. Geuthner, 1946), 35–42, 84–94. See also Trotter, *Medieval French Literature*, 224–26; Tyerman, *Invention of the Crusades*, 53.

55. Tyerman, *Invention of the Crusades*, 67.

56. Tyerman, *Invention of the Crusades*, 67.

57. The crusading loyalties of the trouvère crusaders ought to be compared to the Occitan situation, where the memory of crusades and local crusading activities was distinct from England, France, and Aragón. See Nicholas L. Paul, *To Follow in Their Footsteps: The Crusades and Family Memory in the High Middle Ages* (Ithaca, NY: Cornell University Press, 2012).

58. For further discussion, see Marisa Galvez, "The Voice of the Unrepentant Crusader: 'Aler m'estuet' by the Châtelain d'Arras," in *Voice and Voicelessness in Medieval Europe*, ed. Irit Kleinman (New York: Palgrave, 2015), 101–22; Marisa Galvez, "The Intersubjective Performance of Confession vs. Courtly Profession," in *Performance and Theatricality in the Middle Ages and Renaissance*, ed. Markus Cruse, Arizona Studies in the Middle Ages and the Renaissance (Turnhout, Belg.: Brepols, 2018), 1–16.

59. For a good summary of Veselovsky's work and influence, see the introduction in Alexander Veselovsky, *Persistent Forms: Explorations in Historical Poetics*, ed. Ilya Kliger and Boris Maslov (New York: Fordham University Press, 2016), and, in the same volume, citation from Aleksandr Veselovskii, *Istoricheskaia Poetika: itogi I perspectivy izucheniia* (Moscow: Nauka, 1986), 208. For Kuhn, see Hugo Kuhn, "On the Interpretation of Medieval Artistic Form," in *Spatial Practices: Medieval/Modern*, ed. Markus Stock and Nicola Vöhringer ([Göttingen]: V&R unipress, 2014), 253–66, originally published as "Zur Deutung der künsterlichen Form des Mittelalters," *Studium Generale* 2 (1949): 111–21, translated by Christopher Liebtag Miller.

60. Alexander Veselovsky, *From the Introduction to Historical Poetics: Questions and Answers*, trans. and ed. Boris Maslov (1894), translated in Veselovsky, *Persistent Forms*, 11, 39–64, quotation at 52.

61. Roland Barthes (see following note); *Le Haut Livre du Graal: Perlesvaus*, 2 vols., ed. William A. Nitze and T. Atkinson Jenkins (Chicago: University of Chicago Press, 1932); Jakemés, *Le Roman du Châtelain de Coucy et de la Dame de Fayel*, ed. Catherine Gaullier-Bougassas (Paris: Champion Classiques, 2009).

62. Roland Barthes, *Fragments d'un discours amoureux* (Paris: Seuil, 1977), "choreography," 8.

63. Sheldon Pollock, "Philology in Three Dimensions," *postmedieval: a journal of medieval cultural studies* 5, no. 4 (Winter 2014): 398–413, quotation at 406.

64. Bruno Latour, *Reassembling the Social: An Introduction to Actor-Network-Theory* (Oxford: Oxford University Press, 2005), 61; Bruno Latour, "Why Has Critique Run Out of Steam? From Matters of Fact to Matters of Concern," *Critical Inquiry* 30, no. 2 (Winter 2004): 225–48.

65. For a general overview of vernacular crusade lyric, see Michael Routledge, "Songs," in *Oxford Illustrated History of the Crusades*, ed. Jonathan Riley-Smith (Oxford: Oxford University Press, 1995), 91–111. The Old French corpus is well represented in Bédier and Aubry, *Les Chansons de croisade*. Representative studies of structural analyses of crusade literary texts include Trotter, *Medieval French Literature*; and Dijkstra, *La Chanson de croisade*.

66. See, for instance, the historical reading of Thibaut by William Chester Jordan in "The Representation of Crusade Songs Attributed to Thibaud, Count Palatine of Champagne," *Journal of Medieval History* 25, no. 1 (1999): 27–34; or the traditional homiletic reading of exhortative crusade lyric in studies such as Cole, *Preaching of the Crusades*; and Maier, *Crusade Propaganda and Ideology*. While I recognize the value of these studies, my work on historical poetics offers a different account of crusade literary texts.

67. Stephen Best and Sharon Marcus, "Surface Reading: An Introduction," *Representations* 108, no. 1 (Fall 2009): 1–21, at 11.

68. See Marjorie Levinson, "What Is New Formalism?" *PMLA* 122, no. 2 (2007): 558–69; Eleanor Johnson, *Practicing Literary Theory in the Middle Ages: Ethics and the Mixed Form in Chaucer, Gower, Usk, and Hoccleve* (Chicago: University of Chicago Press, 2013).

69. See the essays in Robert J. Meyer-Lee and Catherine Sanok, eds., *The Medieval Literary: Beyond Form* (Cambridge: D. S. Brewer, 2018).

70. While this study focuses on Western crusade poetry, Carol Hillenbrand has studied how jihadist poetry as an established genre of warfare against Byzantium was modified for crusades against Latins in the East during the twelfth century. See Carol Hillenbrand, "*Jihad* Poetry in the Age of the Crusades," in *Crusades—Medieval Worlds in Conflict*, ed. Thomas F. Madden et al. (Burlington, VT: Ashgate, 2010), 9–23.

71. Robyn Creswell and Bernard Haykel, "Why Jihadists Write Poetry," *New Yorker*, June 8 and 15, 2015.

CHAPTER ONE

1. For quotations from "Aler m'estuet" in this chapter, I use the version in Bédier and Aubry, *Les Chansons de croisade*, 137–39. The song is attested in five manuscripts and was most likely written before the poet's participation in the Fifth Crusade around 1218 (see Dijkstra, *La chanson de croisade*, 153–54). Unless otherwise noted, all translations are my own.

2. Other versions of this figure include Conon de Béthune's "Ahi! Amours, con

dure departie," the Châtelain de Couci's "A vous, amant plus qu'a nule autre gent," and Friedrich von Hausen's "Mîn herze und mîn lip."

3. Lisa Perfetti, "Crusader as Lover: The Eroticized Poetics of Crusading in Medieval France," *Speculum* 88, no. 4 (2013): 932-57.

4. Bédier and Aubry, *Les Chansons de croisade*, 135-37. See Payen's analysis of crusade songs of departure in Jean-Charles Payen, "'Peregris': De l'amor de lonh' au congé courtois," *Cahiers de civilisation médiévale* 17, no. 67 (July-September 1974): 247-55; Payen, *Le Motif du repentir*, 274-76.

5. For an overview of crusade imbued with secular ideals, especially crusade as a knightly enterprise, see Jonathan Riley-Smith, "The State of Mind of Crusaders," in J. Riley-Smith, *Oxford Illustrated History*, 84-90.

6. See Caroline Smith's discussion of the Old French corpus of crusade songs as well as Bédier's editorial decision to publish a genre collection despite most chansonniers' organization by author or opening line, in Caroline Smith, *Crusading in the Age of Joinville* (Aldershot, UK: Ashgate, 2006), 18-22. See also J. Riley-Smith, *Crusades: A History*, 135.

7. See Trotter, *Medieval French Literature*, esp. his review of the scholarship concerning nonnarrative crusade poems, 172-227, and his bibliography; Dijkstra, *La Chanson de Croisade*; Schöber, *Die altfranzösische Kreuzzugslyrik*, 13-24; Martin, *Crusade Lyrics*.

8. Thibaut de Champagne, *Les Chansons de Thibaut*, 187-89.

9. For a classic example see Payen's analysis of *amor de lonh* and the separated heart in Payen, "'Peregris.'"

10. Linda Georgianna, *The Solitary Self: Individuality in the "Ancrene Wisse"* (Cambridge, MA: Harvard University Press, 1981), 101.

11. Innocent III, *Post miserabile*, in *Chronica magistri Rogeri de Houedene*, 4 vols., ed. William Stubbs (1868-1871; repr., Wiesbaden, Ger.: Kraus, 1964), 4:70-75; translation from Innocent III, "*Post miserabile*, 1198," in *Crusade and Christendom: Annotated Documents in Translation from Innocent III to the Fall of Acre, 1187-1291*, ed. Jessalyn Bird, Edward Peters, and James M. Powell (Philadelphia: University of Pennsylvania Press, 2013), 35. All biblical citations are from the Douay-Rheims Version of the Bible.

12. Conon de Béthune, *Les Chansons*, 8.

13. Payen, *Le Motif du repentir*, 271.

14. Henri de Valenciennes, *Histoire de l'Empereur Henri de Constantinople*, ed. Jean Longon (Paris: Geuthner, 1928), 44, paragraph 538. For crusades and confession in the aristocratic context, see Baldwin 194-247. For military religion among crusaders, see Bachrach, *Religion and Conduct of War*. I discuss this passage further in chapter 4.

15. Emmanuel Pasquet, *Sermons de Carême en dialecte wallon: Texte inédit du XIIIe siècle*. Mémoires couronnés et autres mémoires publiés par l'académie royale des sciences, des lettres et des beaux-arts de Belgique, vol. 41 (Brussels, 1888), 42.

16. C. Storey, ed., *La Vie de Saint Alexis* (Oxford: Blackwell, 1968); Félix Lecoy, ed., *Le Chevalier au Barisel: Conte pieux du xiiie siècle* (Paris: Champion, 1955); W. Mary Hackett, ed., *Girart de Rousillon: Chanson de geste*, 3 vols. (Paris: Picard, 1953-55).

17. See J. Riley-Smith, "Crusading as an Act of Love"; Routledge, "Songs," 102.

18. Bernard of Clairvaux, "Epistolae," in *PL*, 182:652–54; translation from L. Riley-Smith and J. Riley-Smith, *Crusades: Idea and Reality*, 97.

19. Bernard, *Opera*, 3:214–15. See also *PL*, 182:922; L. Riley-Smith and J. Riley-Smith, *Crusades: Idea and Reality*, 102.

20. Perfetti, "Crusader as Lover," 939.

21. Innocent III, *Quia maior*, in L. Riley-Smith and J. Riley-Smith, *Crusades: Idea and Reality*, 120.

22. Bédier and Aubry, *Les Chansons de croisade*, 20–22; translation from L. Riley-Smith and J. Riley-Smith, *Crusades: Idea and Reality*, 89.

23. See J. Riley-Smith, "Crusading as an Act of Love."

24. Kaeuper, *Holy Warriors*, 210.

25. Kaeuper, *Holy Warriors*, 184.

26. Bernard, *Opera*, 1:94.

27. See Mansfield's discussion concerning public and private forums, private penance and offences against the church: Mansfield, *Humiliation of Sinners*, 49–55.

28. Bibliothèque Nationale, française (hereafter BN fr.) 13316 (f. 1r); see Zink, *La Prédication*, 49–50, 445; all translations mine unless otherwise indicated.

29. Pasquet, *Sermons de Carême*, 30.

30. Augustine, *On Christian Doctrine*, trans. and with introduction by D. W. Robertson (Indianapolis: Bobbs-Merrill Educational Publishing, 1958), bk. 2, chap. 1, p. 34; Augustine, *De doctrina Christiana*, ed. William M. Green, *Corpus scriptorum ecclesiasticorum latinorum* 80 (Vienna: Hoelder-Pichler-Tempsky, 1963), p. 33.

31. Stephen G. Nichols, "Voice and Writing in Augustine and in the Troubadour Lyric," in *Vox intexta: Orality and Textuality in the Middle Ages*, ed. A. N. Doane and Carol Braun Pasternack (Madison: University of Wisconsin Press, 1991), 137–61, esp. 148–51.

32. C. A. Robson, ed., *Maurice of Sully and the Medieval Vernacular Homily: With the Text of Maurice's French Homilies from a Sens Cathedral Chapter Ms.* (Oxford: Blackwell, 1952), 98; French versions of Latin sermons transmitted during the thirteenth century.

33. Robson, *Maurice of Sully*, 98.

34. Robert Grosseteste, *Deus est*, in Siegfried Wenzel, "Robert Grosseteste's Treatise on Confession, 'Deus Est,'" *Franciscan Studies* 30 (1970): 218–93. See also Thomas Aquinas's allusion to confession as narration and problems arising out of its intermediary role in *Sent.*, bk. 4, distinctio 17, q. 3, a. 4, sol. 1, in *Opera Omnia*, 25 vols. (Parma: Petri Fiaccadori, 1852–73; repr., New York: Musurgia Publishers, 1948–50); see Denery's discussion in Dallas G. Denery, *Seeing and Being Seen in the Later Medieval World: Optics, Theology and Religious Life* (Cambridge: Cambridge University Press, 2005), 50–51.

35. "Sufficiens quidem erit narratio cum vera fuerit, integra, plana, nuda, amara, verecunda," *Deus Est*, 247. See also Denery, *Seeing and Being Seen*, 66–67.

36. Denery, *Seeing and Being Seen*, 65.

37. Ferdinand de Saussure, *Course in General Linguistics*, ed. Charles Bally and

Albert Sechehaye, trans. Wade Baskin (1916; repr., New York: Philosophical Library, 1959), 11–122, esp. 65–70.

38. See Foucault's master narrative of the modern self as emerging through the power structures of confessor and confessee (since critiqued), *Histoire de la sexualité*, esp. 78–84; and Thomas N. Tentler, *Sin and Confession on the Eve of the Reformation* (Princeton, NJ: Princeton University Press, 1977).

39. Simon Gaunt, *Love and Death in Medieval French and Occitan Courtly Literature* (Oxford: Oxford University Press, 2006); Helen Solterer, "Dismembering, Remembering the Châtelain de Coucy," *Romance Philology* 46, no. 2 (November 1992): 103–234. The poetic convention, or topos, of remembering the lady left behind is a common one of crusade love lyrics, most notably in the Châtelain de Couci's "A vous, amant" (c. 1188), a song which, judging from its transmission in eleven chansonniers and its insertion in Jakemé's late thirteenth-century romance, *Le Castelain de Couci* (c. 1280), was very popular.

40. Solterer, "Dismembering, Remembering," 107.

41. Thibaut de Champagne, *Les Chansons de Thibaut*, 187–89 (my emphasis).

42. See Gaunt, *Love and Death*, 104.

43. Gérard Blangez, ed., *Ci nous dit: Receuils d'exemples moraux*, 2 vols. (Paris: Picard, 1986), 1:303.

44. Blangez, *Ci nous dit*, 2:13.

45. Wallensköld 187–88; in the edition of Callahan et al. they translate "voie" as "pèlerinage," thus making the crusading reference more explicit, (299).

46. Cole, *Preaching of the Crusades*, 153, and transcription of the sermon in appendix, 222–26.

47. Bernard, *Opera*, 4:102.

48. "Ut in fornace tribulationum et in angustia laborum sudores nostros t[er]-gentes non fatigem[us] animis nostris sed in agone semper simus recentes et validi ex recordatione dominice passionis" (So that the tribulation in the furnace and in anguish of labors, wiping off our sweat, we do not tire our souls but we are always in fresh and worthy agony from belonging to the recollection of the passion); James of Vitry, *Sermo* 49 in Bird, "James of Vitry's Sermons to Pilgrims," 92.

49. Thibaut de Champagne, *Les Chansons de Thibaut*, 188–89 (my translation and emphasis).

50. Paterson, *Singing the Crusades*, 172. See Barbieri's discussion on Warwick site.

51. Dijkstra, *La Chanson de croisade*, 163.

52. Leo Charles Yedlicka, *Expressions of the Linguistic Area of Repentance and Remorse in Old French* (Washington, DC: Catholic University of America Press, 1945), 28.

CHAPTER TWO

1. In Hugo Moser and Helmut Tervooren, eds., *Des Minnesangs Frühling*, 37th–38th ed. (Stuttgart: S. Hirzel, 1977–88), 81–82 (hereafter cited as MFMT). In the text, I indicate stanza and line numbers from this edition after the quotations, and in the

notes, I indicate page numbers from MFMT; translations with some modifications from Frederick Goldin, trans., *German and Italian Lyrics of the Middle Ages: An Anthology and a History* (Garden City, NY: Anchor Books, 1973), 31–32.

2. MFMT, 428.

3. On the connection between the French and Occitan traditions via Hausen, see Joachim Bumke, *Die romanisch-deutschen Literaturbeziehungen im Mittelalter: Ein Uberblick* (Heidelberg: Universitätsverlag, 1967), 47.

4. Wentzlaff-Eggebert, *Kreuzzugsdichtung des Mittelalters*, 179–86; see also Friedrich Maurer, "Zu den Liedern Friedrichs von Hausen," *Dichtung und Sprache des Mittelalters: Gessamelte Aufsätze* (Bern: Francke Verlag, 1963), 80–94.

5. See Dorothea Carolyn Martin's discussion of *Minnesang* crusade songs in "Crusade Lyics," 251–90.

6. MFMT, 82.

7. MFMT, 80.

8. MFMT, 83.

9. MFMT, 83; my translation.

10. MFMT, 428.

11. MFMT, 428.

12. MFMT, 412.

13. For a discussion of knighthood, love service, and crusade in relation to these lyrics, see W. H. Jackson, *Chivalry in Twelfth-Century German: The Works of Hartmann von Aue* (Cambridge: D. S. Brewer, 1994), 182–93.

14. See Wentzlaff-Eggebert, *Kreuzzugsdichtung des Mittelalters*; Hugo Bekker, ed., *The Poetry of Albrecht von Johansdorf* (Leiden: Brill, 1978). English translation from the Bekker edition.

15. See Martin's summary of scholarship on these poems, "Crusade Lyrics," 260–62.

16. Bekker, *Poetry of Johansdorf*, 54.

17. MFMT, 180.

18. MFMT, 180–81.

19. Bekker, *Poetry of Johansdorf*, 57.

20. Hugo Bekker, citing Wentzlaff-Eggebert, sees "herzevrouwe" as making the distinction between between courtly and uncourtly "of peripheral consequence" because "the lady and the persona are so devoted to each other" (Bekker, *Poetry of Johansdorf*, 58).

21. Gottfried von Strassburg, *Tristan*, ed. Friedrich Ranke and Rüdiger Krohn, 3 vols. (Stuttgart: Reclam, 1980), 2:498.

22. Quoted in Maier, *Crusade Propaganda and Ideology*, 87–89.

23. Quoted in Maier, *Crusade Propaganda and Ideology*, 143.

24. Bekker, *Poetry of Johansdorf*, 67.

25. MFMT, 181–84.

26. MFMT, 181; Bekker, *Poetry of Johansdorf*, 63.

27. MFMT, 182–83; Bekker, *Poetry of Johansdorf*, 70.

28. See Paterson, *Singing the Crusades*, for an overview of this rich diversity.

29. See Paterson, *Singing the Crusades*, 10–13; Luca Barbieri, "Le canzoni di crociata e il canone lirico oitanico," *Medioevi* 1 (2015): 45–74.

30. Stephen G. Nichols, "Poetic Places and Real Spaces: Anthropology of Space in Crusade Literature," *Yale French Studies*, no. 95 (1999): 111–133, at 118, https://doi.org/10.2307/3040748.

31. Jaufre Rudel, *L'amore de lontono: Edizione critica*, ed. Giorgio Chiarini (2003; repr., Rome: Carocci, 2013), 98; my translation.

32. Rudel, *L'amore de lontono*, 96; translation from Frederick Goldin, *Lyrics of the Troubadours and Trouvères: An Anthology and a History* (1973; repr., Gloucester, MA: Peter Smith, 1983), 107.

33. Rudel, *L'amore de lontono*, 126; translation by Linda Paterson, Warwick site.

34. Rudel, *L'amore de lontono*, 126; trans. Paterson, Warwick site.

35. Rudel, *L'amore de lontono*, 126; trans. Paterson, Warwick site.

36. For these practices, see Gaposchkin, *Invisible Weapons*.

37. Peire Vidal, *Poesie*, ed. D'Arco Silvio Avalle, vol. 1 (Milan: Riccardo Ricciardi, 1960), 335–36; translated by Linda Paterson, Warwick site.

38. For further discussion of erotic desire in courtly lyric and romance, see Marisa Galvez, "Dark Transparencies: Crystal Poetics in Medieval Texts and Beyond," in *Philological Quarterly* 93, no. 1 (2014): 15–42.

39. Erkinger Schwarzenberg, "Colour, Light, and Transparency in the Greek World," in *Medieval Mosaics: Light, Color, Materials*, ed. Eve Borsook, Fiorella Gioffredi Superbi, and Giovanni Pagliarulo (Milan: Silvana Editoriale, 2000), 15–16, 27–29.

40. D. E. Eicholz, *Pliny: A Natural History, with an English Translation*, vol. 10, Loeb Classical Library (Cambridge, MA: Harvard University Press, 1962), bk. 37, chaps. 9, 10, pp. 180–85.

41. For an overview of Western iconography of crystal, see Genevra Kornbluth, *Engraved Gems of the Carolingian Empire* (University Park: Pennsylvania State University Press, 1995), 16–18.

42. Schwarzenberg, "Colour, Light, and Transparency," 29.

43. Peire Vidal, *Poesie*, 327.

44. Gaucelm Faidit, "Mas la bella," ed. Giorgio Barachini, Songs Referring to the Crusades no. 167.36, *Rialto*, December 12, 2014, http://www.rialto.unina.it/GcFaid/167.36(Barachini).htm; translation from Paterson, *Singing the Crusades*, 105.

45. Phillips, *Fourth Crusade*, 87.

46. Whether this song is a crusade departure song or a penitential lament anticipating a departure from the world through death has been debated: see Paterson, *Singing the Crusades*, 25–26.

47. Nichols, "Poetic Places and Real Spaces," 116–18.

48. Nichols, "Poetic Places and Real Spaces," 118.

CHAPTER THREE

1. Jakemés, *Le Roman du Castelain de Couci et de la Dame de Fayel par Jakemes*, ed. John E. Matzke and Maurice Delbouille (Paris: SATF, 1936); unless otherwise noted, translations are my own.

2. Recent scholarship has focused on how the eaten-heart legend combines secular and religious systems. See Claire Taylor Jones, "Relics and the Anxiety of Exposure in Konrad von Würzburg's *Herzmaere*," *JEGP* 116, no. 3 (2017): 286–309. Helen Solterer's study of this romance remains fundamental, see Solterer, "Dismembering, Remembering." The eaten-heart legend has been the subject of much commentary. On union and disunion through the body and textual exchanges between lovers, see in particular Solterer, "Dismembering, Remembering." For a review of the tradition of the eaten-heart legend including the *vida* and *razos* of the troubadour Guihem de Cabestanh that celebrates the legitimacy of the lovers, *Das Herzmäre* of Konrad Von Würzburg, and Dante's *La Vita Nuova*, see the volume edited by Catherine Gaullier-Bougassas—Jakemés, *Le Roman du Châtelain de Coucy*, 63–82, and her bibliography.

3. Jakemés, *Le Roman du Châtelain de Coucy*, 71 n. 78; Solterer, "Dismembering, Remembering," 112. For general bibliography on the *Roman* as a version of the eaten heart, see Solterer, "Dismembering, Remembering."

4. This line occurs in the romance in an *envoi* of four lines that appears in only one chansonnier of the lyric (BN fr. 20050) and the manuscripts of the *Roman*. For that reason editors such as A. Lerond do not attribute it to the Châtelain de Couci. It could be the original addition of Jakemés.

5. See Solterer, "Dismembering, Remembering"; Jakemés, *Le Roman du Châtelain de Coucy*; William Calin, "Poetry and Eros: Language, Communication, and Intertextuality in *Le Roman du Castelain de Couci*," *French Forum* 6, no. 3 (1981): 197–211.

6. BNF Nouvelle acquisition française 7514; see Bédier and Aubry, *Les Chansons de croisade*.

7. Solterer, "Dismembering, Remembering," 112.

8. Solterer, "Dismembering, Remembering," 112, notes Nelli's connection between the eaten heart and the tradition of the exchange of hearts between lovers.

9. "la réalisation de la métaphore courtoise," in Jakemés, *Le Roman du Châtelain de Coucy*, 553 n. 83.

10. Jones, "Relics," 299.

11. Jones, "Relics," 306.

12. Jones, "Relics," 301.

13. Solterer, "Dismembering, Remembering," 109–234.

14. Jean-Jacques Vincensini, "Figure de l'imaginaire et figure du discours: Le motif du Coeur Mangé dans la narration médiévale," in *Le "Cueur" au Moyen Âge: (Réalité et Senefiance)*, Senefiance 30 (Aix-en-Provence: Presses universitaires de Provence, 1991), 441–49.

15. Jakemés, *Le Roman du Châtelain de Coucy*, 72.

16. See the *vida* of Cabestanh in Jean Boutière and A.-H. Schutz, eds., *Biographies des troubadours, Textes provençaux des XIIIᵉ et XIVᵉ siècles* (Paris: Nizet, 1964), 531–33.

17. See Calin, "Poetry and Eros."

18. Bédier and Aubry, *Les Chansons de croisade*, 112–15.

19. Simon Gaunt, "Poetry of Exclusion: A Feminist Reading of Some Troubadour Lyrics," *MLR* 85, no. 2 (1990): 310–29.

20. Bédier and Aubry, *Les Chansons de croisade*, 278–79; as edited and translated by Anne Radaelli, Warwick site, with some modification. Radaelli sees the date of provenance of this text as uncertain; it exists in only one thirteenth-century manuscript, the *Chansonnier du Roi*, where it is attributed to Gautier d'Espinau in the text and to Jehan de Nuevile in the table of contents. Radaelli attributes it to Jehan de Nuevile.

21. Marcabru, *Marcabru: A Critical Edition*, ed. Simon Gaunt, Ruth Harvey, and Linda Paterson, (Cambridge: D. S. Brewer, 2000).

22. Nichols, "Urgent Voices," 25.

23. See commentary on these lines in Marcabru, *Marcabru*, 45. The popularizing sound is reminiscent of Guilhem IX's deliberate use of the "-ey" sound in his songs 2 and 3 in William IX, *The Poetry of William VII, Count of Poitiers, IX Duke of Aquitaine*, ed. Gerald A. Bond (New York: Garland, 1982), 6–13. For a discussion of Guilhem's language see Max Pfister, "La langue de Guilhem IX, comte de Poitiers," in *Cahiers de Civilization Médiévale* 19, no. 74 (April–June 1976): 93–115; and especially Frede Jensen, "Deviations from the Troubadour Norm in the Language of Guillaume IX, in *Studia Occitanica: In Memoriam, Paul Remy*, ed. Hans-Erich Keller, vol. 1, *The Troubadours* (Exeter, UK: Medieval Institute Publications, an imprint of University of Exeter Press, 1986): 347–62, esp. 351–53, where he addresses the end rhyme in relation to Marcabru.

24. William D. Paden, "Declension in Twelfth-Century Occitan: On Editing Early Troubadours, with Particular Reference to Marcabru," *Tenso* 18, nos. 1–2 (2003): 67–115. For a discussion of troubadour koine as performance dialect, see Thomas T. Field, "Troubadour Performance and the Origins of Occitan 'Koine,'" *Tenso* 21, nos. 1–2 (2006): 36–54, at 41.

25. For an excellent analysis of sound and voice in troubadour poetry from another perspective, and with fuller theoretical elaboration using Aristotle and contemporary theorists such as Giorgio Agamben, see Sarah Kay, "Circulating Air: Inspiration, Voice and Soul in Poetry and Song," *Paragraph* 41, no. 1 (2018): 10–25.

26. Michel Serres, *Parasite* (1980; repr., Minneapolis: University of Minnesota Press, 2007).

27. See, e.g., Kay, "Circulating Air."

28. François Noudelmann, "What Is an Acousmatic Reading?" *Paragraph* 41, no. 1 (2018): 110–24, at 122.

29. Markus Stock, "Das volle Wort—Sprachklang im späteren Minnesang: Gottfried von Neifen, Wir suln abser schône enpfâhen (KLD Lied 3)," in *Text und Handeln: Zum kommunikativen Ort von Minnesang und antiker Lyrik* (Heidelberg: Winter, 2004), 185–202, quotation at 200.

30. Albrecht von Johansdorf, "Guote liute, holt," in Bekker, *Poetry of Johansdorf*, 92 (trans. Bekker), 85–93; MFMT, 195.

31. Bekker, *Poetry of Johansdorf*, 92; MFMT, 195.

32. Gaston Paris, "La Chanson du Pèlerinage de Charlemagne," *Romania* 9, no. 33 (1880): 1–50, quotation at 44.

33. Bédier and Aubry, *Les Chansons de croisade*, 112–15.

34. Bédier and Aubry, *Les Chansons de croisade*, 116–17n51.

35. Matilda Tomaryn Bruckner, "Marcabru et la chanson de croisade: D'un centre à l'autre," *Cahiers de civilisation médiévale* 53 (July–September 2010): 239–36.

36. Bédier and Aubry, *Les Chansons de croisade*, 110.

37. Goldin, *German and Italian Lyrics*, 232–33.

38. Goldin, *German and Italian Lyrics*, 230–31.

39. Peire Bremen lo Tort, "Mei oill an gran mantenia," ed. and trans. Ruth Harvey, Songs Referring to the Crusades no. 331.2, *Rialto*, January 8, 2013, http://www.rialto .unina.it/PBremTort/331.2(Harvey)/331.2(Harvey).htm; see also Paterson, *Singing the Crusades*, 41.

40. Peire Bremen lo Tort, "En abril quant vei verdier," ed. and trans. Ruth Harvey, Songs Referring to the Crusades no. 331.1, *Rialto*, January 9, 2013, http://www.rialto .unina.it/PBremTort/331.1(Harvey)/331.1(Harvey).htm; see also Paterson, *Singing the Crusades*, 41.

CHAPTER FOUR

1. William A. Nitze and T. Atkinson Jenkins, eds., *Le Haut Livre du Graal: Perles-vaus*, 2 vols. (Chicago: University of Chicago Press, 1932); arabic numerals refer to line numbers in volume 1 of this edition. Translations from Nigel Bryant, trans., *The High Book of the Grail* (Cambridge: D. S. Brewer, 1978).

2. As this study concerns tracing the path of the courtly crusade idiom, I limit my examination to the *Perlesvaus* and the figure of Lancelot; there is plentiful scholarship on crusade propaganda in chivalric romance: see in particular Stefan Vander Elst's comparison of chansons de geste and chivalric romance of the thirteenth century in Vander Elst, *The Knight, the Cross, and the Song*, 99–123.

3. This study does not permit me to discuss the complicated and much discussed homosocial love between Galehaut and Lancelot; see Christiane Marchello-Nizia's discussion of *amour courtois* (courtly love) as love between men in the *Lancelot Proper* in "Amour courtois, société masculine et figures du pouvoir," *Annales, Histoire, Sciences Sociales* 36, no. 6 (December 1981): 969–82; and David Hult's discussion in *La Mort du roi Arthur* (*The Death of King Arthur*) in "Esquisses d'interprétation," in *La Mort du roi Arthur*, ed. David Hult (Paris: Lettres Gothiques, 2009), 75–115. For a thorough study of Lancelot with and without the Grail, see Elspeth Kennedy, *Lancelot and the Grail: A Study of the Prose "Lancelot"* (Oxford: Clarendon Press, 1986); Carol R. Dover, "From Non-Cyclic to Cyclic *Lancelot*," in *Transtextualities: Of Cycles and Cyclicity in Medieval French Literature*, ed. Sarah Sturm-Maddox and Donald Maddox (Binghamton, NY: Medieval and Renaissance Texts and Studies, 1996), 53–70.

4. For a discussion of the prose *Lancelot* in which the tale does not yet incorporate the Grail quest, see Michelle Szkilnik et al., "Lancelot with and without the Grail: *Lancelot do Lac* and the Vulgate Cycle," ed. Elspeth Kennedy, in *The Arthur of*

the French: The Arthurian Legend in Medieval French and Occitan Literature, ed. Glynn S. Burgess and Karen Pratt (Cardiff: University of Wales Press, 2006), 274–324, (hereafter cited as *AF*).

5. For issues of dating and summary of the romance's place in the Grail tradition, see *AF*, 260–64; Kennedy, *Lancelot and the Grail*, 315–20. Kennedy sees the confessional scene and the acceptance that he must renounce the Grail adventure as a strong argument in favor of the *Perlesvaus* as predating the *Lancelot*, 318–19. For *Perlesvaus* as before the *Queste* and the striking nature of the confessional scene and its presentation of love, see Thomas E. Kelly, "Love in the *Perlesvaus*: Sinful Passion or Redemptive Force?" *Romanic Review* 66, no. 1 (January 1975): 1–12.

6. For a discussion of how twelfth-century *chansons* and thirteenth-century romances valorized knighthood, see Kaeuper, *Holy Warriors*, esp. chap. 5.

7. Kelly ("Love in the *Perlesvaus*") and Payen (*Le Motif du repentir*, 425–29) have noted the peculiarity of the confessional scene and the problematic nature of "volenté." Although the sinful relationship between Guinevere and Lancelot is brought to an end through Guinevere's death in the *Perlesvaus* following the confessional scene, Lancelot remains faithful to the queen's memory and never renounces his love. As in the *Lancelot*, he saves Arthur and his kingdom and advances the New Law despite his inability to see the Grail due to his impurity.

8. Toward the end of the first part of the *Lancelot*, the Lady of the Lake addresses Guinevere and explains how although Lancelot's worldly love is a sin, he can defeat such a "folie" if he finds right and honor in it. See Alexandre Micha, ed., *Lancelot: Roman en prose du XIIIᵉ siècle*, 9 vols. (Geneva: Droz, 1978–93); vol. 8, ch. 71a, para. 13, pp. 461–62. See also *AF*, 297.

9. Albert Pauphilet, ed., *La Queste del Saint Graal: Roman du XIIIᵉ siècle* (Paris: Champion, 2003), 65–71; Fanni Bogdanow, ed., and Anne Berrie, trans., *La Quête du Saint-Graal: Roman en prose du XIIIᵉ siècle* (Paris: Le Livre de Poche, 2006); P. M. Matarasso, trans., *The Quest of the Holy Grail* (Baltimore: Penguin, 1969), 88–89; *AF*, 296, with some modifications.

10. *AF*, 297; Kennedy, *Lancelot and the Grail*, 318–19. The dream interpretation scene with Galehaut in the *Lancelot* foreshadows Lancelot's repentance in the *Queste* when Master Hélie de Toulouse informs Galehaut that Lancelot will not be able to achieve the adventures of the Grail because he is not a virgin and chaste in earthly love (Micha, *Lancelot: Roman en prose*, vol. 1, ch. 4, para. 37, p. 53).

11. Micha, *Lancelot: Roman en prose*, vol. 7, ch. 21a, para. 20, p. 257; my translation.

12. Micha, *Lancelot: Roman en prose*, vol. 7, ch. 21a, para. 9, p. 248; my translation.

13. For analysis of the structure of the romance, see Kelly, "Love in the *Perlesvaus*"; Micheline de Combarieu, "Le Personnage de Lancelot dans le Perlesvaus," in *Lancelot, Yvain, et Gauvain: Colloque arthurien belge de Wégimont* (Paris: Nizet, 1984), 85–112, and esp. Lacy's analysis of severed heads as a narrative technique.

14. For such writings, see chapter 4 of Kaeuper, *Holy Warriors*; the sermons in Maier, *Crusade Propaganda and Ideology*; James of Vitry, *Sermones vulgares* ("Ad cruce signatos"), ed. Jean Baptiste Pitra, *Analecta Novissima Spicilegii Solesmensis: Altera Con-*

tinuatio (Paris, 1885–88; repr., Farnborough, UK: Gregg, 1967); Caesarius of Heisterbach, *Dialogus Miraculorum*.

15. For a discussion of the *Perlesvaus* and violence, see Anne Berthelot, "Violence et Passion, ou le Christianisme Sauvage de *Perlesvaus*: *Le haut Livre du Graal*," in *La violence dans le monde médiéval*, Senefiance 36 (Aix-en-Provence: CUER MA, 1994), 21–36, esp. 27; Peggy McCracken, "Damsels and Severed Heads: More on Linking in the *Perlesvaus*," in *"Por le soie amisté": Essays in Honor of Norris J. Lacy*, ed. Keith Busby and Catherine M. Jones (Amsterdam: Rodopi, 2000), 339–55.

16. Barbara Newman, *Medieval Crossover: Reading the Secular against the Sacred* (Notre Dame, IN: University of Notre Dame Press, 2013), 73.

17. For a discussion of internalized feelings versus social acts in the case of Lancelot, see David Hult, "Lancelot's Shame," *Romance Philology* 42, no. 1 (1988): 30–50.

18. Béroul, *Tristan*, in *Tristan et Iseut: Les poèmes français, la saga norroise*, ed. Daniel Lacroix and Philippe Walter (Paris: Livre de Poche, 1989); arabic numerals in text refer to line numbers in this edition.

19. Alberto Varvaro, *Béroul's "Romance of Tristran"* (1963; repr., Manchester: University of Manchester Press, 1972), 98, 90.

20. Matilda Tomaryn Bruckner, *Shaping Romance: Interpretation, Truth, and Closure in Twelfth-Century French Fictions* (Philadelphia: University of Pennsylvania Press, 1993), 68–69.

21. Thomas, *Tristan et Iseut*, in Lacroix and Walter, *Tristan et Iseut: Les poèmes français*; arabic numerals in text refer to line numbers in this edition.

22. Hult, "Esquisses d'interprétation," 84–95.

23. Alfred Ewert, ed., *Gui de Warewic: Roman du XIIIe siècle*, 2 vols. (Paris: Champion, 1933), 2.27–28; arabic numerals in text refer to line numbers in this edition. My translation.

24. Trotter, *Medieval French Literature*, 145.

25. For example see Vander Elst's discussion of *L'histore de Gille de Chyn* in Vander Elst, *The Knight, The Cross, and the Song*, 116–23.

26. J. Riley-Smith, *The Crusades: A History*, 176.

27. Trotter, *Medieval French Literature*, 142.

28. Kelly, "Love in the *Perlesvaus*," 5; Payen, *Le Motif du repentir*, 426–28.

29. Kelly, "Love in the *Perlesvaus*," 3.

30. After he successfully pulls out the bolt in a test by the damsel, Lancelot must undertake two adventures (the Perilous Chapel and the Perilous Castle) as a "grevance" of the offended damsel (lines 8243–47). As the damsel says, "Lanceloz, ceste paine e ceste travail avroiz vos por moi" (lines 8243–44). See Kelly's discussion of the *grevance* as suggesting Lancelot's expiatory penance: Kelly, "Love in the *Perlesvaus*."

31. Kelly, "Love in the *Perlesvaus*," 4.

32. Kaeuper, *Holy Warriors*, 184.

33. See Kennedy, *Lancelot and the Grail*, 315–20, esp. 318.

34. Bogdanow and Barrie, *La Quête du Saint-Graal*, para.79, pp. 214–15; translated passage from Matarasso, *Quest of the Holy Grail*, 89, with some modifications.

35. Lecoy, *Le Chevalier au Barisel: Conte pieux du xiii^e siècle*.

36. See Yedlicka, *Expressions of Repentance*, 124.

37. Micha, *Lancelot: Roman en prose*, vol. 8, ch. 49a, para. 20–22, p. 14; see Payen, *Le Motif du repentir*, 444.

38. Thomas Aquinas, *Opera Omnia*, 25 vols. (Parma: Petri Fiaccadori, 1852–73), vol. 7; *Sent.* Book 4, distinctio 22, q. 2, a. 1, sol. 2. For a discussion on how the contritionist stress on internal reflection is in tension with the emphasis on the performance of the sacrament—that is, the ritualized verbal and physical acts that comprise the sacrament, and especially the effective indispensability of the priest according to the conservative view espoused by Aquinas, see Payen, *Le Motif du repentir*, 558–78; Zink, *La Prédication*. On this same tension in relation to vernacular literature, see Andrew Johnston, "The Secret of the Sacred: Confession and the Self in *Sir Gawain and the Green Knight*," in *Performances of the Sacred in Late Medieval and Early Modern England*, ed. Susanne Rupp and Tobias Döring, Internationale Forschungen zur Allgemeinen und Vergleichenden Literaturwissenschaft 86 (Amsterdam: Rodopi, 2005), 45–63, esp. 54–59.

39. Payen, *Le Motif du repentir*, 427.

40. Marion Bonansea, *Le discours de la guerre dans la chanson de geste et le roman arthurien en prose* (Paris: Champion, 2016), 471.

41. Maier, *Crusade Propaganda and Ideology*, 128–29.

42. On the other hand, in his discussion of various types of chansons de geste, Luke Sunderland discusses how there are many epics where acts of strength are destructive; see Luke Sunderland, *Rebel Barons: Resisting Royal Power in Medieval Culture* (Oxford: Oxford University Press, 2017).

43. Kaeuper, *Holy Warriors*, 101.

44. Louis Brandin, ed., *La Chanson d'Aspremont: Chanson de Geste du XII^e siècle*, vol. 1 (Paris: Champion, 1923), laisse 236, p. 138; Michael A. Newth, trans., *The Song of Aspremont (La Chanson d'Aspremont)* (New York: Garland, 1989), 105. In the more recent edition of François Suard, *Aspremont: Chanson de geste du XII^e siècle* (Paris: Champion, 2008), lines 3593–94, pp. 272–73, the pope orders the crusaders to confess before saying that their penance is to fight: "Toz vos pechiez voiloiz ci regehir / La penitance si soit dou bien ferir!" (Confess here your sins, and your penance will be to fight with all your might!). But this request is followed by the order of Charles to mount right away as he sees the Saracens approach. Suard notes that the pope's language in *Aspremont* resembles Turpin in *Roland*, and both epics have a more forceful call to crusade than that of Pope Urban for the First Crusade.

45. Bernard, *Opera*, 3:215.

46. Henri de Valenciennes, *Histoire de l'Empereur*, para. 523–24, 538, pp. 38–44; my translation.

47. Ian Short, ed., *La Chanson de Roland* (Paris: Livre de Poche, 1990), 164; my translation.

48. Linda Marie Rouillard, "Warrior Relationships with God: From *Roland* to the *Chevalier au barisel*," *Medieval Perspectives* 17, no. 1 (2002): 129–50, quotation at 130.

49. See translation of Simon Gaunt and Karen Pratt, *The Song of Roland and Other Poems of Charlemagne* (Oxford: Oxford University Press, 2016), 80.

50. Jonathan Riley-Smith, *The First Crusade and the Idea of Crusading* (1986; repr., New York: Continuum, 2009), argues that in his preaching of the First Crusade, Pope Urban was already clear about the remission of sins and just violence.

51. Riley-Smith discusses the importance of these historians in *First Crusade*, 135–55.

52. For the "humanization" argument, see Kelly, "Love in the *Perlesvaus*"; see also *The Morgan Crusader Bible: The Picture Bible of Saint Louis*, facsimile edition with commentary by Daniel Weiss and William M. Voelke (Lucerne: Faksimile Verlag, 1998); Noel and Weiss, eds., *The Book of Kings*.

53. See Morris, *Discovery of the Individual*.

54. See Payen, *Le Motif du repentir*, 253–60.

55. Brussels MS 11145, Bibliothèque royale de Belgique, Brussels.

56. Geoffroy Villehardouin, *La Conquête de Constantinople*, ed. Edmond Faral, 2 vols. (Paris: CFMA, 1961), 1:12.

57. W. M. Newman, *Les Seigneurs de Nesle en Picardie (XIIe-XIIIe Siècle): Leur Chartes et Leur Histoire*, 2 vols. (Philadelphia: American Philosophical Society, 1971).

58. For a summary of the dating and Nitze's findings, see Tony Grand, "A Time of Gifts? Jean de Nesle, William A. Nitze and the *Perlesvaus*," in *Arthurian Literature* 13, ed. Keith Busy and Roger Dalrymple (Cambridge: D. S. Brewer, 2006), 130–56.

59. Nitze and Jenkins, *Le Haut Livre du Graal: Perlesvaus*, 409; Bryant, *High Book of the Grail*, 265.

60. Grand, "A Time of Gifts?" 155, 155n140. Active in a literary milieu, Jean is mentioned in three *envois*: in a *tenson* or *jeu-parti* exchanged by Gautier de Dargies and Richart de Fournival submitted to a "seigneur de Niële," and as a recipient of two poems of Audefroi le Bastart (likely Jean's protégé). See Arthur Cullman, *Leben und Werke des Audefroi le Bastard: Eine Literarhistorische und Sprachliche Untersuchung* (Halle, Ger.: Erhardt Karras, 1913), 3; Gautier de Dargies, *Chansons et descorts de Gautier de Dargies*, ed. Gédéon Huet (Paris: Firmin-Didot, 1912), 54; Anna Maria Raugei, ed., *Poesie* (Florence: La Nuova Italia, 1981), 321. See also Richard de Fournival, *L'Oeuvre lyrique de Richard de Fournival*, ed. Yvan G. Lepage (Ottawa: Editions de l'Université d'Ottawa, 1981), 110.

61. Grand, "A Time of Gifts?" 154.

62. W. Newman, *Les Seigneurs de Nesle*, 41–44.

63. Grand, "A Time of Gifts?" 155.

64. See Hult's discussion of how Galehaut reveals the political status of Lancelot in relation to Arthur throughout the cycle and especially in *Mort Artur*, "Esquisses d'interprétation," 91–95. See also Emmanuèle Baumgartner, "Lancelot et le royaume," in *La Mort du roi Arthur ou la crépuscule de la chevalerie*, ed. Jean Dufournet (Paris: Champion, 1994), 25–44.

65. For an overview of crusading imbued with secular ideals, especially crusading as a knightly enterprise, see J. Riley-Smith, "State of Mind of Crusaders."

66. For example, Gawain uses the word in his agreement to comply with Arthur's request for him to engage in a judicial battle in *La Mort du roi Arthur*.

67. See Hult, "Esquisses d'interprétation," 93–96; Baumgartner, "Lancelot et le royaume."

68. See Kennedy, *Lancelot and the Grail*, 72–78, especially her discussion of the crucial role of Galehaut as a rival of Arthur—both Galehaut and Guinevere struggle to possess Lancelot, rather than the rivalry of two men for Iseut in *Tristan*. See also Hult, "Esquisses d'interprétation," 84–87.

69. Hult, "Esquisses d'interprétation," 84–95.

70. Baumgartner, "Lancelot et le royaume."

71. See McCracken, "Damsels and Severed Heads"; Berthelot, "Violence et Passion."

72. See Armand Strubel, introduction to *Le Haut Livre du Graal [Perlesvaus]*, ed. Armand Strubel (Paris: Le Livre de Poche, 2007), 70–71.

73. See Maier, *Crusade Propaganda and Ideology*, and the crusade lyric "Vos qui ameis de vraie amour" (1150–1200), in Bédier and Aubrey, *Les Chansons de croisade*, 20–22.

74. Kelly, "Love in the *Perlesvaus*," 1, 9.

75. Nitze and Jenkins, *Le Haut Livre du Graal: Perlesvaus*, 1:4.

76. For an overview of the Vulgate as written in prose (as opposed to earlier romances in verse, prose had formerly been reserved for chronicles and history) and the growing interest in thirteenth-century prose fiction and romance cycles, see Peggy McCracken, "The Old French Vulgate Cycle," in *The Cambridge Companion to Medieval French Literature*, ed. Simon Gaunt and Sarah Kay (Cambridge: Cambridge University Press, 2008), 35–47.

CHAPTER FIVE

1. Here I am influenced by the cultural theorist and art historian Aby Warburg's idea of image and its *Nachleben*; although he is concerned with the idea of the re-emergence and reformulations of medieval art forms, in the same way I advance an idea of the reformulation and reconfiguration of the courtly crusade idiom as anachronistic, aberrant, "unthought," concrete, and transient—outside of a teleological cultural history. See Georges Didi-Huberman, *The Surviving Image: Phantoms of Time and Time of Phantoms; Aby Warburg's History of Art*, trans. Harvey L. Mendelsohn (University Park: Pennsylvania State University Press, 2017), translation of *Image Survivante* (Paris: Éditions de Minuit, 2002).

2. See Stephen G. Nichols's concept of "anthropology of space" in various genres of texts that treat crusade and pilgrimage in Nichols, "Poetic Places and Real Spaces."

3. See Jaroslav Folda, "Before Louis IX: Aspects of Crusader Art and St. Jean d'Acre, 1191–1244," in Weiss and Mahoney, *France and the Holy Land*, 138–57. For a discussion of how Francophone Outremer manuscripts reflect Byzantine, Arab, and Latin cultures as a syncretic identity, see Émilie Maraszak's study of the Acre mansu-

cripts of the *Histoire ancienne* in Émilie Maraszak, *Les Manuscrits enluminés de l'Histoire Ancienne jusqu'à César en Terre sainte, Saint Jean d'Acre, 1260–1291* (Dijon: Éditions universitaires de Dijon, 2015); Laura Minervini, "Le français dans l'Orient latin (XIIIᵉ-XIVᵉ siècles): Eléments pour la charactérisation d'une scripta du Levant," *Revue de Linguistique Romane* 74, nos. 293–94 (January–June 2010): 119–98.

4. For example, see Karen Rose Mathews, "Mamluks and Crusaders: Architectural Appropriation and Cultural Encounter in Mamluk Monuments," in *Languages of Love and Hate: Conflict, Communication, and Identity in the Medieval Mediterranean*, ed. Sarah Lambert and Helen Nicholson (Turnhout, Belg.: Brepols, 2012); Folda, "Before Louis IX"; Anthony Cutler, "Everywhere and Nowhere: The Invisible Muslim and Christian Self-Fashioning in the Culture of Outremer," in Weiss and Mahoney, *France and the Holy Land*, 253–81.

5. See Nichols, "Urgent Voices," 22–24.

6. Helmut Nickel, "A Crusader's Sword: Concerning the Effigy of Jean d'Alluye," *Metropolitan Museum Journal* 26 (1991): 123–28.

7. Judith W. Hurtig, "The Armored Gisant before 1400" (PhD diss., New York University, 1979).

8. Nickel, "Crusader's Sword," 126.

9. Sharon Kinoshita, "Marco Polo's *Le Devisement dou monde* and the Tributary East," in *Marco Polo and the Encounter of East and West*, ed. Susanne Conklin Akbari and Amilcare Iannucci (Toronto: University of Toronto Press, 2008), 60–86, quotation at 62.

10. Pierre-Vincent Claverie, "Les difficultés de l'épigraphie franque de Terre sainte aux XIIe et XIIIe siècles," *Crusades* 12 (2013): 67–90, esp. 82–84, inscription from 83; image from Johann N. Sepp, *Meerfahrt nach Tyrus zur Ausgrabung der Kathedrale mit Barbarossa's Grab* (Leipzig, 1879), 264; Cécile Treffort, "Les inscriptions latines et françaises des XIIᵉ et XIIIᵉ siècles découvertes à Tyr," in *Sources de l'histoire de Tyr: Textes de l'Antiquité et du Moyen Âge*, ed. Pierre-Louis Gatier and Julien Aliquot (Beirut: Presses de l'Université Saint-Joseph de Beyrouth—Presses de l'Ifpo, 2011), 221–51, esp. 230–32; my translation.

11. See Treffort's account of this epitaph and attempts to find it in the Louvre in Treffort, "Les inscriptions latines," 224n20. I have also been in touch with curators at various archives and museums in France, and they all have not been able to locate this stele. I thank Estelle Ingrand-Varenne for her assistance in this matter.

12. Minervini, "Le français dans l'Orient latin"; Fabio Zinelli, "The French of Outremer Beyond the Holy Land," in *The French of Outremer: Communities and Communications in the Crusading Mediterranean*, ed. Laura K. Morreale and Nicholas L. Paul (New York: Fordham University Press, 2018), 221–46, esp. 232–33.

13. Hans Prutz, *Aus Phönizien* (Leipzig, 1876), 336; Claverie, "Les difficultés de l'épigraphie," 82.

14. Claverie, "Les difficultés de l'épigraphie," 82–83.

15. Auguste Longnon, ed., *Rôles des fiefs du comté de Champagne sous le règne de Thibaud le Chansonnier, 1249–1252* (Paris, 1877); Theodore Evergates, "The Aristocracy of

Champagne in the Mid-Thirteenth Century: A Quantitative Description," in *Social Mobility and Modernization: A "Journal of Interdisciplinary History" Reader*, ed. Robert I. Rotberg (Cambridge, MA: MIT Press, 2000), 48.

16. Malcolm B. Parkes, "The Influence of the Concepts of *Ordinatio* and *Compilatio* on the Development of the Book," in *Medieval Learning and Literature: Essays Presented to Richard William Hunt*, ed. J. J. G. Alexander and M. T. Gibson (Oxford: Oxford University Press, 1976), 115–41.

17. See summary of this manuscript in the O'Sullivan-coedited volume Thibaut de Champagne, *Thibaut de Champagne: Les Chansons*, 39–41. For the establishment of Artesian *auctoritas* through Thibaut, see Daniel O'Sullivan, "Thibaut de Champagne and Lyric Auctoritas in ms. Paris, BnF fr. 12615," in *Textual Cultures* 8, no. 2 (2013): 31–49, esp. 39–44.

18. Parkes, "Influence of *Ordinatio* and *Compilatio*"; inventory of BN fr. 12581 in F. Bourquelot, *Memoires prés. Par div. sav. à l'Acad des Inscriptions*, 2d ser., vol. 5 (1865); MS Pb10 in Gaston Raynaud, *Bibliographie des Chansonniers français des XIIIᵉ et XIVᵉ siècles* (New York: Burt Franklin, 1972), vol. 1, pp. 150–52, chansons of Thibaut featured in fol. 87v–88v, 230–232v, 312v–320v, and 375. See also my discussion of this song and Thibaut in chapter 1.

19. Emmanuèle Baumgartner, "Presentation des chansons de Thibaut de Champagne dans les manuscrits de Paris," in *Thibaut de Champagne: Prince et poète au XIIIᵉ siècle*, ed. Yvonne Bellanger and Danielle Quéruel (Lyon: La Manufacture, 1987), 35–44, esp. 37–38.

20. Christopher Callahan reviews the manuscripts to reconstruct the corpus of Thibaut with a critical eye toward the edition of Wallensköld; he foregrounds the fluidity of attribution. See Christopher Callahan, "Thibaut de Champagne and Disputed Attributions: The Case of MSS Bern, Burgerbibliothek 389 (C) and Paris, BnF fr. 1591 (R)," *Textual Cultures* 5, no. 1 (2010): 111–32; as well as the recent edition coedited by Callahan, Grossel, and O'Sullivan: Thibaut de Champagne, *Thibaut de Champagne: Les Chansons*.

21. Thibaut de Champagne, *Les Chansons de Thibaut*, xvii. Translation of this quotation and discussion of Thibaut as compiler of his songs in Sylvia Huot, *From Song to Book: The Poetics of Writing in Old French Lyric and Lyrical Narrative Poetry* (Ithaca, NY: Cornell University Press, 1987), 64–66.

22. Huot, *From Song to Book*, 64–66. For further discussion of Thibaut's personal songbook in the chansonniers, see Luca Barbieri, "Note sul Liederbuch di Thibaut de Champagne," *Medioevo romanzo* 23, no. 3 (1999): 388–416; Barbieri, "Le canzoni di crociata"; O'Sullivan, "Thibaut de Champagne and Lyric Auctoritas."

23. Barbieri, "Note sul Liederbuch."

24. Barbieri, "Note sul Liederbuch," 392.

25. Huot, *From Song to Book*, 66.

26. Thibaut de Champagne, *Les Chansons de Thibaut*, xvii–xviii n. 3.

27. Evergates, "Aristocracy of Champagne," 45–62, quotation at 48.

28. Evergates, "Aristocracy of Champagne," 48.

29. Joseph Linskill, ed., *The Poems of the Troubadour Raimbaut de Vaqueiras* (The

Hague: Mouton, 1964), from which the *Epic Letter*, pp. 303–312, hereafter will be cited in text as *EL* with laisse and line number. All translations are from this edition, with slight modifications at times.

30. J. Riley-Smith, *Crusades: A History*, 135.

31. See Linskill, *Poems of Raimbaut*, p. 224. Raimbaut's attitude about crusade is illustrated in his hesitation in the song "Ara pot hom conoisser e proar" (lines 73–78, pp. 219, 220). Linskill sees it as "no more than a traditional concession" (p. 224, n. 74) and is confirmed by his earthly reasons for taking up the cross in the *Epic Letter* (Linskill, *Poems of Raimbaut*, pp. 304–5, 309–10). The twelfth-century troubadour Gaucelm Faidit hopes that his lord will provide him with suitable financial support and equipment as he prepares for his departure for the Third Crusade in "Mas la bella de cui" and "Ara nos sia guitz," in *Les Poèmes de Gaucelm Faidit: Troubadour du XIIe siècle*, ed. Jean Mouzat (Paris: Slatkine, 1989), 454–59, 460–67.

32. Linskill, *Poems of Raimbaut*, pp. 204–15.

33. See Oscar Schultz-Gora, *Le Epistole del Trovatore Rambaldo di Vaqueiras* (Florence: Sansoni, 1898); Oscar Schultz-Gora, "Noch Einmal zu den Briefen des Rambaut de Vaqueiras," *Zeitschrift für romanische Philologie* (*ZfRP*) 21 (1897): 206–12; Klara M. Fassbinder, "Formales und Technisches in der höfischen Dichtung des Raimbaut von Vaqueiras," *ZfRP* 47 (1927): 619–43. The transmission of the *EL* among the manuscripts is problematic, which is why I indicate the texts that are transmitted in the chansonnier I discuss, BN fr. 856 (known as troubadour chansonnier C).

34. Linskill, *Poems of Raimbaut*, pp. 304, 310.

35. Schultz-Gora, *Rambaldo di Vaqueiras*, 109n27.

36. Linskill, *Poems of Raimbaut*, pp. 217–19.

37. Linskill, *Poems of Raimbaut*, p. 219.

38. Linskill, *Poems of Raimbaut*, p. 312.

39. Linskill, *Poems of Raimbaut*, p. 344, n. 118.

40. Linskill, *Poems of Raimbaut*, p. 344, n. 118.

41. The song appears not in troubadour chansonnier C, BN fr. 856, but in three other chansonniers: Chansonniers M, Sg, R.

42. Linskill, *Poems of Raimbaut*, pp. 204–15, translation at p. 208, with slight changes. See also Gilda Caïti-Russo, *Les troubadours et la cour des Malaspina* (Montpellier, Fr.: Centre d'études occitanes, 2005), 310–13.

43. See Caïti-Russo, *Les troubadours*, 312n5; she cites De Bartholomaeis.

44. Linskill, *Poems of Raimbaut*, translation at p. 209, reset in verse form.

45. See Linskill, *Poems of Raimbaut*, pp. 301–2; Federico Saviotti, "Il Viaggio del poeta del testo: Per un approccio geografico a Raimbaut de Vaqueiras e alla sua tradizione manoscritta," in *Semestrale di teoria e critica della letteratura X.2*, ed. Alberto Cadioli and Maria Luisa Meneghetti (Pisa: Fabrizio Serra Editore, 2009), 43–59, esp. 58; and Anna Ferrari et al., eds., *Intavulare: Tavole di canzonieri romanzi*, 8 vols. (Vatican City: Biblioteca Apostolica Vaticana, 1998–), I.X; Simone Ventura, *Barcelona, Biblioteca de Catalunya Sg. (146)* (Modena, It.: Mucchi, 2006).

46. See Saviotti, "Il Viaggio del poeta," as well Paolo Di Luca's discussion of the liminal position of the *EL* in these manuscripts citing Caterina Menichetti's work, in

Paolo Di Luca, "La réception de la lettre épique de Raimbaut de Vaqueiras dans sa tradition manuscrite," *Revue des langues romanes* 121, no. 1 (2017): 43–68.

47. Ventura, *Barcelona*, 59–60.

48. Penny Eley, "The 'Saragossa Fragment' of the 'Roman de Troie,'" *Studi francesi* 107 (May/August 1992): 277–84; Miriam Cabré and Sadurní Martí, "Le Chansonnier SG au Carrefour Occitano-Catalan," *Romania* 128, nos. 1–2 (2010): 92–134, esp. 100–101, 134; Fabio Zinelli, "Les Històries franceses de Troia i d'Alexandre a Catalunya i a ultramar," *Mot So Razo* 12 (2013): 7–18, esp. 9.

49. Ventura, *Barcelona*, 35.

50. Cesare Mascitelli develops Saviotti's observations in Cesare Mascitelli, "Il sonetto provenzale di Paolo Lanfranchi tra Raimbaut de Vaqueiras e la Corte d'Aragona," *Carte Romanze* 3, no. 1 (2015): 127–56, at 146.

51. Di Luca, "La réception de la lettre épique," 50.

52. Saviotti, "Il Viaggio del poeta," 43–59.

53. Di Luca, "La réception de la lettre épique," 56; Paolo Savj-Lopez, "La lettera epica di Raimbaut de Vaqueiras in un nuovo manoscritto," in *Bausteine zur romanischen Philologie: Festgabe für Adolfo Mussafia* (Halle: Niemeyer, 1905), 177–192, at 177.

54. Di Luca, "La réception de la lettre épique," 55–56.

55. See Eley, "'Saragossa Fragment'"; Cabré and Martí, "Le Chansonnier SG"; Zinelli, "Les Històries franceses de Troia."

56. See Saviotti, "Il Viaggio del poeta," 59; Ventura, *Barcelona*, 68. For an overview of Occitan-Catalan troubadour production, see Courtney Joseph Wells, "Introduction: The Multilingualism of the Occitan-Catalan Cultural Space," *Tenso* 33, nos. 1–2 (Spring-Fall 2018): iv–xxvii; Miriam Cabré and Sadurní Martí, "Poetic Language in the Multilingual Crown of Aragon," *Tenso* 33, nos. 1–2 (Spring-Fall 2018): 67–91.

57. See Wells, "Multilingualism of Occitan-Catalan Cultural Space."

58. Ventura, *Barcelona*, 67–68.

59. Ventura, *Barcelona*, 68.

60. Jehan de Journi, *La Disme de Penitanche*, ed. Glynn Hesketh (London: Modern Humanities Research Association, 2006), 115; my translation.

61. See the introduction to Jehan de Journi, *La Disme de Penitanche*, 3–5.

62. Keith Sinclair, "The Versified Adaptation of the Prône Prayers by Jean de Journy," *Romanische Forschungen* 92, no. 3 (1980): 247–50; J. B. Molin, "'L'Oratio fidelium': Ses Survivances," in *Ephemerides liturgicae* 73 (1959): 310–17; Robert Cabié, *The Church at Prayer: An Introduction to the Liturgy*, ed. Aimé Georges Martimort, trans. Matthew J. O'Connell, 4 vols. (Collegeville, MN: Liturgical Press, 1986), 2:155–57.

63. See Sinclair, "Versified Adaptation"; J.-B. Molin, "Les Prières du Prône à Provins au XIVe siècle," *Bulletin de la Société d'histoire et d'archéologie de l'arrondissement de Provins*, no. 114 (1960): 57–59; J.-B. Molin, "Les Prières du Prône à Provins au Moyen Âge," *Bulletin de la Société d'histoire et d'archéologie de l'arrondissement de Provins*, no. 116 (1962): 45–54.

64. Joseph A. Jungmann, *The Mass of the Roman Rite: Its Origins and Development*

(Missarum Sollenmnia), trans. Francis A. Brunner, 2 vols. (New York: Benziger Bros., 1950), 1:488.

65. Jungmann, *Mass of the Roman Rite*, 1:489n46.

66. For more discussion on the history of the Prône and its importance in the later Middle Ages as a communal rite, see Katherine Lualdi, "Change and Continuity in the Liturgy of the Prône from the Fifteenth to the Seventeenth Centuries," in *Prédication et liturgie au Moyen Age*, ed. Nicole Bériou and Franco Morenzoni (Turnhout, Belg.: Brepols, 2008), 373–89.

67. See Lualdi, "Change and Continuity in the Liturgy," 373–75, 389.

68. Gilles Grivaud, "Literature," in *Cyprus: Society and Culture 1191–1374*, ed. Angel Nicolaou-Konnari and Chris Schabel (Leiden, Neth.: Brill, 2005), 219–84, 267.

69. Jehan de Journi, *La Disme de Penitanche*, 114–15; my translation.

70. For further discussion of this call for action, see Marisa Galvez, "Jehan de Journi's *Disme de Penitanche* and the Production of a Vernacular Confessional Text Outremer," in *Medieval Francophone Literary Culture Outside France: Studies in the Moving Word*, ed. Nicola Morato and Dirk Schoenaers (Turnhout, Belg.: Brepols, 2018), 191–210.

71. See, for example, the fifteenth-century BN fr. 13258. Such prayers were common during the thirteenth century: see Sinclair, "Versified Adaptation."

72. See Molin, "'*L'Oratio fidelium*'"; Molin, "Les Prières du Prône à Provins au Moyen Âge"; Molin, "Les Prières du Prône à Provins au XIVᵉ siècle"; Sinclair, "Versified Adaptation." In this study of contrafacture in the *Disme*, Emma Dillon's and Ardis Butterfield's work on the translation and re-creation of song through its divisible and mobile binaries of word and melodies, poetry and music have been influential. See Emma Dillon, "Unwriting Medieval Song," *NLH* 46, no. 4 (2015): 595–622, esp. 602; Ardis Butterfield, *Poetry and Music in Medieval France* (Cambridge: Cambridge University Press, 2003).

73. Molin, "Les prières du Prône à Provins au XIVᵉ," 58.

74. For *Cronaca del Templare di Tiro* (1243–1314), see *La caduta degli Stati Crociati nel racconto di un testimone oculare*, ed. Laura Minervini (Naples: Liguori Editore, 2000); *The "Templar of Tyre": Part III of the "Deeds of the Cypriots,"* trans. Paul Crawford (Aldershot, UK: Ashgate, 2003). For *Les Gestes des Chiprois*, see *Recueil de chroniques françaises écrites en Orient au XIIIᵉ et XIVᵉ siècles* (1887; repr., Osnabrück, Ger.: Zeller, 1968). I refer to stanza (in brackets) and page number in the Minervini edition, here *La caduta degli Stati Crociati*, [294], 237–40; and the translated Crawford edition, here *"Templar of Tyre,"* [530], 123–24.

75. Rutebeuf, "La Complainte d'outre-mer," in Bastin and Faral, *Onze poèmes de Rutebeuf*, 57–63.

76. See Grivaud, "Literature," 242–43.

77. Grivaud, "Literature," 219–84, quotation at 244.

78. *La caduta degli Stati Crociati*, [294], 239.

79. Grivaud, "Literature"; Laura Minervini, "Modelli culturali e attività letteraria nell'Oriente latino," *Studi medievali*, 3d ser., 43 (2002): 337–48; David Jacoby, "La

littérature française dans les états latins de la Méditerranée orientale à l'époque des croisades: diffusion et création," in *Essor et fortune de la Chanson de geste dans l'Europe et l'Orient latin* (Modena, It.: Mucchi, 1984), 617-46.

80. Such as BN fr. 844; see John Haines, "The Songbook for William of Villehardouin, Prince of the Morea (Paris, Bibliothèque nationale de France, fonds français 844): A Crucial Case in the History of Vernacular Song Collections," in *Viewing the Morea: Land and People in the Late Medieval Peloponnese*, ed. Sharon Gerstel (Washington, DC: Dumbarton Oaks Research Library and Collection, 2013), 56-109.

81. Jacoby, "La littérature française," 626-28.

82. Jacoby, "La littérature française," 636.

83. Nichols, "Poetic Places and Real Spaces," 128, 132. See also Elizabeth Siberry's discussion of vernacular poets in Siberry, *Criticism of Crusading*, 97.

84. *La caduta degli Stati Crociati*, [294], 237-40; *"Templar of Tyre,"* [530], 123-24, with some modifications.

85. Benoit de Sainte-Maure, *Le Roman de Troie*, ed. Léopald Constans, 6 vols. (Paris: Firmin Didot, 1904-12), 1:7; my translation.

86. On the fabliau, see Fritz Schalk, "Die moralische und literarische Satire: Contes, Dits und Fabliaux," esp. "Poemes und chansons," in *Grundriss der romanischen Literaturen des Mittelalters* VI.1 (Heidelberg: Carl Winter, 1968), 245-60. For the short comic tale, see R. Howard Bloch, *The Scandal of the Fabliaux* (Chicago: University of Chicago Press, 1986).

87. See introduction by Michel Zink to Rutebeuf, *Oeuvres complètes*, ed. Michel Zink (Paris: Librairie générale française, 1989-90), 27-33.

88. Rutebeuf, "La Complainte d'outre-mer," 58; see also Rutebeuf, *Oeuvres complètes*, 846-47n2.

89. Rutebeuf, "La Complainte d'outre-mer," 63; translation from Rutebeuf, "Rutebeuf's 'Lament of the Holy Land,' ca. 1266," trans. and ed. Daron Burrows, in Bird, Peters, and Powell, *Crusade and Christendom*, 390-93.

CHAPTER SIX

1. Olivier de la Marche, *Mémoires*, ed. Henri Beaune and J. d'Arbaumont, 4 vols. (Paris: Libraires Renouard, 1883-88); translation from Andrew Brown and Graeme Small, eds., *Court and Civic Society in the Burgundian Low Countries c. 1420-1530* (Manchester: Manchester University Press, 2007), 42, 46.

2. Raoul Lefèvre, *L'Histoire de Jason: Ein Roman aus dem Fünfzehnten Jahrhundert*, ed. Gert Pinkernell (Frankfurt: Athenäum, 1971), 208; my translation.

3. *Art from the Court of Burgundy: The Patronage of Philip the Bold and John the Fearless 1364-1419* (Cleveland: Cleveland Museum of Art, 2004), 125; published in conjunction with an exhibition of the same title, organized by Stephen N. Fliegel, Sophie Jugie, et al., and presented at the Musée des Beaux-Arts de Dijon, May 28-September 15, 2004, and the Cleveland Museum of Art, October 24, 2004-January 9, 2005.

4. Teresa G. Frisch, ed., *Gothic Art: 1140-c.1450: Sources and Documents* (Englewood Cliffs, NJ: Prentice-Hall, 1971), 136-47.

5. Aristotle, *The Nichomachean Ethics*, trans. R. W. Browne (London: George Bell and Sons, 1889), 95; Thomas P. Campbell, *Tapestry in the Renaissance* (New Haven, CT: Yale University Press, 2002), 15.

6. Christina Normore, "Sensual Wonder at the Medieval Table," in *A Feast for the Senses: Art and Expression in Medieval Europe*, ed. Martina Bagnoli (New Haven, CT: Yale University Press, 2016), 74–83, quotation at 75.

7. See Normore's discussion of Olivier de la Marche's "concerns about the seriousness of the event" with the political agenda in Normore, "Sensual Wonder." See also Rolf Strøm-Olsen, "Political Narrative and Symbolism in the Feast of the Pheasant (1454)," *Viator* 46, no. 3 (2015): 317–42; Richard Vaughan, *Philip the Good: The Apogee of Burgundy* (Harlow, UK: Longman, 1970); Agathe Lafortune-Martel, *Fête Noble en Bourgogne au XVe Siècle, Le Banquet du Faisan (1454), Aspects Politiques, Sociaux et Culturels* (Montréal: Bellarmin, 1984).

8. Campbell, *Tapestry in the Renaissance*, 15.

9. On the Burgundian library, see Georges Doutrepont, *La littérature française à la cour des Ducs de Bourgogne: Philippe le Hardi, Jean sans Peur, Philippe le Bon, Charles le Téméraire* (Paris: Champion, 1909). On the genre of "pseudo-historical" or "historico-realist" fiction, see the work of Rosalind Brown-Grant, "Narrative Style in Burgundian Prose Romances of the Later Middle Ages," *Romania* 130, nos. 519–20 (2012): 355–406. For Philip the Good's library as it relates to crusade and the Feast of the Pheasant, see Judith Guéret-Laferté, "Le Livre et la Croisade," in *Le Banquet du Faisan*, ed. Marie-Thérèse Caron and Denis Clauzel (Arras, Fr.: Artois Presses Université, 1997), 107–14.

10. Danielle Quéruel, "Le Personnage de Jason: De La Mythologie au Roman," in Caron and Clauzel, *Le Banquet du Faisan*, 145–62.

11. On the Burgundian concept of Jason used at the Feast of the Pheasant, see Quéruel, "Le Personnage de Jason."

12. See Quéruel, "Le Personnage de Jason."

13. Olivier de la Marche, "Espitre pour tenir et celebrer la noble feste du thoison d'or," in *Traités du duel judiciaire, relations de pas d'armes et tournois par Olivier de La Marche, Jean de Villiers, seigneur de l'Isle-Adam, Hardouin de La Jaille, Antoine de La Sale, etc.*, ed. Bernard Prost (Paris: L. Willem, 1872), 97–133, quotation at 107; my translation.

14. Strøm-Olsen, "Political Narrative and Symbolism," 323–24.

15. Strøm-Olsen, "Political Narrative and Symbolism," 323. See also Quéruel, "Le Personnage de Jason"; Lafortune-Martel *Fête Noble en Bourgogne*, 119–28.

16. Quéruel, "Le Personnage de Jason," 152–58; Lafortune-Martel, *Fête Noble en Bourgogne*.

17. Doutrepont, "Jason et Gédeon patrons de la Toison d'or," *Mélanges offerts à Godefroid Kurth*, (Paris-Liège, 1908), 194; Lafortune-Martel, *Fête Noble en Bourgogne*, 120. See Anne Hagopian van Buren, "The Model Roll of the Golden Fleece," *Art Bulletin* 61.3 (1979): 359–76, for other accounts of Jason and the Golden Fleece in other media during this era, including Caxton's description of Hesdin in the introduction to his English translation of *Livre du Jason et de Médée*, see Vaughan, *Philip the Good*, 162.

18. Morgan MS 119, Pierpont Morgan Library, New York (MS B). The four manuscripts are the perhaps autographed MS O, Arsenal 5067 (1467) with ten miniatures; MS A, BN fr. 12570 in paper, with the arms of Jean de Wavrin; and MS B and MS C, BN fr. 331, parchment manuscript belonging to Louis of Bruges, Lord of Gruthyuse; see Lefèvre, *L'Histoire de Jason*, 17–35. MS A and MS O likely share the same artist and have the same miniatures except for two (see Lefèvre, *L'Histoire de Jason*, 21n17).

19. C. Dehaisnes, "Documents inédits concernant Jean Le Tavernier et Louis Liédet, miniaturists des ducs de Bourgogne," *Bulletin des Commissions royales d'art et d'archéologie, Commission royale des monuments et des sites* 20–21 (Brussels, 1881–82): 32–34.

20. Sophia Ronan Rochmes, "Color's Absence: The Visual Language of Grisaille in Burgundian Manuscripts (PhD diss., University of California–Santa Barbara, 2015); Sophia Ronan Rochmes, "Philip the Good's Grisaille Book of Hours and the Origins of a New Court Style," *Simiolus Netherlands Quarterly for the History of Art* 38, nos. 1–2 (2015–16): 17–30, quotation at 25.

21. Strøm-Olsen, "Political Narrative and Symbolism," 322.

22. Such as the cookbook the *Viandier*, an influential recipe collection of the late Middle Ages, by Guillaume Tirel, who was called Taillevent. Taillevent served the French royal court from the 1320s until his death in 1395; see Taillevent, *The Viandier of Taillevent: An Edition of All Extant Manuscripts*, ed. and trans. Terence Scully (Ottawa: University of Ottawa Press, 1988).

23. De la Marche, *Mémoires*, 2:367; Christina Normore, *A Feast for the Eyes: Art, Performance, and the Late Medieval Banquet* (Chicago: University of Chicago Press, 2015), 45.

24. De la Marche, *Mémoires*, 2:367; Normore, *Feast for the Eyes*, 203n1; 84.

25. Normore, *Feast for the Eyes*, 24.

26. Taillevent, *Viandier*, 300.

27. Normore, *Feast for the Eyes*, 24; Normore, "Sensual Wonder," 82.

28. See Strøm-Olsen, "Political Narrative and Symbolism," 318 on the Feast of the Pheasant as sui generis; Normore's discussion of de la Marche's defense in Normore, *A Feast for the Eyes*, 85–101.

29. Campbell, *Tapestry in the Renaissance*, 15.

30. Vaughan, *Philip the Good*, 162. See also Anne Hagopian van Buren, *Art Bulletin* 61, no. 3 (1979): 359–76, esp. 370–76; Doutrepont, *La littérature française*, 150.

31. François Tabard, "The Weaver's Art," in *The Book of Tapestry: History and Technique*, ed. Pierre Verlet et al. (New York: Vendome Press, 1978), 188–224, quotation at 192.

32. Best and Marcus, "Surface Reading"; Sharon Marcus, Heather Love, and Stephen Best, "Building a Better Description," *Representations* 135, no. 1 (Summer 2016): 1–21; Levinson, "What Is New Formalism?"

33. Peter Stabel, "Le Goût pour l'Orient: Demande cosmopolite et objets de luxe à Bruges à la fin du Moyen Âge," *Histoire urbaine*, no. 30 (April 2011): 21–39.

34. Luca Mola, "A Luxury Industry: The Production of Italian Silks 1400–1600," in *Europe's Rich Fabric: The Consumption, Commercialisation, and Production of Luxury*

Textiles in Italy the Low Countries and the Neighbouring Territories (Fourteenth–Sixteenth Centuries), ed. Bart Lambert and Katherine Anne Wilson (Burlington, VT: Ashgate, 2016), 205–34, at 224–25; Campbell, *Tapestry in the Renaissance*, 18–19.

35. See Normore's extensive discussion of this tapestry in Normore, *A Feast for the Eyes*, 143–44.

36. Campbell, *Tapestry in the Renaissance*, 18.

37. Campbell, *Tapestry in the Renaissance*, 18.

38. Georges Chastellain, *Oeuvres*, ed. Baron Kervyn de Lettenhove, 8 vols. (Brussels, 1863–66), 3:90, 4:93–94.

39. Adolf Cavallo, *Medieval Tapestries in the Metropolitan Museum of Art* (New York: Metropolitan Museum of Art, 1993), 49.

40. Campbell, *Tapestry in the Renaissance*, 62–63.

41. Campbell, *Tapestry in the Renaissance*, 48.

42. Campbell, *Tapestry in the Renaissance*, 63.

43. Campbell, *Tapestry in the Renaissance*, 62.

44. Campbell, *Tapestry in the Renaissance*, 18.

45. Katherine Anne Wilson, "Tapestry in the Burgundian Dominions: A Complex Object," in *La Cour de Bourgogne et L'Europe: Le rayonnement et les limites d'un modèle culturel, Actes du colloque international tenu à Paris les 9, 10, et 11 octobre 2007*, ed. Werner Paravicini et al. (Ostfildern, Ger.: Jan Thorbecke Verlag, 2013), 318–19.

46. See Léon Laborde, *Les ducs de Bourgogne: Études sur les lettres, les arts et l'industrie pendant le XVe siècle et plus particulièrement dans les Pays-Bas et le duché de Bourgogne* (Paris, 1849–52); Cavallo, *Medieval Tapestries*; Campbell, *Tapestry in the Renaissance*. On the silk industry, see Molà, " Luxury Industry"; Sharon Farmer, *The Silk Industries of Medieval Paris: Artisanal Migration, Technological Innovation, and Gendered Experience* (Philadelphia: University of Pennsylvania Press, 2016). On luxury objects and medieval cultural exchange, see Cecily J. Hilsdale, *Byzantine Art and Diplomacy in an Age of Decline* (Cambridge: Cambridge University Press, 2014).

47. Cecily J. Hilsdale, "The Thalassal Optic," in *Can We Talk Mediterranean? Conversations on an Emerging Field in Medieval and Early Modern Studies*, ed. Brian A. Catlos and Sharon Kinoshita (Cham, Switz.: Palgrave, 2017), 19–32, at 23.

48. See Bruno Latour's call for new modes of description about things as assemblages in Latour, *Reassembling the Social*; Latour, "Why Has Critique Run out of Steam?" See also his discussion of new materialism in Bruno Latour, "Can We Get Our Materialism Back, Please?" *Isis* 98, no. 1 (March 2007): 138–42. On Geertz's "thick description," see Clifford Geertz, "Thick Description: Toward an Interpretative Theory of Culture," in *The Interpretation of Cultures* (New York: Basic Books, 1973).

49. See, for example, E. Jane Burns, *Courtly Love Undressed: Reading through Clothes in Medieval French Culture* (Philadelphia: University of Pennsylvania Press, 2002).

50. Quéruel, "Le Personnage de Jason," 155–57.

51. Quéruel, "Le Personnage de Jason," 156; for "Le Congé d'Amour," see Robert Deschaux, *Un poète bourguignon du XVe siècle: Michault Taillevent (Edition et Etude)* (Geneva: Droz, 1975), 59–86, 251–57, verse quotation at 252.

52. De la Marche, *Mémoires*, 2:358.

53. De la Marche, *Mémoires*, 2:360; A. Brown and Small, *Court and Civic Society*, 47.

54. De la Marche, *Mémoires*, 2:361; my translation.

55. Normore, *Feast for the Eyes*, 36.

56. De la Marche, *Mémoires*, 2:357.

57. Jean Porcher, *Les Manuscrits à peintures en france du XIIIᵉ au XVIᵉ siècle* (Paris: [Bibliothèque Nationale, France], 1955), 143-45.

58. Quéruel, "Le Personnage de Jason," 158.

59. Rochmes, "Color's Absence," 94.

60. See examples in Pascal Schandal, "Le Maître du Champion des dames," in *Miniatures flamandes, 1404-1482*, ed. Bousmanne, Bernard, and Thierry Delcourt, with Ilona Hans-Collas et al. (Paris: Bibliothèque nationale de France, 2011), here no. 103, ill. 272.

61. See Rochmes's discussion of color symbolism during this period in Rochmes, "Color's Absence," 42.

62. See Lorraine Daston and Katherine Park, *Wonders and the Order of Nature* (New York: Zone, 1998), 67-108, at 104-5.

63. Rochmes, "Color's Absence," 40.

64. Rochmes, "Color's Absence," 15-16.

65. Till-Holger Borchert, "Color Lapidum: A Survey of Late Medieval Grisaille," in *Jan Van Eyck: Grisallas*, ed. Till-Holger Borchert (Madrid: Museo Thyssen-Bornemisza, 2009), 239-253, at 251.

66. Borchert, "Color Lapidum," 251.

67. Rochmes, "Color's Absence," 70.

68. Georges Didi-Huberman, "Grisaille," in *Phalènes: Essais sur l'apparition, 2* (Paris: Les editions de minuit, 2013), 280-305, quotation at 281.

69. Rochmes, "Color's Absence," 70.

70. Rochmes, "Color's Absence," 84-86.

71. Rochmes, "Color's Absence," 86.

72. Rochmes, "Color's Absence," 88.

73. Schandal, "Le Maître du Champion," pp. 368-69.

74. Schandal, "Le Maître du Champion," p. 369; my translation.

75. Schandal, "Le Maître du Champion," pp. 367-69, quotation at 369.

76. Lefèvre, *L'Histoire de Jason*, 150-51; my translation and emphasis.

77. I purposefully evoke the positive valence of "stray details" as described in Marcus, Love, and Best, "Building a Better Description," 11.

78. Lefèvre, *L'Histoire de Jason*, 208; my translation.

79. Recent scholarship on French texts Outremer reinforce the view that these performances probably inspired Arthurian performances in the West; see Jacoby, "La littérature française"; David Jacoby, "Knightly Values and Class Consciousness in the Crusader States of the Eastern Mediterranean," in *Mediterranean Historical Review* 1 (1986): 158-86. The corpus of Old French texts circulated in Outremer has been reassessed as well as the speakers of the French language in the Latin East among Westerners in the Crusader States, especially after the establishment of the eastern terri-

tories by Christian settlers. See Morreale and Paul, *French of Outremer*, esp. 2–5; Uri Zvi Shachar, "'Re-orienting' *Estoires d'Outremer*: The Arabic Context of the Saladin Legend," in Morreale and Paul, *French of Outremer*, 150–78.

80. *Les gestes des Chiprois*, in *Recueil de chroniques françaises*, 220; Jacoby, "La littérature française," 630–31; Jacoby, "Knightly Values," 167.

81. Matthew of Paris, *Chronica Majora*, ed. H. R. Luard, 7 vols. (London, 1872–83), 5:318–19; Jacoby, "Knightly Values," 167.

82. Rather than arguing for the ineffability of an object or metaphor or an affective suspension made through medieval poetic texts—recent innovative approaches advanced in relation to devotional lyric and art—I argue for an intermedial description of "form" and aesthetic responses through a multiplicity of media produced in relation to an event. The idiom exists through a community of participants by means of their active engagement at the feast, through their specific usage of the idiom in, through, and with these media. For a recent example on affect and form that takes a different approach, see, for instance, Evelyn Reynolds's discussion of absorption in devotional texts using affective image theories of Hans Belting, Michael Fried, and others, in Evelyn Reynolds, "Trance of Involvement: Absorption and Denial in Fifteenth-Century Middle English Pietàs," *Journal of English and Germanic Philology* 116, no. 4 (October 2017): 438–63.

CONCLUSION

1. For instance, see William R. Polk, *Crusade and Jihad: The Thousand Year War between the Muslim World and the Global North* (New Haven, CT: Yale University Press, 2018); Paul M. Cobb, *The Race for Paradise* (Oxford: Oxford University Press, 2014).

INDEX

Page numbers in italics refer to figures.